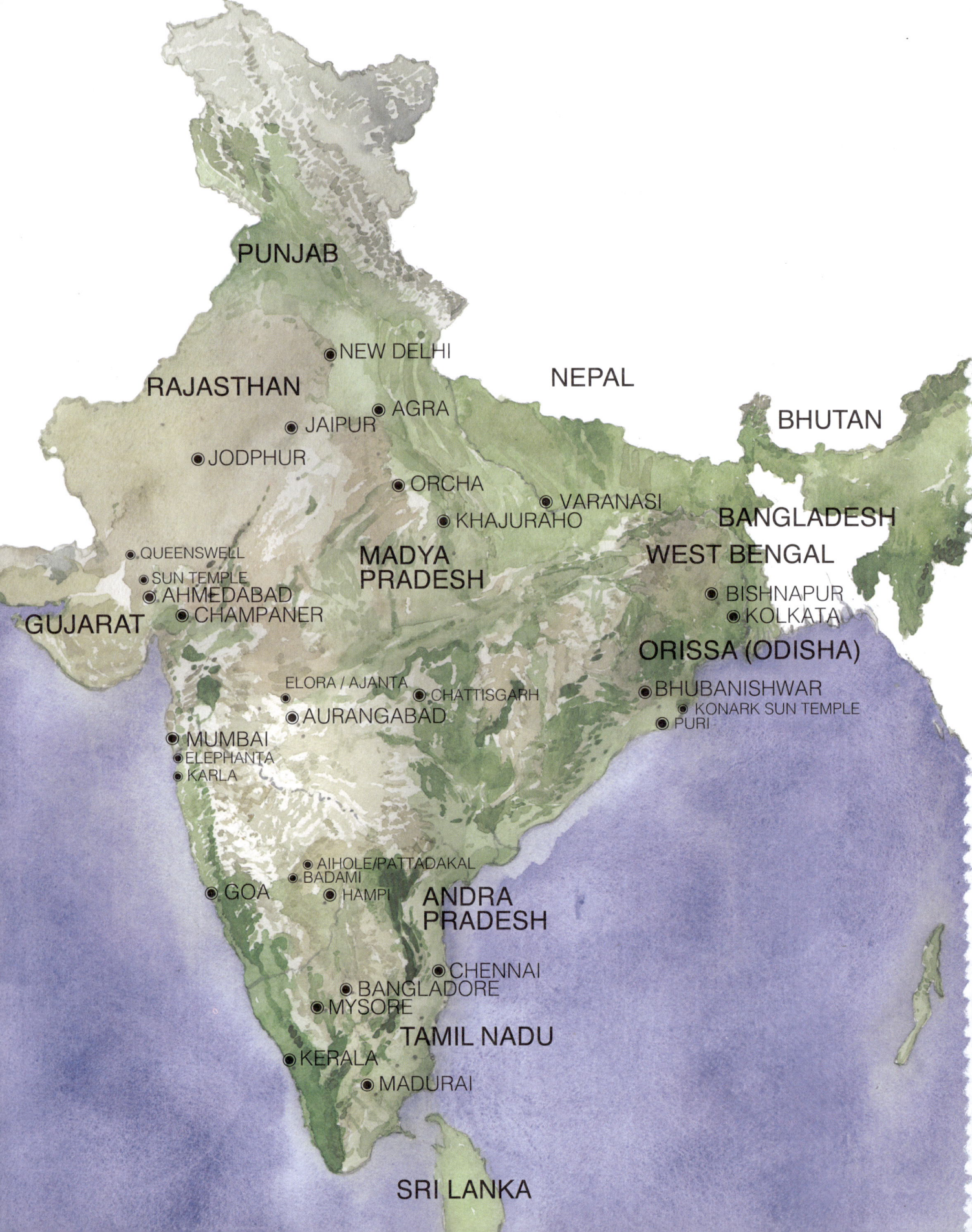

TIRTHAS

THE THIN PLACES WHERE EARTHLY AND DIVINE MEET

TIRTHAS
THE THIN PLACES WHERE EARTHLY AND DIVINE MEET

AN ARTIST'S JOURNEY THROUGH INDIA

DANA WESTRING

FOREWORD
François Borne

PREFACE
Gayatri Rangachari Shah

G Editions

CONTENTS

Foreword François Borne	9
Preface Gayatri Rangachari Shah	15
Roots	18
Ozymandias Effect	26
The Thin Places	31
Jasmine	34
Mumbai, Aurangabad, Ajanta, Ellora	34
Trimurti	38
From Wood to Stone	42
Cliffs and Crevasses	44
Salty Soil	53
Cool, Dark Chambers	58
Champaner	62
East Across the Continent	66
Now He Is My Son	70
Pencils and Paper	76
Pattern Books	79
The Pompeii of India	80
Bell Tones and Chants	98
Red Roses	104
My Indian Brother	107
Toward the South	109
The Coromandel Coast	118
Cheeky Monkeys	121

Chariots	127
Danish Accent	130
Lord of the Dance	132
Sun and Silk	139
Harvest Festival	143
Temple City	146
Off the Road in Chettinad	151
Sir, I Impress You	161
Terracotta Horses	166
Divine Intervention	169
200 BCE University	172
High Emotions	180
Baker's Ovens	183
The Remains of the Raj	184
The East India Company Capital	188
Terracotta Temples	198
Your Drawing Is Meditation	208
Iron Construction	217
Palm Leaf Drawings	221
Wedding of Shiva	225
On the Ghats	237
Looking In	241
Acknowledgments	245

Foreword
François Borne

The views of Indian Temples that Dana Westring drew over the past decade on his yearly visits to India occupy a singular place in the artist's work. These drawings are not the result of commissions but are a personal response to a spiritual encounter with the holy sites of one of the most ancient cultures in the world. They illustrate what the artist calls a pilgrimage and records a journey through the architectural history of the Divine, in a country which is not his own. Presented and published together these watercolours are an homage to India and reflect the fascination its civilisation has exercised upon the rest of the world for centuries. India's spirituality, like the water at the bottom of the ancient stepwells in Gujarat, meets those who make the effort to scale down the stairs to reach it. It is an exploration in which Dana Westring did not only transcribe in pencil and watercolor, but one that he also conveyed in writing, as so many visitors had done in the past. Reading the text alters one's approach to the drawings, just as looking at the drawings clarifies the points made in the text. Drawings and text complement each other. In the same way that a crystal light seems to bathe Dana Westring's views, his writing style is candid, informative and spontaneous. His words play the part of subtitles to his majestic vision of India's temples.

This essay will try to go beyond a mere aesthetic appreciation of the drawings. It will endeavor to show how an American artist keen on discovering more of India than what tourists normally see brought two cultures, so rarely coupled, in direct contact with each other through the study of Indian temples. Hopefully, it will allow connoisseurs, the majority of whom are accustomed to a strictly Anglo-Indian approach, to discover an American perspective on India. Indeed, Dana Westring's fascination with the monumentality of Nature, inherited from the American Transcendentalist movement, seems to have found its perfect expression in his dramatic depiction of Hindu temples. In these deceptively simple and luminous views,

the artist celebrates how Nature transcends architecture in order to celebrate the meeting of gods and mankind at holy places, the "thin places" used as title to this book. A close analysis of these drawings, drawn in an open-air outdoor environment, called en plein air, reveals unexpected affinities which, like a translucent cobweb, unite the Indian and American cultures.

Very few American artists of note ever toured India to seek direct inspiration from its monuments and its culture. Only two in the past seem to have done so, during the Gilded Age of the late 19th century America: Edwin Lord Weeks (1849-1903) and Lockwood de Forest (1850-1932). Both men came from wealthy East Coast families with fortunes built on international trade, and shared a fascination for India. De Forest, although a painter by training, was more of a businessman, interested in the Decorative Arts. In 1879 he joined Louis Comfort Tiffany in partnership with Associated Artists, the leading firm of architectural woodwork inspired by the American Aesthetic Movement. In the same year, he and his wife left for India where they travelled extensively. In Ahmadabad, they started a woodcarving company to promote Indian arts across the world. There they met with Edwin Lord Weeks, who was on his first foray into India. Born in New England, Weeks was an American expatriate in Paris in the 1870s. Having trained with the Orientalist painter Gérôme and the portraitist Léon Bonnat, he settled in Paris climbing the slippery ladder of the French art establishment. However, by nature, Weeks was more explorer than painter. He visited India three times, in 1882, 1886 and 1892. These trips had been commissioned by *Harper's Magazine*. In 1896 *Scribner's Magazine* published an account of his travels, "From the Black Sea through Persia and India," recounting his adventures. He received from the French government at the very young age of forty-seven the *Légion d'Honneur*.

Serendipitously, the lives of Dana Westring and Edwin Lord Weeks, although a century apart, mirror one another. Both trained as artists, but their ambitions extended well beyond their initial choice of professions. Dana Westring, of Swedish descent, was born and brought up in Nebraska, on the Great Plains of the United States. Passionate about architecture and design, Westring achieved recognition as a trompe l'oeil painter, a demanding technique that he practiced most successfully on a large scale all over the world, but particularly on commissions in the Middle East. Yet, as an answer to such a peripatetic existence, on the model of Voltaire's *Candide*, Dana became an innovative garden designer challenging the climate of the Northern Virginia Piedmont, in the valley between the Bull Run and Blue Ridge mountains. In the same way that Weeks had succumbed to the lure of India, Westring decided in 2009 to add a further dimension to his life. For ten years Westring would spend some of the winter months touring India, traveling sometimes with friends, but for the most part on his own off the beaten tracks. He shared with Weeks a taste for adventure that is palpable both in their artistic productions and diaries. Both artists reveal a similarity of approach in their depictions of famous sites. Both favor open spaces saturated with warm clear light. In Weeks's paintings, architecture, although at the heart of his work, is never magnified. It is almost understated, merely used as backdrop to street life. The same un-theatrical manner is noticeable in Westring's work: This time architecture is almost enhanced by the absence of figures in his compositions. Both artists avoided grandiloquence, wishing to convey the natural beauty and sanctity of a place respectfully.

The most important influence on Dana Westring's work remains, however, the Anglo-Indian landscape tradition. His views of Indian Temples pay homage to Thomas Daniell, whose compositions had influenced so markedly the way in which the Western world had come to perceive those fabled lands. Until the middle of the eighteenth century, the publication of accounts of merchants, explorers and diplomats were the only means of information available to an educated and therefore restricted audience. It was the wide distribution of single prints combining exoticism with traditional

European landscape conventions that suddenly enflamed European imagination. In his diary, Dana Westring described the spell such framed images had cast on his mind when visiting an English country home. In 1785, just as Johan Zoffany and Ozias Humphrey had done a few years earlier, Thomas Daniell and his nephew, William, sailed for Calcutta where the East India Company provided them with protection and financial support. They toured the country for the following nine years. As early as 1788, the first print showing a view of Calcutta was locally published. On the 7th of November, 1788, Daniell wrote to Ozias Humphrey, who was back in London: "The Lord be praised, at length I have completed my 12 views of Calcutta... You know I was obliged to stand Painter Engraver Copper-smith Printer and Printers Devil myself. It was a devilish undertaking but I was determined to see it through at all events." To catch the charm and distinctive character of a foreign location and to transcribe them in a composition which can successfully convey that uniqueness to a wider audience remains to this day the greatest challenge that any artist faces while traveling.

Another significant European influence on Dana Westring is the tradition of en plein air painting which, having started as an experimental process in Italy during the Renaissance and the Baroque eras among artists suffering from working in the seclusion of their studios, developed steadily through the Romantic age, culminating with Impressionism and becoming a rage among dilettanti.

As a result, painting or drawing en plein air became a hobby associated with the lifestyle of world travelers dabbling with art. Such an image contributed greatly to the decline of the genre over the last century. Most people, however, who have tried their hand at that technique find it most demanding. Indeed, it is a technique that requires sustained effort and even physical endurance. The discomfort of working in the open air either in blazing sunshine as in India or in-between cold showers in Scotland is, to say the least, disruptive. Speed of execution is paramount: Finding the ideal spot, identifying the correct angle of observation, laying out the limited equipment at hand, coping with ever-changing light and colors are as many concerns that an artist could share in a military context with an elite sniper. The execution of any view has to be swift, precise, and consistent. Yet, the artist's sensation of being engulfed in the very nature of his work is at the very core of the experience. It is intoxicating and turns into an adventure in its own right, a triumph of the mind over matter. Each view tells its own story, recording a moment of intense encounter with Nature. Today the practice seems, however, to have gone out of fashion. The triumph of digital photography has somewhat defeated the purpose of such high-level self-discipline.

Such artistic traditions are alien to the Indian culture. Its school of painting does not subscribe to the exclusive use of perspective to define space. This is in direct opposition to the architectural training received by Dana Westring in the West. Where the human figure is at the centre of all representation in classical Indian painting, Westring chooses deliberately to keep his depiction of temples, normally filled with worshippers, almost clear of any human figures. Indian masters burnish with agate the *verso* of their miniatures in order to achieve a perfect smoothness of surface, from which all trace of human craftsmanship has been carefully removed to enhance the preciosity of the object as a work of art.

In contrast, Dana Westring approaches the creative process in a radically different way. At first, en plein air, the artist outlines softly in pencil the shape of a temple, on a large sheet of paper, using the grain of the paper to conjure the temple into existence. As the composition takes shape, each stroke of pencil becomes stronger, until the highlights of light and shadow applied as finishing touches, indent ever deeper in the fibre of the paper, rising to a crescendo. Like a magician, the artist orchestrates the emergence of his composition on paper. Ultimately, each building achieves its own degree of realisation on paper: Some remain sketchy, trapped in the haziness of a far distant vision; some seem to gush out

of the surface of the paper; others end up washed with watercolour, a process that ends up warping irretrievably the sheet of the paper. Such dramatic handling of the material, delicate in some aspects, rough in others, seems to be the ineluctable result of a metamorphosis taking place on paper through the hands of an artist submerged by the intensity of his encounter with the Divine.

For Hindus, temples mark the "thin places" where Gods reveal themselves to mankind. The Brahmins watch over these sacred locations where such encounters with the Divine are sought out. Such places abound in India. In his "great compilation" called the *Brihat-Samhita,* by the 6th century astrologer, Varahmiriha, stated that "the gods always play where groves are, near rivers, mountains and springs." Mountains are an essential part of the symbolism of temples. In Indian mythology, the sacred river, the Ganges, flows from the Mountain of Shiva. As George Michell stressed in his remarkable study on Hindu temples, "a temple is an architectural facsimile of the sacred places of the gods providing for the worshipper the merit that would be his through an actual visit to the mountains." The superstructures shooting up in the sky that are such a distinctive feature of any Hindu temples are called Shikhara, or "mountain peaks" or "crests." These soaring towers are placed on platforms called in turn Bhumi, "soil" or "earth." In a similar way to mountains, caves represent the most sacred part of a temple and indeed the most famous places of pilgrimages are real caves. But in most temples the sanctum sanctorum are similarly man-made grottoes in which the gods reside in a symbolic representation of the wilderness. Thus, a temple brings together two essential aspects of Nature: mountains and caves. The sanctuary in the shape of a cave, dark, small and confined, finds itself placed directly beneath the summit of the mountain in a vertical alignment or cosmic axis, supporting the heavens over the universe. The temple is therefore an act of worship celebrating Nature through which the Divine reveals itself to mankind.

Interestingly such symbolism became widely debated in the United States from the beginning of the 19th century onwards, in a manner which has influenced the American culture greatly. Transcendentalism became a movement that developed on the East Coast of America in the 1820s and 30's, gained in popularity through the writings of Ralph Waldo Emerson and his friend and follower, Henry David Thoreau. Their conviction was that attempting to perceive the Divine through Nature helped individuals reach beyond their human condition. In 1849 Emerson published an essay entitled *Nature* in which the author compared Nature to a language that could teach new words to mankind as it reveals itself to those who observed it. That quest for spirituality coincided with a longing to explore and discover the virgin lands of North America. This was in no way a new phenomenon. The French Huguenots of the 16th century had thought that the remnants of the Garden of Eden were in Florida. Puritans had found refuge in a new England. Fleeing the French Revolution, political refugees such as Talleyrand and Du Pont de Nemours sailed to America. In 1791 the Marchioness de la Tour du Pin, former lady-in-waiting to Queen Marie-Antoinette, had found security in becoming a farmer near Albany, New York, giving a new meaning to Jean-Jacques Rousseau's writings. The following year, Chateaubriand traveled to Niagara Falls and later recounted his experience in his magnum opus, *Le Génie du Christianisme*, in a chapter entitled, "The Proof of the Existence of God through the Marvels of Nature." In the same way, the Hudson River School of painting strove to depict the American landscape as a reflection of God.

It was only after 1854, however, that Thoreau started to make clear references to Hindu Vedic texts in *Walden, or Life in the Woods*, in which the author described his years of self-isolation in the wilderness of Concord, Massachusetts. From 1875, the interest in Indian Vedic texts became more esoteric, resulting in the creation of the Theosophical Society in New York as a kind of religion, by the eccentric Russian émigré Helena Blavatsky. The

popularity of Ashrams among a dissatisfied generation of Westerners in the 1960s and 1970s proved how deeply rooted in the American mind was the appeal of Indian spirituality. As a result of such persistent trend of thought, it is therefore not surprising to detect a shared vision of Nature between the Hindu tradition and Dana Westring's American perception of the sacred ground of the "thin places."

The charm of Dana Westring's depictions of Hindu Temples lies not so much in their exotic and romantic dimension but in the almost classical timelessness of their monumentality. There is a sense of majestic grandeur to the whole series. It conveys a tremendous sense of respect for these extraordinary sites. It is a fact that the Western world has always been very keen on preserving its monuments for the future, not only cathedrals, but the smallest log cabin or even the primeval forests of America kept "archeologically" if artificially alive, a concept that is inconceivable in India. Museums in India are rather sad affairs. Temples last as long their divinities keep revealing themselves to the worshippers. When they stop being visited by them, the buildings are progressively abandoned and their fabrics are left to crumble. The same was true of palaces such as Fatehpur Sikri. Although run by the central government, the Archeological Survey of India faces an uphill battle to preserve these sites. In a very subtle way, Dana Westring avoids making the distinction between the ruins and the active places of worship. We have already mentioned the absence of figures, which endows the sites with an eerie stillness; but the artist restricts voluntarily the range of colour he uses in the watercolours. Unlike Victorian watercolours blazing with colours, the only vibrant pigment used by the artist is the intense blue of the sky. The contrast between such celestial blue and the metallic sheen of the pencil used to draw the cliffs and stones of the buildings creates a dramatic effect bordering on the austere. In the jargon of painters and draughtsmen, one often judges the quality of a work of art on its ability to catch the eye when hanging on a wall. When looked at from a distance some work imposes itself to the attention of the public. So do most of Dana Westring's views.

The quality which, however, should be ultimately emphasised in the conclusion of this essay is one which derives from the level of energy emanating from Dana Westring's draughtsmanship. The artist is evidently impetuous, driven by his wish to transcribe as much of the specific intensity of each place. When visiting Ellora, the artist obviously thought that the rocks out of which the temples had been carved contributed as much to his sense of wonderment as the architecture itself. Rather than downplay that overwhelming mineral dimension of the place, the artist found a way of expressing the clash between what has been hand made and what came directly from the earth in a striking manner. Using his pencil boldly, the artist drew the cliffs in a rhythmic, almost violent hatching. The drawings of Ellora breathe with life. One feels that his pencil at the moment of creation danced and raced over the paper providing a drawn choreography as background to the temple he was depicting. Such technical bravura reveals the force of the artist's purpose: his spontaneous response to an extraordinary place.

Preface
Gayatri Rangachari Shah

When I was introduced to Dana Westring's work through a mutual friend, I was stunned by his commitment and devotion toward India, at how widely he had traveled through the country, and how deeply immersed he was in our cultural and religious traditions. Since time immemorial, India has held a fascination for the outside world. From travelers to traders to invaders to colonizers, it has been a sought-after land for those in search of wanderlust and fortune. Americans will recall that a few centuries ago, Christopher Columbus had set out for India when he instead landed on the shores of the future United States. In the last century, India drew those in search of spiritual or religious "awakening." A confluence of cultures gives this vast subcontinent a diversity that isn't found anywhere else in the world.

India has had an extraordinary ability to simultaneously captivate and repulse. Yet for those able to move past the latter, the country and its culture can be transformative, imbuing an individual with the types of experiences that seemingly defy reality. The sensory overload of sights, smells, sounds—all the cliches apply. Perplexing, intriguing, magical, seductive, enveloping, maddening—India is an assortment of emotional adjectives balled up into one: unique.

Yet oftentimes the lure of a foreign land can result in fetishizing, exoticizing, and even demonizing. Dana, with his nuanced understanding, has clearly done none of that. Looking at his beautiful watercolors and drawings of India's pilgrimage sites, or *tirthas*, reminds me of those eighteenth- and nineteenth-century European travelogues with their vivid drawings penned by artists reproducing, and sometimes interpreting, what they saw. Indeed, Dana's depiction of these tirthas, many frequently away from more popular tourist

PREFACE

routes, offer the world a window into places of worship that are, in fact, less accessible but no less magnificent than those that are more widely visited. In an era when most knowledge is cursory, Dana's text, which accompanies his artwork, revels at the complexities of this country. The writing is non judgmental—a skillful observer's take on a society rooted in the ancient world but also embracing of the modern.

In this hyper digital age of camera phones, when imagery is instantly clicked and deleted, how wonderful that Dana chose to pursue a painting tradition that harks back to humanity's earliest creative impulses. We all know that a book will endure far longer than a Pinterest mood board.

Dana's multifaceted approach, honed over decades of his own interdisciplinary career as a landscape artist, illustrator, and muralist, are laudable. He carries on an artistic tradition that, at its finest, introduces the world's wonders to a new audience. That this can still happen in the twenty-first century, when we are all so globally entwined and digitally addicted, is all the more remarkable. I do hope others will enjoy this book and its accompanying artwork as much as I have. It certainly deserves to be on the shelf of not just every Indophile, but anyone with even a fleeting interest in drawing, landscape art, architecture, and indeed, the wider world.

ROOTS

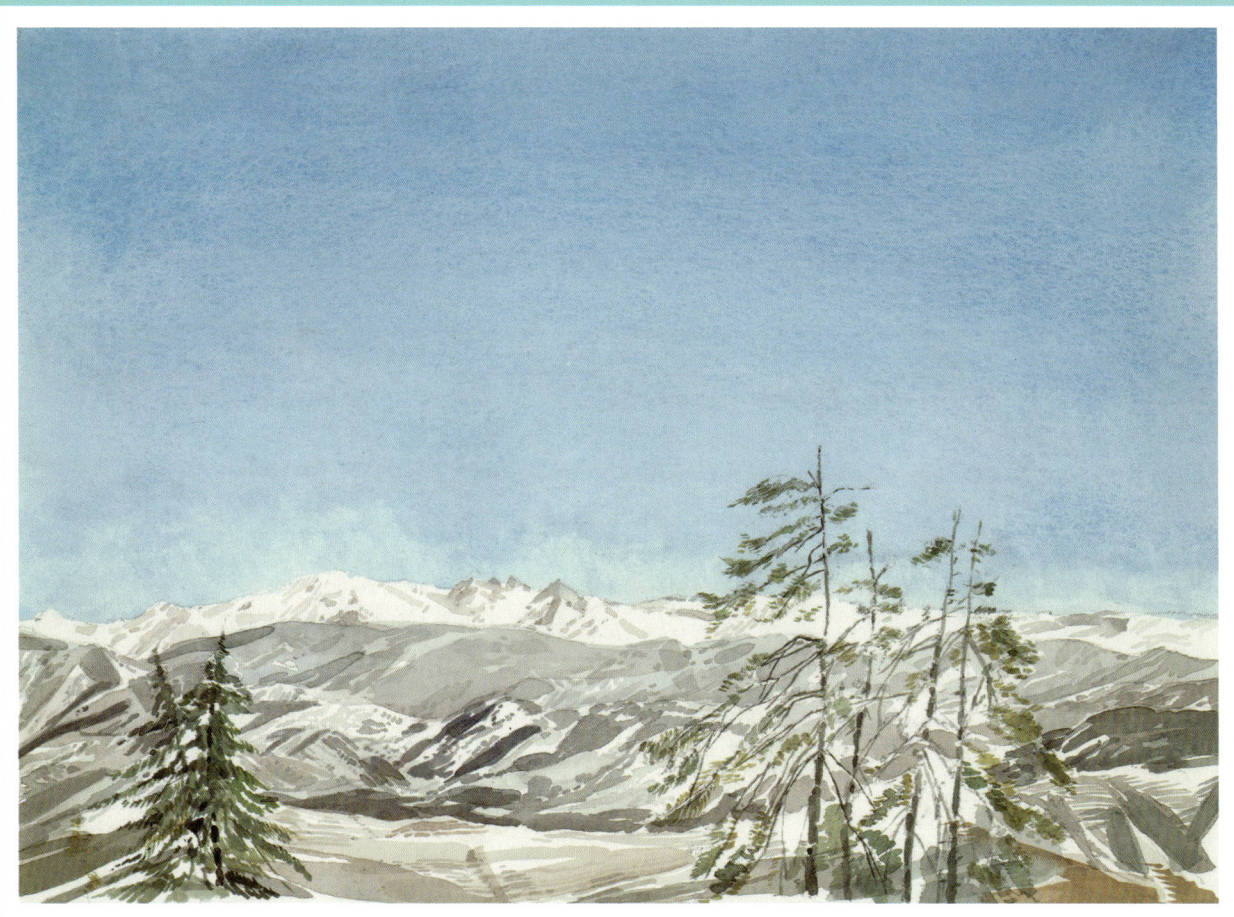

Himalayas at Wildflower Lodge

Roots

When I was a boy, there was a gentle old lady in the little town on the plains where I grew up. She had never married and had inherited a chunk of rich farmland when her father died. She had been his cook, housekeeper, and companion, and when he was gone, in her middle age she decided she would see the world. She discovered an intrepid traveler within herself and began planning journeys to far-off exotic places. She went by ship, train, and bus to places few people in that Nebraska town had even dreamed of seeing: Asia, Africa, Europe, South America, Scandinavia. She packed her trunk and went. I used to spend hours sitting with her, paging through her scrapbooks that bulged with mementos, bits of paper with scribbled notes, museum receipts, and postcards. She told me stories about Masai warriors, Swiss villages, and the great cathedrals of European capitals, views of the Himalayas, and cottages in Sweden. It was there one summer day that I first saw images of the Taj Mahal. I can still see the very page where the postcard was pasted—tall narrow minarets at the corners of the domed tomb reflected in still, shimmering pools.

If you tell someone that you are traveling to India you receive a surprisingly predictable list of reactions and insights—from those who have been to India *and* those who have not, and that list mostly features contrasting extremes: it's noisy/it's peaceful; it's filthy/it's... okay, just dirty; it's staggeringly rich/it's crushingly poor; it is almost inconceivably ancient and startlingly modern. The list of these contradictions is inexhaustible. Oddly, the same list of extremes is recited in India, too.

ROOTS

The first time I went to India I had been invited to join a group of friends on a ramble through Rajasthan. The itinerary was a perfect introduction. We visited cities for the urban madness and took long drives through the countryside to remote forts and ruins. It's possible to drop into the easy and accessible parts of India for a few days or maybe a couple of weeks and visit the places that most people list as reasons to go: Delhi for shopping and the imperial architecture of the British Raj; maybe the Red Fort; Agra for the iconic and sublime Taj Mahal; and Jaipur, Udaipur, Jodhpur…

One evening on that holiday I was at a dinner party in Delhi, and a well-known and respected author ticked off some of the polarities of India in a bemused matter-of-fact way. My reaction then was to wonder at his passivity and vaguely bewildering recitation of these extremes. If many Indians are the richest, why are so many the poorest? If you can drink from the tap in any of the embarrassingly, breathtakingly luxurious hotels in Delhi, why is there not a drop of clean water in the pipes ten minutes away?

"I'm afraid it is all about scale," the author told me, with a sideways nod of his head. "Too many people, powerful inertia, and, of course, dharma." At the time, fresh off the plane, slightly off-balance with jet lag, and staying in one of those indulgent and pampering hotels, I began forming an idea.

ROOTS

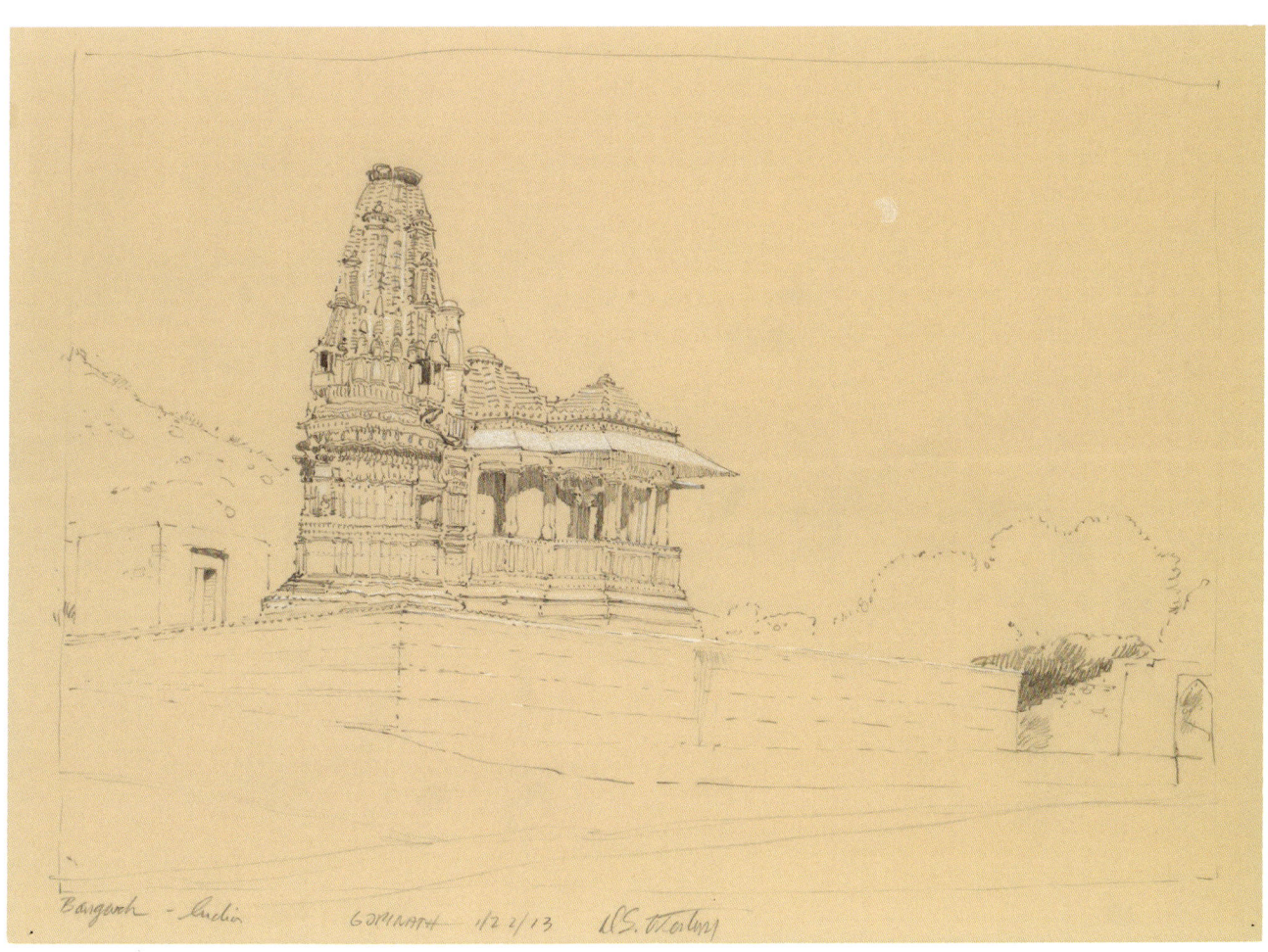

Bhangar—India Gopinath

ROOTS

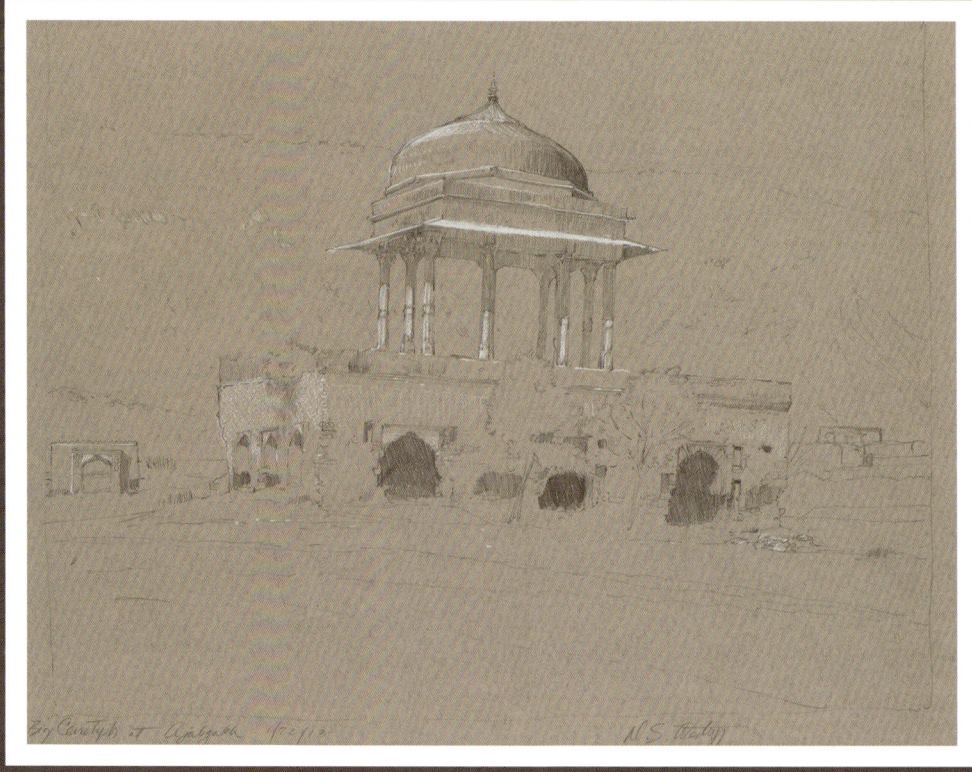

Raghunath Temple, Ajabgarh

ROOTS

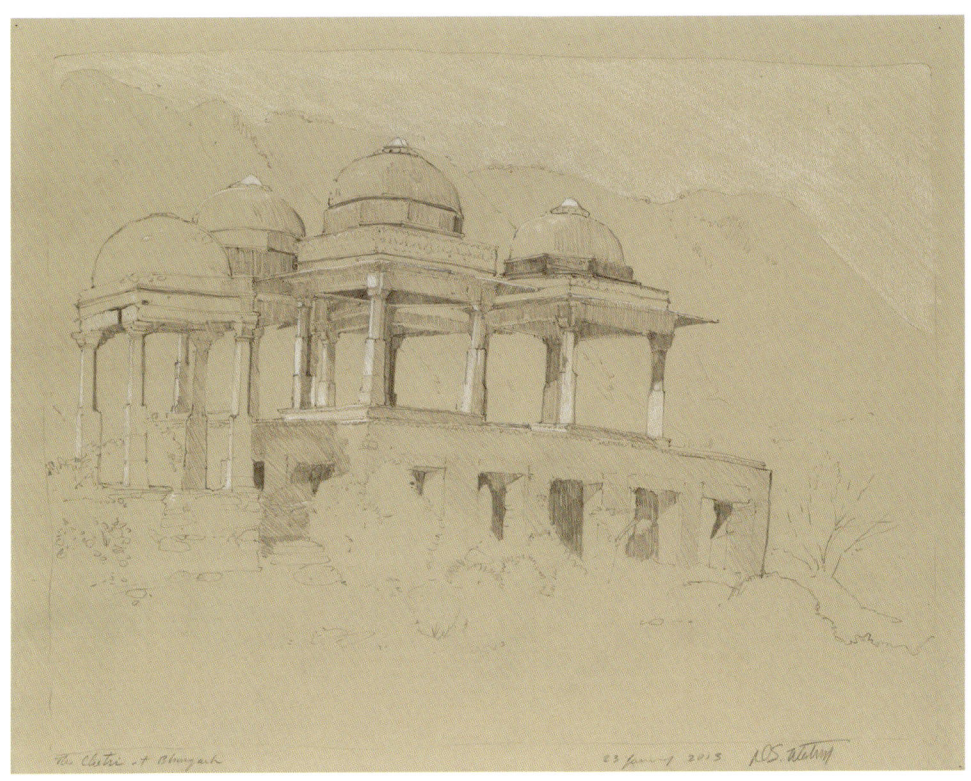

The Chatri at Bhangarh

23

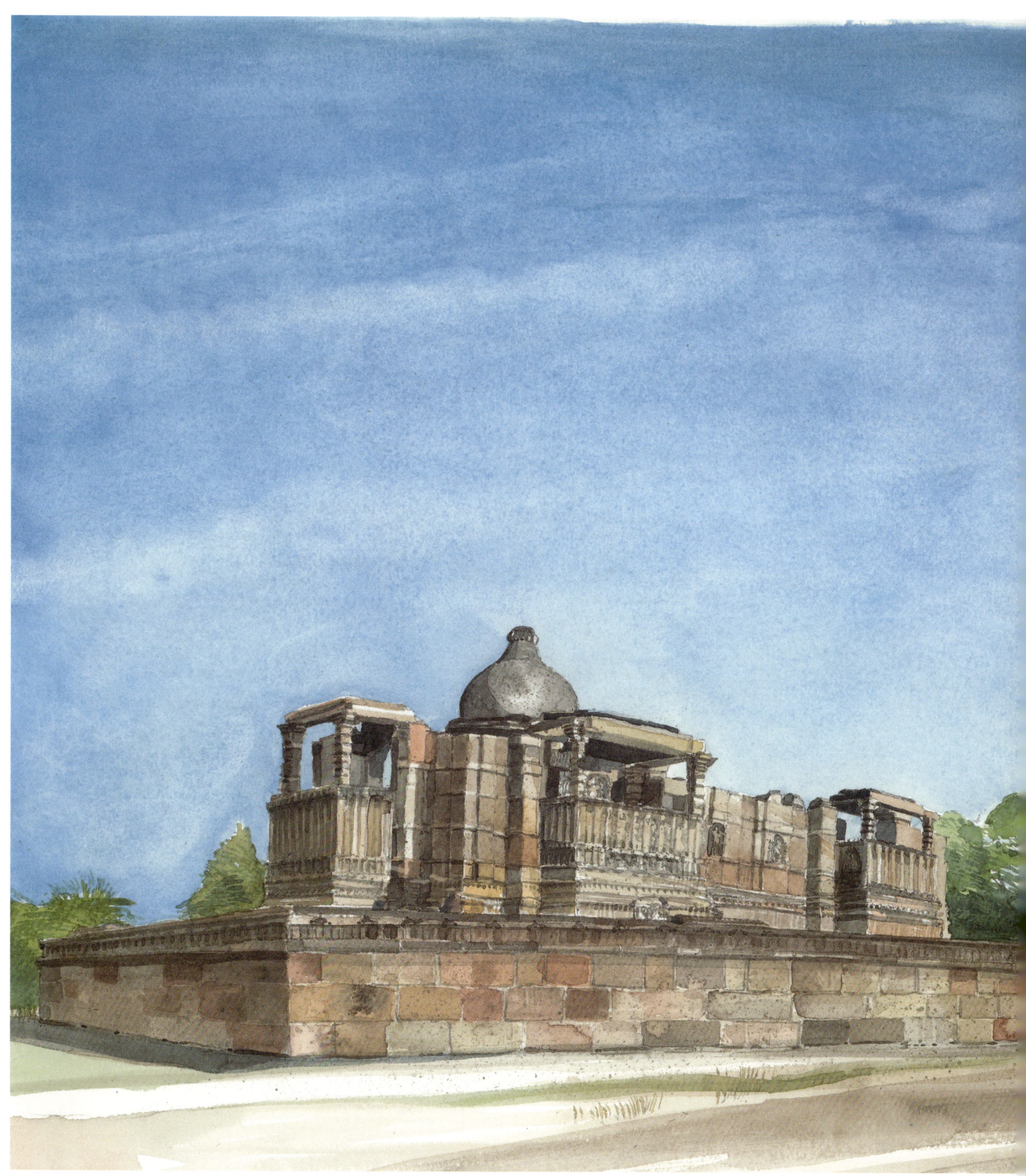

Magarmandi Mata – Chhatra Sagar

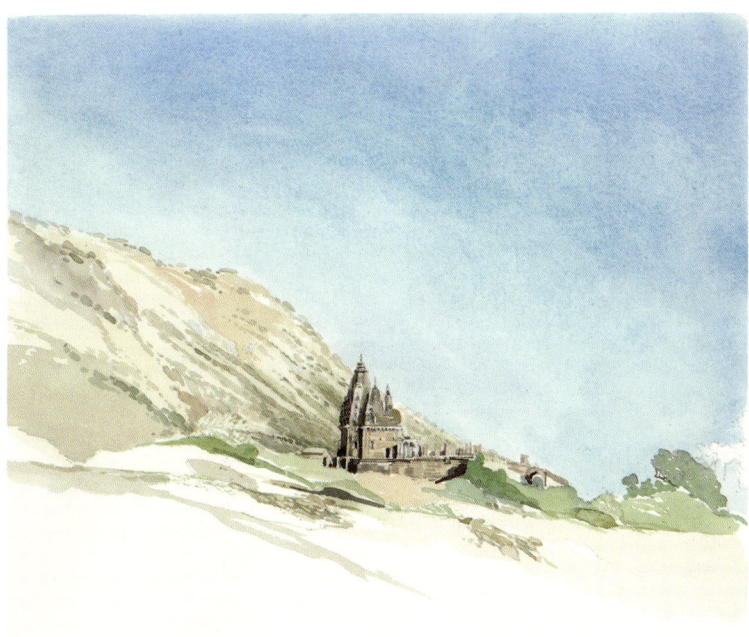

Temple near Bhangra

OZYMANDIAS EFFECT

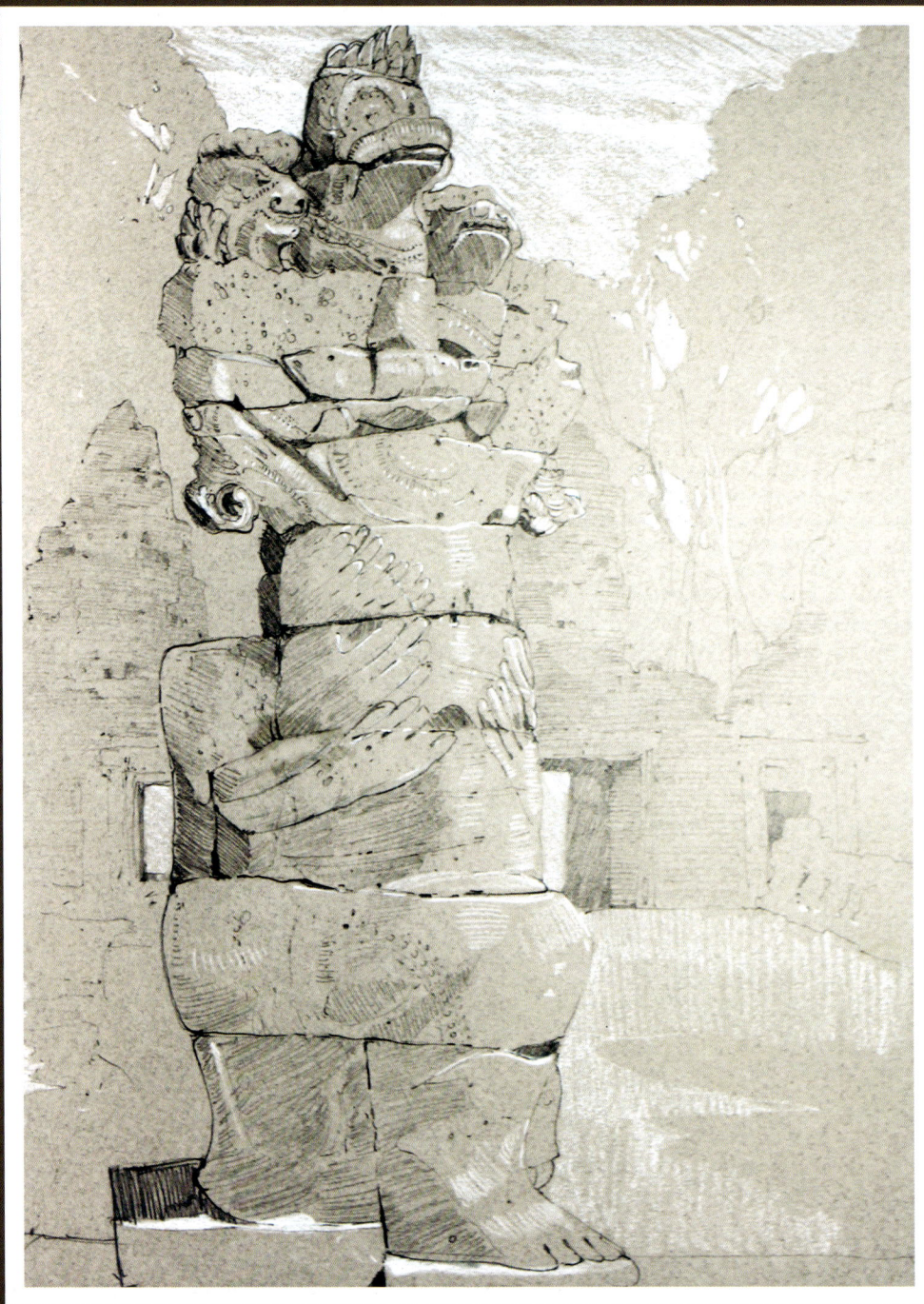

Naga at the Preah Khan Causeway

Ozymandias Effect

India has always held the imagination of the West. In the eighteenth century, engravings and paintings by artists working for the East India Company stirred popular interest in India's exotic landscape and people, as did later collections of photographs like those of Linnaeus Tripe in the nineteenth century. I've always loved the drawings and watercolors of William and Thomas Daniell who traveled to India in the late eighteenth century and published a series of engravings of Indian views that created a sensation in England, launching a "Hindoo" fad in architecture and decoration. I spent a weekend once with friends at one of the great English country houses in West Sussex several years before and my room had a few of these beautiful, tinted engravings hanging on the walls. I fell asleep looking at Indian temples and tropical landscapes and thinking of that dear, sweet woman who had opened her yellowed scrapbook to the little image of the Taj.

Before my first trip to India, I had been exploring Cambodia for a couple of years, drawing and painting the great Khmer sites. I was drawn to the narrative of Man's ambition and hubris that these vast complexes seemed to illustrate. I think of it as the "Ozymandias Effect."

Ozymandias

I met a traveller from an antique land
Who said: "Two vast and trunkless legs of stone
Stand in the desert... Near them, on the sand,
Half sunk, a shattered visage lies, whose frown,
And wrinkled lip, and sneer of cold command,
Tell that its sculptor well those passions read
Which yet survive, stamped on these lifeless things,
The hand that mocked them, and the heart that fed:
And on the pedestal these words appear:
'My name is Ozymandias, king of kings:
Look on my works, ye Mighty, and despair!'
Nothing beside remains. Round the decay
Of that colossal wreck, boundless and bare
The lone and level sands stretch far away.

– Percy Bysshe Shelley

India has relics of lost kingdoms that stir the same sense of transience. It's not uncommon to catch sight of a crumbling tower off some dirt road, or to reach the collapsed gateway of a city and find the stone foundations of palace complexes and markets along today's streets clogged with shops. There may not be the broken, "trunkless legs," but evidence of faded human ambition is scattered everywhere.

That first trip to India was in the north, the Golden Triangle, as it is often called. We started in Delhi and visited many of the important and beautiful sites in that part of India. The plan included a balance of urban experiences with forays into the deep countryside. In the cities we stayed in five-star hotels, and in the country, picturesque lodges and inns. I began sketching and did a few watercolors while with the group and then stayed on a few weeks to dig in a little deeper.

After that first trip, I began pondering how I might experience the places the Daniells had illustrated. I began plotting and ultimately planning journeys through India to see and draw these complicated and challenging sites. My journey evolved with the intention of exploring India by stepping off the two-week tour track to see the exotic and romantic places that had captured the imagination of the eighteenth- and nineteenth-century artists. I wanted to go where medieval Indian civilization had thrived—where kingdoms with wealth and security had built sophisticated cities with populations of up to a million souls, while Paris and London were villages with muddy streets and struggling with plague. Many of those ancient cities that had spread over many miles are now just scattered ruins on rocky plains. The descendants of these proud, lost kingdoms are the farmers winnowing grain in the wind. But the temples where their ancestors worshiped are still living, sacred sites.

While my first intention was simply to sketch and paint these shrines, my interest in these places has deepened over the course of several years because I have been drawn into a deeper conversation with the culture. I'm attracted to these places not only for the beauty of their temples and shrines, but also for the holiness that seems to emanate from them, from the very ground. Once a Hindu deity is installed in a temple, it must be continually tended. If a temple is abandoned, it is very rarely resanctified. The god to which it was dedicated has fled and cannot be enticed back. It's a physical as well as a spiritual presence because of the belief that the carving in the sanctum sanctorum is a living embodiment of the deity. I'm religiously agnostic, but the flickering lamp in a

remote shrine tended by a lone Brahmin priest moves me inexplicably. I long to understand the culture that has tended these places, its people acting out the same rituals for centuries.

It turns out that is a difficult and demanding undertaking. It is like Hinduism itself: you may study it and have glimpses of insight, but in truth, unless you have grown up with it, unless you have it planted in your soul and in your psyche from birth, it will elude you.

So what you are left with is the curiosity and the search for insight—the hope of catching sight of the reality of the place. It's like turning a corner and seeing a figure step into a doorway across the street. You think you may have recognized someone you know, someone just familiar enough to leave you a little unsure. India leaves me needing to cross the street.

The Thin Places

I'm not an academic. I don't claim to understand the subtleties of ancient religions. I am not a social scientist, but the human condition draws me in. I have an artist's eye for observation, so I connect threads of similarity in art and architecture. I love to think about cultural evolution and conflict. I'm interested in sharing the way I experience it. It's a very personal journey. I observe and record. I search and discover.

There is a Sanskrit word, *tirtha*, used to designate a sacred place. It is often described as a "thin place" where this world and the divine are close to each other. Temples are tirthas, and just as often, an ancient tree is a tirtha. There is a saying in India: "All temples are tirthas, but all tirthas are not temples." In many parts of India, a village shrine might be a small altar with a few stone figures lined up on a flat stone. These images are tended and "fed" daily with ghee—melted, clarified butter and milk. They blacken and details are lost because of the ever-thickening layers of ritual feeding. They also often have daubs of bright paint decorating their features and sometimes are dressed in scraps of fabric or even elaborate silk robes. A living temple will have a Brahmin priest in attendance, always with a hand held out for a small donation for the preservation of the site and to pay him his only meager wage. Brahmins are the priestly caste, so all priests are born into their role.

THE THIN PLACES

Many Hindus invest significant time and energy in following classical pilgrimage routes. These can take a matter of minutes (in the circumambulation of a temple, for instance), hours, days, weeks, years, or a lifetime. I stumbled into a sort of pilgrimage after that dinner party in Delhi. I found the tirthas compelling on many levels. My curiosity about faith and divinity nudges me forward and heightens the aesthetic appeal of the places. The Hindu belief that gods are a living presence, driving events large and small, is a constant in India. The turn you take on a road, the place you stop for lunch, or the book you find in a shop are all due to the intercession of the gods.

In the event, my pilgrimage became about drawing and painting sacred sites. I observe and experience them on whatever level I am allowed. The distances are often vast. It can take a day or two to get to a remote or important temple site, so meeting India head-on comes with the journey.

These drawings and watercolors record my pilgrimage. I wandered through the eighth-century caves of the state of Maharashtra and spent days at the early sixth-century temples across Karnataka. I walked the streets of lost capitals of great kingdoms. I have been chased out of "Hindu only" temple cities in Tamil Nadu and Odisha, and welcomed into dark inner chambers of village temples where I was blessed with the perfumed scent of burning ghee, draped with jasmine garlands, and anointed with sacred oils and pastes.

I traveled alone with my drawing board and watercolors. I tried to tread lightly. Looking for inspiration, I visited remote sites and hiked through rocky landscapes to reach hilltop shrines and often stepped into temples where no Westerner had been for decades. Sometimes it was a rocky cliff with a tiny sanctuary cut into it that drew me in. In many places, the great stone temples with dark passageways and damp chambers called me.

I did this to create these images while walking in the footsteps of countless pilgrims. As they sought enlightenment, I walked in the hope of understanding something about the contradictions of the place. I guess I was hoping to experience the spiritual comfort found at the "thin places," trying to look into the eyes of the face that had slipped into the dark doorway.

This journal is assembled from the notes I took over the course of several years and many trips to India. In some instances, I have kept the original context about moving from one site or city to another because exploring India is, in an important way, *about* covering distances. Most of rural India is a time capsule that preserves ancient traditions—it takes an investment of time and miles on the ground to get past the easy prejudices that we arrive with from the West.

In choosing the sites and destinations, I looked for important archeological and spiritually significant places with the help of my travel agent in India, Emma Horne. We crafted itineraries (often to the bemusement of drivers and guides) that focused on the architecture, art, and archeology of the Divine.

Jasmine

Mumbai, Aurangabad, Ajanta, Ellora

It's not easy to forget the mid-day heat of India. It has a weight that is unlike any other place on Earth. It first feels like a wave rolling over you, or the wind pushing against you as you lean into it from the refrigerated interior of a futuristic airport or a pristine five-star hotel. It is thick—almost creamy somehow.

 Mumbai is the financial center of India. It is, of course, notorious for its slums, which are exploited by popular and well-known "slum tours" on air-conditioned buses. The city's beautiful hotels are isolated behind security walls and gates. The terrorist attacks in November 2008 triggered an extreme heightening of hotel security. Guards at gates check every vehicle, looking with mirrors at the undercarriages and opening engine hoods and luggage compartments. There are metal detectors at every entrance and hand luggage is x-rayed. Most public places (museums, etc.) still have remnants of similar security measures, but as with many government projects in India, there is very little follow-through or maintenance, so the metal detectors stand idle and the guards do only a cursory check of backpacks.

Mumbai has contemporary art museums, galleries, and a vast history museum with a lovely gallery of calico-printed cotton, classical indigo, and intricately conceived batiks (just to name few). It is a great cultural center. Young professionals spend evenings in bars and clubs comparable to ones in Brooklyn, Los Angeles, Chicago, or London. There are sparkling hip restaurants with beautiful people hovering at the bar. Next door one may find homey traditional restaurants with small, shared tables serving veg meals. Vendors in their narrow street stalls still sell the traditional *paan*, a little packet of dried fruit and herbs, perhaps with some betel nut folded into a betel nut leaf and smeared with lime paste. You tuck it into your cheek and chew on the edge as the flavors and chewy bits dissolve in your mouth. It's an acquired taste, but a classic after-dinner digestif.

Market streets are geared to tourists wandering shoulder-to-shoulder through Nike and Reebok stores that are right next to busy sari shops. It's a jumble of Indian and Western tastes and interests. Hashish dealers mix in the crowd offering their goods (although illegal) and pimps wander the streets. It's not unusual to find a thin young man walking at your side offering any number of possible variations of companionship for an evening.

Prostitution is legal in India, although, paradoxically, all the ways to hire a prostitute are illegal (if rarely enforced). At the same time, there is a strange conservative impulse in Indian officialdom. You might see a young couple being questioned in the street by a policeman who has spotted them kissing in public. That is balanced by the strangeness of a bar with pulsing music filled with hostesses trying to catch your eye and cadge a drink and maybe twenty minutes in the rooms upstairs. These places can also serve as the meeting ground for the large, mostly closeted gay world. At night, along the waterfront above the India Gate, you will hear the clinking of small glass bottles as massage boys walk up and down the causeway. They are signaling their availability.

Mumbai is, as you would expect, filled with remnants of the British Raj: parish churches, vast government buildings, and complicated traffic circles. It is chaotic and confusing, but worth taking the risk of getting lost just to wander on foot even a few blocks from the confines of a hotel. You can find a tailor who will make up a suit in twenty-four hours, buy yards of hand-woven silk on almost every street, and pick up a new iPhone along the way.

There are several ancient Buddhist sites in and around the city, but even though the Buddha received his enlightenment in Bihar

in northeastern India, Buddhism is almost lost in India. It was exported and embraced by the rest of Southeast Asia, and then faded away (or was suppressed) in its birthplace.

Mumbai has dozens of Hindu temples, largely built in the eighteenth and nineteenth centuries because most of them were destroyed during the various invading occupations of the city. Virtually all temples would have had a carefully built stone-lined reservoir, called a tank. The early twelfth-century Banganga tank rests in what has become one of the more posh neighborhoods in Mumbai, Malabar Hill, and had a temple that was pulled down by the Portuguese in the sixteenth century. It is a quiet and contemplative place. The spring that pours into one corner of the reservoir is icy cold, and people bathe and wash laundry there. Ducks and geese paddle around and occupy sections of the steep steps. The small buildings and quiet temples that surround the tank look as though they are in a country village. There are little shops with used clothing for sale and trinkets for offerings in the temples.

There are large and beautiful mosques too. Muslims are a minority, at about 20 percent of the population. With the rising Hindu nationalist movement of the last few years, there is some grumbling about the calls to prayer, and a movement to limit the use of amplified speakers in some neighborhoods has caused tension.

The neighborhood also has Krishna temples, which are very interesting to visit. Krishnas are considered unorthodox by Hindus and are not welcomed in the sanctums or into the holiest pilgrimage temples. Because of this, Krishnas build their own temples in most cities. I can't quite get a clear explanation of this attitude, since Krishna is actually one of the incarnations of Vishnu (as is the Buddha and, in some traditions, Jesus). Hinduism is a mystical philosophy (it's not really a religion) that you must be born into to be viewed as a legitimate adherent. Hinduism also vigorously enforces the caste system. One's caste will determine how far one is welcomed into restrictive and conservative holy sites. Converts, for instance, are considered not clean enough to enter the holiest sanctum in the most holy temples.

Krishna temples, on the other hand, are places of expansive love and inclusion. Wandering into a Krishna temple is a peaceful and serene experience. There are monks prostrating themselves on the floor before the statues of Krishna. Others are sitting on the floor reciting prayers, rocking gently.

I once spent an hour chatting with a Krishna monk who had a vague accent, hard to place in the polyglot world of Mumbai—he was Canadian, it turned out, about 25, I'd guess, skin and bones with the classic Hare Krishna top knot, curly and sun-bleached blond at the ends. The most delicious perfume floated from him. He said they dab jasmine oil on their wrists in the morning to perfume the temple through the day. I could have embarrassed myself with a swoon. When he put his arms out to hug me as I turned to leave, I felt like some character in an E. M. Forster short story.

The International Society for Krishna Consciousness (SKCON) has built a surprising presence in India since its founding in the mid-1960s in New York. There is a vast temple being built in the city of Mayapur in West Bengal. It is several hours north of Kolkata and is also the headquarters of the movement. It is an astonishing sight with its cerulean blue dome and a slightly bizarre mix of classical Hindu architecture and modern, pared down functionalism. It is crowded with a mix of pilgrims—many Western—and tourists who have come to marvel at the gigantic site on the bank of the Hooghly river.

Trimurti

The Elephanta Caves are about an hour offshore from the docks below Mumbai's magnificent India Gate, which was built for the visit of King George V and Queen Mary in 1911. The plaza in front of the monumental gate is crowded with vendors, shoppers, pickpockets, and tourists of all stripes. You buy a round-trip ticket and you are squeezed onto a ferry, often climbing from one boat to the next (lashed together) to get to the one that's leaving next for Elephanta. The mix of Indian and Western day-trippers is colorful and friendly. The ferry ride across the bay is unique. You motor past the remains of an eighteenth century fort that guarded Bombay and huge petroleum transfer stations.

On the island, the fifth- to eighth-century caves are cut from granite ledge. There are two temple groups, one Hindu and the other Buddhist. The wide, steep steps up to the terraces of the temples are lined with shops selling souvenirs, statues, necklaces, and paintings. You can actually hire a sedan chair with four bearers to carry you up the steps. These bare-footed men negotiate the uneven steps quickly, shouting at the throngs of climbers to clear the way.

It's hard, at temples like these, to find a place (out of the flow of tourists) to sit and draw. It's not unusual for people to stand and watch when I draw. If possible, I'll choose a place to sit that is out of the way and not so visible. The curious will look over my shoulder, maybe whispering to a companion. School groups squeeze close to see what I'm doing and often people will take pictures of me, the polite ones asking if I mind. I don't. If I have a guide, a driver, or maybe even a temple guard (whom I've tipped) they will often move

people away from me. Most will watch for a few minutes, looking back and forth from my drawing to the view I'm working from, checking my accuracy, I guess, and then move on.

The most important carving on the island is in what is simply called Cave 1. It is of the Trimurti—three deities. It's a huge figure with three faces: Brahma, Vishnu, and Shiva. These three main gods of the Hindu pantheon are occasionally referred to as the "Hindu Trinity" although there is some thought that the idea of a trinity was grafted onto Hinduism by Christian missionaries attempting to suggest a universal "Christianity".

Hinduism is almost inconceivably complex, but these three gods are the foundation of everything else. The basic (oversimplified) explanation is that Brahma is the creator of the universe, Vishnu is the protector, and Shiva is the destroyer who annihilates the universe at the end of an age so a new world can be born. Through the eons, the universe has been born and destroyed many times and each epoch evolves through the efforts of these gods. All deities have multiple avatars, wives (with their own multiple incarnations), children, adversaries, advocates, defenders, and so on. Some are regional and many exist as manifestations for particular tasks or intercessions. There are thousands, perhaps millions of gods, and even Indians who have grown up in the traditions of classical Hinduism are hard-pressed to keep track of them. It's easy to find a temple dedicated to Vishnu, Shiva has the most devotees, and you almost never find a temple devoted to Brahma.

This massive Trimurti sculpture stands monumentally in a sort of recessed chamber looking almost stage-like behind a proscenium arch. Today's guides will even carry lights to brighten the dark spaces, which heightens the theatrical effect. There are many other carved reliefs of Shiva and his wife Parvati—some badly defaced—on the chamber's other walls.

The temple is cut from one massive basalt formation. The arrival of every ferry brings a wave of explorers, and the milling crowds and often electronically amplified guide descriptions make it less imposing than it might be. The Archeological Survey of India (ASI), which is the huge government agency that manages all archeological sites in India, and which I bump against often, has built security fencing around the scattered sites. The general lack of sensitivity the ASI shows on these sites intrudes on the experience even more. If you are not Indian, there is a gate charge at most ASI-managed sites. It's only a couple of dollars, but the ASI is planning to double or triple the ticket charges. There is a lot of grumbling by guides and drivers who fear it will cut their client base.

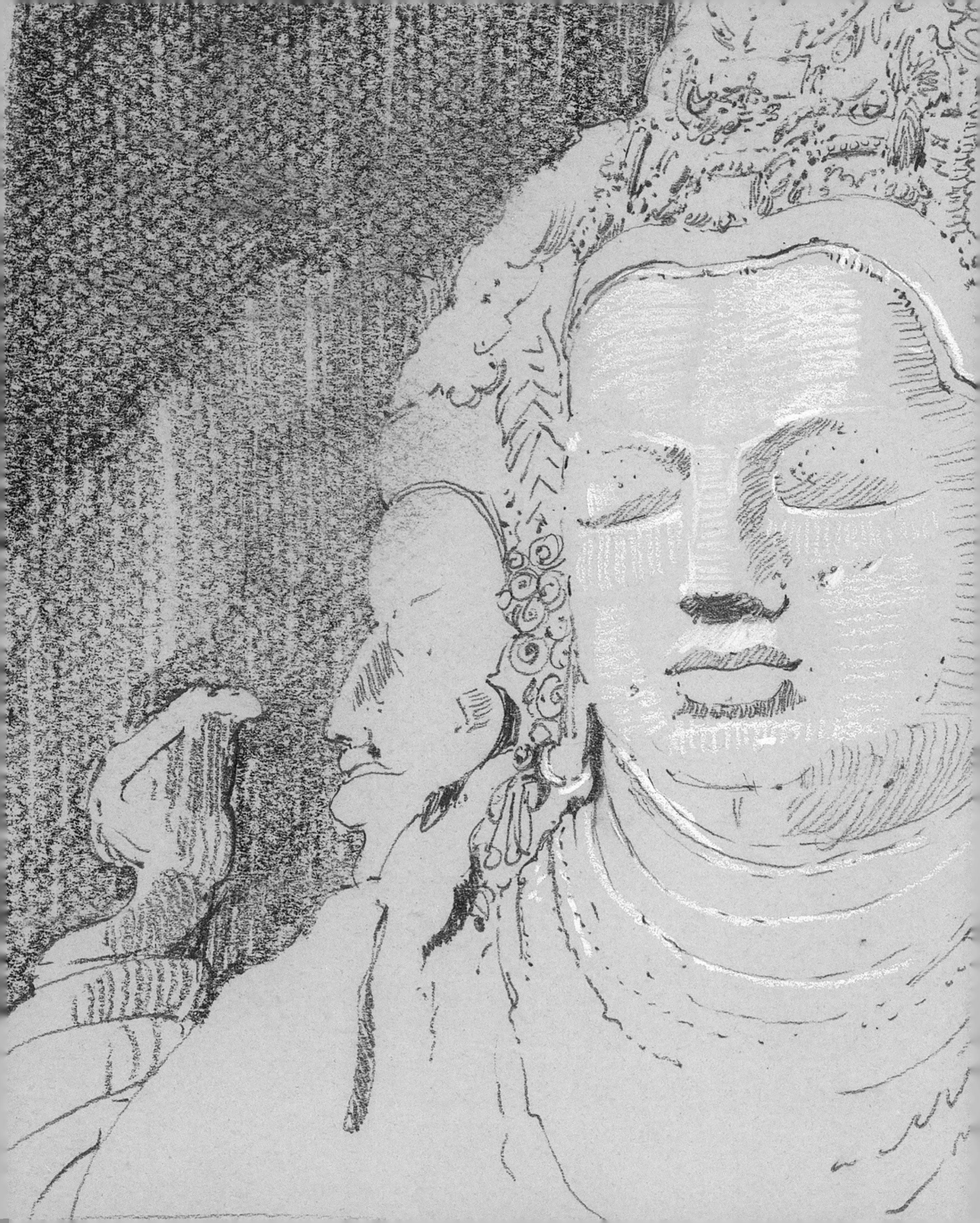

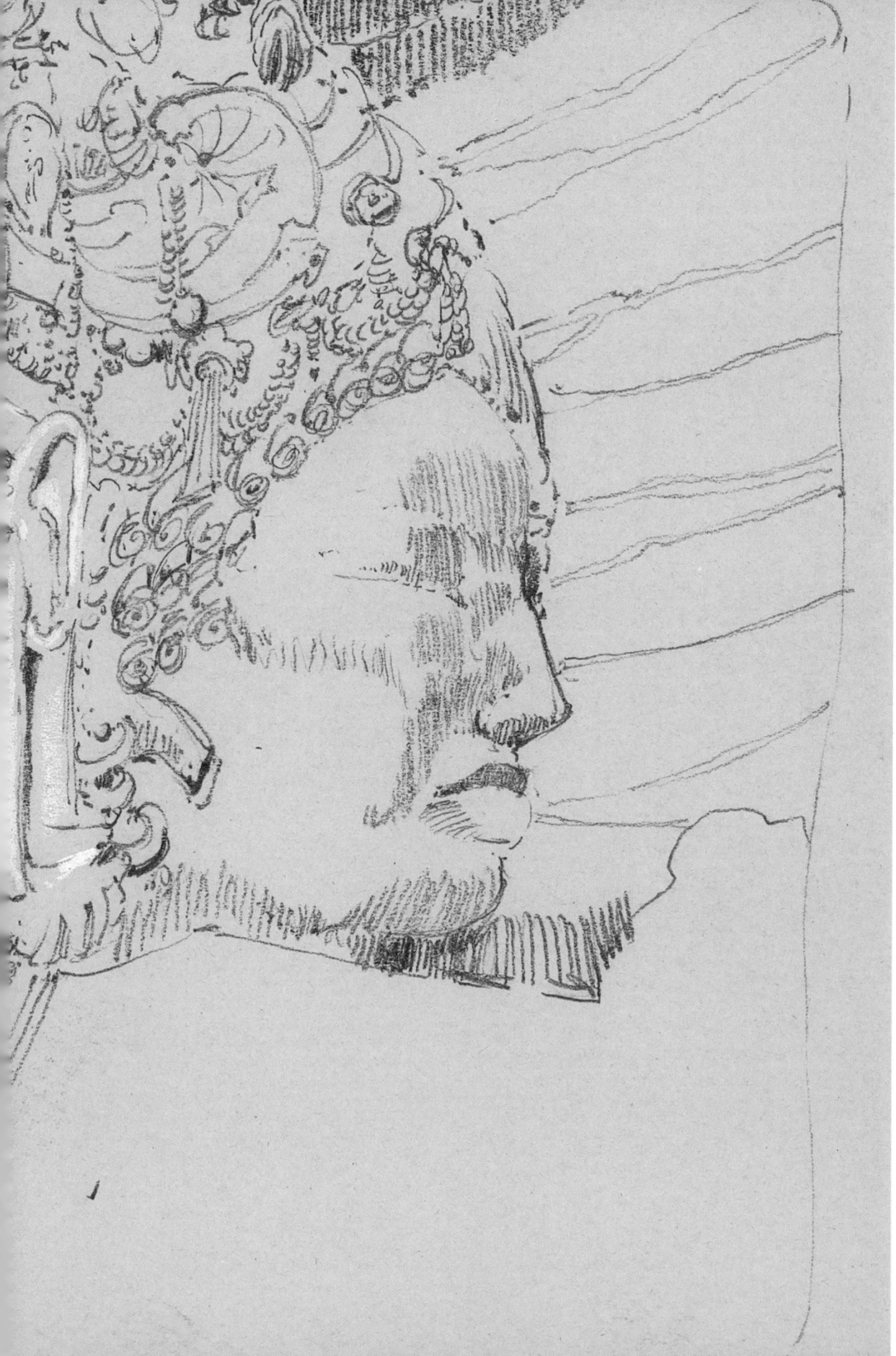

Trimurti—Elephanta

From Wood to Stone

A few miles southeast of Mumbai, by way of a winding road through miles of residential tower developments, scrappy semi-industrial areas, and open fields full of lilac-colored hibiscus, there is a lovely ancient mountain temple complex called Karla. A long climb up on winding irregular steps leads to the temple. The whole stairway is lined with stalls selling sweets, flower garlands and trinkets. All this because there is a modern temple built just in front of the fourth-century cave temple. It's very active as a pilgrimage site for women who are looking for divine intervention with conception. It might be a hundred years old, painted gaudily, and has all the trappings of other popular pilgrimage sites—crowd-control barriers, steel security grates, and lots of bright garlands hanging at the entrance.

At the top of the 350 steps is a series of Buddhist caves. Some are temples and others were carved as dormitories for monks. The most important second-century temple, the Great Chaitya hall, has a beautiful narrow vestibule with figurative panels framing the entrance and a sun window—a huge arched opening cut into the face of the cliff to let light flood the interior. Life-sized carvings of elephants stand guard at both ends of the forecourt. The space has what is called an "elephant ceiling"—a barrel vault with deep ribbing imitating wooden construction methods used before stone-cut temples evolved. Many stylistic elements of temples like this one are in fact based on wooden models. It's interesting because the vaulting, of course, doesn't serve a structural purpose, but shows a curious vestigial remnant from ancient timber temples. The earliest wooden temples had thatched roofs, wooden beams, and bamboo columns. Banks of octagonal columns with lotus capitals topped by groups of figures representing the temple's patrons line the space. A huge domed stupa with an umbrella carved in stone above was the sacred purpose of the space. A stupa is the domed mound for the burial of relics of Buddhist saints. I worked for a couple of hours on a drawing of the forecourt. I would have chosen the main chamber, but there wasn't even a ledge to prop myself against, so the recess at one end of the court was too tempting.

FROM WOOD TO STONE

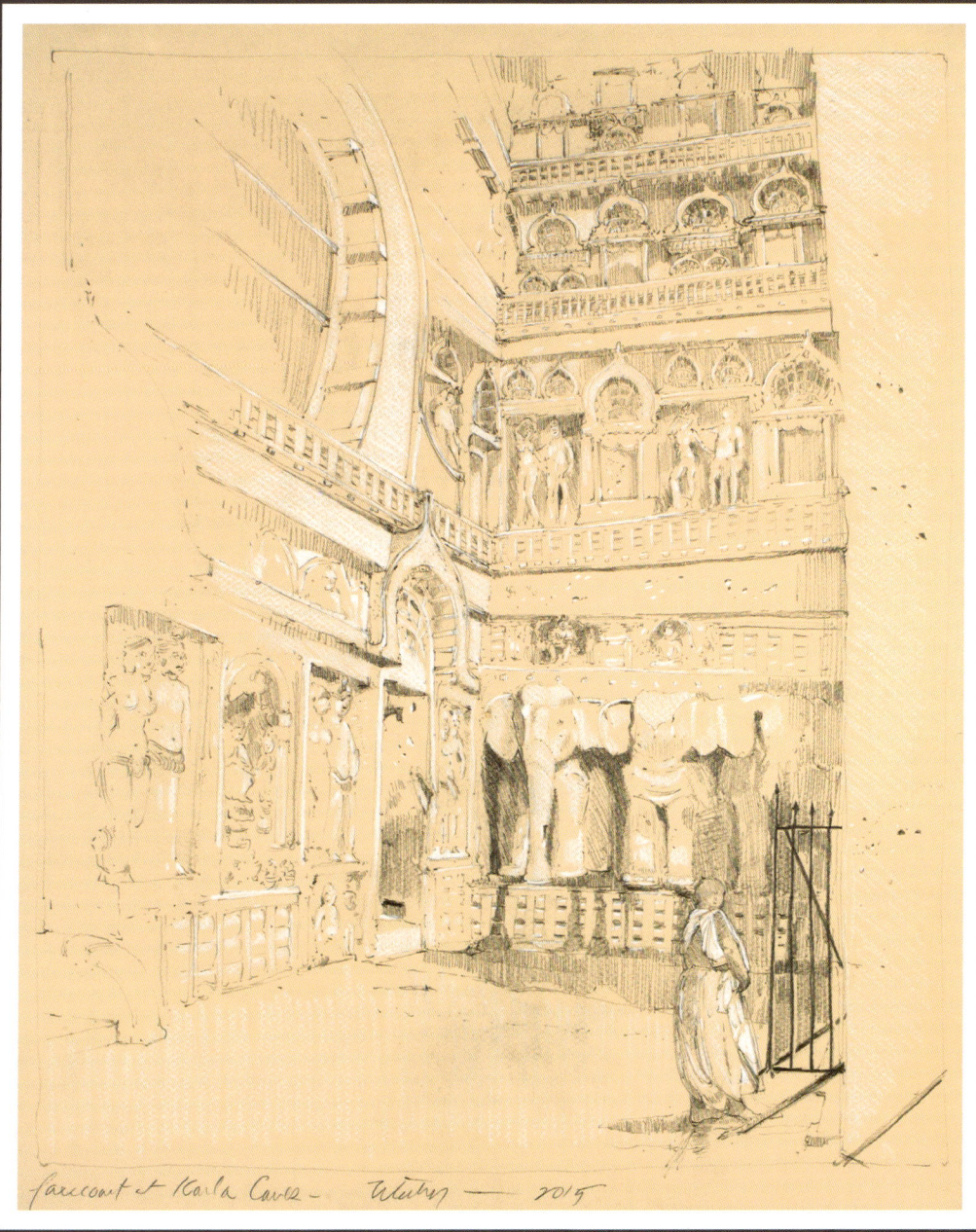

Forecourt at Karla Caves

CLIFFS AND CREVASSES

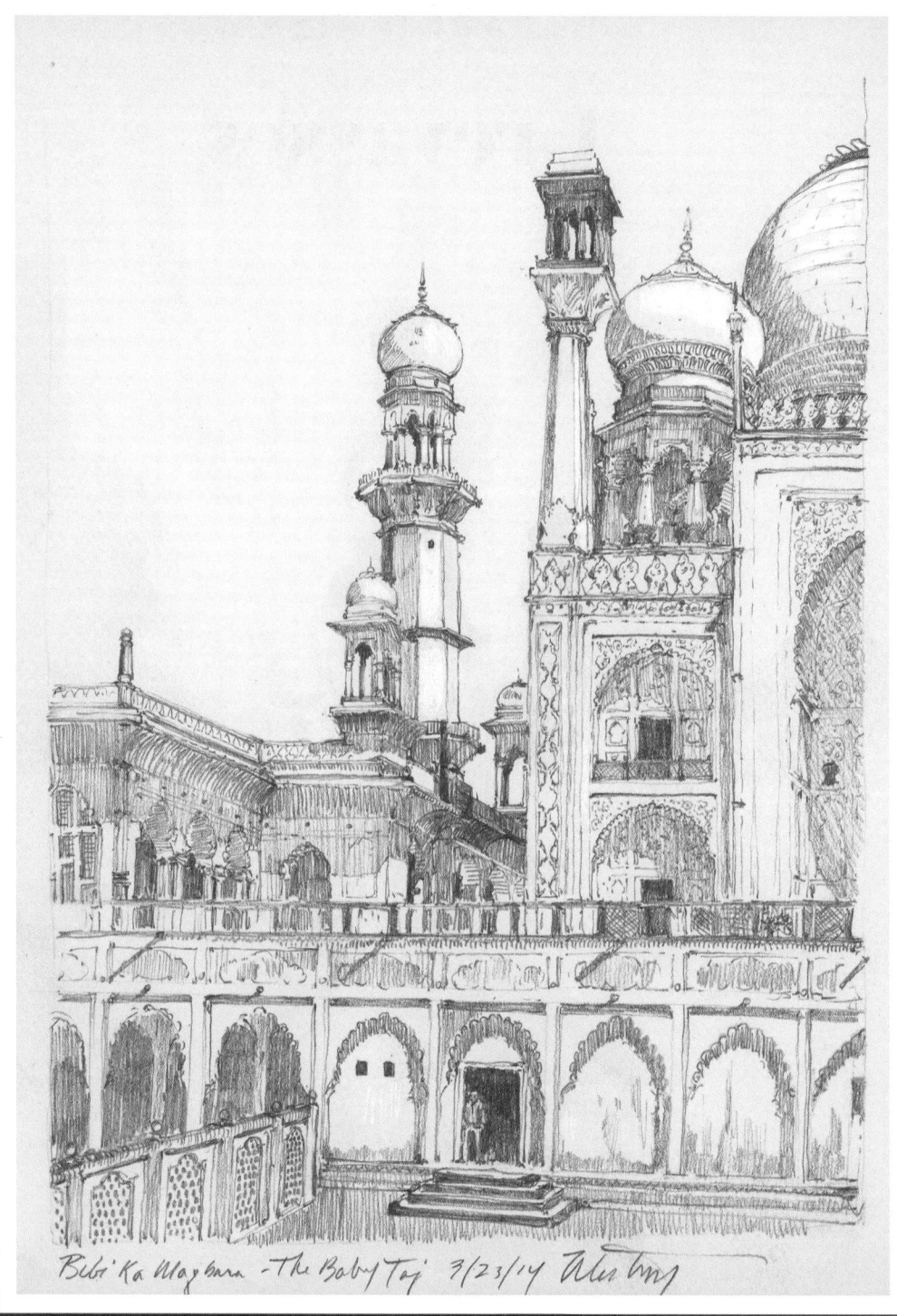

Bibi Ka Maqbara, the "Baby Taj"

Cliffs and Crevasses

A short flight from Mumbai takes you to Aurangabad. The city has a lovely site to visit before you make the drive out to the most dramatic and glorious caves that make this part of India important archeologically. The site is affectionately called the Baby Taj—Bibi Ka Maqbara. It is a mausoleum built in the late seventeenth century by Azam Shah for his mother. It's believed to have been modeled on the Taj Mahal. It is smaller, simpler, and a decidedly quieter place to visit. It is peaceful and beautiful. The tomb is built of stone, but rather than being surfaced with miles of inlaid marble, it is mostly modeled stucco and tile. There are pools and rills and a few fountains that bubble away. It has the serenity of a memorial site (which the Taj is, but lacks) and a remoteness that lets you pretend you have discovered something. It is possible to visit the Baby Taj and find yourself completely alone, which rarely happens in India.

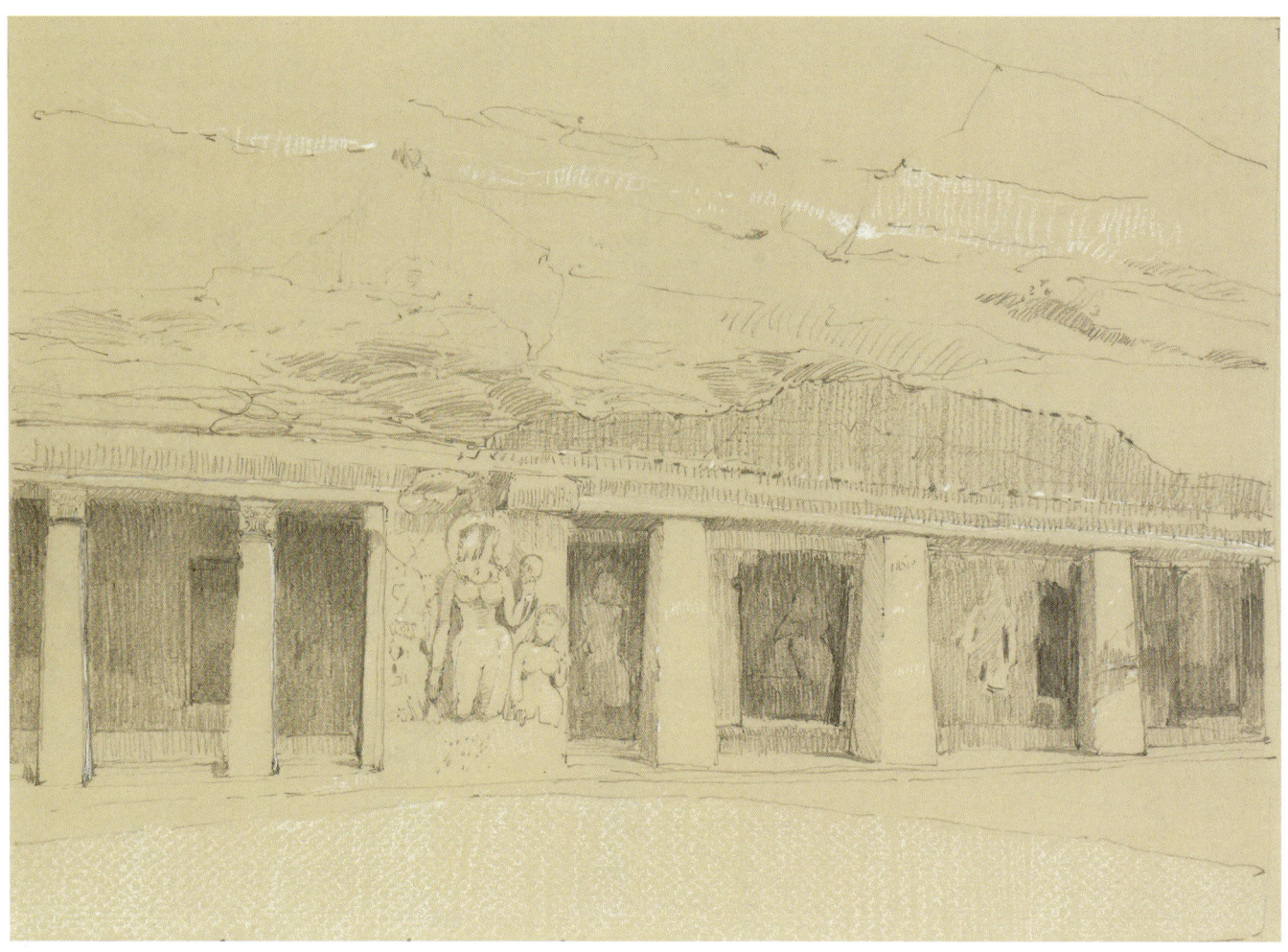

Buddhist caves above Aurangabad

The reason to come to Aurangabad, however, is to visit two sites some distance from the city, Ajanta and Ellora. There is a third cave site called simply the Aurangabad Caves on the edge of the city, which has a handful of Buddhist shrines. It's hardly visited because of the glories of the other sites, but is aloof and haunting in its own way. The cliffs are similar to the more famous sites—cut into vertical faces of granite, although they do not hang above the deep crevasses as Ellora and Ajanta do. They open above shallow steps without complicated porches or halls. They are unguarded and windblown and they hint at the more developed and spectacular sites.

CLIFFS AND CREVASSES

The Ajanta Caves are two to three hours away from town and sit along the cliffs above a dry riverbed. In the rainy season, water cascades over the faces of some of the caves and the chasm at the bottom of the gorge churns and roils with the runoff. These caves were very early Buddhist monasteries. They were begun around 200 BCE and had periods of abandonment and renewal until about the seventh century CE, when work stopped and the Buddhist communities disappeared. These caves were unknown except by local villagers until 1819, when a British hunting party stumbled upon the overgrown, vine-draped caverns.

The caves vary from very simple, deeply cut entrances with blocky columns opening into fairly low-ceilinged chambers to breathtaking, airy interiors with elaborately carved square columns and astonishingly painted ceilings and walls. Given the fact that they sat unprotected until 1819, the tempera decoration is even more amazing. I've done drawings from the hills across the valley from the caves and wandered through the interiors, and then sat in the shade of the entrance of the most elaborate temple to draw. The caves are numbered, not named, and it's Cave 26 that I've drawn, which has a huge stupa inside under the elephant ceiling.

Ajanta Caves

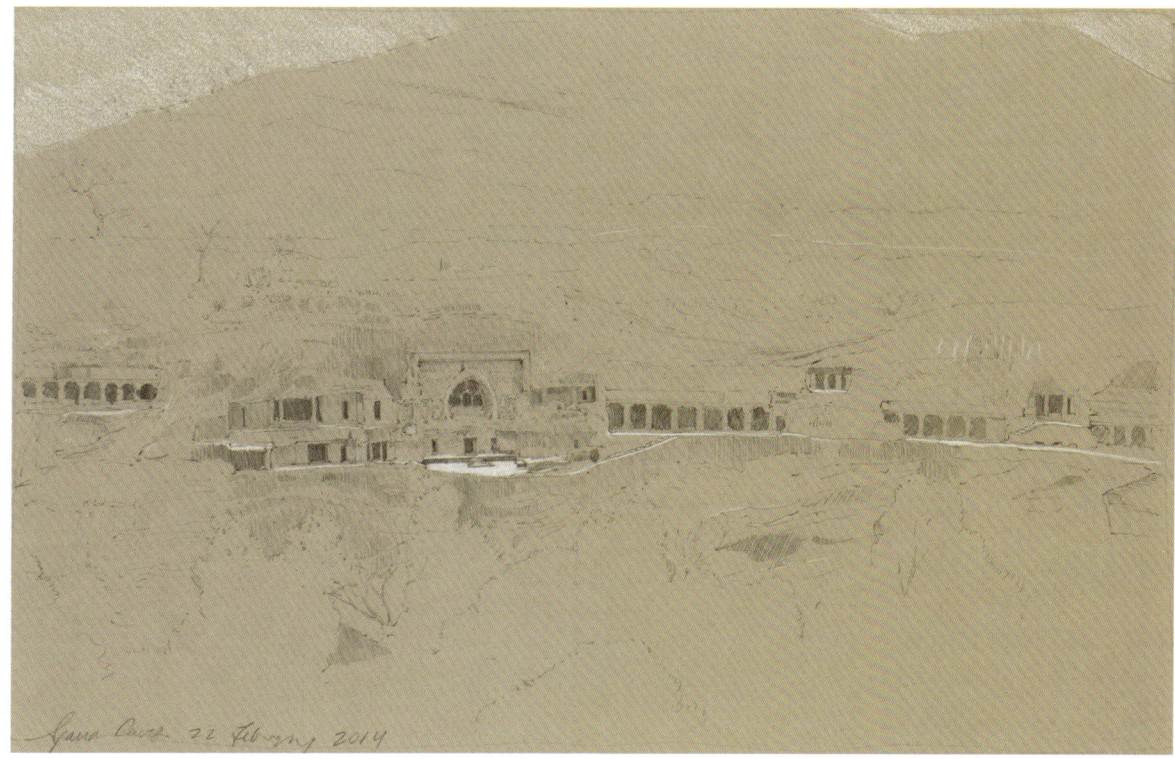

CLIFFS AND CREVASSES

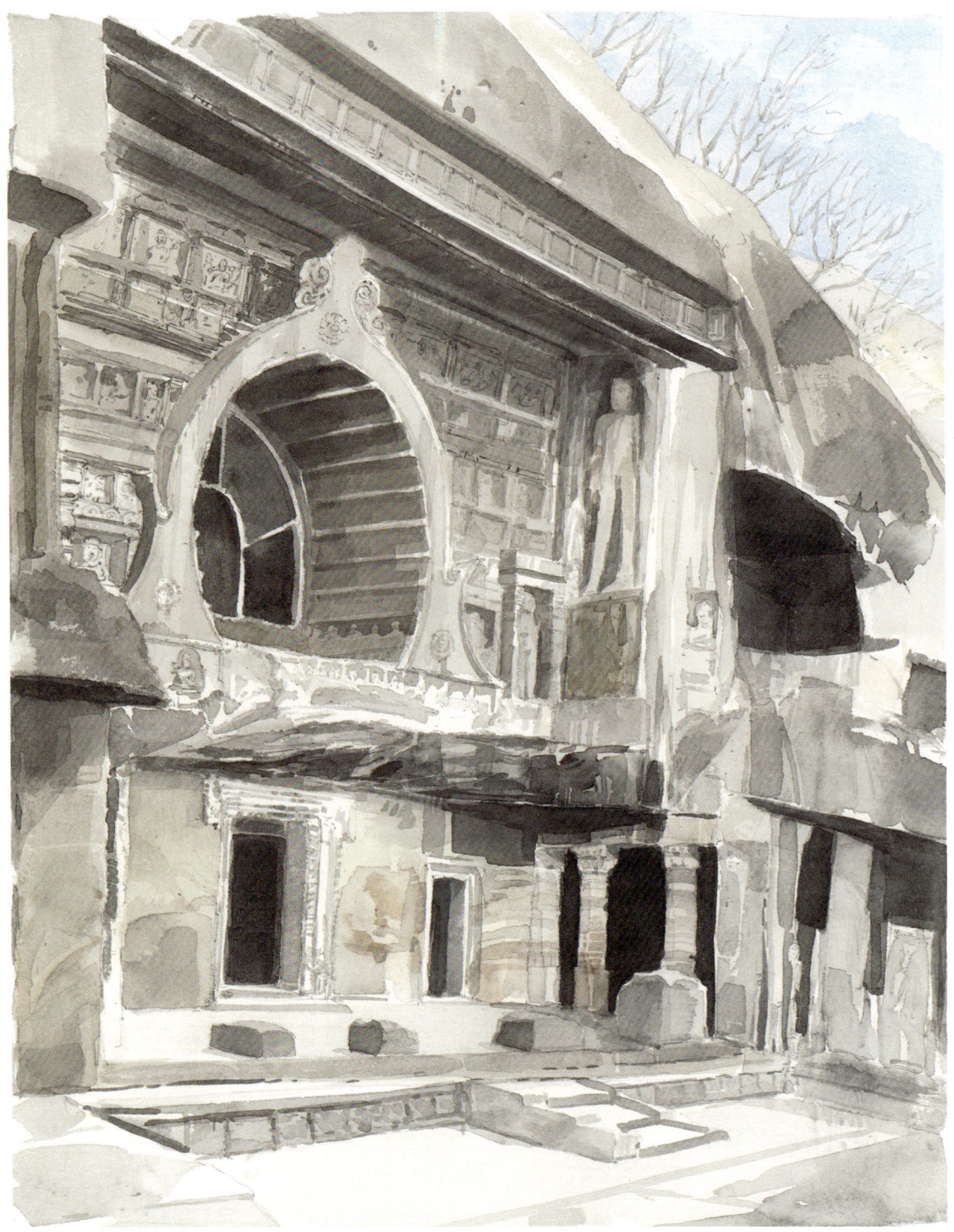

Ajanta sun window

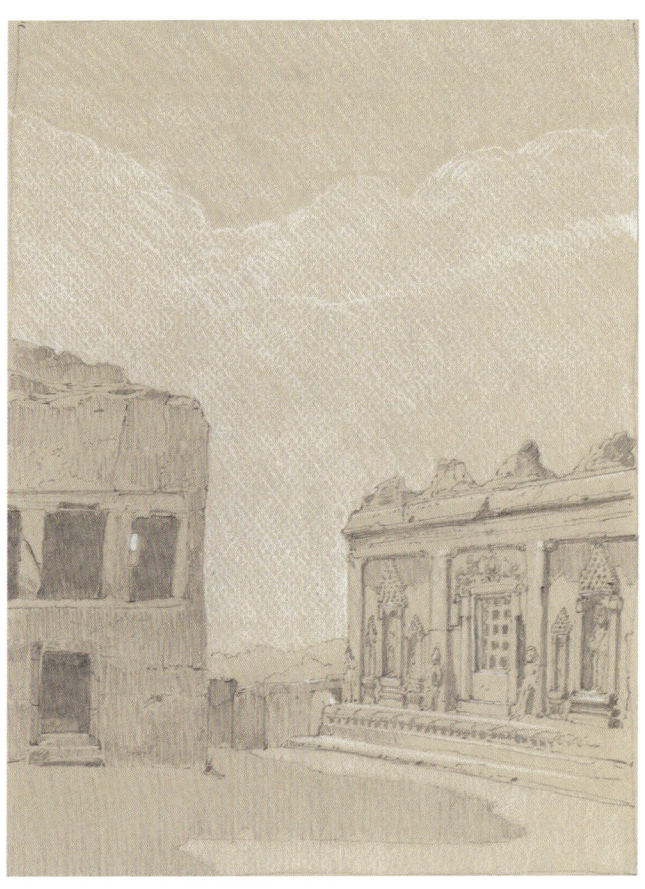

Temple 15, Ellora Caves

At archeological sites in India you will find licensed guides hoping to be engaged. In most instances it's a good idea to hire a guide with the help of your travel agent in advance or from the hotel. I have traveled to many places relying only on my driver to get me there. Occasionally, a guide won't bring much to your experience except that he might be able to bypass long entrance lines or be certain that you don't miss a particular chamber in a temple, but I have also had wonderful, insightful guides who dig deep into their experience to show me sites that they believe will move me. The drawback to arriving at a site unaccompanied is that you can fall victim to the charms of an unlicensed young man offering to just show you around, who will firmly demand a tip at the end. I usually use a guide if I have plans to draw. The rules of the Archeological Survey of India forbid drawing at sites under their control, but those rules are inconsistently enforced. A local guide (who probably knows the gatekeeper and the guards) can often tip the guards and smooth the way for me to bring in a drawing board. It's possible to take thousands of photographs (without tripod), but sitting down to draw can bring calls of, "Sir, sir. It is forbidden."

The Ellora caves are close enough to the Ajanta caves to make a trip to both sites possible in the same (very long) day. Because I like to spend several hours at any given cave or temple, I have to plan loosely. India is not a place to explore on a tight schedule. The cultural norms will always slow you down and the madness of traffic and driving styles will leave you exhausted and frustrated if you are racing from one site (city, state, region) to the next. I know people who have gone to India with a list of things that must be done to experience it and spent a week flying from place to place. It's a murderous thing to attempt.

Ellora's caves were carved from the fifth to the tenth centuries and are numbered (consecutively, not chronologically) like those at Ajanta, although there are traditional names connected to some of them. They are a mix of Buddhist, Hindu, and Jain traditions.

CLIFFS AND CREVASSES

Several temples have deep forecourts and it's difficult to imagine their scale. Cave 15 has a beautiful freestanding pavilion in front of it. The main cave has two tiers of six columns separated by a thick slab of flat-faced stone. The dividing slab is about four feet thick. The height of the horizontal openings is probably close to ten feet and the width of the whole facade must be sixty feet. All of this is chiseled out of the granite of the cliff.

The most extraordinary temple is Cave 16, and called Kailasa by tradition. It is a huge, intricately carved temple with high gray walls standing behind it from which it was carved, nothing built. You enter the temple through a strange chamber that hints at the marvels to come but doesn't really prepare you. Every surface is embellished with carvings of deities and the dizzying effect of the size and complexity is stunning. The fact that the entire object before you is cut from a monolithic stone formation is hard to comprehend. It's not possible to call it a structure because it's carved. It's a vast sculpture. The scale and ambition of the carving take your breath away. Life-sized elephants line the rear face of the temple, carrying the structure on their backs.

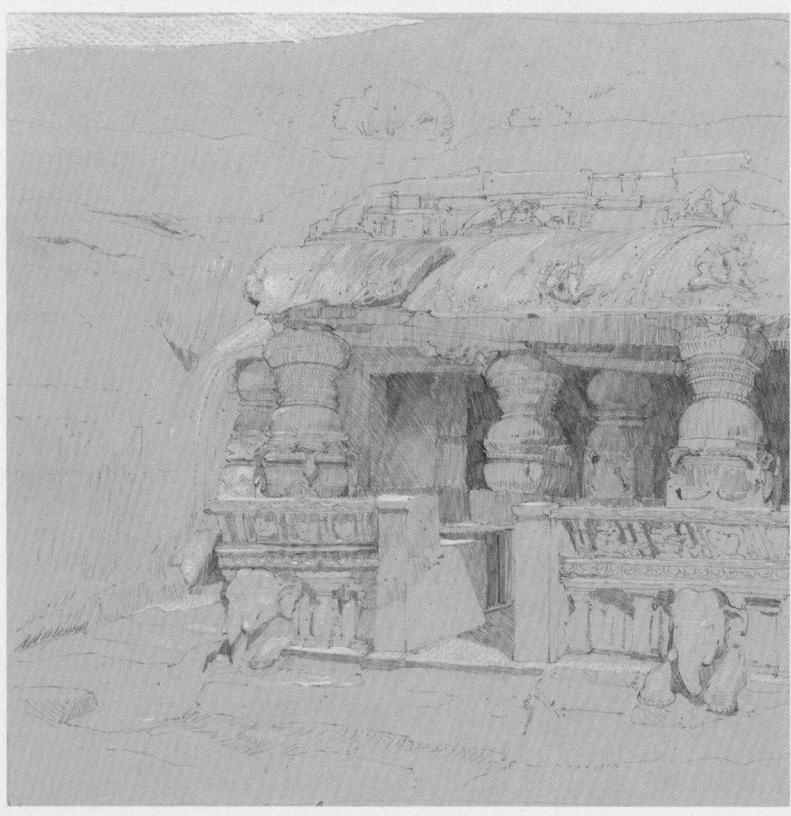

Jain temple at Ellora

CLIFFS AND CREVASSES

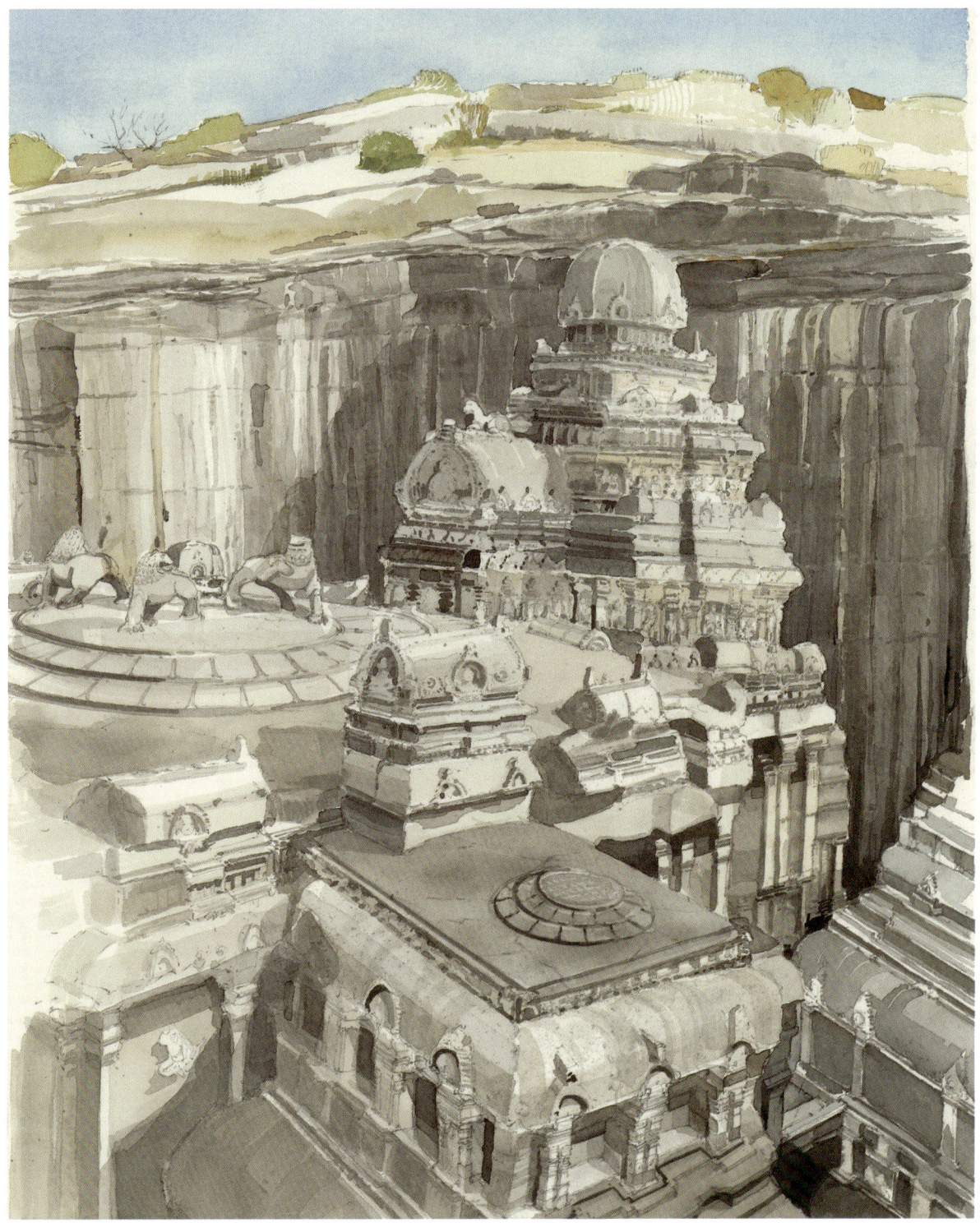

The Kailasa Temple

51

CLIFFS AND CREVASSES

The entire temple was once stuccoed and painted; the stucco still survives in some places, and a few traces of paint are still visible. Large interior spaces and deep arcades provide shade. This cave is one of the great archeological sites on Earth, yet totally unknown beyond Indian scholars or intrepid travelers. It's on a scale that approaches the great Western cultural monuments like cathedrals or the Colosseum in Rome.

I clambered up the hill beside Kailasa to find a viewpoint that let me capture the strangeness and complexity of the site. There was a ledge where I could sit, and I spent several hours drawing and painting. Some of the caves are only partially finished, so you can actually see the process that was used to cut the stone: A cave here completely hewn, but elements left unembellished, another a hundred feet away with roughed-out chambers and unfinished floors—ridges of the cut stone still in place waiting to be recut into the smooth, even floors of a shrine. In the unfinished spaces, you feel as if you might stumble across tools left behind when the workers stopped for the day. The caves stretch along the granite outcrop and were not carved consecutively; a huge facade will be followed by a tiny one. Occasionally, there's a cave looking as though it was abandoned after preliminary excavation, possibly because of unstable stone or a cleft discovered after a year or two of cutting.

In the completed caves, the large chambers are lined with smaller, square rooms—believed to have been living quarters for the monks. Several caves have upper levels reached by wide, shallow steps. These have intricately carved images and sophisticated geometric reliefs cut into the wide, square columns.

The caves at Ellora are registered as a UNESCO World Heritage site and recognized as one of the most magnificent archaeological relics on Earth. Though carved only with simple axes and chisels, they survive to humble us in their sophistication and grandeur.

Salty Soil
Gujarat

Ahmedabad is a city with ancient roots but is quickly modernizing. It is the fastest growing city in India, the state where Prime Minister Modi began his political career, and is poised to become the industrial center of the new India. Residential towers are filling the suburbs, but the center of the old city, The Heritage City, is still a wonderful place to wander. Lovely small fifteenth- and sixteenth-century mosques are tucked into neighborhood streets and the most dramatic and monumental, Jama Masjid, and Sarkhej Roza with its beautiful tank, are an easy tuk-tuk ride. Sidi Saiyyed Mosque is a small, exquisite place with intricate jalis, "lattices," cut with a tree-of-life pattern. The sun sparkles through them and it is a busy place when the call to prayer echoes through the city. I am greeted with smiles and nods when I settle in to enjoy the architecture. It's pleasant to hear the chant before dawn from my hotel across the street. The population is around 20 percent Muslim now, but historically, the city was predominantly Islamic through its several hundred years of competing sultanates and the eventual domination of the Mughals. Ahmedabad was a major recipient of Hindu flight from Pakistan during the partition in 1947.

In the center of the old city there is a carefully marked heritage walk that takes you through gated neighborhoods called pols. These closed homogenous communities evolved in the eighteenth century for security when the gates to the narrow streets would be closed at night and guards posted. Apparently, Jainism was a

dominant sect when these traditions evolved. Jains are dedicated to nonviolence and the resulting labyrinths made escape from danger and confrontation easy. Thieves or raiders could barely navigate the alleyways, and a closed door in a narrow passageway, which would actually be the route through the neighborhood, might look like the door of a private house. In a quiet neighborhood not far from the city center is a Jain temple called Hutheesing that is a fantasy of Indo-Saracenic nineteenth-century architecture. After recent restoration work and a fresh coat of paint it looks like a series of spun sugar towers.

While not the capital, Ahmedabad is the largest city in the western state of Gujarat. Tribal weaving, stamp dying, and needlework have always been an important part in Gujarati culture. There are several museums of tribal art and craft in Ahmedabad. A wonderful museum at a local middle school, called the Shreyas Foundation, is eye-opening with amazing examples of sophisticated textile work, and the famous Calico Museum is worth reserving a date to explore it.

The Gujarati countryside is filled with efficient, large farming operations. Gujarat is the main producer of culinary cumin in India. Miles of castor bean also grow along the roads. The extremely poisonous castor bean—the source of the deadly ricin—is treated with steam to neutralize the poisonous protein in the seeds and then pressed for castor oil. Another important crop is Indian plantago. The husk of the seed, called psyllium, is used to produce dietary fiber. The majority of world production of this crop is produced here and it's oddly a good crop for this ground. Much of the land in northern Gujarat is salt-laden, and plantago will grow in the inhospitable soil.

There are also fields of cotton. Gujarat used to be a major weaving state but now has become mostly a traders' economy—not as much is grown as in the past, but virtually all the cotton in India is traded here.

Vast automobile factories are being built here too. We passed a sparkling new Suzuki plant that stretches for several miles. The road passing the plant is already four lanes wide, but rough and crumbling after two years of construction traffic, and cattle amble along the median dodging trucks, cars, and tuk-tuks. The gleaming silver Suzuki buildings rest serenely behind high fences and walls. They look like outposts on a distant planet. Prime Minister Modi made a deal with the Japanese (after attempting a deal with the US) with huge government subsidies, and in return guarantees of using Indian workers—at least 51 percent—with training facilities included. It will change this part of rural India radically. There are ten- and twenty-story apartment buildings going up for the workforce. The Japanese management lives in gated compounds and it's not possible to see a Japanese face anywhere.

Laborers' camps are scattered at the outskirts of the site, with tarpaulin shanties and children playing. Other large manufacturing centers are appearing everywhere, and windowless logistics centers hum away. Within a few minutes of all this twenty-first-century activity you step back into the world of small repair shops, tea stalls, and markets. A new highway is being carved across the land to connect this part of Gujarat to the western coast where shipping to the world will be possible.

A couple hours from Ahmedabad is the village of Modhera. Its early eleventh-century Sun Temple was completely destroyed by Mughal troops attacking from Delhi in the early fourteenth century. The temple's remains laid in a rubble field for hundreds of years. Surprisingly, very little was pilfered through the centuries beyond the stones of periphery, chatris, "shrines," and some of the stone from the central octagonal tower. In the mid-1960s, a herculean restoration project was begun. Today, the rebuilt temple is one of the most dramatic archeological sites in India. It is actually two pavilions. One is a hall for dance; the other—the sanctum—is for ritual worship. The sanctum is filled with eight-sided columns and each has a section that renders romance, seduction, and consummation with a little playful imagery of group sex thrown in. It seems that sex in eleventh-century India was not only about procreation. It's appropriate here because the sun was the source for all living things. Sex was the joyous completion of the sun's intention. The temple's exterior has images of the sun god, the moon god, and the fire god. Theses deities manage the earthly needs of humans while the three supreme gods—Brahma, Shiva, and Vishnu—are the guides and protectors of spiritual life.

The temple stands on a lotus-shaped platform and above a magnificent stepwell called Surya Kund. The well acts as a reflecting pool as I approach the site. Classic tank steps zigzag down all four sides of the well and create a cubist effect mutating and narrowing as they near the water at the bottom. The shadows lengthen and darken while I sit for a couple hours working on a drawing.

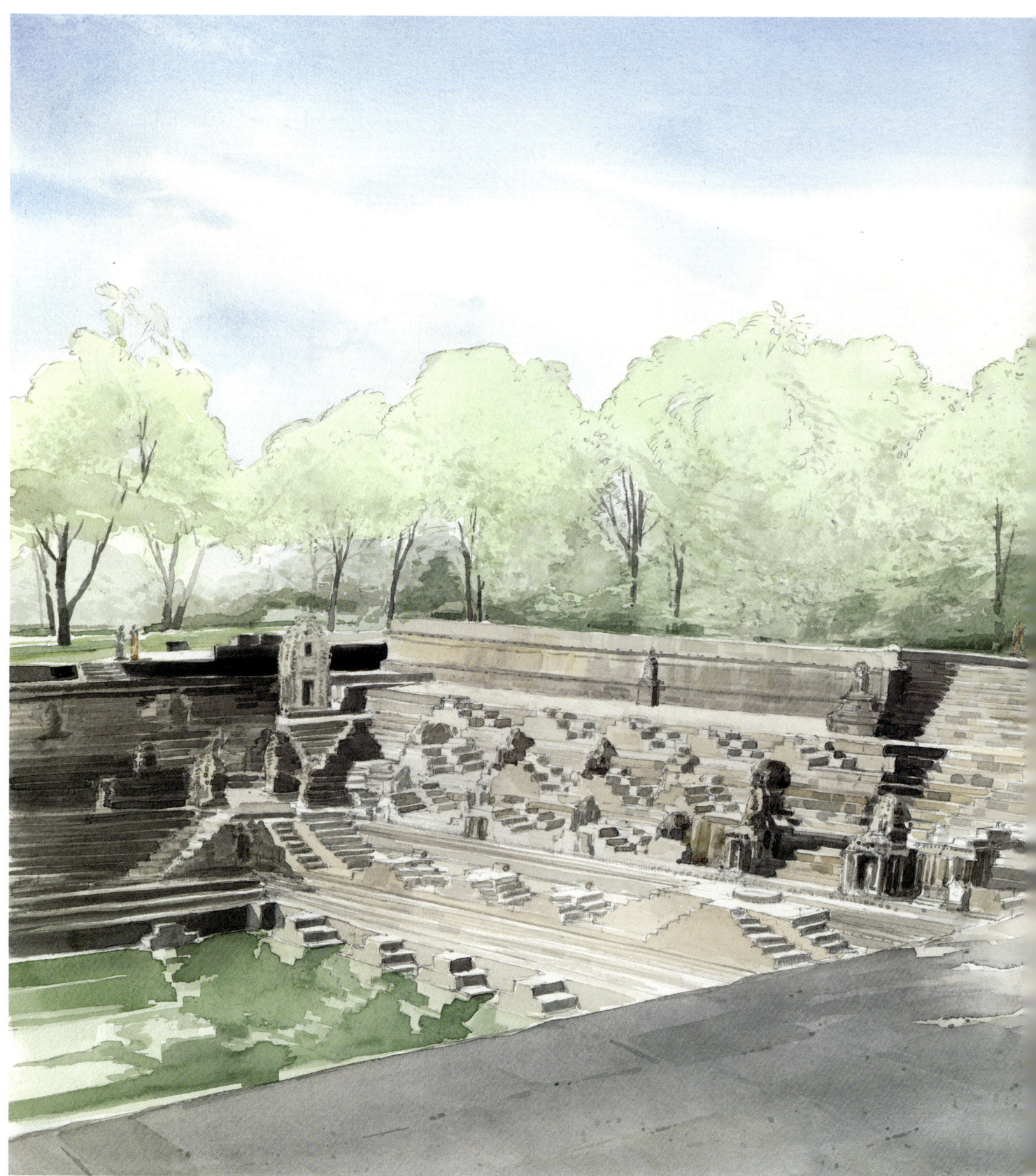

Sun Temple, Modhera

SALTY SOIL

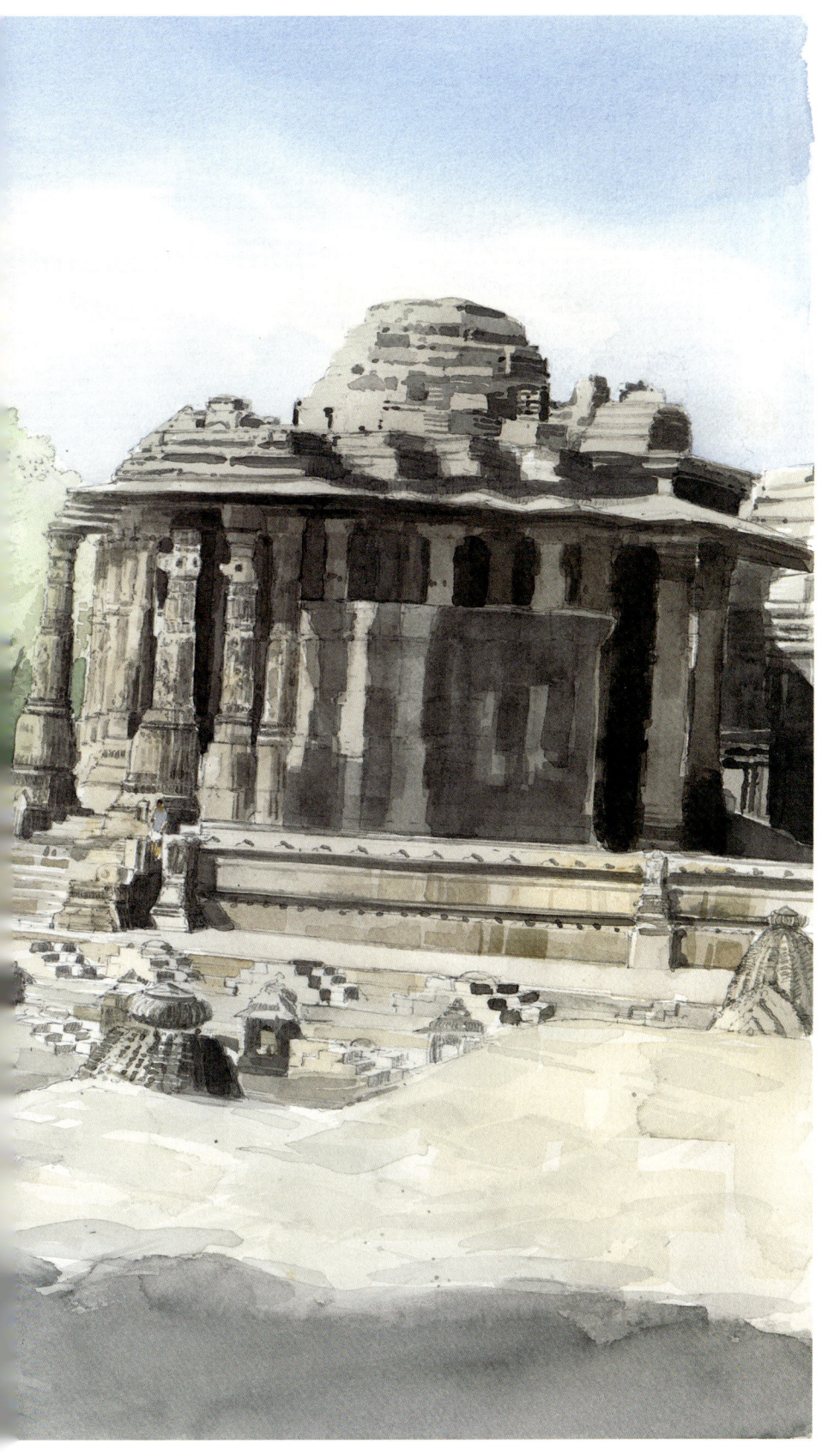

COOL, DARK CHAMBERS

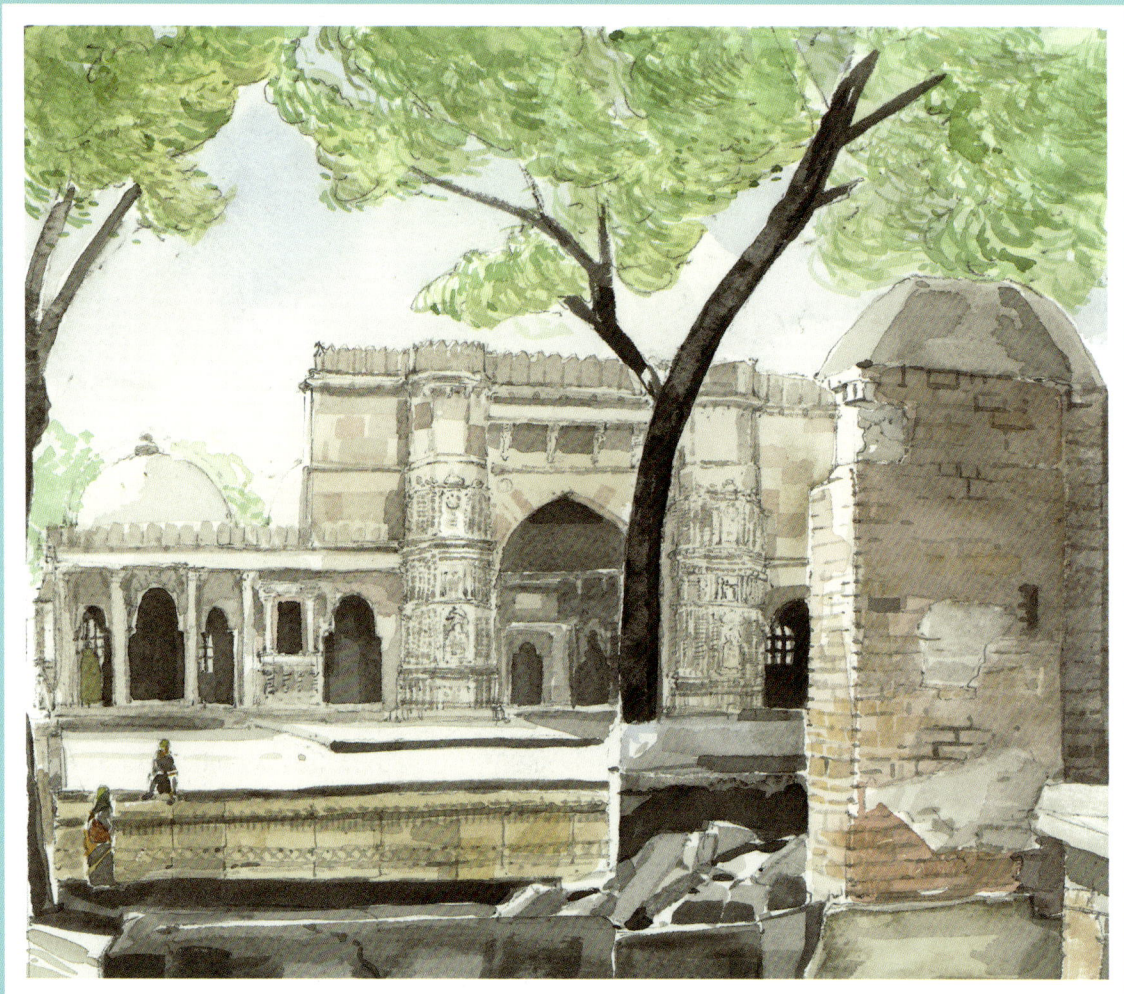

Stepwell at Adalaj

Cool, Dark Chambers

About half an hour outside the city of Ahmedabad is the village of Adalaj. On a quiet street in a neighborhood of small shops, and with a soccer field next door, is a peaceful stepwell with a small mosque standing beyond. The well was begun by Queen Rudavedi, the wife of Rana Veer Singh, in the fifteenth century. Legend tells a romantic but tragic tale about this well. The king was overthrown, and his beautiful queen was preparing for *sati,* the Hindu ritual whereby a widow throws herself onto her husband's funeral pyre. It took legal prohibitions by the English in 1829 to control the practice, but it took another law written in 1987, called the Sati Prevention Act, to eliminate the ritual completely from Indian village life.

The conquering king fell in love with the widow and promised to complete the stepwell for her if she promised to marry him. She agreed, and when she visited the finished well and circumambulated it, she threw herself into it. It was considered haunted from then on, and it took several generations for the well to be considered safe to use.

The well has five levels and the elegance of all the royal wells in Gujarat. Bridges and columns frame the wide shallow steps that lead down into the shady, cool lower chambers. The wells were used for socializing by the women of the communities. It's easy to believe and understand why. The heat of the day can be brutal, and the natural chilling effect of the water keeps the spaces ten to fifteen degrees cooler than the ground level.

COOL, DARK CHAMBERS

Another well built for a queen, the Queen's Well, Rani Ki Vav, is in a place called Patan, which was Gujarat's capital in the eighth century. In the early 1950s, an ancient text was discovered that described the building of a royal stepwell. Archeologists began searching in the area described in the text and found a nineteenth-century stepwell built with some stone that was clearly from an ancient structure. They began disassembling that well and discovered one of the most completely preserved wells in India. Earthquakes and erosion had completely buried the well and hidden it from invaders. It is now a UNESCO World Heritage site.

Seven levels descend deep into the cool, stone, underground palace-like structure. Galleries, balconies, chambers, halls, and wide stairways open below as you stand on the virtually featureless surface level of the well. Hundreds of sculptures decorate this seven-level space. It measures about 213 feet by 66 feet and is almost 92 feet deep. Each tier has friezes of gods, goddesses, and beautiful women involved in everyday activities. Naturalistic, stylish, and sensual, some are doing their makeup and hair, others bathing, holding children, picking fruit, or looking into a mirror. These are women's activities—the well was built for the queen's use. Only she would come here to bathe. After her bath, the water was used to water the gardens surrounding the well.

Even though the sun was hot on my back, I perched on a ledge and worked on a drawing. The space is wonderfully complicated, like an Escher engraving.

. The Queen's Well, Gujarat

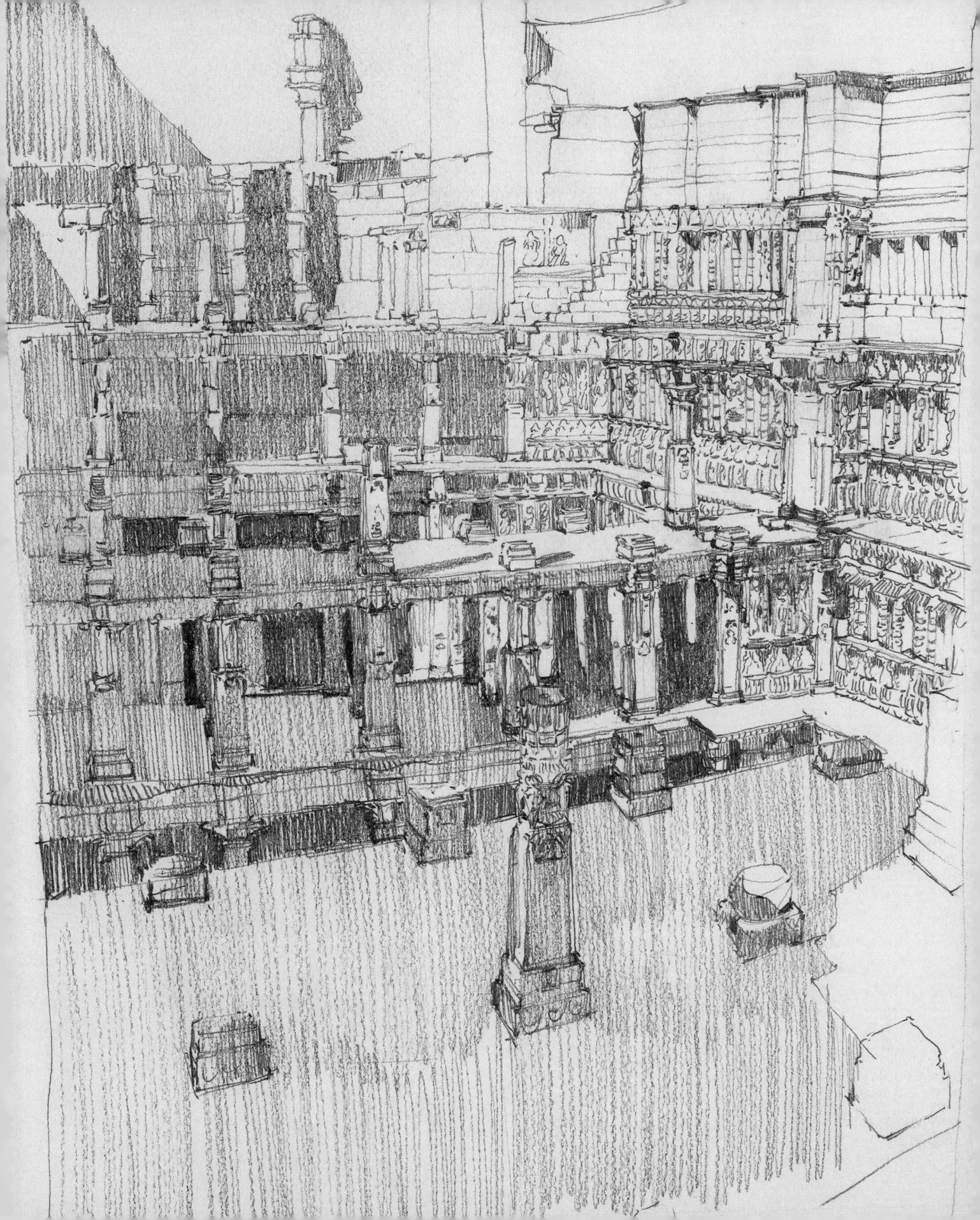

Champaner

Like most ancient sites in India, the story of Champaner is one of conflict between ruling clans and kingdoms. The remains of the city are almost five hours southeast of Ahmedabad. It was made the capital of Gujarat by Sultan Mahmud Begada when he captured the city in 1484. The city prospered because the Sultan hoped to make Champaner a pilgrimage site that would compete with Mecca as a holy city. A complex water collection system, including an almost abstract sculpture in the form of a circular stepwell, was created and still functions today, and elegant mosques were built in the valley below the impenetrable fort, called Mandu, that still dominates the landscape.

 The greatest of the mosques is the Jami Masjid. It rests on a high plinth and is surrounded by stone walls pierced with intricately carved balconies. Its one-hundred-foot-tall minarets stand silhouetted against the sky. The once-paved courtyard is now a grassy park-like sward. Inside, there are a dozen domes with fantastical swirling peacock tail paisleys carved into the interiors.

Ceiling Paisley, Champaner

CHAMPANER

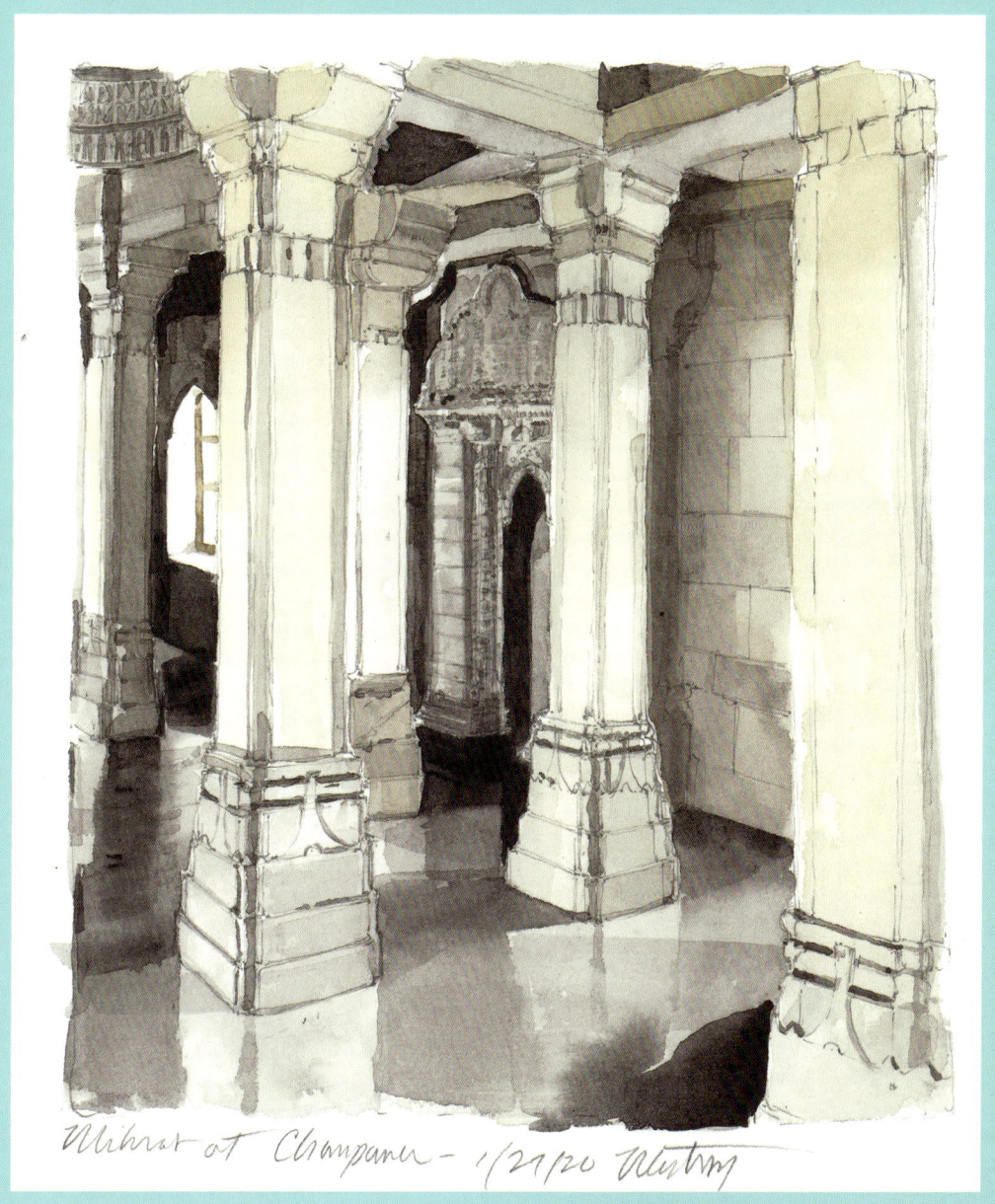

Mihrab at Champaner

CHAMPANER

It is quiet and deserted as I wander through the hall and sketch the elaborate mihrab—the recess in a mosque that indicates the direction of Mecca. The octagonal columns that support balconies and the roof are perfect examples of the Indo-Saracenic hybrid architecture. The designers, engineers, and stone workers who created the mosques scattered through this valley were from the ancient stone working Hindu clan called Sompura, which literally means "stone carvers." There were eleven divisions of laborers, as in a guild—architects, engineers, rough cutters, rough carvers, movers, assemblers, detailers, and others. The inevitable blending of medieval Hindu traditional forms with the nonfigurative Islamic standards produced beautiful patterns of plants and geometry in place of the gods and goddesses that inhabit Hindu temples.

You can find other smaller mosques along narrow tracks in the valley, where they stand in meadows of tall wispy grass, and lizards scatter when your shadow passes through the vaulted entrance porches.

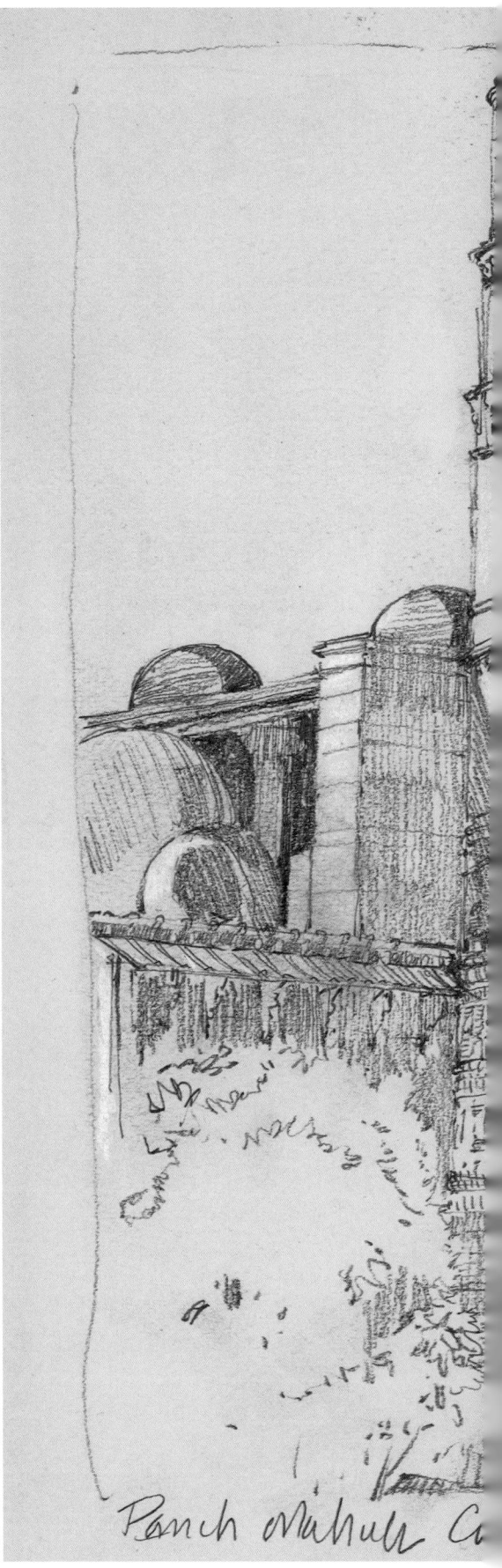

Panchmahal, Champaner

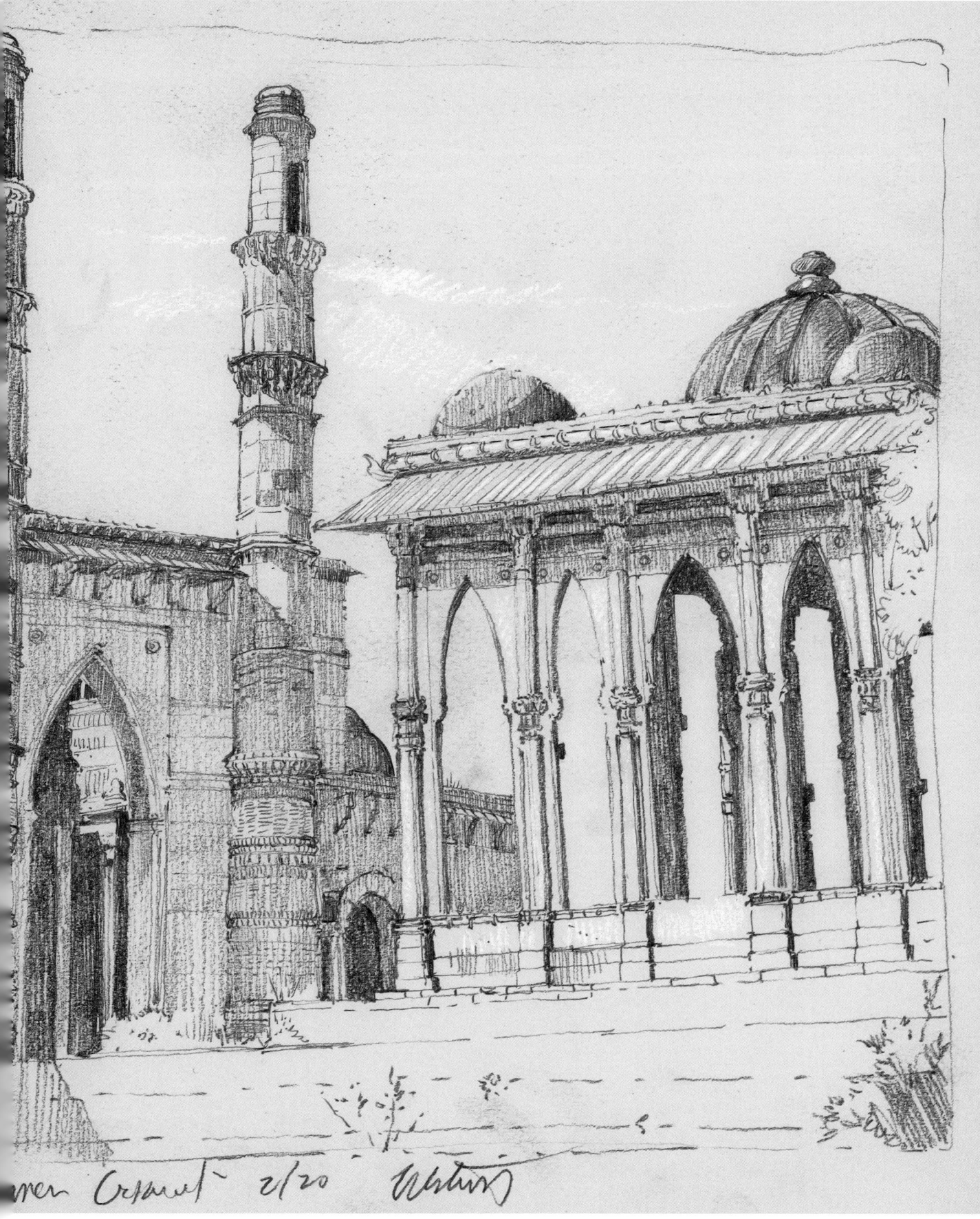

EAST ACROSS THE CONTINENT

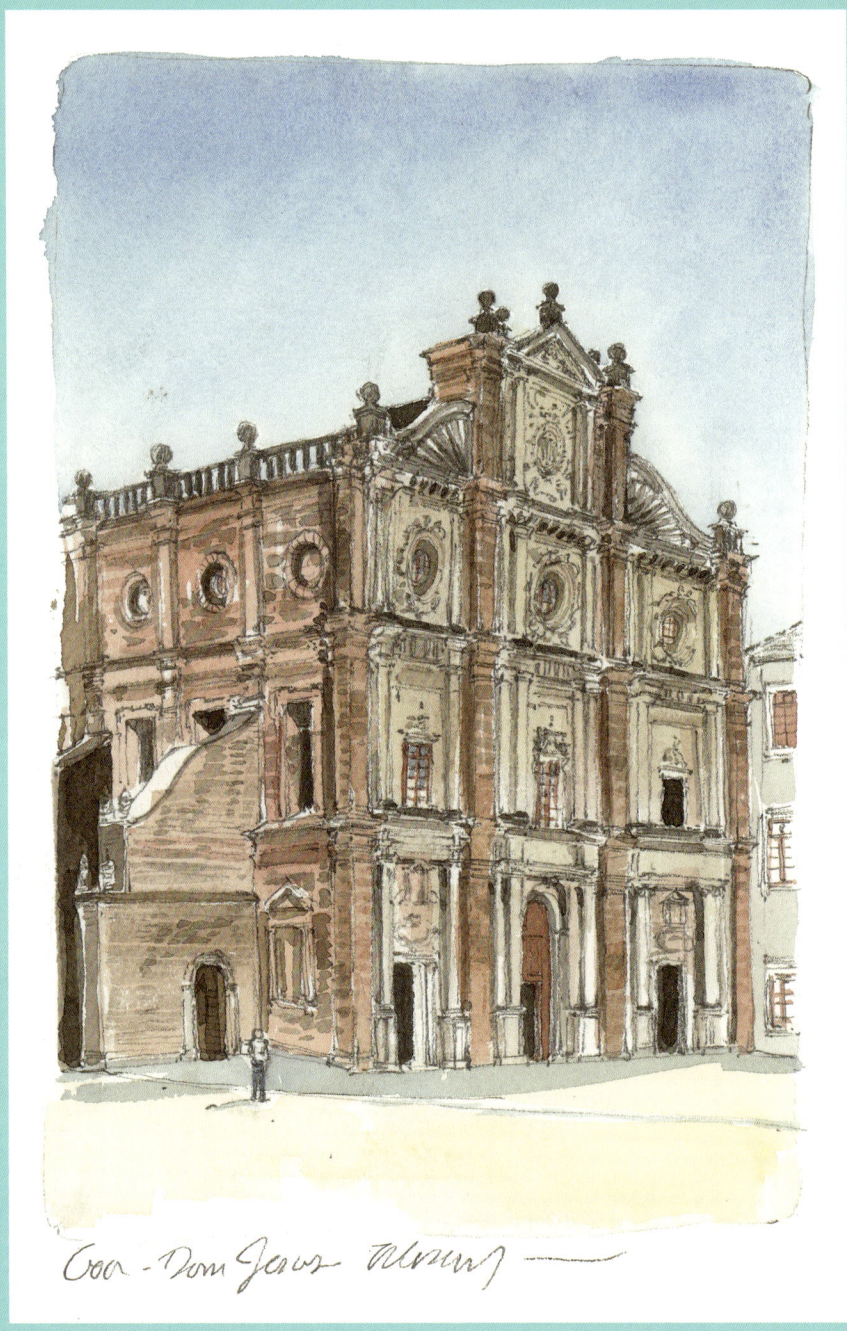

Goa—Basilica of Bom Jesus

66

East Across the Continent

Goa, Badami, Aihole, Pattadakal

My first trip to Goa included the introduction to a fellow who would become my companion for several weeks. Nadeem Sayad was supposed to simply be my driver. He began our time together with a sort of formality that his employer demanded. He wore the company uniform while driving. He was nervous about eating with me, and he jumped out of the car to open the door for me when we stopped. After a few days, I was able to get him to drop the formalities and we soon became friends.

Goa is on the western Arabian seacoast of India, about three hours south of Mumbai by plane, and often described as a beach holiday destination. The Arabian Sea is a calm, glistening ocean, which hovers around 80 degrees Fahrenheit year-round. It does not make for a very refreshing swim. The beaches are crowded during the day, but one might well see a kingfisher after the sun has set. The cafes and hotels lining the beach are pleasant places for dinner—they are sandy and noisy, with local musicians entertaining in the evening. Lumbering tourist hotels are filled with families on holiday, but you can find smaller boutique guesthouses after winding through the palm-lined roads past Portuguese-style nineteenth-century villas.

South Goa is actually a series of villages strung together. As you pass through the tropical-feeling flats along the sea, you come to villages with narrow streets, where deeply shaded balconies and verandas tip toward the road.

EAST ACROSS THE CONTINENT

Old Goa is the vestige of the sixteenth-century capital of Portugal's colony in India. It seems that there was not a seagoing nation that didn't find its way to India to either buy (from a local princely house) or just seize a scrap of land and build an outpost of European occupation. Amazingly, many of these colonies were held deep into the mid-twentieth century. These cities and towns are often affecting. All over India it's easy to find examples of the hope and intention to create a copy of the English, Danish, Swedish, or French world left behind. Barracks, clubs, lodges, and churches are laid out in tidy streets with a mind to orderliness and familiarity. The memorial plaques and grave markers in the churches are frequently moving in their longing for home; the young captain sent out to India who never returned, or the list of dead children from a cholera epidemic in 1820 can sweep you back to a sense of the constant dangers and dislocation that these determined settlers must have lived with.

Goa shows, in the most colossal way, the conviction that these were permanent outposts, for the scale of the imperial colonizing impulse is breathtaking here. From the terrace of the Chapel of Our Lady of the Mount you look down at the wide, slow-moving Mandovi River and what you see are the towers of the surviving churches of Old Goa, once numbering around three hundred. The city had more than fifty thousand people living here at its peak.

These churches and the cathedral are wonderful—huge piles of stuccoed masonry all whitewashed and blazing in the sun. All, save for the Basilica of Bom Jesus, which is unpainted laterite stone (the basic volcanic foundation stone for most of India) and looks for all the world like a renaissance church transported from the banks of the Arno with palm-shaded cloisters. The cathedral is vast, with three-foot thick walls and baroque chapels lining the sanctuary. Vigorously muscular carved altars are gilded and putti-laden.

A cathedral museum features odd portraits of the succession of bishops and priests as well as governors and other notables. It is obvious that the Portuguese planned to be here forever.

There are many contemporary commentaries about Goa's colonial heyday. Its opulence rivaled any European capital. Wide boulevards with palaces and gardens lined the river—it was a city of gold. All this came to an end in the mid-nineteenth century when, after repeated bouts of cholera culminating in a crushing epidemic and because of the constant threat of malaria, the capital was moved a few miles away to Ponda. There, the air was thought to be better, without the miasma that was blamed for the pestilence, but it didn't save the city or the Portuguese presence in India. The colony struggled with declining fortunes as the coastal jungle began reclaiming the old city. India finally expelled the Portuguese militarily in 1961. The decline of the Portuguese colony in India had begun centuries earlier, however. The staggering wealth of the outpost had risen from the spice trade with the southern kingdom of Vijayanagara—now in the state of Karnataka. After many years of successful defense against invaders from the north, Vijayanagara—which was actually a kingdom forcefully united by a king determined to resist the Muslim armies—was finally defeated and erased from the face of the earth in 1556. Goa's main trading partner was lost and the blow to the trading economy was terminal.

Now He Is My Son

Driving east and inland from Goa to Badami is a six or seven hour trip over uneven roads, and slow going when you are climbing a steep hill behind the inevitable transport or bus. Some sections of toll road with fresh smooth macadam carve time off the long trip. In the old language of the region, badami means the "color of almonds," referring to the color of the stone bluffs surrounding the town.

Badami is the center of a farming area. Piles of white onions lie in the sun with cleared fields behind them, and there are miles of cotton fields too. Driving with Nadeem, he swerves around a small truck tilting dangerously with a mountainous load of white cotton bursting from the seams of a tightly tethered dome of blue plastic.

The fields surrounding the villages are still mostly plowed by oxen and are all planted by hand. There are not many tractors in sight—and this is India's breadbasket. Even on the main roads you will often have to work your way around herds of cattle or goats being driven home. After getting through one particularly big herd of cattle, maybe forty animals, Nadeem says, "He is a rich farmer." Each cow is worth 30,000–50,000 rupees, or $300–$800; $3,000 is a good annual salary in most parts of India.

As you drive further east and south toward the sea, you pass fields of mulberry bushes cultivated for silkworms. Here, silk manufacturing replaces most of the other agriculture—Bangalore being the center of silk weaving in the state of Karnataka.

NOW HE IS MY SON

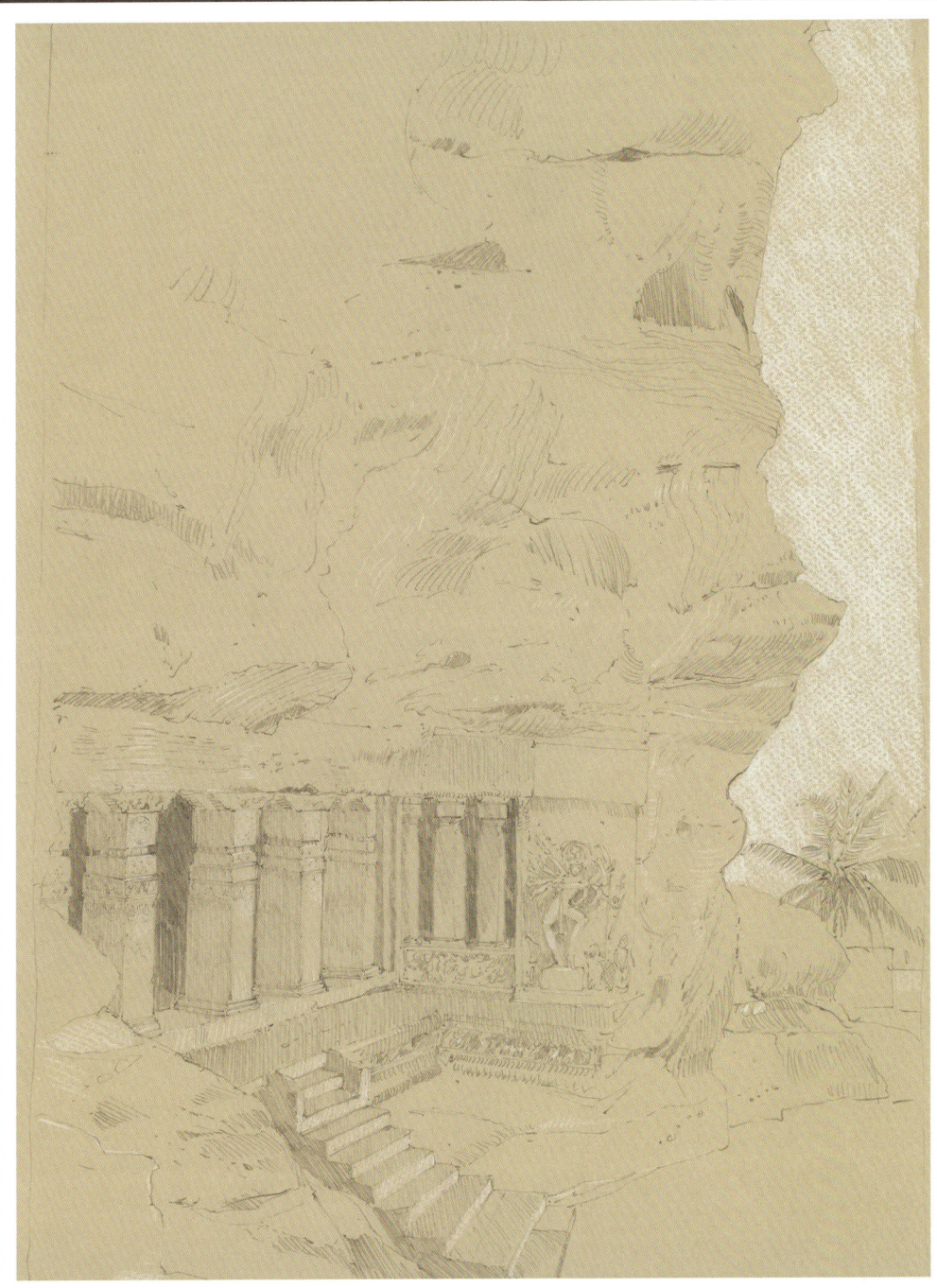

Badami Caves 1, Dancing Nataraja

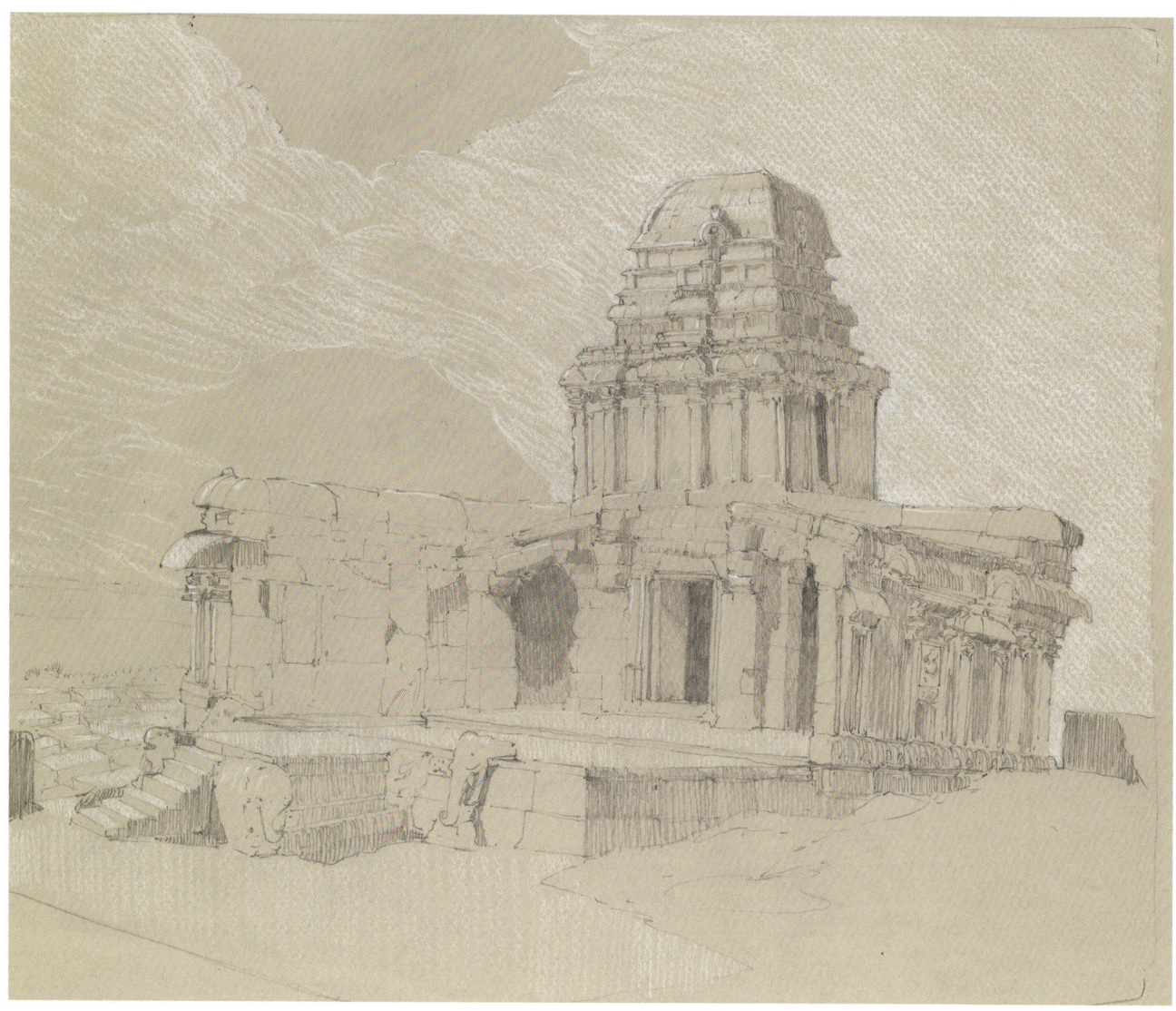

Upper Shiva leya, above Ajanta

In Badami there is a series of temples cut into the sandstone mountain. The earliest cave temples are from the sixth century. The stone here, unlike the granite of the caves near Aurangabad, is golden with swirls of amber and rust. You climb a series of steps to landings on which the temples are carved.

 The caves have flat facades with wide openings framed by square columns. Some columns are embellished with garlands and geometric patterns. Inside, low-ceilinged chambers are cool and dark, with images carved on some of the walls. In the recessed chambers you find lingas, the phallic avatar of Shiva and symbol

of fertility. Usually lingas in Shivaic sanctums rest in the corresponding uni, the female counterpart. Water poured over the linga drains into the uni, which acts as a basin. The water is channeled to a trough and then to a port in the wall of the sanctum. There, devotees collect the holy water for their ablutions as it spills out. I climb the stairs to a landing above Cave 1 and spend three hours on a drawing there. Five square columns open into a dark space with 164 feet of sandstone cliff above. At the facade there are two framing panels, left and right. A deep relief of Shiva dominates my view—the only extant eighteen-armed version of this avatar of the god of destruction. Some hands hold weapons, and he is dancing with one foot raised. It is a wonderful image. The drawing is interesting with the sun behind the mountain so that only a few flickering surfaces catch the light.

Nadeem and I then walked through the narrow streets toward the entrance of the other series of mountain temples. As we wandered up one tiny street, a woman was standing at her door talking to another woman across the street. Nadeem asked her for directions to the entrance, and they struck up a conversation. I suspect she was wondering about me. They chatted for a few minutes and we went on our way. Nadeem told me that she had invited us to come back for tea. I was surprised that she would invite two strangers into her house, just like that.

We found the stone gate to the mountain temples and came to a series of long flights of steps built between sheer cliffs that look very much like the ancient city of Petra in southern Jordan. At the top there is a fort, which must have been a grim retreat of last resort.

I sat for a couple of hours drawing the temple on top of one outcrop that is called The Upper Shiva Temple. The building, at the edge of the cliff, can be seen from the entire city below. There is a square chamber, but the traditional porch is long gone. The temple has a bold, unembellished square tower. Surrounded by bare stone and throwing dark shadows in the hot mid-morning sun, it looks like it was built to be seen from far away, its deep undercuts defining the geometry.

I spent the rest of the day drawing another temple called Bhootnath, on the bank of the lake at Badami. The village has been separated from the temples lining the hill above the lake by chain-link fence. I wandered around three tightly locked stone temples and finally the caretaker appeared, offering to open them for me. They are dark, low-ceilinged chambers with some shallow carving on the thick jambs. Women were washing laundry on the steps below me. A man was coaxing his buffalos into the water

from the steps where he splashed water over their heads as they swam in circles. The man was singing as he managed the bull and his song echoed off the cliffs and hills behind me.

On the way back to the car we passed the same house and the woman was standing in her doorway. She smiled and bowed slightly and invited us in for tea.

Her small square room with its stone floor was cool even in the afternoon heat. She and Nadeem chatted. He was clearly explaining who I was and what I was doing in India. He also told his own story, and at one point she began dabbing her eyes and reached out to put her hand on his shoulder. He explained to me that he had been talking about the death of his mother two years ago. She brought out snacks to accompany the tea—puffed rice mixed with little bits of dried mango and chilies. The tea was strong and milky and very hot. After about a half hour with this elegant lady, we left. As we walked down the steps from her house to the street she gestured toward Nadeem and said, in English, "Now he is my son."

NOW HE IS MY SON

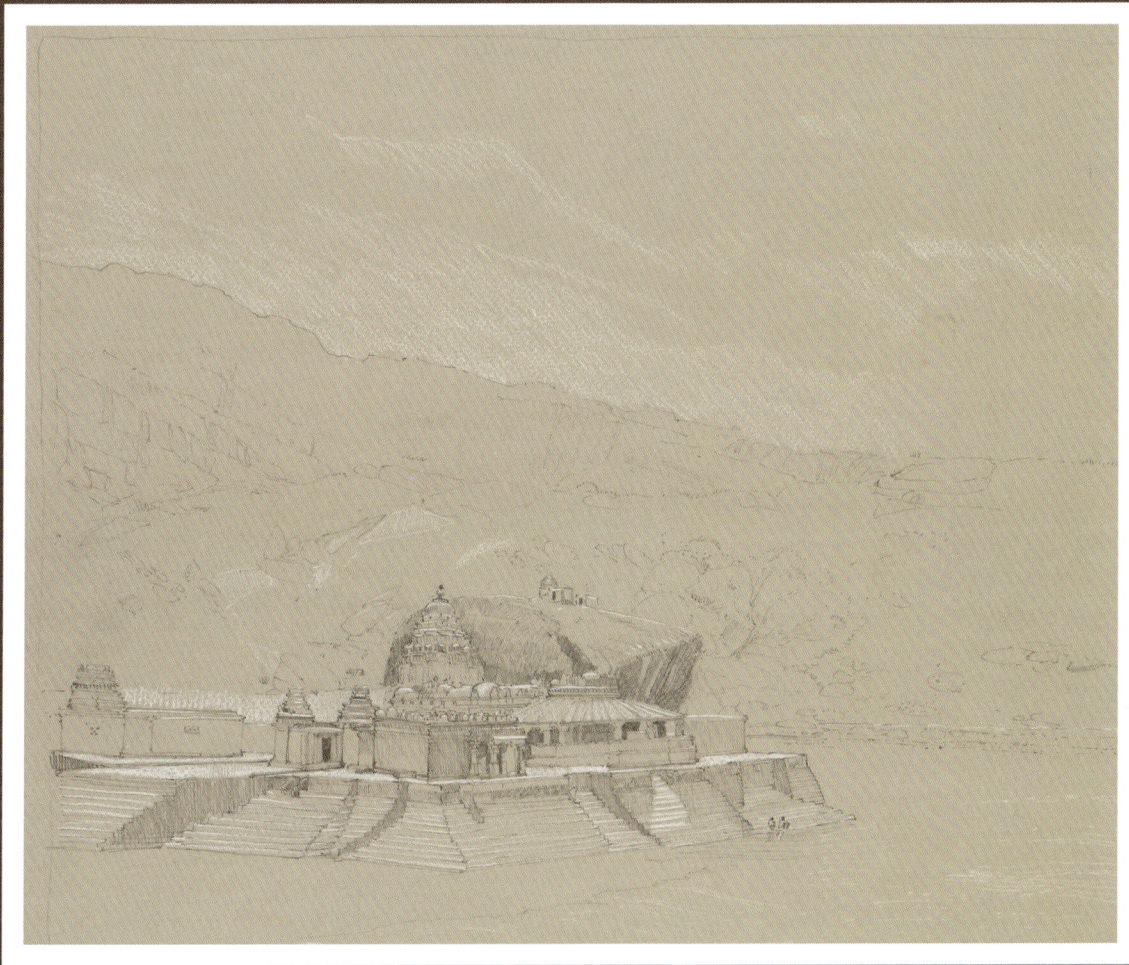

Bhootnath Shiva temple, Badami

Pencils and Paper

Many visitors to India will only eat in their hotel. I tend to be cautious, but if your driver knows a small street stall or if you can watch as a samosa is fried in front of you, it is (usually) safe. I have spent time and had many lunches at a little restaurant stand on the edge of the Pattadakal temple complex near Badami. Once, while having lunch there with Nadeem, a young fellow came in and sat down at another table. He was crippled in a painful looking way—one leg shorter, limping on one foot and the toe of his other foot—a pocket full of felt tip markers staining his shirt.

 The owner said to me, "This boy is an artist too." Obviously, Nadeem had told him I was hoping to draw the temples. Nadeem asked if I would show them my drawings. He got the portfolio I carry with paper and my drawing board from the car. I took out my drawings and several watercolors. A small crowd gathered as I laid them out. The boy grinned and reached for the drawings and held them up to look at them. He was particularly intrigued by the drawings on tinted paper. I got my pencil box, fished out a white Conté pencil and a couple of soft graphite drawing pencils, and pulled a sheet of thick, stiff watercolor paper and several sheets of soft gray drawing paper out and handed them to him. He held them close to his eye and felt the deckle edge of the heavy paper. He started to hand them back to me and I said, "No, they are for you." He was a little confused and paused to take it in.

In addition to this boy who drew, whom the owner seemed to feed every day, there was a laborer who came in and sat and ate what was clearly his only meal of the day. The owner sat down at the table next to me and smiled, looking at him. "He really is a sweet man," he said. He had, just minutes before, poured a plate of milk for a wild-looking cat that wandered in and I had seen him feed a pair of tiny puppies that could barely walk, they were so young. This food stall ended up being the place we went every day while I explored the area around Badami and Pattadakal.

A day or two after I had given the boy those simple drawing tools, he came in again during lunch and, standing near the back, passed an envelope up to me. In it was a drawing on a small piece of the paper I had given him and six other drawings. I looked at them and got up to thank him. His right hand was crippled and he kept it pushed into the pocket of his trousers, so as I put my hand out to shake his, the owner said, "He can't shake hands because..." I put my hand out and took his left hand. I said, "Tell him I draw with my left hand too."

It's remarkable and very moving that a man who must just barely get by running a lunch stall and who stands behind the stove himself, his dark t-shirt covered with flour from making flatbread, takes on strays and the needy.

The weather can be surprising this time of year. March is the beginning of the hot season, but there can be cool, clear days. It does get hot in the afternoons, but not any hotter than Virginia in July. Rarely, there can even be some rain this time of year, before the monsoons. I have been trapped under the cover of a tenth-century porch when the sky suddenly opened. The next moment the sun was searing and the streets billowed with steam.

It is almost impossible to avoid shopping along the way. The weaving patterns and traditions are very specific to each region. Simpler cotton patterns can be beautiful, but the variety and opulence of the silk saris is fantastic. New designers are creating bold nontraditional patterns that are sold in boutique-like shops now, and there are vast air-conditioned shopping malls in every city along with the tiny sari shops run by women to bring in a little extra cash. The traditional shopkeepers, however, are men. They spend much of the day sitting on the stoops of their shops, gossiping and drinking tea while waiting for a customer or two. Nadeem took me to a place that he knew in Badami and I casually sorted through shelves and shelves of saris. I had never tried on the traditional wrapped cotton loincloth, called a *dhoti,* which old men in the villages still wear and which city men wear for tradi-

tional weddings (in silk with gold banding). There is an interesting cultural thing about the dhoti. Men are constantly re-tucking it, flipping it, carrying the bottom edge lifted, folding it half up, and tucking it loosely in front. The women often do the same with their saris, readjusting the draping over the shoulder or pulling it around over their hair. It's sort of a cultural tick.

 I asked if they sold dhotis. They were surprised and amused that I was interested and offered to teach me how to wrap and tie it. They took me into a back room where I undressed, and they draped the whole thing in place. It's a yard wide and five yards long. It is folded, tucked, and wrapped differently in each region. It's now possible to buy a dhoti pre-tied, stitched in place, and shaped like trousers. I like the stiff, starched cotton ones that crackle and fold sharply as you wrap them. I bought the dhoti and a *kurta*, the traditional long shirt, and the owner offered the final touch: saffron-orange powder dipped from a jar and drawn from the bridge of my nose to my hairline. The shop owner threw in an entire matching setup for Nadeem. The sale was celebrated by a neighboring shopkeeper appearing with a tray of green coconuts, the tops cut open and the bottoms trimmed flat, a bright plastic straw standing in each. The cool sweet coconut milk is a standard roadside refresher. My closets are full of bits and pieces of traditional clothing now. Once, I met a maharaja who, at a dinner party, taught me how to wrap a turban Jaipur-style.

 I had dinner with Nadeem at the home of the owner of the stall where we had been having lunch. The village had no street signs, so it took verbal directions and a couple of cell phone calls to find the house; Hospitality for a stranger traveling alone.

Pattern Books

A couple of hours from Badami is Aihole (pronounced eyeholay), one of the most ancient temple sites in India. Close by is another wonderful site called Pattadakal. Aihole was begun during the sixth century and the architectural style evolved slightly in the temples of Pattadakal. These two sites can almost be seen as pattern books for temple design in the rest of India. There are more than one hundred temples (or their scattered remains) at Aihole. They are built of golden cut stone and are up to three stories high, although most are on one level. They are intricately carved and many have fascinating stone grills banked along the sides of the chambers to let in light.

Pattadakal is about ten miles away. This compound is where the local kings were traditionally crowned in the twelfth century. It is important archeologically for the hybrid style of architecture that seems to have evolved here. Each temple shows a slightly different design with its own unique features.

I found a shady place against a wall in the courtyard of the main temple to sit and paint a watercolor. The priest seemed bemused that I was there and offered me a blessing when I had finished my work. School children wandered by and asked me for pencils. I handed some to them and they squealed with delight.

These temples form a collection of tightly connected courtyards and terraces, like a campus. There is a beautiful large Nandi resting calmly at the entrance to the main temple where he patiently waits under a stone canopy to transport Shiva. Nandi is the bull that carries Shiva on his travels. Every Shivaic temple has a carving of Nandi facing the door of the sanctum.

THE POMPEII OF INDIA

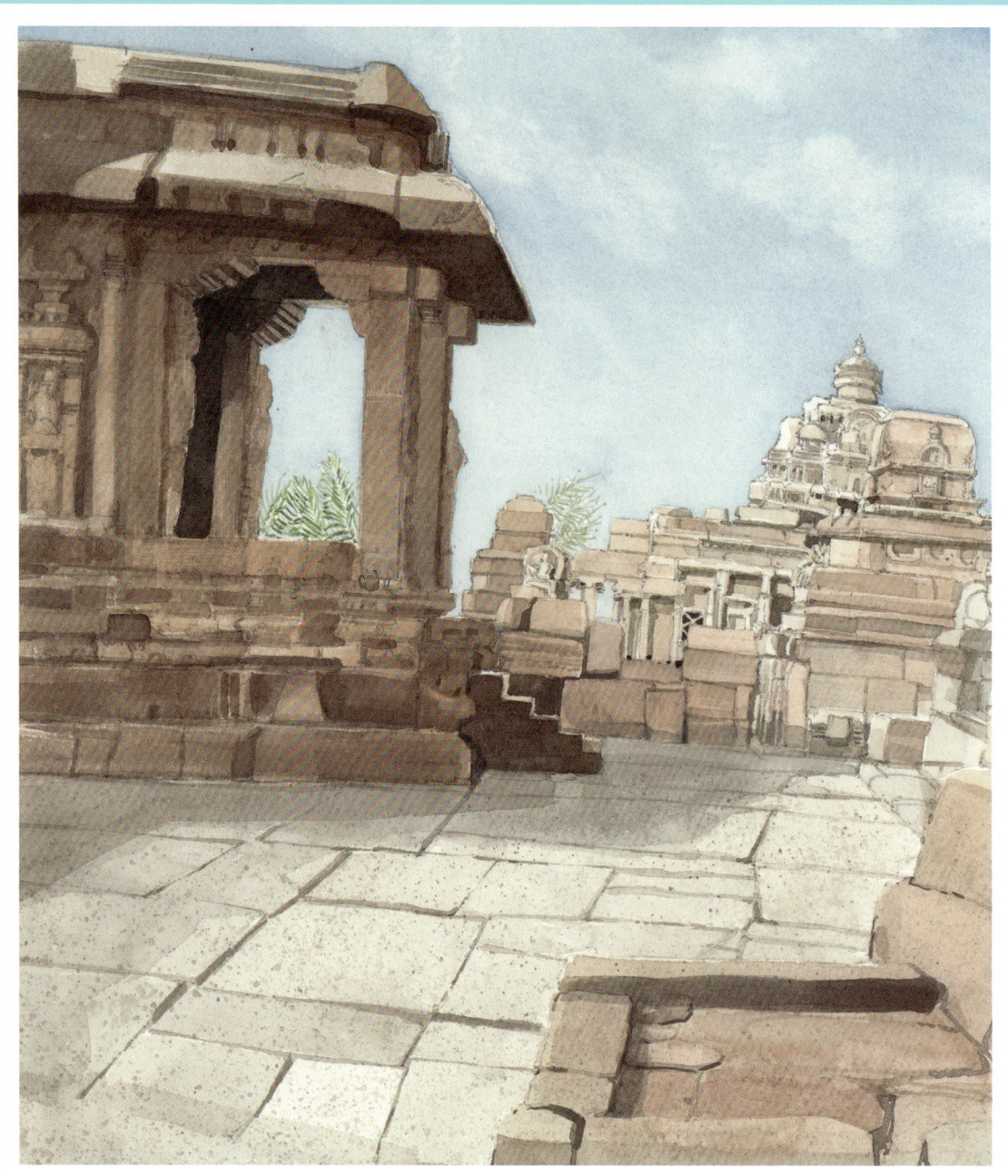

Virupaksha Temple and Mallikarjuna Temple

The Pompeii of India

Hampi

It is a five- or six-hour drive from Aihole to Hampi—the modern town that now stands around the ruins of the ancient capital, Vijayanagara. The last half hour is through wide, emerald-green fields of rice. Huge outcroppings of warm, buff-colored boulders of granite loom between the rice fields, creating a lovely contrast between the wildness of the rocks and the tamed fields with water pouring out of them. Ditches and road margins are filled with wild hibiscus, giant elephant ear plants, and stands of intensely orange canna lilies. Ancient gnarled trees and an occasional clump of bamboo shade the roads.

 It is also possible to approach Hampi from the south by flying into Bangalore and driving north. It is about seven hours by car. It is a grueling road trip on one of India's most congested highways, though. This highway is actually the first big road project ever conceived in India and can get you from Bangalore to Bombay in twenty-four hours. It starts as a six-lane highway in Bangalore, but after three hours you leave that toll road and slog along a two-lane highway with careening and overloaded trucks hauling freight. At one point along the route I got a glimpse of the incongruity of life in India. There appeared on the distant hills, through the afternoon's shimmering heat waves, still or slowly spinning wind turbines. An hour later, after creeping along a congested length of highway, I passed three massive trucks pulled up and standing in the highway, each with one wind turbine blade strapped to the

THE POMPEII OF INDIA

flatbed. They looked like huge, finned sea creatures. On the trash heap beside the road a woman in a bright sari was picking through the rubble—new and old India at a glance.

There are some new, modern, and flashy hotels being built on the outskirts of Hampi and there is rumor of a five-star hotel in the works. There are new flights into the small airport near Hospet, just a half hour away, which will add more tourists to the usual congestion of pilgrims.

I was introduced to Viru Pakshi, by way of the British archeologist George Michell, as the best guide in Hampi. He has helped me negotiate the confusing hurdles that are sometimes built around access to drawing and painting in Hampi. Viru taught me more about Hampi than any of the reading I have done. He has taken me off the grid to some of the more remote sites surrounding the area.

The ancient city of Vijayanagara has been under excavation and restoration for decades. The kingdom was a group of small, usually warring states brought together by one charismatic and

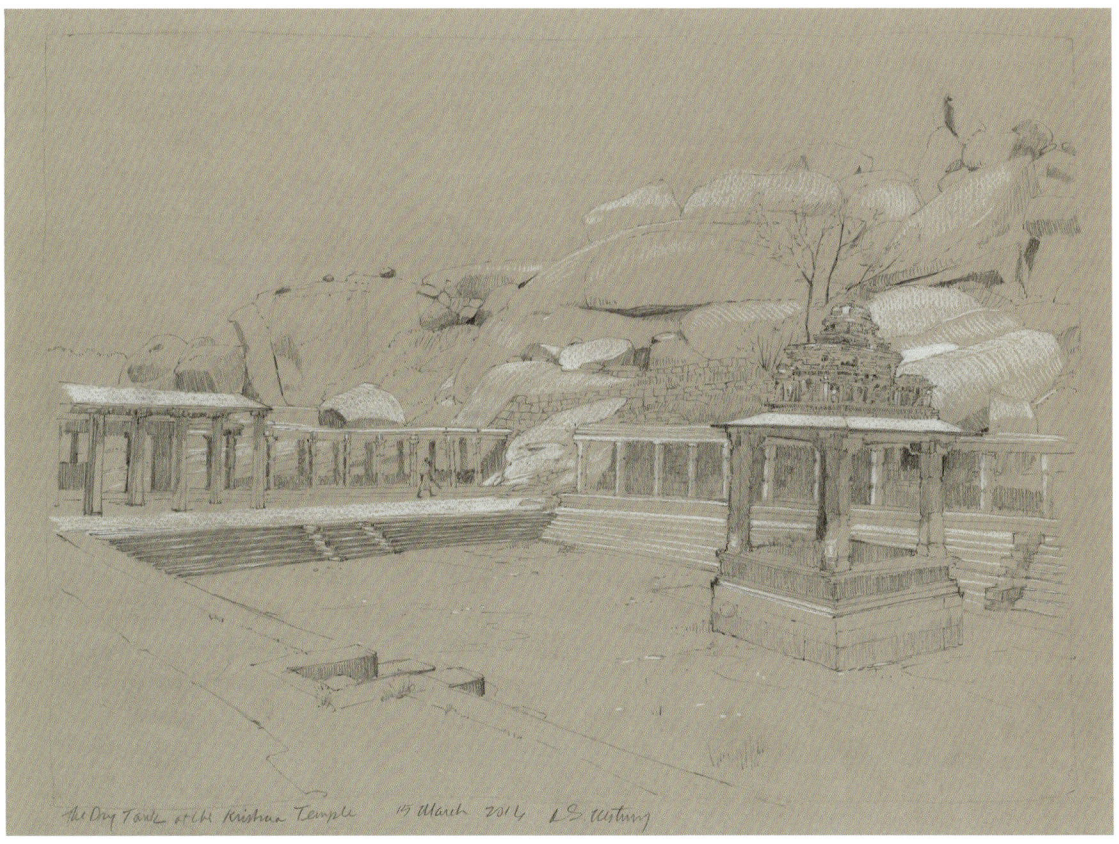

The Dry Tank at the Krishna Temple

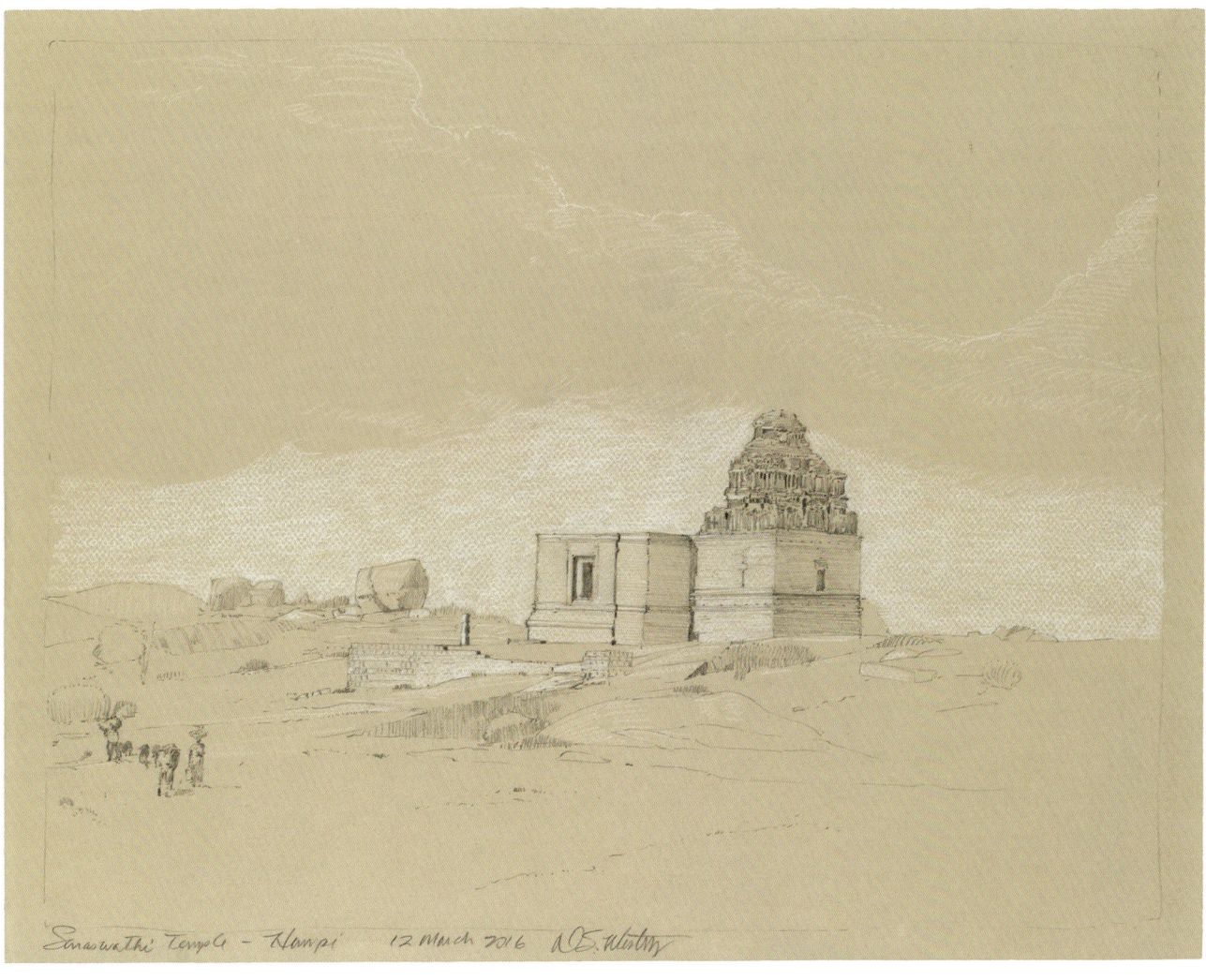

Saraswathi Temple, Hampi

able Hindu king in the fourteenth century. He united them and managed through treaties and alliances with surrounding Muslim sultans to create the richest kingdom on the subcontinent.

Surrounding Hampi is the Pompeii of India. The streets carry the marks of carts pulled centuries ago. The scale of the ambition to create a monumental city is still visible and the shadows of the people who lived here still seem to move through the temples and empty water tanks. Although there was not a geological event that buried the city, it was lost in a dramatic military catastrophe that scattered its citizens and left it to be buried by the blowing sands of the Deccan Plateau.

The complexity and beauty of the architectural remnants of Vijayanagara are due in large part to the blending of traditional Hindu and Islamic cultures and architectural styles. Domes and

pointed arches of Indo-Islamic design satisfy all of the romantic "Hindoo" images westerners hold in their heads. Hundreds of years of cross-pollination in architecture mean that all over India, mosques—particularly in northern Gujarat—adopted Hindu features, and Hindu domestic architecture in the south showed appreciation for the elegance of Persian models.

The evolution of Vijayanagara into the most powerful kingdom in south India is complicated and bloody. The constant warring between sultans, kings, governors, siblings, sons, generals, and mercenaries led to the overthrow of several dynasties and the reckless antagonistic hubris of the final king, Rama Raya.

The final defeat of Vijayanagara's army and the collapse of the kingdom was swift and brutal. The king had unwisely harassed the surrounding territories, raiding and looting his neighbors who ultimately united and marched toward the city's high walls and the dangerous waters of the Tungabhadra River, which had acted as a moat for generations. Years of proximity with the Muslim kingdoms had led to the integration of Muslim troops into the Vijayanagara army. A neighboring Sultan had made it clear that he would not join in this assault on Vijayanagara. The Hindu king, in an act of folly, led his army out of the city to do battle, discovering that the neighboring sultan had in fact joined the forces against him and, as the battle raged, two of the king's Muslim generals declared their allegiance to the Sultanates, turned on him, captured, and beheaded him. The battle for the great kingdom was over in three hours. In 1565, the Hindu army was crushed, and this great and powerful kingdom was destroyed. Hundreds of Vijayanagara's citizens committed ritual suicide as word spread of the defeat.

The victors looted and burned the city (which had up to a million inhabitants by some estimates) for six months. They executed hundreds of inhabitants each day until there could be no further threat of an uprising. Those who could, fled. Then began an occupation that never really took hold in the remains of the once-great city, and it was eventually abandoned.

The glory of the capital city is only partially visible in the surviving granite temples. The huge complex of palaces is gone except for the massive foundations inside the walls of the royal enclosure. There were meeting halls, living quarters, covered walkways, and pavilions. All were made of sandalwood. One record by a European witness tells of the ground pooling with gold as it melted from the burning sandalwood palaces.

In the royal enclosure, where some of the high defensive walls still stand, there is a wonderful stepwell. It was excavated in the 1990s and the aqueduct that fed the intricate waterworks from a

nearby lake has been rebuilt. The remains of the king's plastered swimming pool are still visible. It is about 300 feet by 100 feet and has a wide set of stairs for the king to descend into the tank. The theory is that these were ritual baths attended by hundreds of witnesses—not strictly for the king's pleasure. At the far end of the tank there was a covered pavilion for musicians to serenade the king during his ablutions.

Not far from the king's tank, past collapsed foundations of store houses, vaults, and royal apartments, there is a largely intact festival platform. Tiers of granite steps carved with elephants,

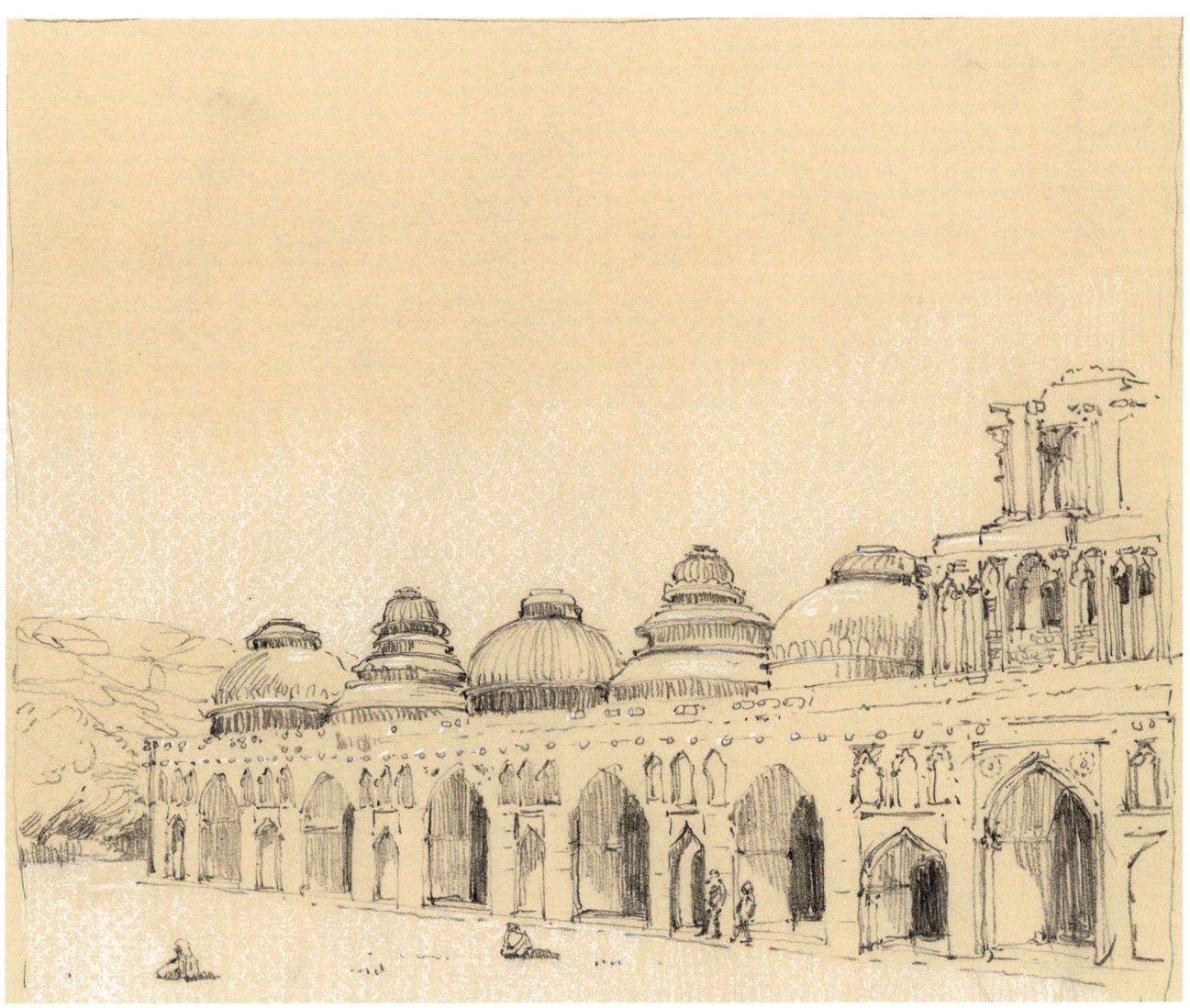

Elephant stable, Hampi

THE POMPEII OF INDIA

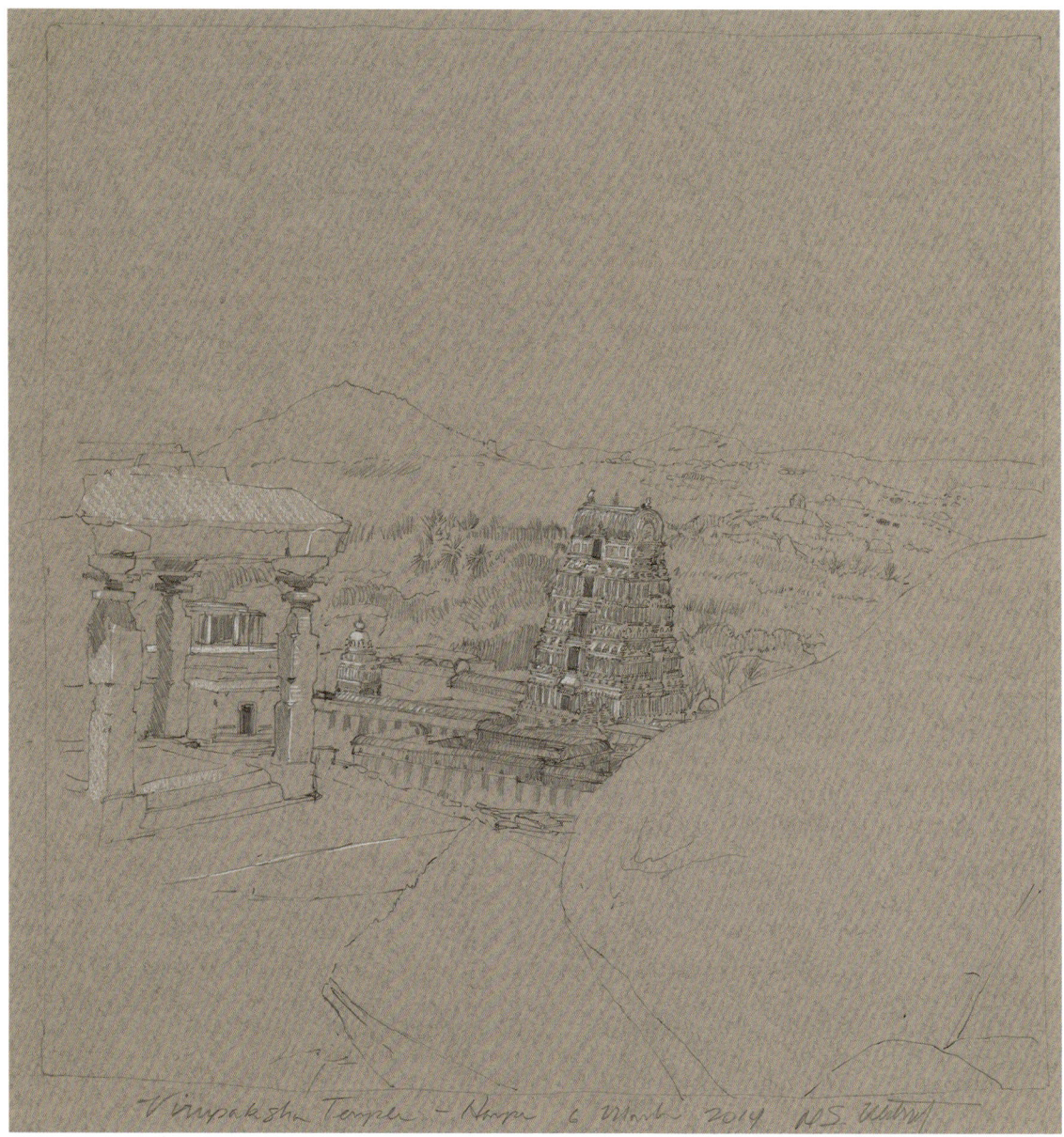

Virupaksha Temple, Hampi

horses, battling soldiers, and fighting lions are all topped by a wide terrace. Square-cut mortices on the terrace surface are still visible. They were anchoring points for the sandalwood canopy that shaded the king.

The queens' enclosure is not far away. The king had multiple wives, with a rotating favorite. In the center of the enclosure there is a brick and stuccoed pink pleasure pavilion called the Lotus

Mahal. The wide-open elegant building has hollow walls. Water was hauled to a tank in the roof and flowed down through the walls, keeping the hall cool. This pavilion rests on a raised platform and has recessed Moorish fluted arches under deep eaves, and it rests on a raised platform. It's a perfect example of the hybrid mix of Hindu and Islamic architecture. The foundations of the queens' palaces are all that remain of what must have been fantasies of sandalwood construction. The high stone walls with their eccentric, almost theatrical, guard towers at the corners surround the women's court and are fitted together with tight precision. They reminded me of the stonework in Machu Picchu.

Nearby is the queens' bath, again a pink-stuccoed building with a deep tank in the middle. A narrow moat hugs the foundations of the high walls. It fed into pipes that poured through lions' faces into the interior tank. There was an umbrella pavilion in the center of the tank to shade the queen while she was bathing. Surrounding the tank is a hallway with arched openings and several bays with big, flat stone slabs. They feel cool to the touch, even on a summer day.

Just beyond the walls of this enclosure is what is traditionally called the Elephant Stables, although there is some argument about what the building was actually used for. It is a series of large rooms with Moorish arched openings. The rooms read almost as separate pavilions because each has a differently styled domed roof: the first, classic medieval Hindu; next, Islamic; then a strange one, almost classical western. There was trade with the West in ancient India and there are second-century Indian bronzes that seem to have a hint of Greek aesthetic. Next to this wonderful structure is the royal wrestling academy, with wrestlers carved into the foundation rocks of the wall nearby. Formal wrestling, called kushti, was not just sport but an important feudal and chivalric part of court life. Important wrestlers were often well-known and supported by the court in lavish ways. Wrestling has survived to today—there are still wrestling gyms in India that teach and maintain the lifestyle and traditional techniques. They are very rough-and-tumble and often outdoors. I have tried to visit a wrestling club in Kolkata and I was firmly discouraged from visiting the part of the city where they might be found.

The main temple at Hampi is called Virupaksha. Its towers are visible from miles away and it is a very active, crowded pilgrimage site resting on the flat land below a vast roll of golden granite. I sat with my back against a boulder on this escarpment with my drawing board on my knees and worked on a large watercolor for several

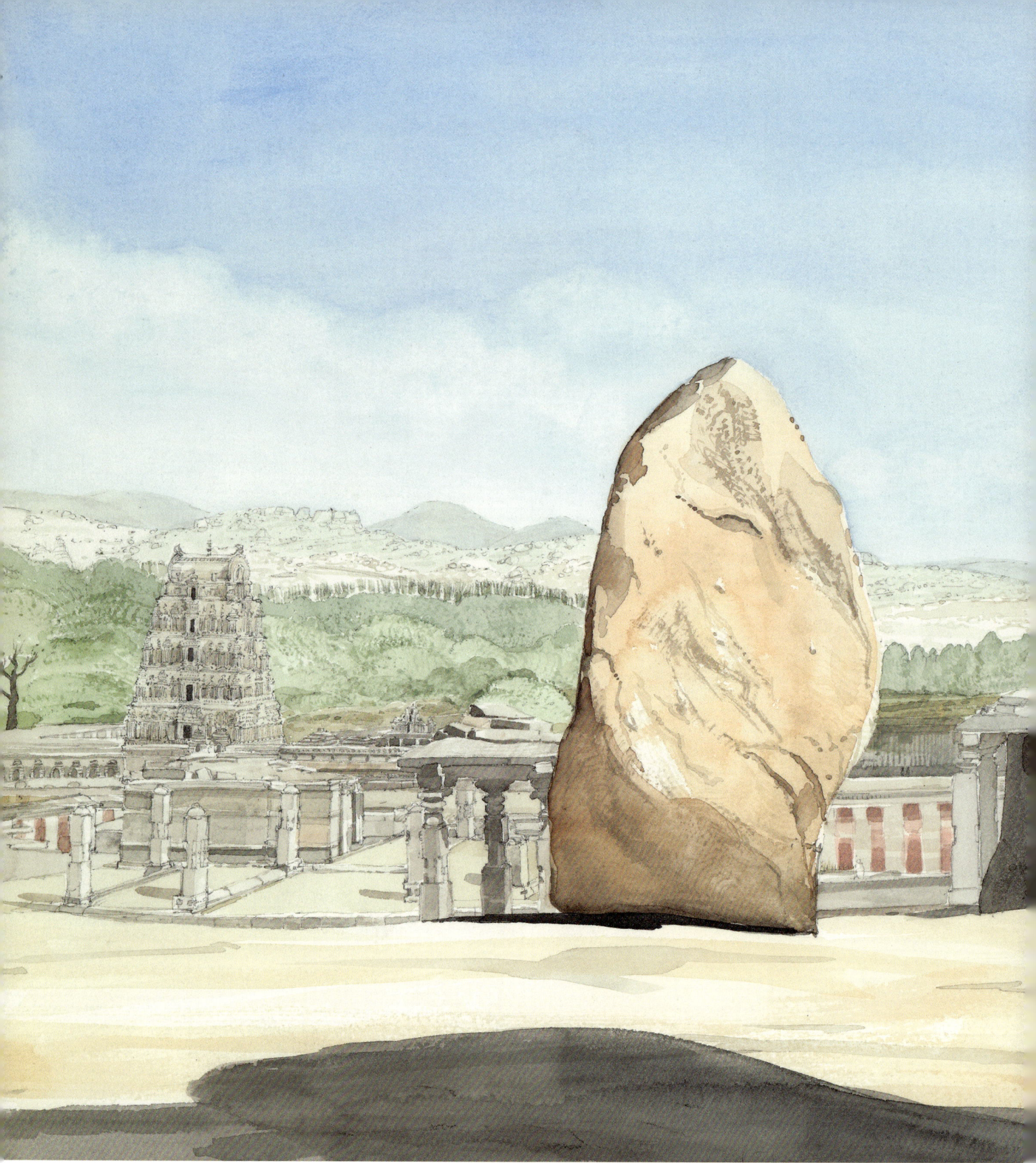

Virupaksha Temple at 9 a.m.

THE POMPEII OF INDIA

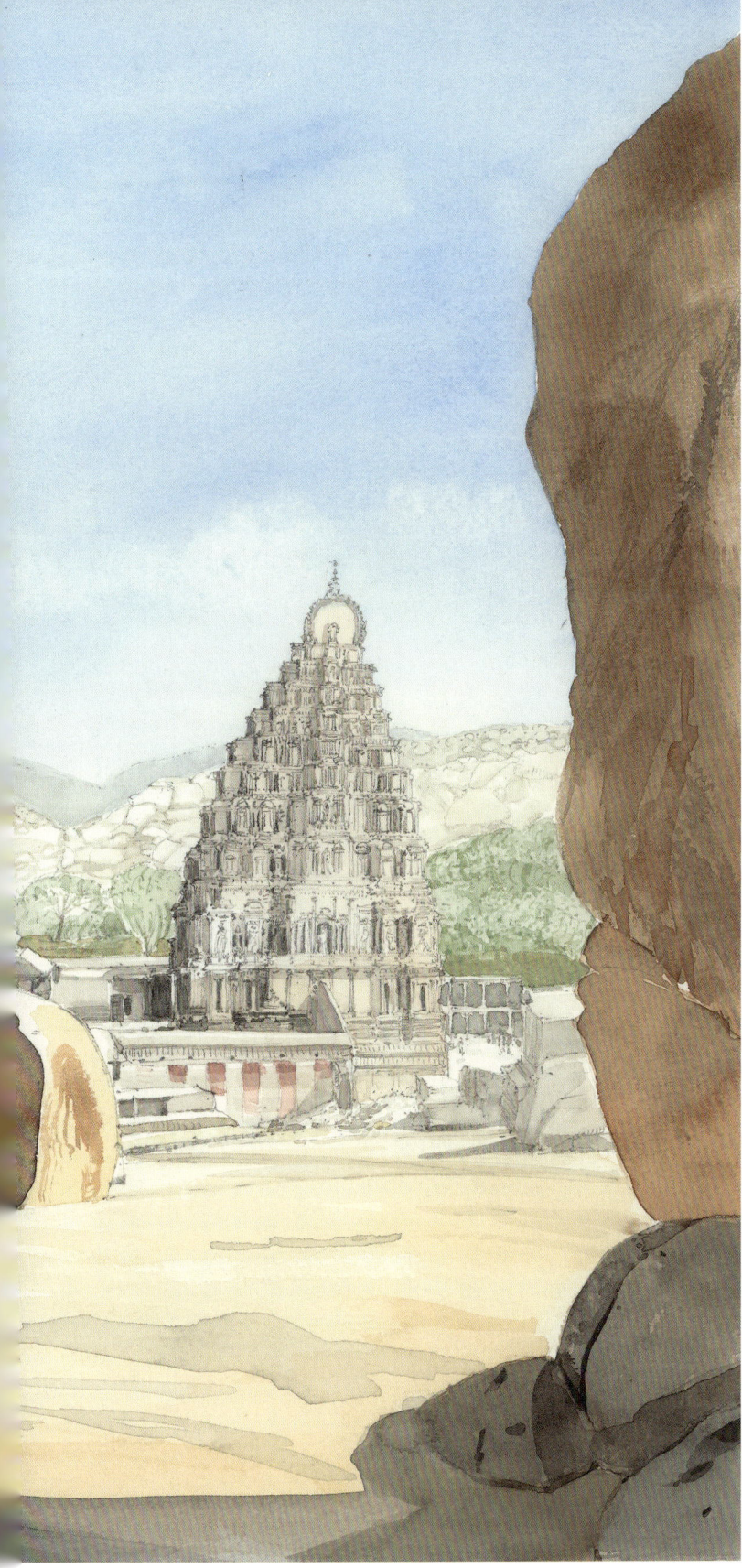

hours. The shadows of the curious upright boulders leaning across my painting seem to dwarf the temple in the background.

The most ancient pavilions and temples in Hampi stand above the main enclosure on this stone hillside. Virupaksha has a tall narrow gopura (an entrance tower at the gateway to a temple) that opens into the walled compound, and just inside there are several faded statues of Nandis on low pedestals looking longingly at the temple. Covered terraces lead you to dark chambers, and a secondary gateway that takes you to the deep tank just outside the high walls. I find a shady place under the covered gate at a stairway into the tank to draw.

Archeological excavation has recently uncovered the main market street—the agora—which acts as a long, wide approach to the main temple. It looks for all the world like the classical models that guided Thomas Jefferson as he designed the University of Virginia. Low columned arcades are punctuated by two-story pavilions. They have been altered through the centuries and even occupied by local families who laid brick and stone between the columns to make houses out of them. All the residents have now been moved out and the agora is being slowly restored. That effort has included the unpopular demolition of shops and houses that had been built on the fringes of the market street.

Behind the market, there is a paved street that turns toward a wide terrace where steps descend to the Tungabhadra River. Pilgrims stand knee-deep washing clothes and laying them on the stone banks to dry. Small temples built into the boulders with steep steps rising from the water's edge are visible at a bend in the river. It is possible to hire a boat and be taken downstream to explore these shrines. The boats are an ancient design of a reed frame bent into a circle and stretched with canvas. The boatmen paddle slowly along, pulling up to partially submerged steps to let you explore.

THE POMPEII OF INDIA

Remains of collapsed walkways lead to other temples lost in the jumble of boulders scattered like the playthings of giants. The river is low in the dry season but through the narrows it rises fifteen to twenty feet to the foundations of these riverside shrines. In the far distance, on the crest of a silvery gray hill, you can see the outline of an ashram. A few bits of collapsed temples dot the hillside down to the water. The valley floor is scattered with the remains of other structures, and in several places you can walk through ruins of the city's fortified gateways. The main and most important gate structure has tight angled turns inside massive stone walls. It slowed traffic to a crawl to make the collection of taxes manageable and to make the defense of these passageways possible.

Huge images of gods carved from the single boulders rest under stone canopies in several places in Hampi. One is the lion-headed avatar of Vishnu, called Narasimha. The seven-headed Naga, King Shesha, hovers above its head. Hindu and Buddhist mythology are filled with tales and representations of Nagas—a magical race of creatures who can be part human or wholly in snake form. A Naga is often shown wrapped around the waist of, or coiled on the ground under, Vishnu.

Nearby, a small temple with a linga now stands in a pool. The interior is flooded by an irrigation ditch. Flooding was not the original intent, but the water flowing through and around the raised linga gives the space a sort of haunting effect. Not far from this image, a giant Ganesha is carved from a huge boulder. He sits cross-legged and serene. Ganesha is the beloved half-elephant, half-man god who presides over all new ventures. He is the remover of obstacles, the creator of happiness, and the god of wisdom.

THE POMPEII OF INDIA

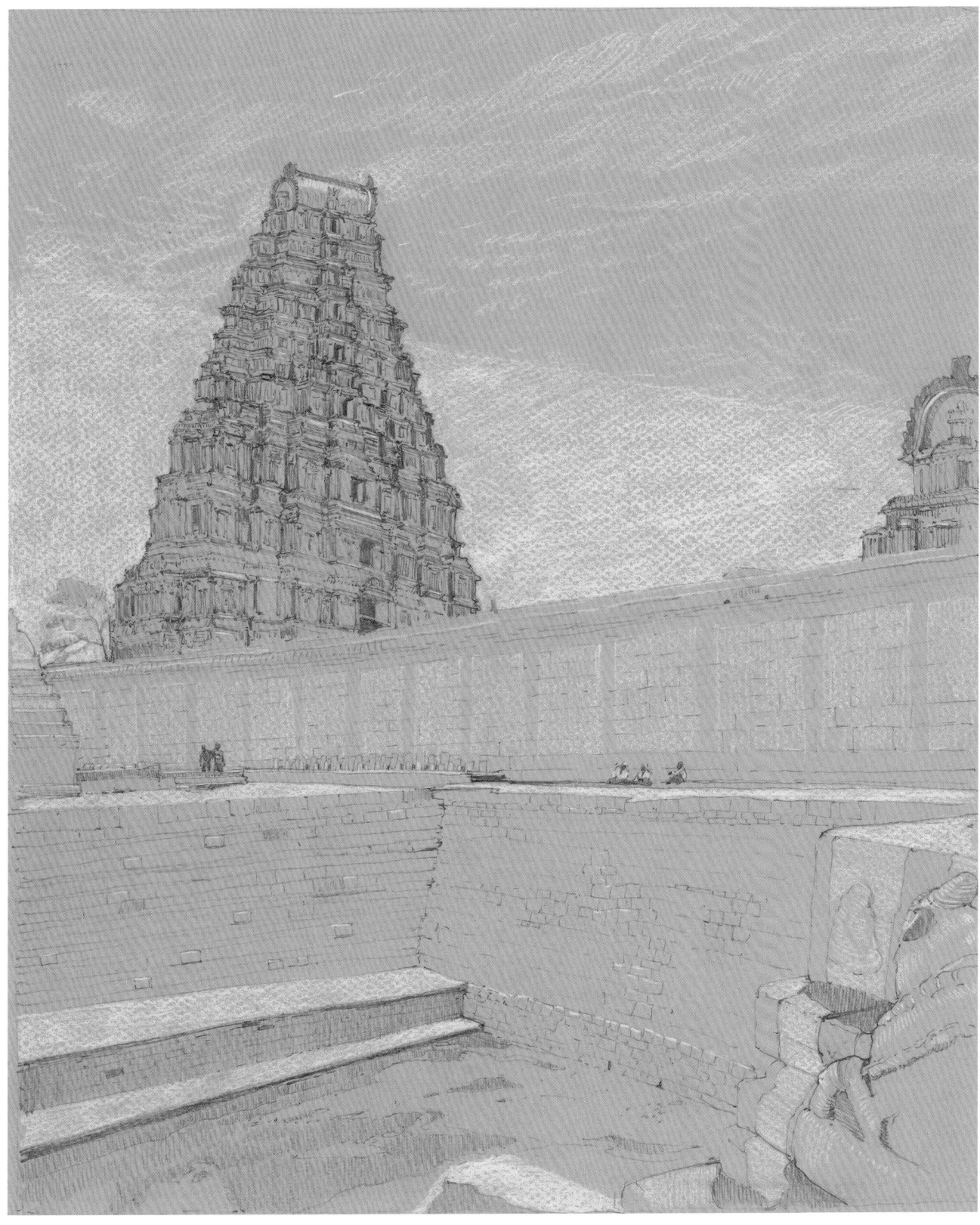

Virupaksha Temple at 9 a.m.

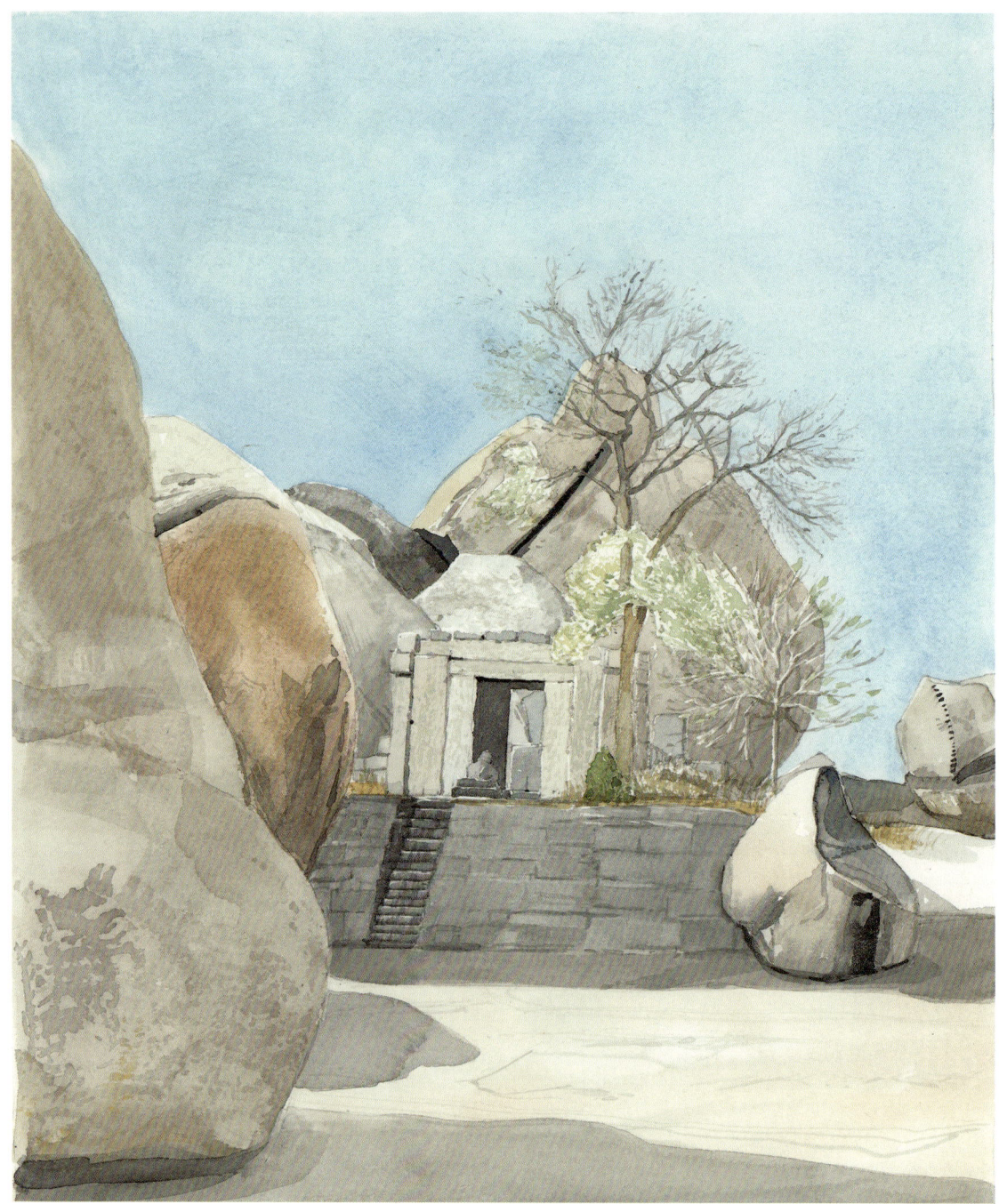

Ruined Shrine

THE POMPEII OF INDIA

Achyutaraya Temple, Hampi

THE POMPEII OF INDIA

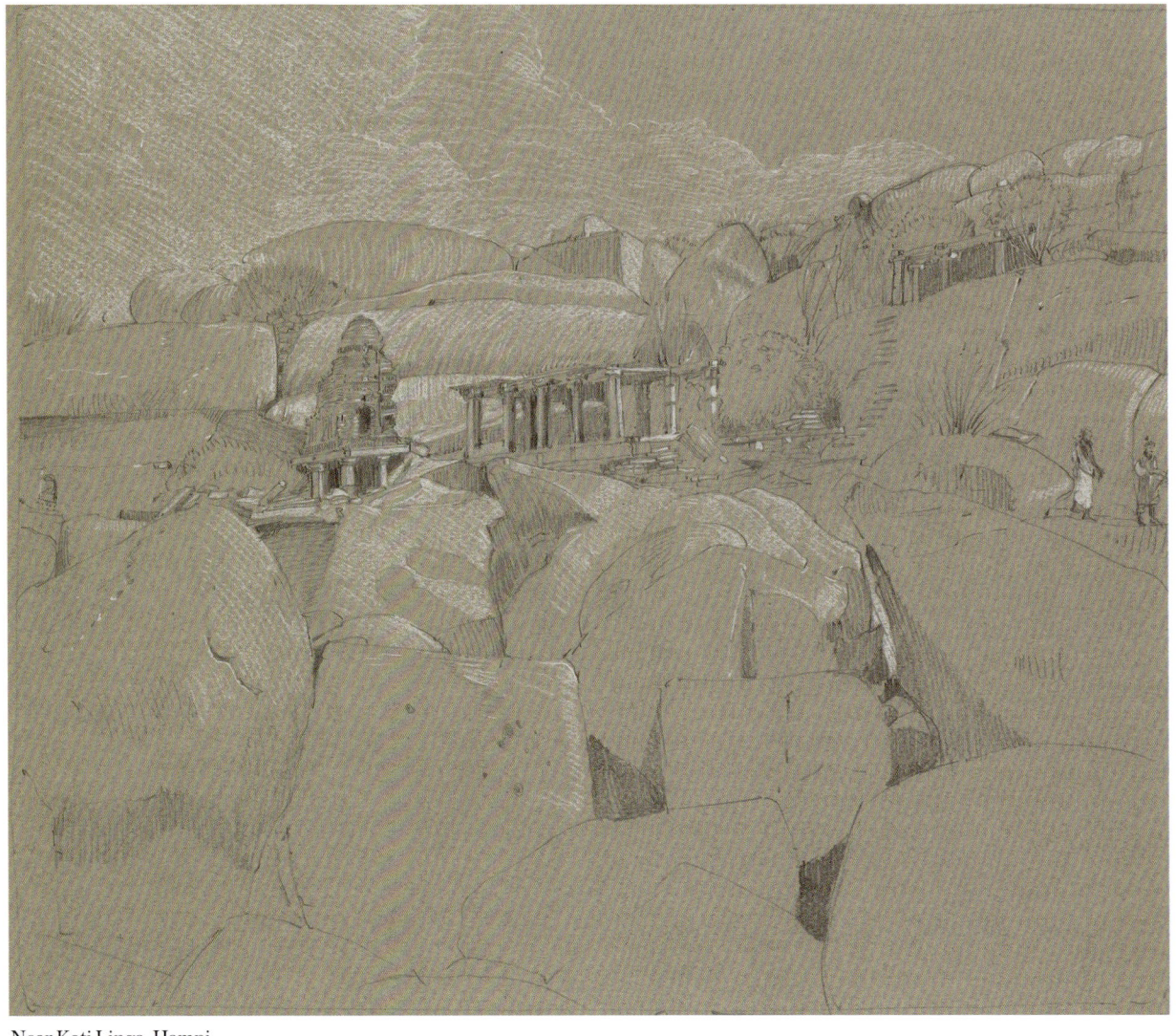

Near Koti Linga, Hampi

94

THE POMPEII OF INDIA

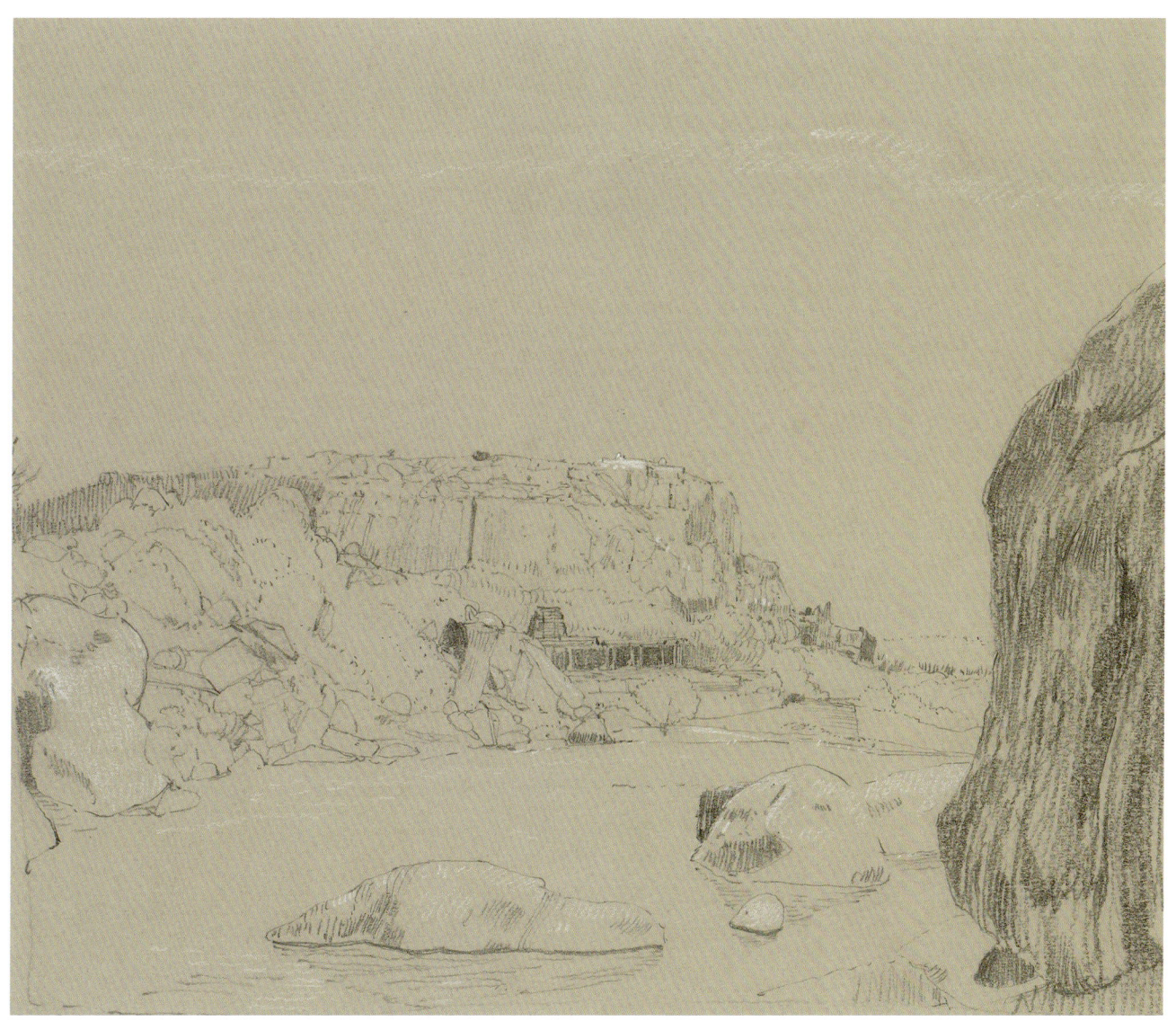

Chandrashekhar Temple

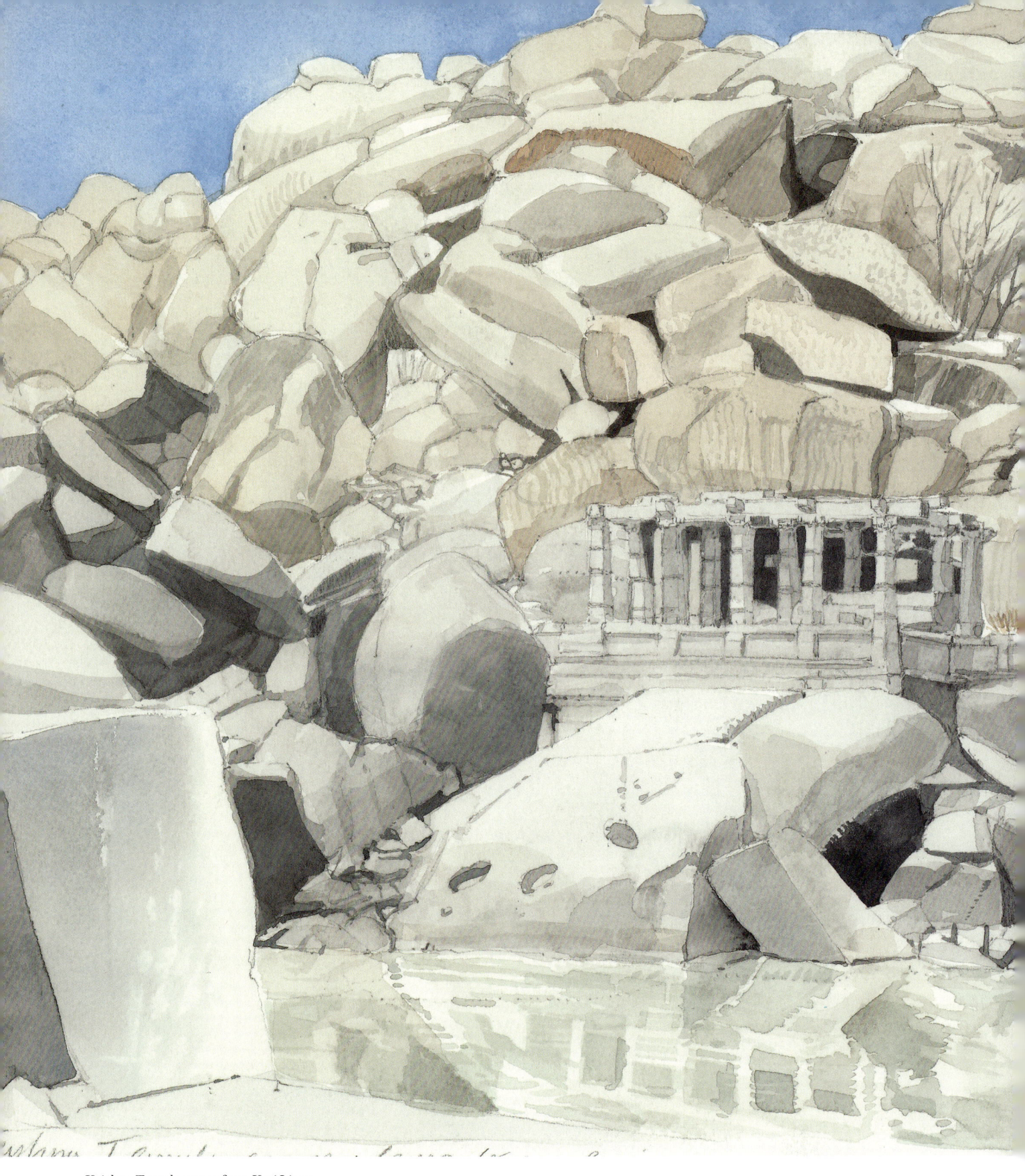

Krishna Temple across from Koti Linga

THE POMPEII OF INDIA

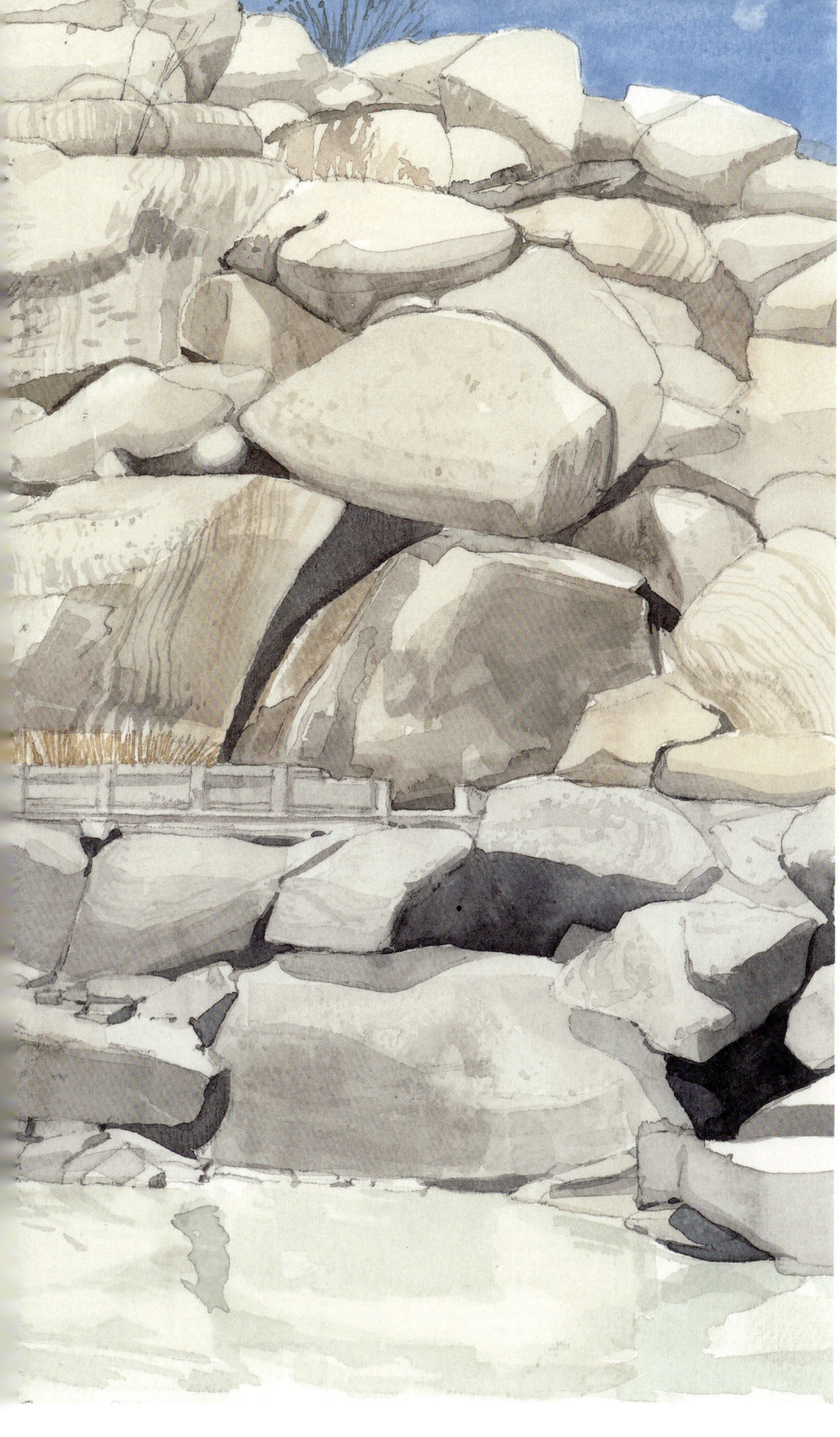

BELL TONES AND CHANTS

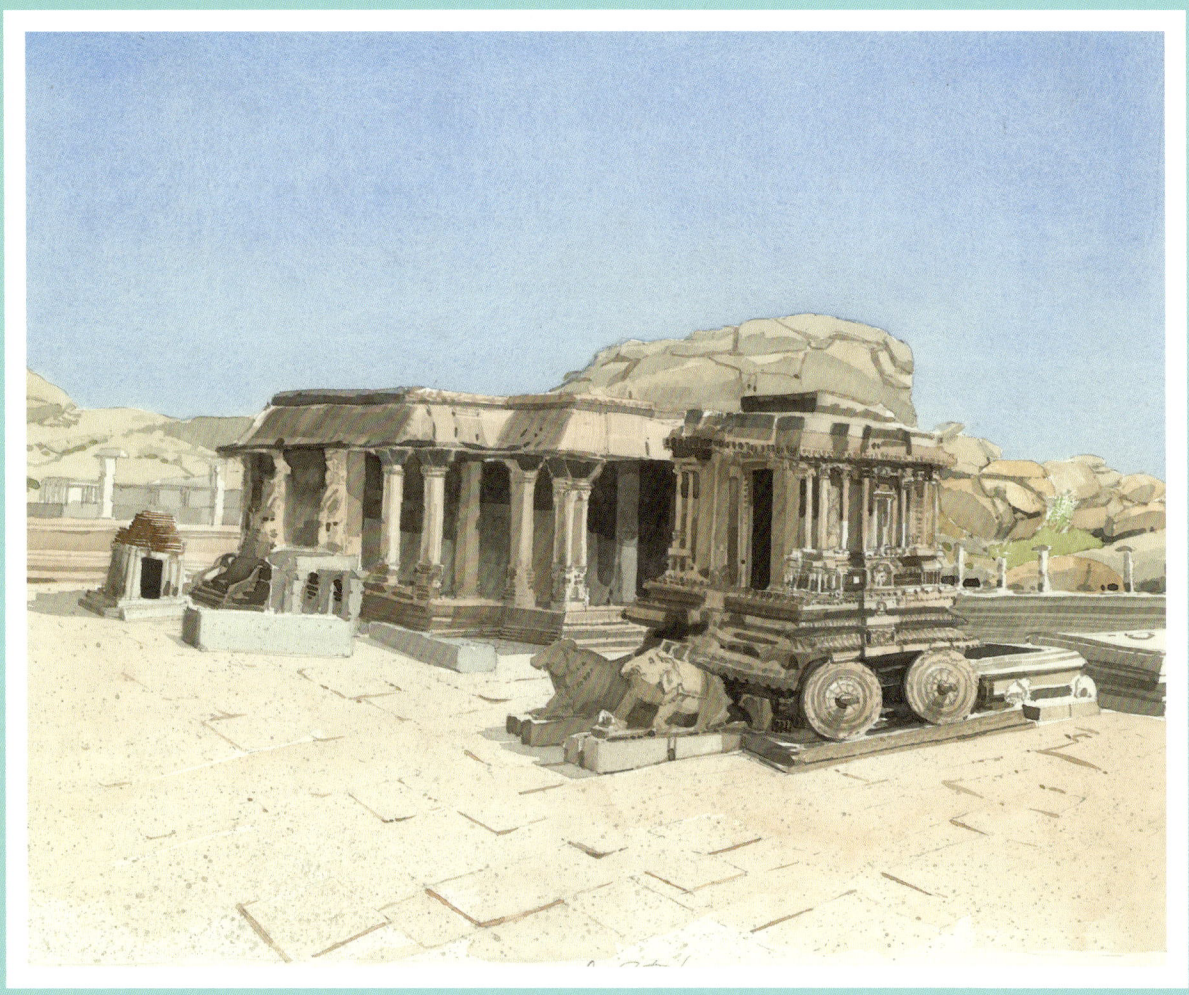

Vijaya Vittala Temple, Hampi

Bell Tones and Chants

A short drive from the royal enclosure down a dusty road is the Vittala complex. It was built in the early sixteenth century, away from the city center and toward the boulders and fortifications surrounding the city. It was an indulgent gift from the king to his second wife, who had been a temple dancer. Dancers held an important place in the temple rituals and many temples had pavilions for their performances. The pavilion is elaborately carved with lace-like delicacy and has some very special qualities. The huge stone roof is held up by ranks of columns with narrow bays of octagonal columns resting on the common base. These slender columns hold the magic of the place—this pavilion is really a giant musical instrument.

The columns are carved from beige/pink granite, and are actually tuned like instruments. If you rap on them, they ring. Royal musicians stood by each column, playing complex music to accompany the dancers. Today, for a tip, the temple guards might rap on the columns, sending bell-like tones through the space.

Elsewhere in India, I've seen temple grounds that were quite literally academies of dance. The music, handbooks, and directions for dance rituals are carved into courtyard walls, but in this pavilion, you can hear the music too.

BELL TONES AND CHANTS

On the approach to the Vittala temple are the remains of another market street with rows of columns running the length of both sides, and several water tanks have been discovered. Only a fraction of the ruined city has been excavated and many unstudied sites are spread across the valley floor.

Imagining the mechanics of a city from this era and of this size is really impossible. Management of the volume of food, not to mention waste, must have been a huge civic task. Along one of the roads through the site there are, unmarked, the remains of a barracks dining hall. Inside the former hall, long, relatively narrow slabs of stone have a channel cut down their middle and are carved with shallow recesses like dinner plates. Two or three smaller plates, left and right of the dinner plate, are cut into the stone. These were permanent place settings. Leftovers were washed away into the central trough before the next diner would sit down. It was a simple, functional, and incredibly efficient design, which must have been somewhat unique in fourteenth-century culture.

Above Vittala there is another active temple with the almost unpronounceable (to a Western tongue) name of Malyavanta Raghunatha. It is occupied and active twenty-four hours a day by monks who chant and ring bells in three shifts—all in the worship of Shiva. The chanting is amplified electronically, filling the valley with exotic twelve-tone incantations. Paths from the back of this compound take you up a steep granite escarpment. Along the way there are Shivaic shrines with rows and rows of lingas cut into the edges of a natural crevasse. In the rainy season, water pours over these shallow lingas and then runs into the temple enclosure, washing the entire site with holy water.

On this sacred rocky outcrop, next to these rain-washed lingas, there is a small, square, stuccoed temple where a priest tends the fire every day. These temples I'm visiting are not dead places. They are sites where a belief in a power that humans struggle to define and understand has been nurtured and revered for many hundreds of years. When you walk into one of these temples and find a priest passing out blessings and tending to the lamps that honor the deity living in that temple, it is like a time machine. These rituals don't evolve and adapt. They are the exact chants and gestures that have been practiced for millennia. I can't help but be moved and encouraged pondering the comfort and hope they offer, and wonder at the richness and complexity of the culture they enliven.

BELL TONES AND CHANTS

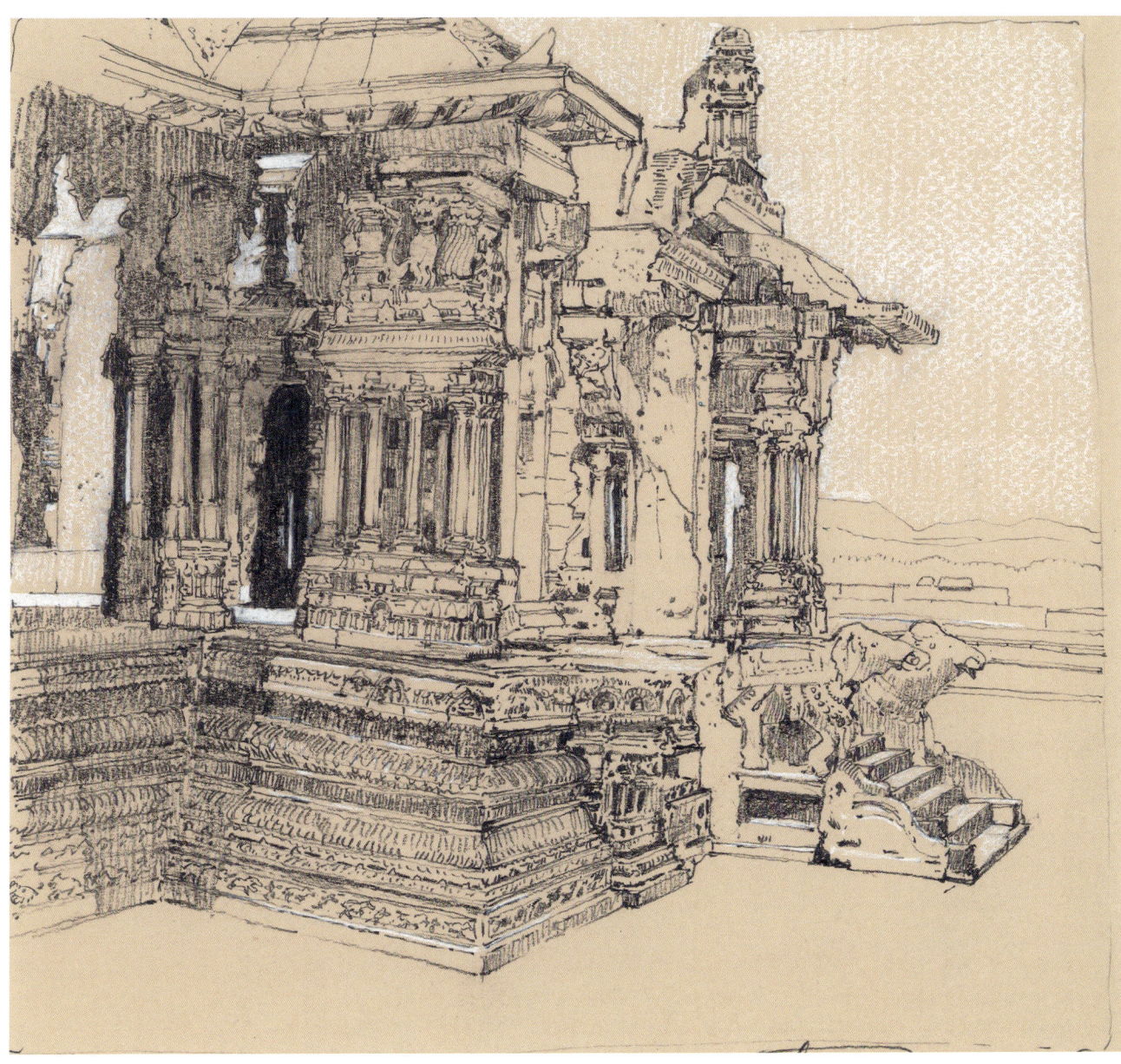

Vittala, Hampi

BELL TONES AND CHANTS

I climb over broken steps and boulders to explore the shrines around the main temple. Circling the temple compound, where some sections of wall have collapsed and others have been coarsely rebuilt with cinderblock and cement, I find a smooth boulder, where I sit and draw the temple gate. As I'm drawing, my guide, Viru, is involved in an extended debate with a street sweeper who is pushing leaves away from the entrance terrace. It turns out she is unhappy that I am drawing, afraid that the more senior caretaker might arrive and find me, whereupon she might be punished for letting me draw. Viru manages to convince her that I should be allowed to draw. It's a funny trickling down of the ASI prohibition to a non-ASI site. The sweeper at the entrance to this remote temple has heard that there are prohibitions for some reason and, without really understanding or being subject to ASI rules, adopted them.

BELL TONES AND CHANTS

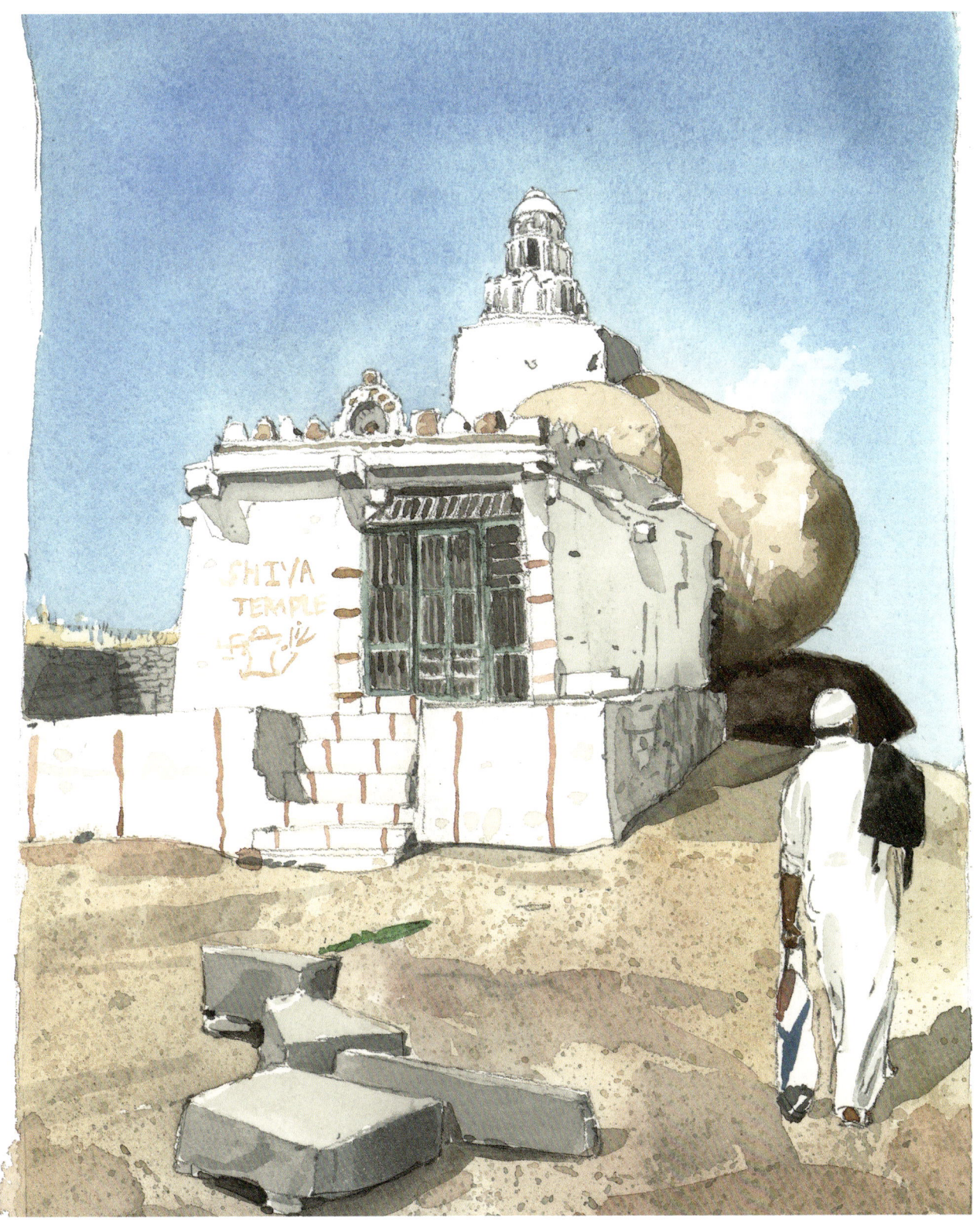

Swami Shiva Temple, Hampi

RED ROSES

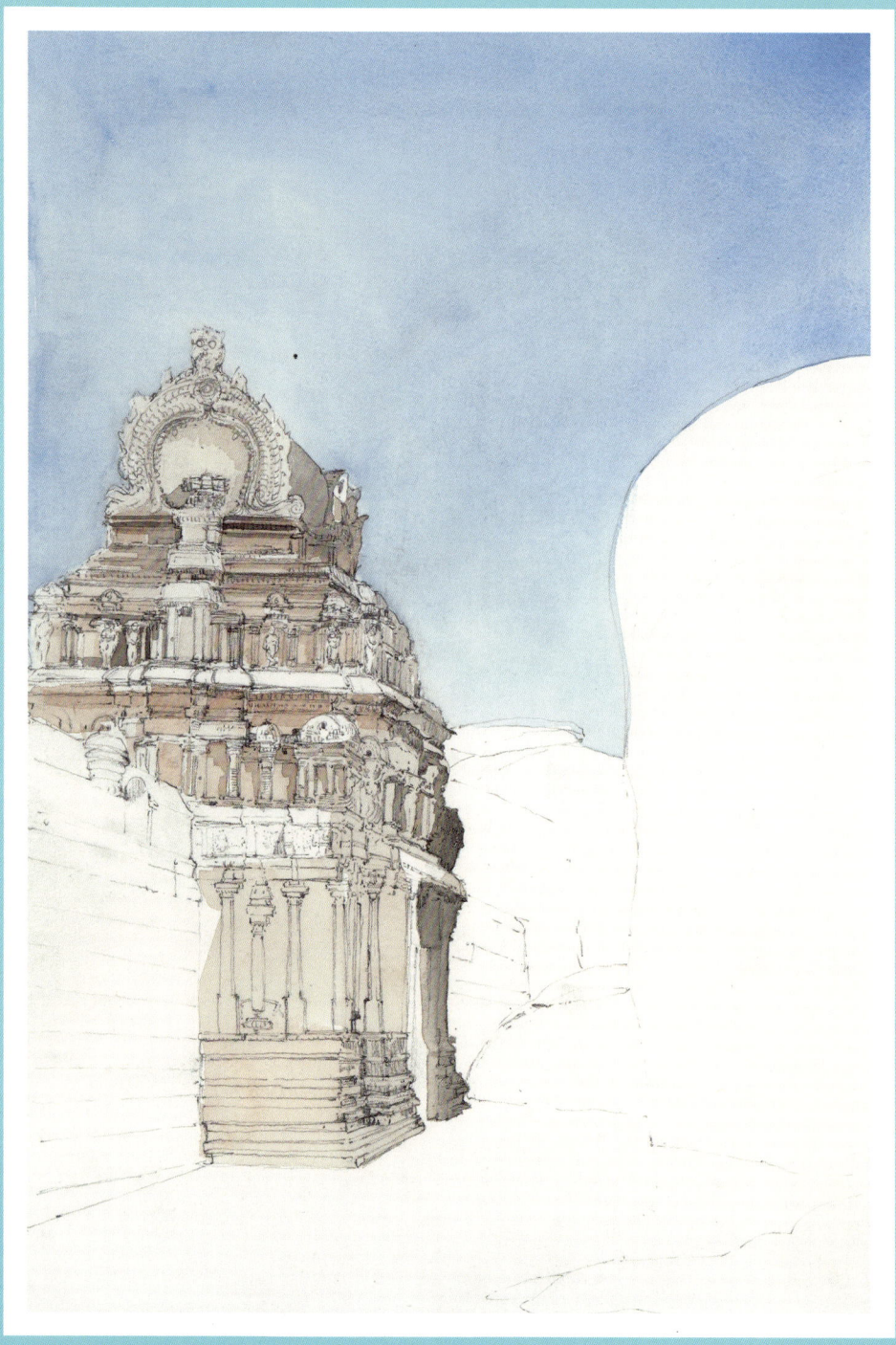

Malyavanta Raghunatha, Hampi

104

Red Roses

The first time I explored Hampi, I had traveled with my driver Nadeem for almost a month. It turned out that his home was less than half an hour away from Hampi in the small city of Hospet. One day, he asked if I would come to his home for a meal.

 I was staying at a wonderful lodge called Hampi Boulders and I had been driven to the river crossing every morning by a hotel driver. I arranged to meet Nadeem at the crossing one morning, and as I sat in the shade waiting for him to arrive, people passed by and asked me, "Where is Nadeem?" "Is he late?" "Should I call him for you?" It is like a very small town where everyone watches and knows what is going on.

 I got a glass of tea from a little stand and enjoyed the town coming to life around me. Boys were swimming in the river next to a stone temple partly submerged in the water. It looked like an Indian Thomas Eakins painting. They dove from the rocks and lounged on the steps of the flooded temple. A few pilgrims walked by, naked but for white loin cloths and the smear of red almond paste on their foreheads. Monkeys chattered in the trees overhead, and the inevitable ratty dogs skittered around, occasionally picking a fight.

 Nadeem arrived with his son to fetch me. Both were dressed in white and wearing prayer caps. Nadeem was very happy with himself and enjoyed showing off his little boy who was around two years old. I sat with the boy for a few minutes while Nadeem ran an errand. He happily munched on peanuts from a little paper cone that I bought for him. We drove about twenty minutes to Hospet where Nadeem lived. He made a couple of stops on the way to pick up some things and we then made our way to his aunt's house.

There was a tiny sari shop in the front, and children floated in and out to have a look at me and try out a few words of English. To my surprise, I was offered breakfast of an omelet and a dish of spicy spinach paneer. After an hour of nodding and smiling, the teenage sons of Nadeem's aunt arrived to meet me. They were shy but spoke perfect English and talked about coming to America sometime in the future. Nadeem's auntie pinned a red rose on my jacket and opened a shawl, which she folded narrowly and put over my right shoulder as a gift.

The main event, however, was lunch at Nadeem's. We walked through narrow streets with everyone watching curiously as we passed, a trail of small children following us.

Nadeem's house was a traditional village house made of concrete, with no furniture to be seen. He was very proud of his three-month-old second son who was hanging in a mesh sling from the ceiling, cooing. Nadeem took him out of the sling for me to admire. He was dressed in all white with kohl underlining his eyes, and a black beauty mark on his left cheek.

The house seemed to have three rooms. I was in the main room and there was a second room, which was a bedroom, and of course the kitchen. Soon, Nadeem's very pretty wife emerged from the bedroom, where I think she'd been changing her sari. He explained to me that the dressmaker had not been able to get a blouse made for the sari I had bought for her in Badami a couple of weeks earlier. Anyway, she bowed and spoke English quite well with me for a minute, and then disappeared into the kitchen for the remainder of my visit. Nadeem rushed around adjusting a fan and screwing in a couple of bulbs to light the room. Eventually, five of his friends showed up and we all gathered knee-to-knee on the floor to eat our lunch. Pots of food arrived with mutton curry, vegetables in a ground peanut sauce, dal, piles of fried rice, and dishes of sauces.

They all spoke a little bit of English, but it was a pretty limited conversation, with lots of smiling and nodding; "Where are you from, sir?" "How many children do you have?" "Why are you a bachelor?"— all standard questions I have gotten from every taxi driver or shopkeeper. One of them said, "I will come to America and be your driver!" They all laughed, but I suspect the dream of America is not a joke to these hard-working men.

After lunch, I thanked Nadeem's wife. We did not exchange a handshake—she was a conservative Muslim. Nadeem's friends walked us to the car, then stood smiling and waving as we drove off. Nadeem thought it was a great success.

My Indian Brother

The Muslim Prayer for the Dead

Allaahum-maghfir lahu warhamhu, wa 'aafi-hi, wa'fu 'anhu, wa 'akrim nuzulahu, wa wassi' mud-khalahu, waghsilhu bilmaa'i waththalji walbaradi, wa naqqihi minal-khataayaa kamaa naqqay-tath-thawbal-'abyadha minad-danasi, wa 'abdilhu daaran khayran min daarihi, wa 'ahlan khay-ran min 'ahlihi, wa zawjan khayran min zawjihi, wa 'adkhilhul-jannata, wa. 'a'ithhu min 'athaabil-qabri[wa 'athaabin-naar].

O Allah, forgive him and have mercy on him and give him strength and pardon him. Be generous to him and cause his entrance to be wide and wash him with water and snow and hail. Cleanse him of his transgressions as white cloth is cleansed of stains. Give him an abode better than his home, and a family better than his family and a wife better than his wife. Take him into Paradise and protect him from the punishment of the grave and from the punishment of Hell-fire.

 I received a text message from a friend of Nadeem's. The text said that Nadeem had died of a heart attack at 8:00 a.m. that morning. He must have been younger than forty-five, with two small children. The news shocked and saddened me more than I can describe. I had written Nadeem to tell him I was coming to India again but that I would probably be too far from him to connect. He had written back saying that he would figure out a way to get together.

MY INDIAN BROTHER

I have re-read my notes from last March and I have been reminded that most of my experiences on that trip were shaped by him. He was supposed to be just my driver, but in the weeks we spent together, he stepped into situations where I needed a guide, a translator, or a friend. He suggested places for me to see that I could not have known about and, most importantly, introduced me to a more intimate and otherwise inaccessible experience of India than I could have anticipated. He had a generous spirit and wanted to share this place with me. He was proud of his friendship with me in a simple and honest way. He wanted to introduce me to his friends and, I think, extraordinarily, to his wife. He was a conservative Muslim and his wife was veiled when in public. One of his friends wrote to say that Nadeem saw me as a brother. I was moved and feel fortunate to have had this time with him in his short life. I weep for the loss of my friend.

Toward the South

Mysore

Bangalore is a good place to start a trip in south central India—in the state of Karnataka. It is the high-tech center of India; Bangalore's big shiny new airport testifies to the power and wealth of the country's tech industry. The city is a university town and has great, glamorous business hotels, a few charming guesthouses, and huge glass and steel apartment blocks rising everywhere.

Three hours southwest by car is the ancient capital city of Mysore. It's surprising how quickly the aesthetics of India begin to seduce me once out of the city. Oxcarts filled with coconuts squeeze by cows along the highway, sugarcane fields fill the view in the distance. Family groups clinging to motor scooters make the road tests of courage and will.

Mysore is called the City of Palaces. You can get a glimpse of some of these palaces along the streets. Most have become government offices or seem to be divided into flats. The only great palace open to the public is the Royal Palace in the center of the city. It's a huge complex built in 1910 by the twenty-fourth Maharaja of Mysore in Indo-Saracenic style designed by an English architect named Henry Irwin, and it survives in all its confusing glory. There are domed towers, Moorish pointed archways, and stained glass everywhere. It looks like the Marquis of Bute's Cardiff Castle in Wales. There was tremendous pressure on Edwin Lutyens when he was designing the viceregal palace in New Delhi to work in a similar style, and there are surviving sketches of elevations using pointed arches. Lutyens, however, resisted, and Delhi avoided the romantic "Hindoo" version of colonial architecture.

TOWARD THE SOUTH

Mysore's Royal Palace has huge halls with polychromed plasterwork and mural-painted ceilings. There is one vast room with life-sized tinted photographic portraits of the royals staring gloomily out at us from the past—turbaned, weighed down with ropes of pearls, and resting in state on tufted Victorian settees. The south face of the palace has an expansive covered viewing platform where the maharaja would gather his court to witness the royal parade ground displays of precision military drills and regimental glory. The owner of the travel agency that has organized my time here, has come all the way from Chennai, some eight hours by car, to meet me and make certain that the plans we have sketched out make sense. The casual business-like meeting we have doesn't hint at the impact Sundar Singaram will have on my experience of India.

We look over my list and make a plan. The first site is the City Temple, or hill temple. It is called Sri Chamundeshwari Temple. It is a half-hour drive from the hotel up a winding road that passes a giant black stone Nandi about halfway up the mountain. The shrine is crowded with pilgrims and draped with garlands. Small lamps burn at the base of the sculpture and buses stop to let more pilgrims off while I am there.

When we reach the temple, there are pilgrims filling the street where the resident deity stands. It has just been taken from the temple to circumambulate its perimeter. Walking around the temple is one of most basic acts of veneration. In this case, the deity is making the trip, but it is also a personal ritual. Most temples have narrow passageways behind their inner chambers to allow worshipers to perform this act.

Drummers and pipes contribute a bit of chaos and color to the festive event. The line to visit the interior snakes around the temple—the interiors of most pilgrimage temples are generally carefully managed, with barriers to control the crowds, which can be huge. There is something powerful about the crowded temples, though. India is a place where our Western sense of personal space is always being tested. In a crowded temple people push up shoulder-to-shoulder for a glimpse of the deity in the sanctuary. All Hindu temples, regardless of scale, are processional spaces moving you toward a small space where the god resides. The stone sculptures are usually dressed in dhotis or saris, and hung with garlands of flowers that have been donated by worshipers.

I decide not to get in line to visit the main temple. There is a small Shivaic temple a few hundred feet west of the main walls and we make our way toward that. A priest is at the door. He ties a beaded marigold-colored cord onto my wrist and smears a

TOWARD THE SOUTH

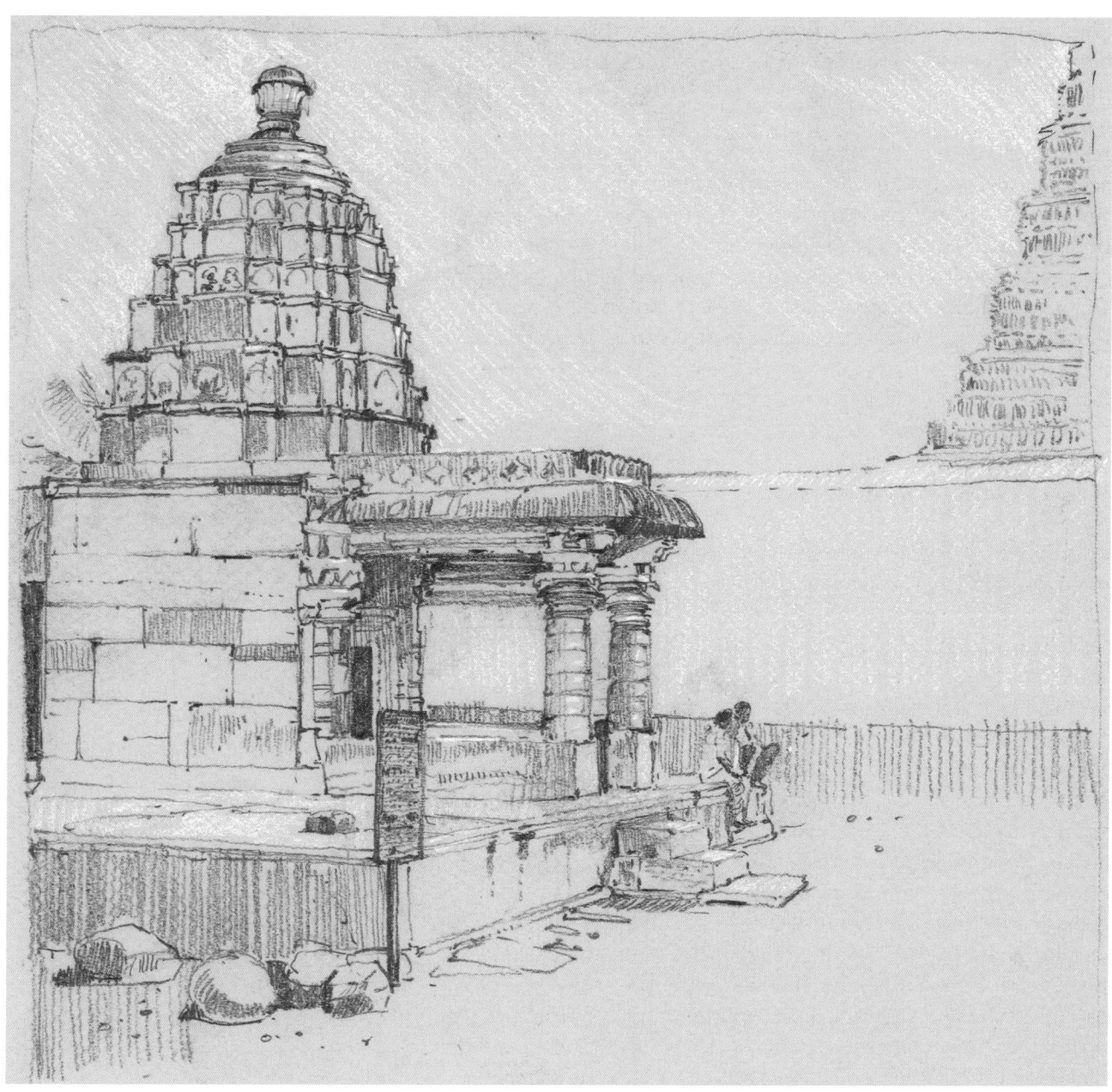

Shiva shrine near Mahabaleshwar Temple

bright vermillion mark on my forehead as I put some rupees on the tray he holds.

The interior is smoky with incense. A handsome young priest with a bright orange lungi wrapped around his waist tends the sanctuary. He reaches out and adds an ash mark to my forehead. The space is tiny, still, and warm. I'm alone in the dark with the flickering light of the lamps lit at the feet of Shiva. It has a feeling of ancient holiness that feels universal. I'm moved and feel my emotions swell, and suddenly tears are running down my face. The air is hot and close. I blink at the hazy sky when I walk out. I say to Sundar, as we leave the little temple, that it is wonderful being in such a holy place. Later he tells me that because of that remark he knows we will meet again.

The yellow painted tower of the main temple stands behind a high wall next to this little shrine. Most temples in Tamil Nadu, except for the greatest and grandest, which are totally stone, are a combination of stone and soft brick. Usually the foundations, steps, platform, and the first story or two are built of cut stone. The remaining structure of chambers and towers is stuccoed and painted brick. The soft brick will dissolve and crumble unless it is protected. A fresh coat of paint is daubed onto the brick every few years. It is functional but also an act of devotion. It makes these ancient buildings look like towers of marzipan.

The main reason to come to Mysore, for me, is to visit the thirteenth-century Keshava temple at Somanathapura, about an hour outside of town. It is possibly the most perfect example of Karnataka's Hoysala, or horizontal architecture, named for the ruling Hoysala family living in great opulence in their capital in Vijayanagara several hundred miles north of Mysore. High walls separate the beautiful temple from the village, where it rests elegantly behind them. There is a shady columned, raised gallery of cells for the attendant monks along the walls.

The dark gray granite of the temple is carved in the most intricate manner imaginable. Every surface is worked like a piece of jewelry. The whole structure stands on a star shaped platform with six tiers of lively renderings of elephants, horses, geese, and dwarfs. The temple itself has beautifully animated carvings of the ten incarnations of Vishnu sensually looking down at you from the main register. There are deep overhanging eaves and two almost impossibly complex towers. It dances in the sun. I came two days in a row and spent several hours drawing and then painting a watercolor of this temple. The system of embellishment here is almost incomprehensible in its sophistication. The design seems to shift

TOWARD THE SOUTH

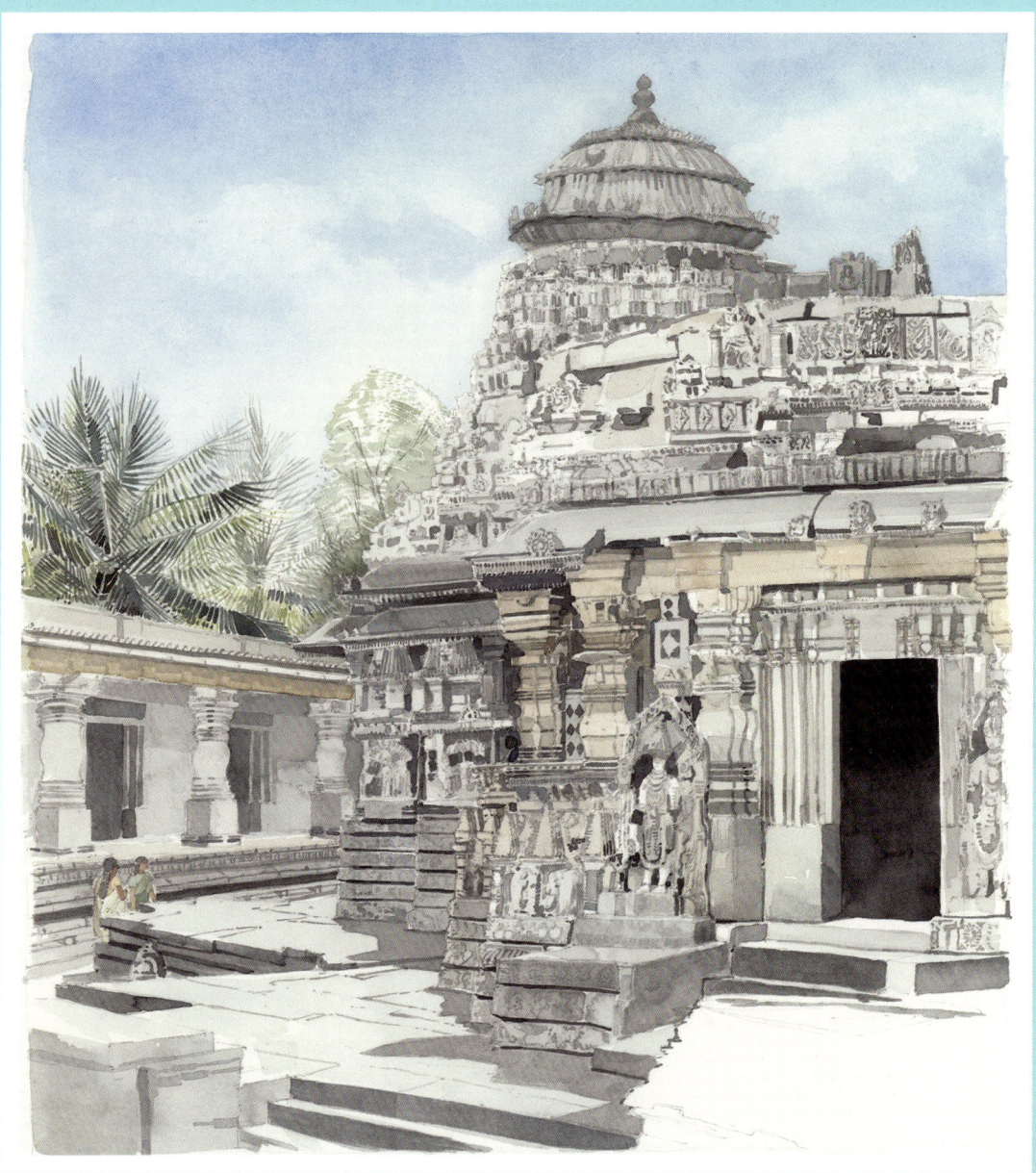

Keshava Temple, Somanathapura

and mutate as it rises from the base. The carving is so intricately rendered that it begins to read like a vast puzzle. You spot places where you see the pattern, but then at the next angle shift you lose the rhythm and find yourself squinting in vain to follow the thread of the design.

The interior has three main sanctuaries with various deities, but they are behind bars and, so, not very satisfying. Theft is a constant threat at these rural sites and often these ancient and irreplaceable sculptures must be behind grills. There are no priests in attendance but it's still a holy site, so shoes are left outside the door. In active temples you are asked to remove your shoes at the bottom of the steps before the raised platform. The interior has lathe-turned soapstone columns supporting deeply coffered ceilings. Each recess has elaborately carved banana flowers in varying states of ripeness. The whole space is black and shiny from centuries of oil lamps burning along the walls.

About half an hour north is another temple compound called the Sand Temples. We pass through numerous villages on the way. The houses have elaborate wooden porches held up by carved wooden columns, now faded to a dusty tint from their former blue or lime green. Little shop stalls are everywhere, each seeming to sell the same goods, and each featuring big plastic jars of cookies or cellophane-wrapped candies and, always, a stove with boiling water to make sweet tea or coffee.

Only three temples remain of a huge complex of more than thirty temples that sat on the edge of the Kaveri River, the most important river in Karnataka.

They have an interesting and unique problem, which explains why only three are visible. They were built on the bedrock of the shore after the sand of the riverbank was dug away and high walls were constructed to keep it from drifting back in. These walls have collapsed and been rebuilt many times through the centuries. When the walls were neglected, the temples would disappear under the sand. Many temples are thought to be at least partially intact and scattered along the river but buried by these shifting sands.

Keerthi Narayana Temple has a large gatehouse—a gopura—and a newly rebuilt tower painted yellow. This gopura is a high-ceilinged pavilion with chambers left and right. The main temple is partially shrouded in scaffolding for restoration. The tiny sand temple, Maruleshwara, has lots of railings to control the crowds. The site is a pilgrimage destination for a particular Shivaic sect and despite being down a narrow dirt road through a tiny village, it is organized to accommodate the huge crowds. A big, square

TOWARD THE SOUTH

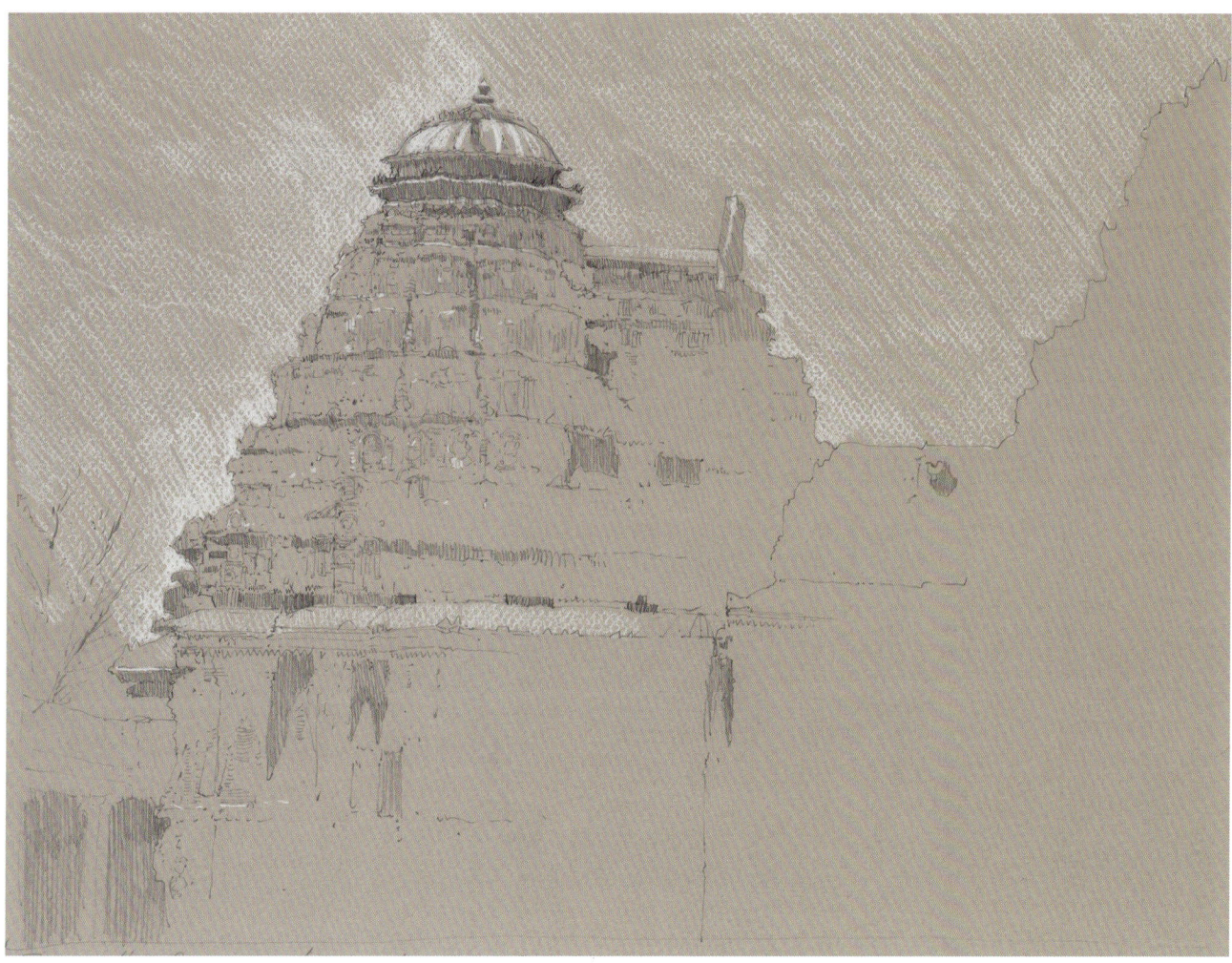

Keshava Temple, Somanathapura

stepwell in the center of the compound is undergoing a major restoration. In-ground sprinklers are visible around the perimeter (a surprisingly modern idea), and dark topsoil is spread about. It looks like a planting scheme is in place behind a chain link fence that seems to suggest that the ASI, which has taken over the control from the local government, has big plans for the site. The third temple is a simple version of Hoysala architecture. It has all the vocabulary of Somanathapura but without the embellishment. It looks unfinished next to the extraordinary complexity of its neighbor.

TOWARD THE SOUTH

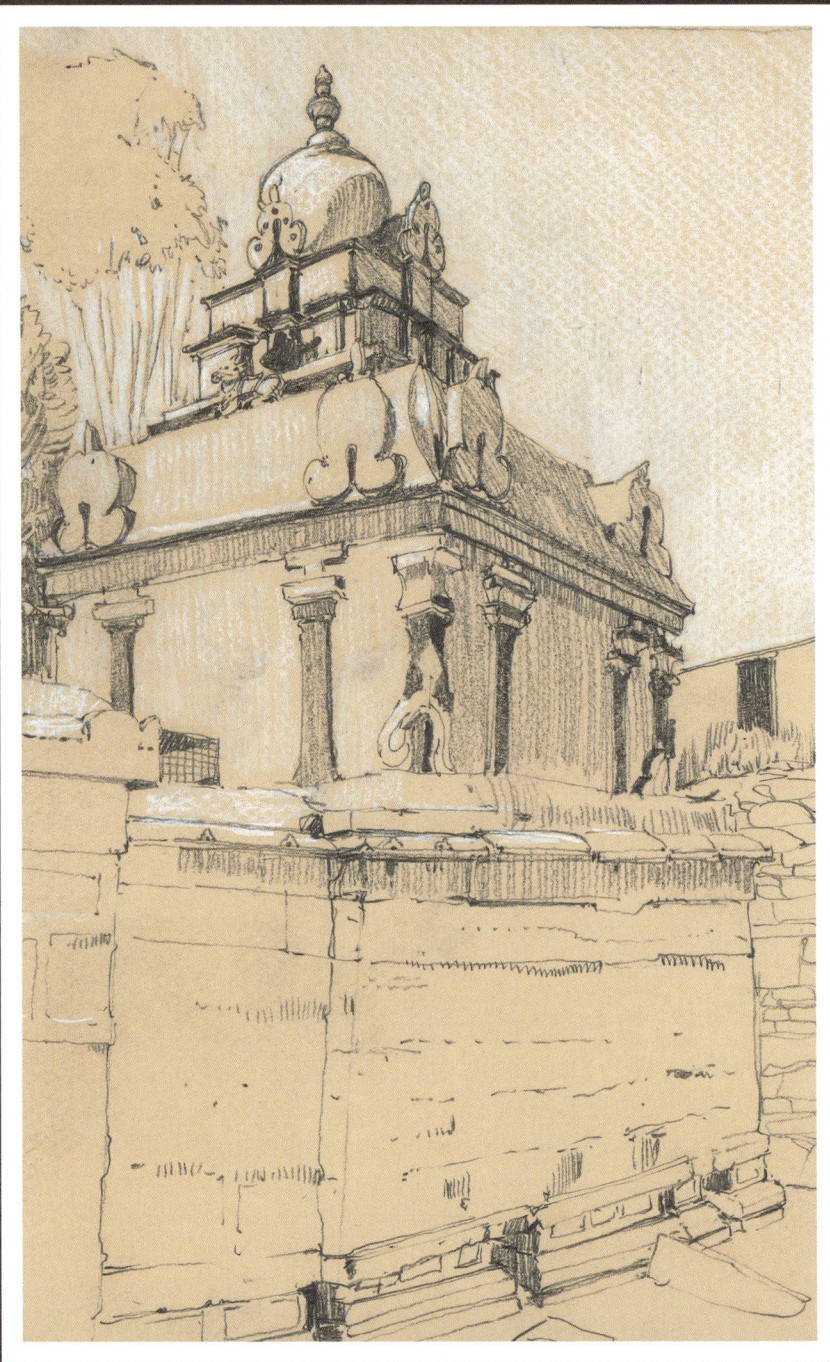

Maraleshuara Sand Temple

Rice is being harvested everywhere. I watch the workers loading rice straw onto bullocks and spreading the rice onto the road in a pretty efficient threshing technique.

The next crop of rice is already planted in many fields—tidy divisions with raised edges and ditches running between. Water everywhere. Some have clumps of green lined up in neat rows already sprouting new leaves. Other plots are bright mint green with a carpet of flooded rice plants standing out against the adjacent fields of sugarcane or bananas. At cane juice stalls, the vendor will run a length of sugarcane through a press for you, filling a little glass with the woody but incredibly sweet juice. You can also buy a piece of cane and chew on the fibrous stalk, sticky sap running down your chin.

The Coromandel Coast
Tamil Nadu

I love Tamil Nadu. It is consistently complex, welcoming, and surprising. And it's impossible to drive anywhere without stumbling across temple sites. There are simple village shrines and, in the south, vast temple cities. There are sites deep in the rural countryside that hold treasures of devotional sculpture stunning in their sophistication and execution. It takes planning, some research, and a local guide, but the payoff for the effort makes your heart race.

Pondicherry is a big coastal city and was the capital of the French colonies in India. It has a European street grid and the remains of a freight canal that connected the docks to the city. Now, essentially abandoned and filled with litter, the canal runs through the middle of town. There are rumors of restoring it, but everything in India is political, so opposing forces often sacrifice good ideas in order to diminish the successes of opponents. Pondicherry had a uniquely effective trash and litter collection program in place several years ago that kept the streets clean. When the local government was defeated, the street cleaning program was abandoned because it had been a success of the previous administration. The curse of plastic litter is omnipresent and there is a "No Plastic Litter" campaign in some regions.

The French zone is scattered with the remains of many colonial houses—some grand and freshly painted, and some moldering away. Many have been pulled down through the years and replaced by blocky, ugly concrete offices and shops. A wide paved esplanade separates the crashing sea from what were once grand waterfront buildings. Many were government offices, but you can see shadowy piles that must have been very stylish seaside villas.

The piers of the main dock still stand a hundred yards out from what was the customs house (now a trendy restaurant). In the center of the old French town there is a collection of buildings belonging to the Sri Aurobindo ashram. You cross from the relatively dirty streets of the town into their territory and suddenly it's very clean and the buildings are perfectly maintained. Small groups of pilgrims wander toward the main building—the holy and venerated site of the tomb of Mother. She was the inheritor of the ashram of the great nineteenth century guru Sri Aurobindo who was an interesting character all in all. He was sent to school in England as a boy and spent fifteen years there. He returned to India essentially a foreigner and began a career in the British Civil Service. Only then did he begin discovering the lost world of his heritage—not unlike Gandhi. He eventually began studying the meditation and yogic mysteries of India and developed into a seer and guru, eventually founding this ashram in Pondicherry.

Mother, as she is known, was a French Jew, Mirra Alfassa, who came to India without any particular interest in Hinduism, but who fell under the spell of this guru. She survived him to build the sect into a large and revered center of yoga, meditation, and spiritualism. She eventually landed on the idea of creating a compound—a world, really—where no government would exist, no hierarchy of faith or religion. It is called Auroville and is about an hour outside of Pondicherry.

Oddly, it's not an ashram in the traditional sense of the word, nor even a place of meditation, but a place that she saw as a center for world peace. One would arrive there—the intention was that people would commit to life there as permanent members of the community—and pass the time concentrating on the divine and on world peace. The whole thing is oddly cultish. A flurry of construction in the sixties resulted in a huge high temple in the form of a gold sphere with lots of symbolic elements and technical-sounding mumbo jumbo about sunlight being captured and directed through a central channel to a large crystal orb in the base of the building. It's not designed to be a place of meditation or prayer. It is described as a place for the initiated to simply

stand and concentrate on the divine. It's all a little obscure and you have to reserve two days in advance to be ushered into the temple to attempt this concentration. Crowds wander the compound; most are just curious. Despite its vague, new age quirkiness, there are many thoughtful Indians who believe that this place as a retreat is a reasonable notion. (The ashram in town is crowded and is more focused on traditional yoga and meditation.)

A large model of the envisioned city shows that it was meant to contain lakes, canals, and gardens along with housing for fifty thousand residents. Mother died just as the main golden temple was completed and it seems that the place just barely gets by now with the production, on the grounds, of household goods and decorative stuff sold to tourists. There are shops here, as well as a very fancy shop in Pondicherry.

It is a bit tragic that this place of ambitious vision sits in the middle of rice fields and really seems doomed. There must have been huge funds donated when all this began. I suspect that when Mother died, the devotees lost the force of her character and its draw. It wasn't supposed to be merely a tourist destination, but that is what it has become.

Cheeky Monkeys

A couple of hours inland from Pondicherry are the remains of a great fortified city: Gingee. It is remote and almost deserted except for schoolchildren playing on the lawns surrounding the temple. The route to Gingee passes through miles of farmland and nurseries growing straight, narrow, bamboo-looking crops. This is a plant called Casuarina. It's the strong rigid tree grown for use, almost universally, as construction scaffolding. It's rare to see steel scaffolding in India. These trees are lashed together, tier on tier, and often wrapped in green plastic netting to shade the workers.

Gingee's main temple is huge and very complex. The walls of the city are vast and seem impenetrable. Three layers of fortifications eventually climb a steep rocky mountain topped by a fortress. Scattered around the fortress are several shrines, and at the very top is a two-level pleasure pavilion with open walls that look out on the wide green valley below. Inside the second wall is the royal

CHEEKY MONKEYS

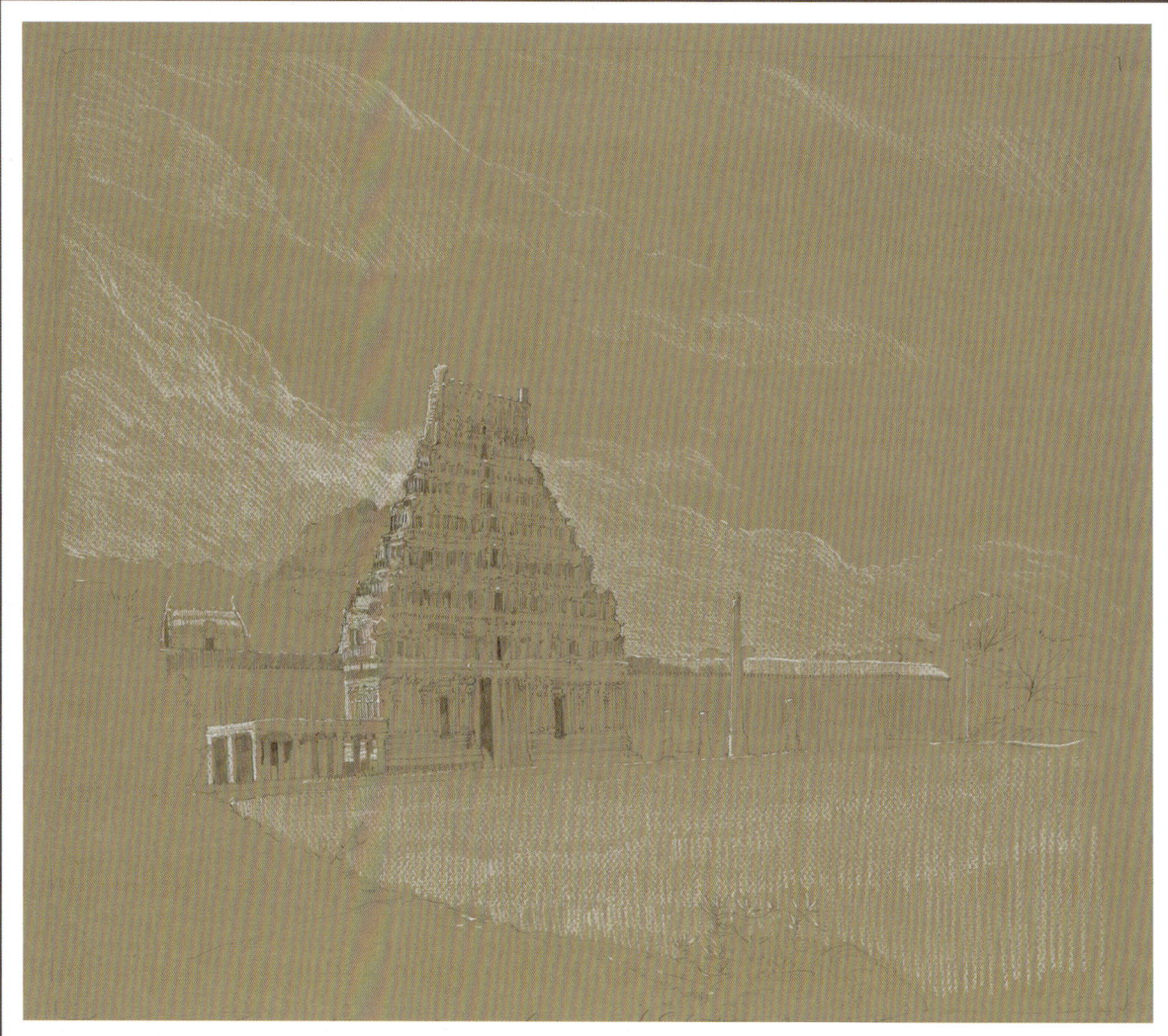

Venkataramana Temple, Gingee

enclosure with a collection of civic buildings and a huge granary—dark and cool. It must have been able to hold tons and tons of rice. There is also a building marked "gymnasium"—in English—which my guide told me was the king's wrestling academy, sort of a military school, with very high windows and plastered walls void of decoration. Around a large court is the royal stable with pointed arched openings. Gingee was abandoned in the thirteenth century after it was conquered by Muslim invaders. All traces of the former palace are gone. As in most other ancient cities, the residential structures were wooden, so long lost.

I settle in to work on a drawing in the shade of a clump of palms with an interesting view of the gopura of Venkataramana, the main Vishnu temple. Everything is in shadow as the temples face east and it has gotten to mid-afternoon. Schoolchildren on an outing come straggling by to look at what I'm doing. They call the woman with them "auntie," so she is not their teacher but more likely their guardian. They probably live with her at a home for abandoned children. India is filled with these places, which scrape by through private donations.

I hear their singing and the sounds of their play while I work. Every now and then there is a cry raised and I assume they are playing some game. I discover later that it is a shout of alarm because one of the monkeys watching from the trees has sneaked close enough to their gathered backpacks and satchels to upturn one and grab what it can. It is like some sort of game, actually. The children know it will happen and they thrill at the chase of the cheeky little creature. When I am preparing to leave, they all want pictures with me and love seeing the images on my camera.

Earlier, as we walked through the temple, the custodian walked with us and pointed out bits and pieces here and there. He showed us a magnificent Thousand Pillar Temple, which is a kind of structure repeated at many larger and important temples in southern India. They were open-air universities. Young Brahmins were sent to these temples to study Sanskrit and learn the sacred texts

Venkataramana's courtyards and covered halls have tall granite columns all elaborately carved and decorated. All of the sculpture has been stolen through the years before it became a protected site. These temple grounds are a collection of shrines, each dedicated to a different divinity. There is one sanctuary here that, unusually, has had a new deity installed. Candles flicker in the damp interior. The figure is black and greasy from offerings of milk and ghee repeatedly poured over it.

CHEEKY MONKEYS

As we leave, the gatekeeper offers to show us the interior of the gopura. We use the huge wooden gate swung open against the wall as a ladder and clamber up to a high landing. Steps rising through a low, narrow opening in the ceiling lead to the interior of the tower, where we can see the sophisticated engineering of the thing. The walls are probably more than three feet thick at the start and taper and narrow as the tower rises. The tower is hollow to its peak, with each ascending register stepping in toward the cavity. It is filled with light because there are openings (seven windows, one on each level) washing the space with sunlight. It is smooth brick with a few patches of plaster and it's wonderful to see the structure revealed from the interior.

I tip the gatekeeper 200 rupees, about $3.50, as we leave, and he grins and bows. The amount of money these people live on is almost incomprehensible. The general tipping expectation here is very low and I (even though cautioned against it) always overtip. Handing a priest in a temple 20 rupees is an acceptable donation. I always put much more on their plate and frequently I get stopped for a special blessing.

Porters are routinely tipped 40 rupees for carrying bags to your room. A guide who is probably being paid 1,000 rupees a day (maybe $18) will be your friend for life if you tip him another 1,000. Admittedly, what it takes to live here may be small, but when these numbers sink in, it just seems criminal to hand someone these trivial amounts knowing that at home we wouldn't blink at handing a valet $10 or even $20. A friend of mine was telling me he was going to take a bus for ten hours, for a fare of 1,000 rupees. You can hire a car and driver for the same distance for 5,000 rupees ($80) and cover the ground in four hours. The contravening view described by Sundar is that Western tipping ruins the locals. A priest in a temple who should be happy with 30 or 40 rupees begins to feel cheated if a Westerner doesn't leave 1,000 on his tray. Children who have no particular reason to beg will routinely ask for money because they have been handed money by Westerners. Sundar's view is that the dignity of both the sulking priest and the village children are diminished by the begging.

We drive back into town through ripening fields of rice and a few villages with their market day crowds. We lunch at a streetside stall. Waiters with steel pots and a ladle stroll by and scoop a serving onto a banana leaf. This universal meal is called *thali*—dal, rice, various combinations of vegetables, spicy and steaming. All around me are families, babies sleeping on laps despite the noise. Every place like this has a pitcher of water in the center of

the table and a stack of aluminum glasses. I order a bottle of cold water from the fridge. Tap water is universally a dangerous thing to drink in India and it is a good rule to never eat raw vegetables, salads, or unpeeled fruit. I've only been really sick once in India, when my guide in Varanasi took me to a local bar for a beer one afternoon. He ordered some snacks—crunchy fried bread that had chopped green onions on top. I knew I shouldn't eat them, but I felt obliged. I was sick for a week and it took two courses of antibiotics in India, and a final round after getting home, to recover. I've become more daring since then, however. Generally, people say that the food in the south is safer where there are better systems for keeping water clean.

Even Indians will sometimes refuse water offered at the table. The "best hotel" rule can even fail. Friends ordered hamburgers in Delhi at their five-star hotel and were miserably sick. The standing rule for tourists is that you should never order Western food, particularly meat. The standards and rules of safe meat handling we live by in the West just don't apply here. That being said, I eat everything else. Even street food, which most Westerners would avoid, is something I will eat in the south.

On the road we pass through a village where women are tending stalls with big canvas bags of brightly colored sand. I can't pass up the scene. The young women and girls tending the shops are shy and surprised by my interest. They are selling these colored sands for the approaching four-day harvest festival called Pongal. The sands are used to make patterned decorations on the ground called *rangoli*. While the colored sands are for festival decoration or at the entrances to temples, most families use rice flour to pour an offering to nature in front of their doors—it feeds the ants and it is believed it keeps them out of the house.

Pongal is variously described as the sun god festival, the nature festival, or the farmer's festival. The first day is dedicated to Indra, the goddess of rain, in hopes of a successful farming season. The second day is dedicated to Surya, the sun god. The third, and seemingly most joyous, is the day dedicated to the cow. Each day has particular rituals, but there is a constant background hum of music and drumming floating through the air. The final day is for visiting friends and relatives.

CHEEKY MONKEYS

I was invited to visit the dairy of a local family on the third day of the festival. The cows are bathed and fed sugarcane and fruit. Garlands of flowers are hung on the bulls and their horns painted. I saw two white bulls with horns painted bright cerulean blue.

The family had gathered from far and wide. An uncle from America and an aunt from London came. Dozens of family members and the dairy workers were there along with the four beautiful daughters of the current head of the family. The traditional arrangement of a tripod of three black sugarcane stalks with a little clay pot of boiling rice and jaggery—the dark crystalized sugar collected from the bottom of the pot when boiling cane—was set up at the entrance to the dairy barn. Pongal actually means "overflowing" or "boiling over," and a common greeting on that day is, "Has the rice boiled?" A priest was there to say the prayers and everyone was given a gift of a few hundred rupees for good luck.

Chariots

There are several wonderful sites along the central western coast near Mahabalipuram. The first is called the Shore Temple. It is the sole surviving structure from what is believed to have been Seven Temples, which by tradition were used as a landmark by sailors for hundreds of years. The ruins of the six other temples are submerged off the coast and were briefly exposed during the tsunami of December 2004 when the surf was drawn back by the oncoming wave. The Shore Temple, which is made up of three pyramidal towers, has a vast collection of Nandis assembled on its surviving low walls. It sits near a sandy holiday beach and is separated from holiday-going families by a security fence. It is a popular site for dance festivals, and the crowded parking area along the road is a little intrusive, but the temple itself is a small gem with the sea glittering behind it.

 Just south of the Shore Temple is a wonderful series of cave sanctuaries and cliff carvings. The carved ensemble is called the Descent of the Ganges. It is a fantastic series of deep reliefs, climaxing in a cleft in the granite where water pours over the stone. The complicated imagery represents the celestial river pouring over the head of Shiva, who divides the waters into the five great rivers of India. Beside Shiva are dozens of beautifully rendered animals, devotees, gods, and goddesses all worshiping him. The work was supposedly carved to celebrate the defeat of Buddhism by Hinduism.

CHARIOTS

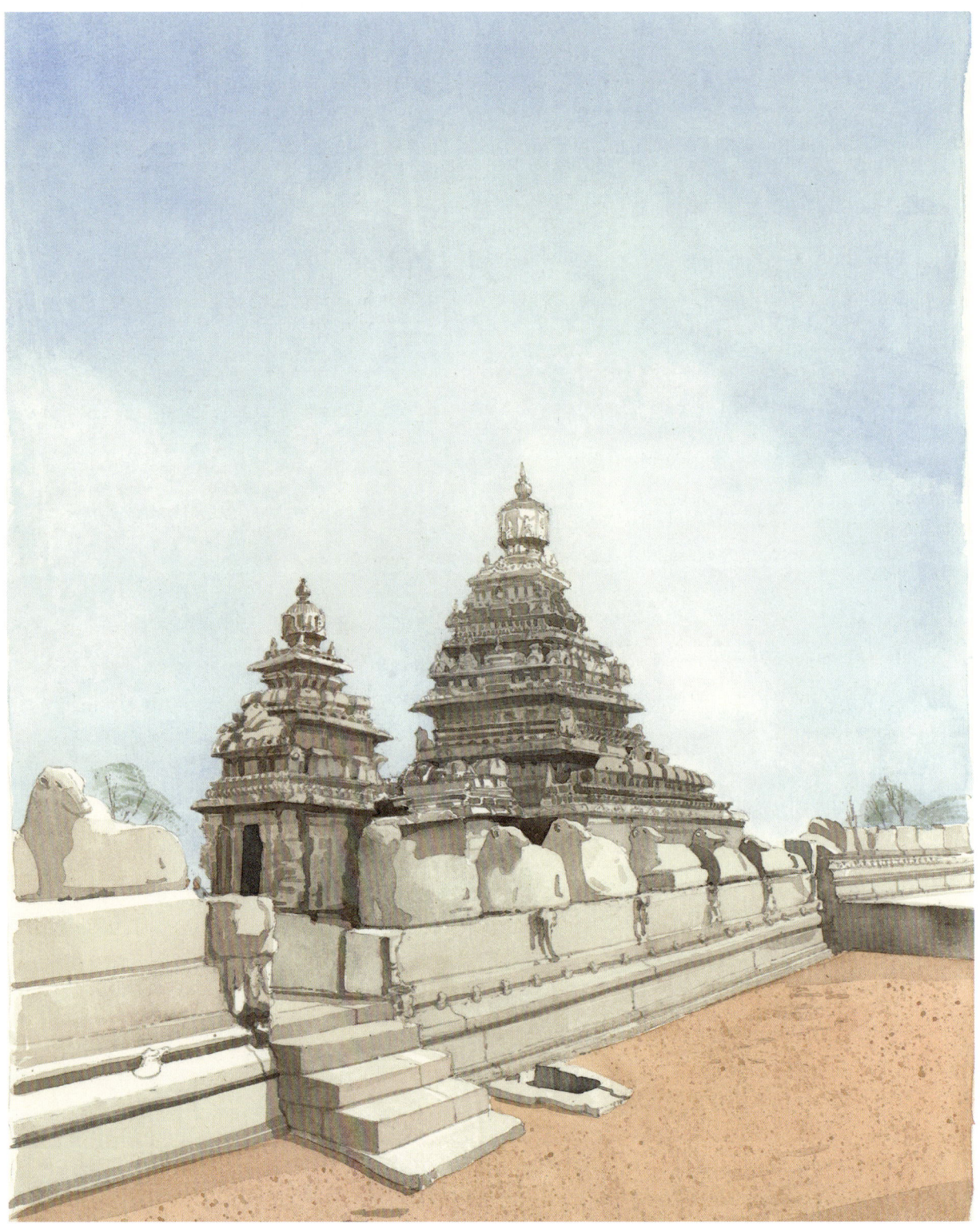

The Shore Temple, Mahabalipuram

CHARIOTS

The most unique part of Mahabalipuram is the Five Rathas—the five chariots—begun in the fifth century. The Five Rathas are really sculptures carved from giant boulders and they represent the five styles of early Indian architecture. The Rathas were commissioned and only partly carved for King Narasimhavarman I, who didn't live long enough to complete the project. Each is distinctive and several have unfinished faces or roughed-out details. They are called chariots because they, more or less, look like temple festival chariots used to carry deities on high festival days. They are small pavilions, except for one, a life-sized elephant, which has all the pared-down style of an sculpture.

It is a magical place, but along with the other sites in this spread-out complex of shrines, it is popular and crowded.

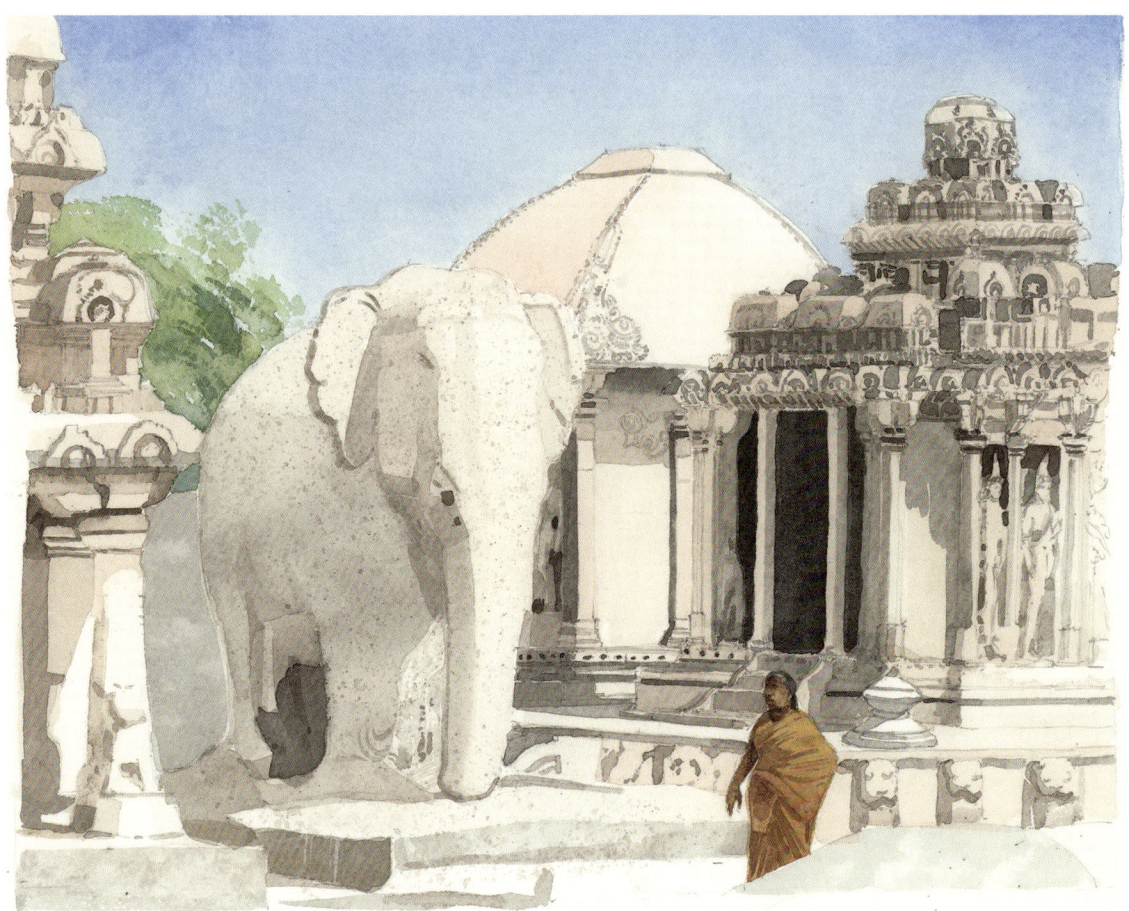

The Five Rathas

DANISH ACCENT

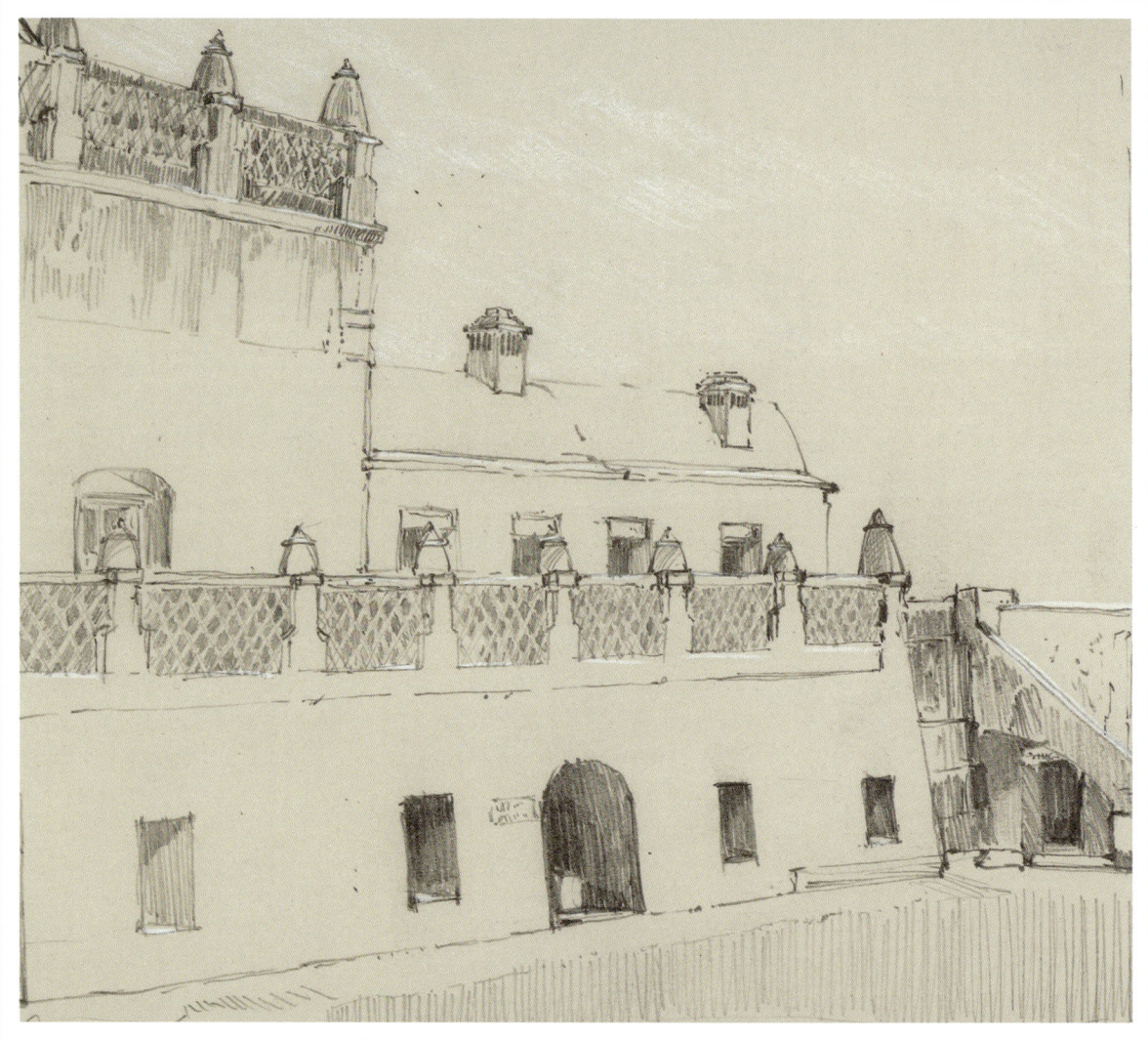

Danish Fort, Tranquebar

Danish Accent

Tranquebar was an early Danish colonial settlement. The ground it's on was bought from the local maharaja in the late seventeenth century. A fort was built in the eighteenth century and finally a full-on colony emerged. It is probably what Pondicherry (its much bigger neighbor and more popular holiday destination) looked like a century ago.

There is a village along the main road with a busy market and a small temple at the crossroads. The dusty track leads to a gleaming white stucco gate, currently being restored by the Archeological Survey of India, into the old Danish town. Immediately you are navigating a gridded street plan with stucco buildings in a vaguely European style. Each one has a deep shaded porch and simple neoclassical detailing: thick columns, shutters, balconies. I stay in what was a private house now renovated into rooms for the larger hotel down the street, which was the customs house. That building, besides having been the main office compound for the colony, was also the center of social life. After you pass through its square entrance hall, which has ranks of closed doors, you come to a wooden stair that circles up to the main floor. A very big square hall with a twenty-foot ceiling welcomes you there. Even on a hot day cool air rushes up the stairs and out the cupola above. The room is bright white with blue paint decorating the carving on the recessed panels. It looks for all the world like a ballroom. Wide, shady balconies open from this space. It's another example of the impulse these colonists had to create familiar and comforting worlds. This must have been a very dusty and remote destination.

I couldn't find out how many souls had lived here at Tranquebar's zenith, but it must have been a busy town. There are three very big churches—the most impressive being the Danish Lutheran. Above the altar is a gilded panel with an inscription about New Jerusalem. The rear wall has engraved stone memorial plaques dedicated to the preachers and worthies who never made it back to the cool, never-darkening summers of Denmark.

Lord of the Dance

In the middle of what at first glance appears to be the small town of Chidambaram, there is a temple called Nagaraja a huge pilgrimage site. Nagaraja is the King of Dance—nata means "dance" or "performance," and raja literally means "king"—and the dancing god is honored here by many sanctuaries of dark and crowded halls. Temple names are often difficult for Western ears to take in. It is because they are actually like sentences. They can start with an honorific or a description of the place, next a deity, and followed by a location or patron.

There is a ritual opening of the chamber where the most revered image of Lord Shiva in his most beloved form is held. Worshipers gather for the moment when the doors are opened and an ecstatic energy flows through the crowd. The dance he performs is the dance of bliss—the dance of continuous creation and destruction of the universe. Bronze statues from the tenth-century Chola kingdom established the form of this classic sculpture. Shiva dances with a raised foot and a ring of cosmic fire hovers above him. He holds a drum in his raised right hand for beating out the passage of time and his raised left hand holds the flame of destruction.

A large group of Americans had gathered around a pair of priests performing a ritual. Hindu rituals are performed for groups in temples like the revealing of a deity at a certain auspicious date

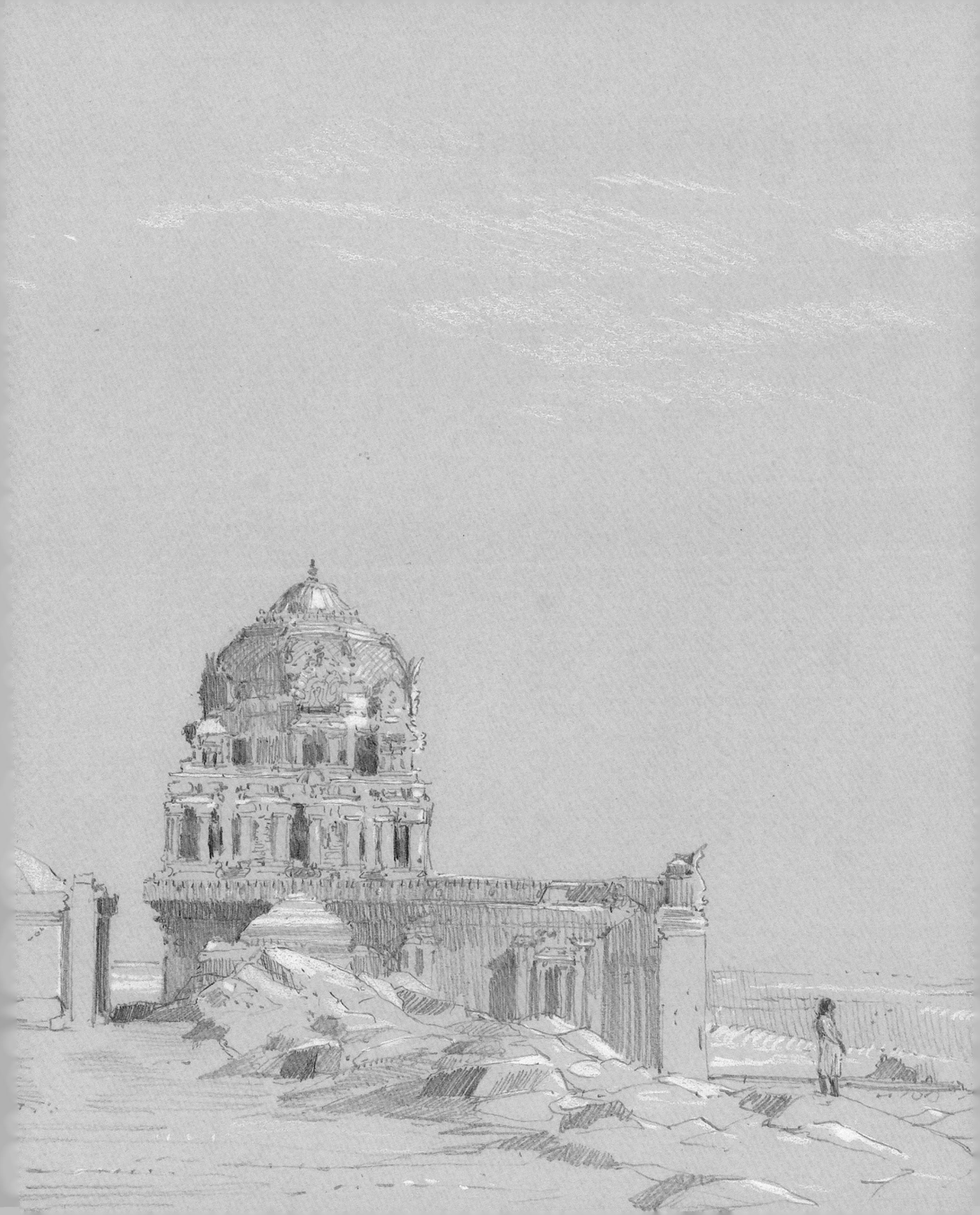

LORD OF THE DANCE

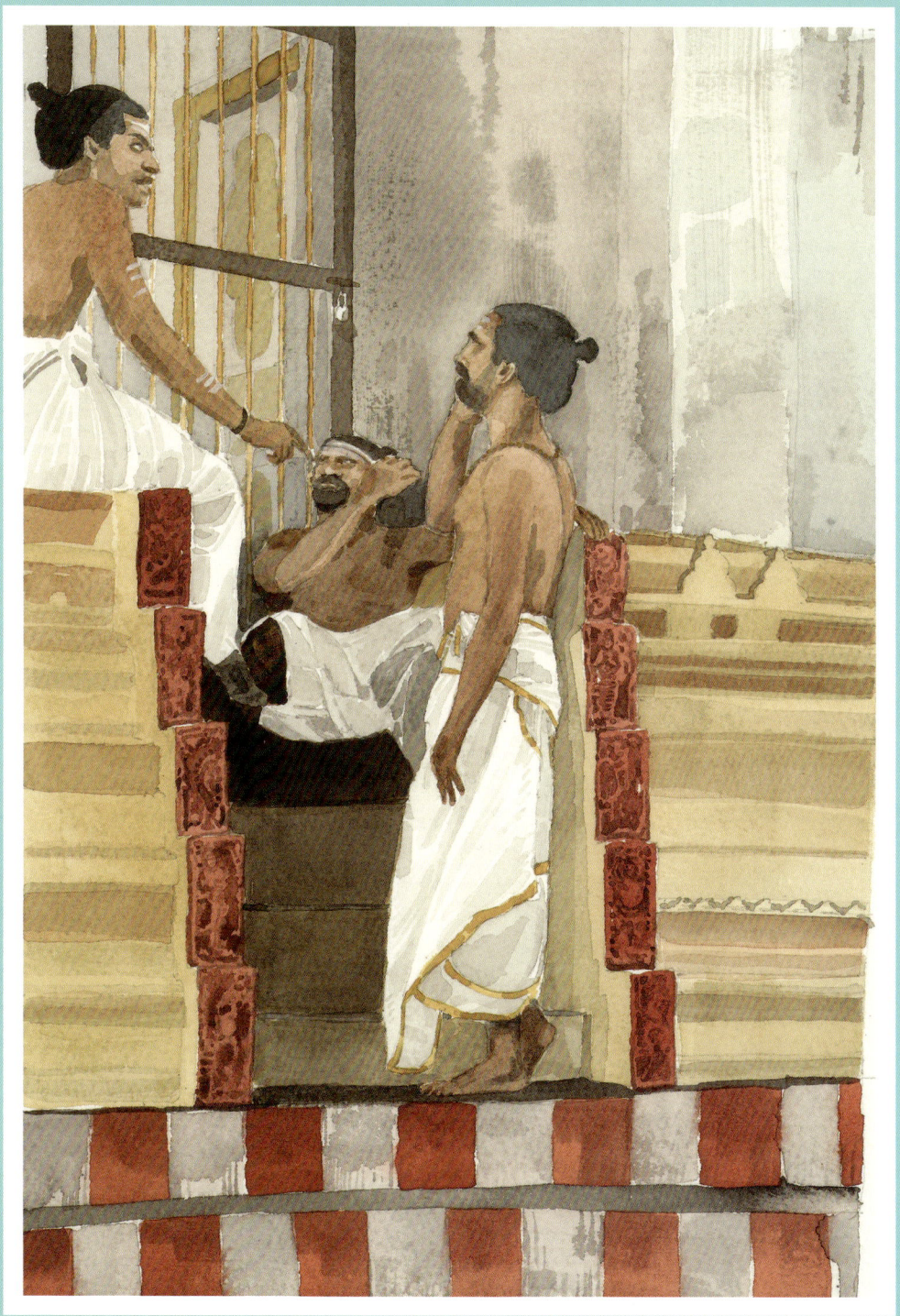
Priests at Nagaraja Temple, Chidambaram

or a closing ceremony at the end of a day or the elaborate Fire Ritual where offerings are burned in a sacred fire, but the interaction with a deity is usually a private personal act. Festivals, of course, are another matter and are often crowded and joyous with thousands of people. There was a time when a Brahmin Priest was the only way a worshiper could have access to a deity. A sort of spiritual revolution evolved that took the worship out of the hands of the Brahmins and it became possible for an individual to approach the god without the intercession of a priest. The most common form of worship is called Darshan—the act of "seeing" the deity, but also about the deity seeing the worshiper. It is an exchange—an acknowledgment. Sight is an important part of Hindu tradition. When a statue of a deity is carved or cast in bronze, the last thing that is done to the figure is to "open" the eyes—a ritual around carving the last feature to invite the god into the statue.

When a worshiper enters a sanctum, these blessing rituals always take the same form. The priest lifts a tray with a small cup of oil and a wick burning. Prayers are said to the deity and the flame is held before the god with the smoky flame flickering and the fumes floating over the god. The tray is then held out to you—you pass your hands through the flame and either cup them over your face or brush your hands over the top of your head. You are then offered a dab of almond paste or ash to place between your eyes or the priest will touch a finger in the ash and put a mark between your eyes. In Shivaic temples, it is always ash, to remind you of the transience of life. You will probably be offered a sip of holy water too.

Another temple in Chidambaram, called Vaitheeswaran, is not as grand, and I was the only Westerner there. An ancient neem tree in the courtyard made it cool and the light dappled.

The interior was full of activity, with bells being rung and drumming. There are, again, several sanctuaries with priests and worshipers. Along one dark corridor is a wide doorway opening onto a large stepwell with high walls and a pavilion in the center. I could see fish in the well nosing the surface for the rice that people were sifting onto the water. We stopped outside the gates for a cup of tea from the cart standing there. No one drinks cold drinks. It's always something hot, supposedly to cool you down.

We stopped at one more village temple, Thirukadaiyur, along the way. It was closed but I wandered through the covered court and peeked through the gates at the inner temple.

LORD OF THE DANCE

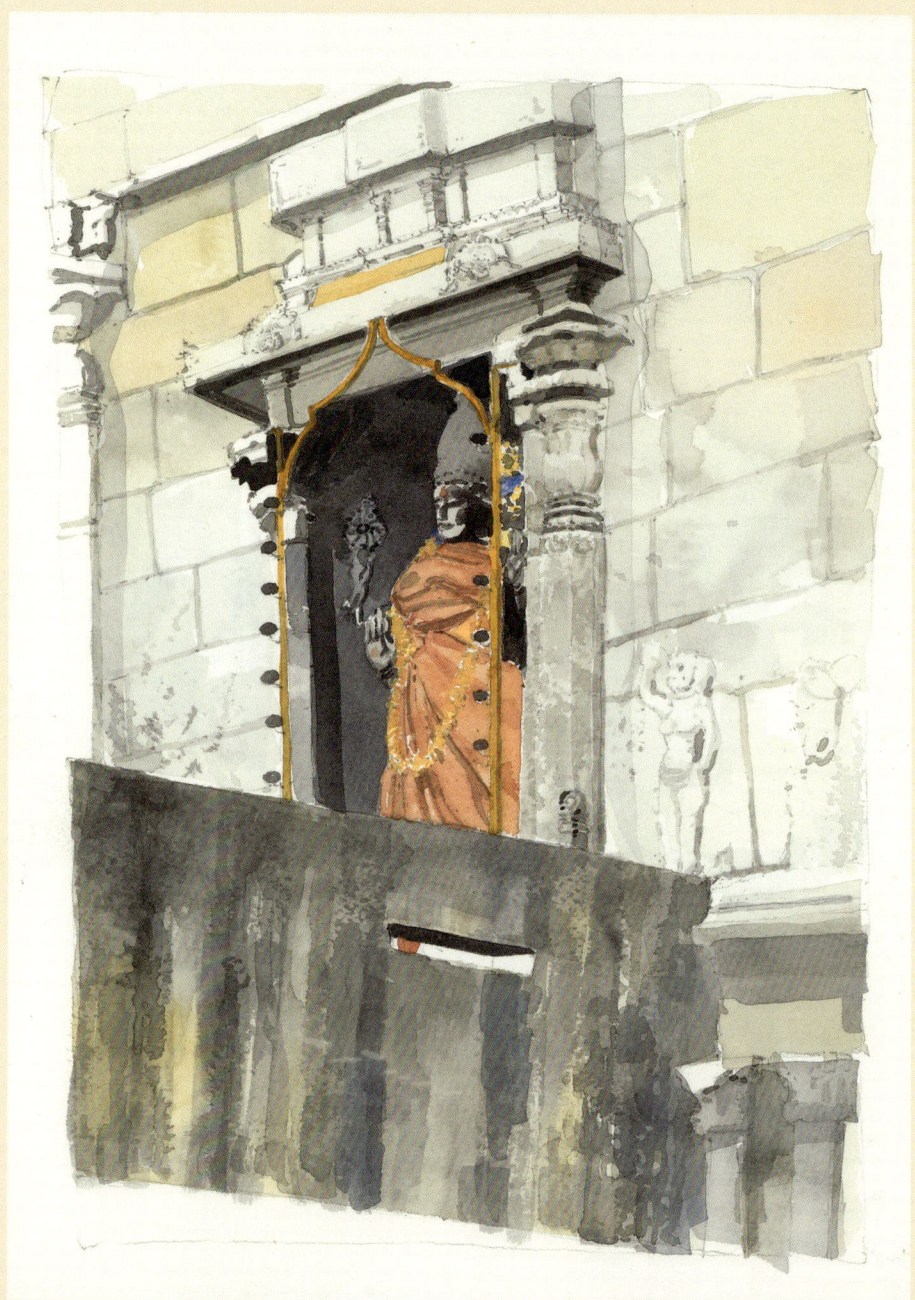

Draped god, Chidambaram

LORD OF THE DANCE

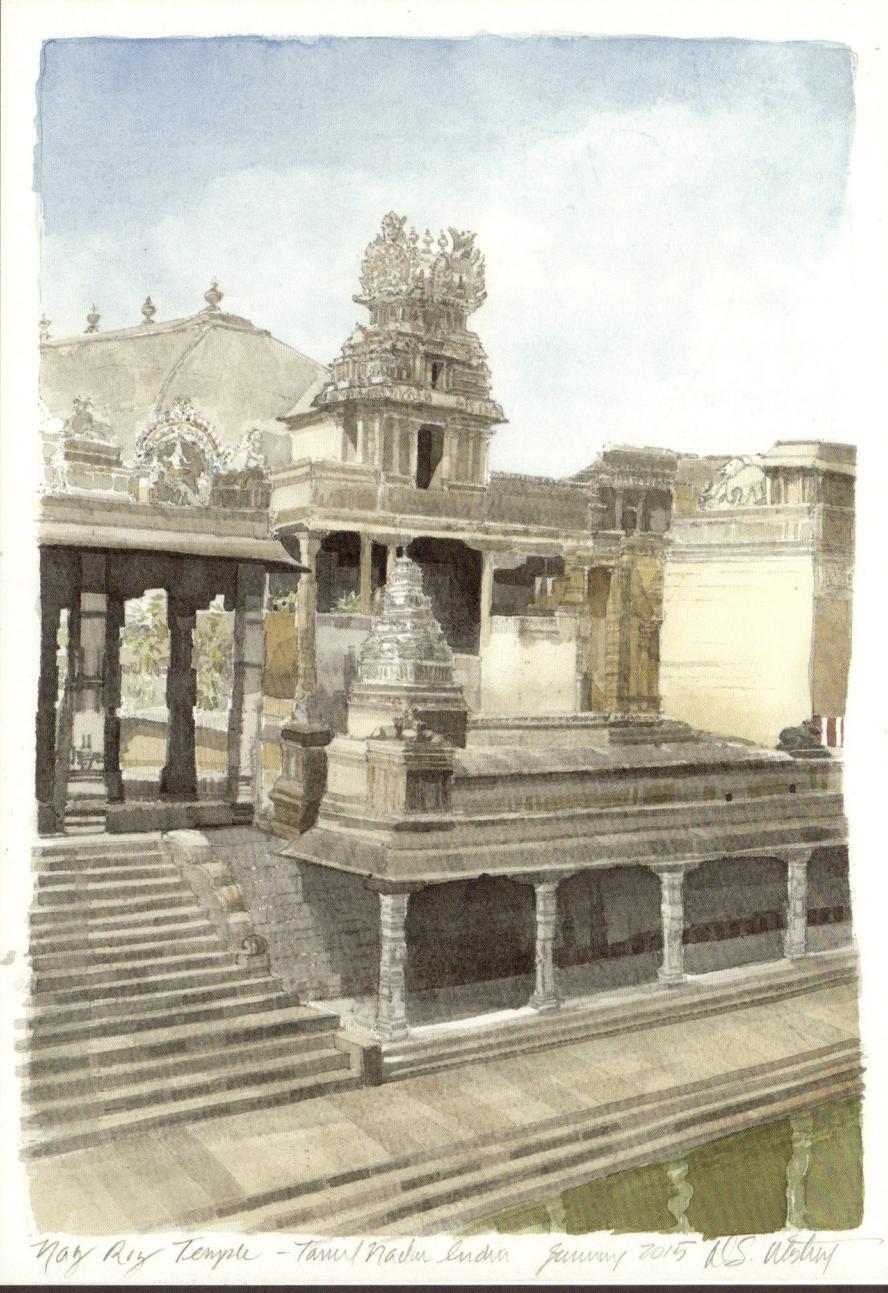

Nagaraja Temple, Tamil Nadu

All three of these temples, except for their size, were essentially the same design. They have tall tapering towers at the entrances with first stories of granite and vividly painted brick and stucco above. The traditional polychrome decoration of these towers evolved in the nineteenth century with the development of commercially available, inexpensive paint.

 The boldness of the decoration has always seemed a little jarring to a Western aesthetic looking for the picturesque. But after I made a remark about the paint to a friend, he made a very thoughtful comment: "They paint them as acts of devotion." It brought me up short because I realized I have been indulging in a view of these sites as architectural, historical monuments, when what really makes them important and relevant to India is that they are living places of spiritual life. Beautiful they may be, but the temples with active sanctuaries and priests in attendance resonate with something more—holiness. The connection with the divine in these temples is personal and moving.

Sun and Silk

Kumbakonam is the third largest city in Tamil Nadu. I book into the Grand Gardenia Hotel. The front of the building looks like a fairly new hotel, although traditional, with a covered but open reception area, where three girls in saris are nodding and smiling. Behind the garden is a large dining room with tables under shady porches. Through a gate and across a dusty street, a group of cottages look like they might have been nineteenth-century guesthouses. These little buildings sit next to a wide rushing river, and a cool breeze blows from it. Goats are tethered to a covered pen and a few dogs lope around with puppies following behind. It turns out that the compound's whole traditional scene was conceived and built by the hotel's smart and creative owner. She seeks me out to greet me and eventually comes by my cottage to look at my drawings late one afternoon.

Most hotels in India have an Ayurvedic massage center. Classic Ayurvedic massage is performed by four hands on a wooden table with raised edges. The edges are to hold the oil that is poured onto you for the massage. The technique is supposed to open the flow of life force in order to cleanse and revitalize the body. I'm not sure about the life force benefits, but it is an amazing experience.

The reason to come to Kumbakonam is that within a few miles there are three important and beautiful temples. The closest one, Darasuram, is under ASI control and intimate enough in scale that I have been anticipating spending the morning drawing there if my letters of permission work. It turns out that the effort to get the official paperwork in place wasn't necessary here. Arriving with a guide (all the local guides are known to the gatekeepers) seems

to fix everything. I find a shady spot on the south gallery beside the priest's cells and I have a quiet morning while the temple guide keeps curious children at bay.

I agree to visit a weaver a few steps outside the temple gate. Often a guide will suggest and direct you to a shop or craftsman. Actually, these are not impromptu suggestions, but most often are coordinated with the vendors who give the guide a commission for steering you to them. Sometimes these stops can be interesting if you are taken to an actual weaver of saris, for instance, or to a potter at a wheel. That does happen often and it's likely that the first time you are taken to a sari shop you will be charmed by the careless and dramatic way a shopkeeper will unfurl yards of silk before you. Salesmen can be aggressive, and you will likely pay more than you should and buy more than you'd planned, but it does give you a glimpse of the traditional marketplace. The most discouraging version of this is when you are taken to a souvenir shop with the common tourist stuff for sale. In order to avoid these shops, you have to be direct and clear, but even a sympathetic guide whom you think understands what you are interested in will press you to make a stop. You can be surprised, though, by what might be hidden away in what appears to be a shop window with shelves of brass and bronze figures gleaming in the sunlight. I was introduced to a shop owner in Ahmedabad who had Aladdin's cave in the lower level of the shop. I had been looking at tribal objects of Gujarat and my guide, Yuvraj, wanted me to see the collection of textiles. I found shelves and shelves of antique rugs, pashminas, and tribal embroidery. It was a collection of museum-quality objects.

The second temple complex near Kumbakonam is Gangai-konda. It is a huge, empty temple standing on a very high platform. There are twenty tall steps up to the sanctuary, where a beautiful tower of pinkish granite stands over the inner sanctum. The entrance tower is gone—long collapsed. This temple, built in the mid-eleventh century, is second in size only to the nearby temple in Thanjavur (built by this builder's son) and many scholars think the quality of the sculpture here is better. The Cholas were the ruling family in this part of India for many generations and gave their name to the local style of architecture. Their kingdom collapsed in the mid-twelfth century. There is a theory that some natural disaster created the opportunity for a neighboring kingdom or Muslim invaders to displace them. The temple's massive carved stone base has a rhythm of projecting shrines each with images of Shiva, and recessed, stylized fountain sculptures. The royal palace compound was just outside the walls of the temple, and there are remains of a tunnel that connected them.

SUN AND SILK

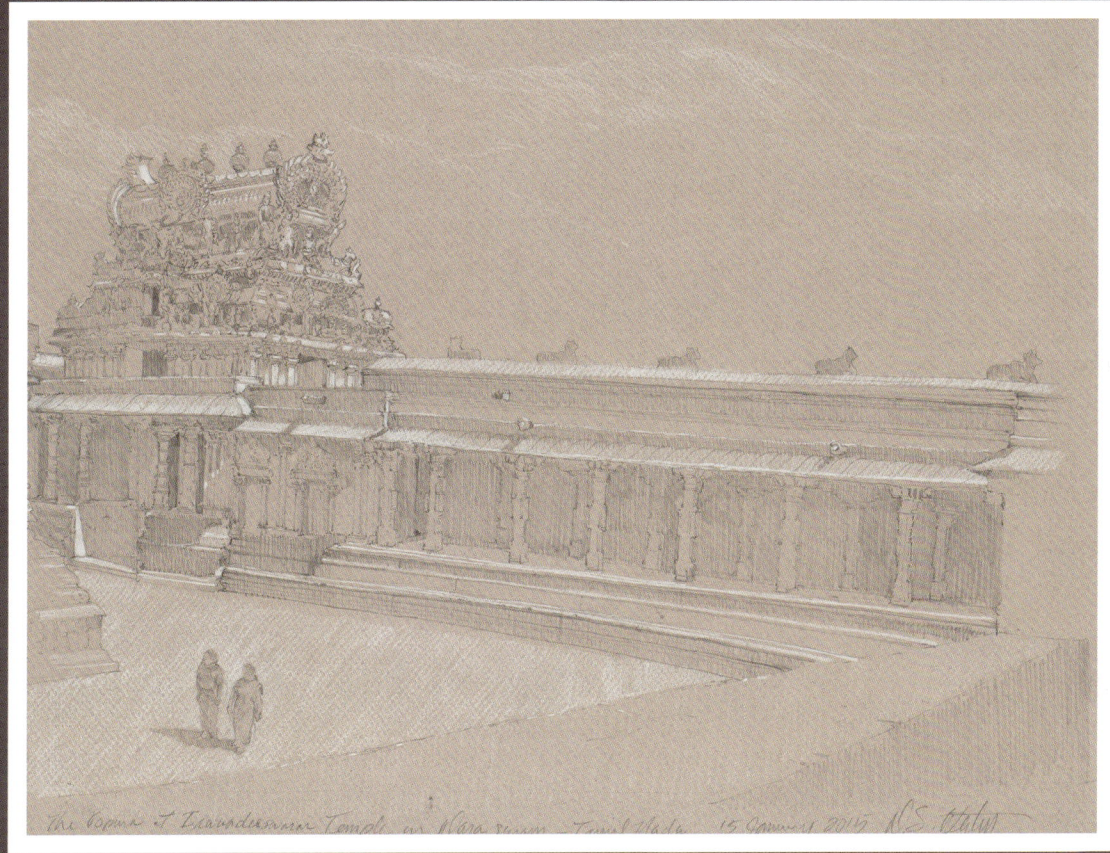

The Gopura at Irava Temple, Darasuram

SUN AND SILK

Small temples flank the main tower near its western corners. On the north side, there is the curious and wonderful Lion Well, so-called because standing over the well is a twenty-foot high carved lion. A gate between his legs leads to steps that take you down to the well below. Nandi, the bull, rests nearby on a raised platform, without his canopy, gazing toward the entrance of the temple.

 We cross a wide river on a bridge built by the British. My guide points out crocodiles lazing in the shallows and on the sandy shoals. I can't help but be reminded of Mrs. Moore's remark in *A Passage to India*: "... horrible... and wonderful!"

 On the way back to town my guide serenades me with some traditional prayer songs in quarter-tones in a high falsetto. He is eager to sing for me and goes on with love songs from popular music of the sixties.

Harvest Festival

The third and most important temple is Brihadishwara (more often called the Tanjore Temple) is vast, towering at 182 feet, beautiful, and often thronged by a complete crush of people. Festival days and certain pilgrimage dates make this a crowded and confusing place to visit. Even outside the gates I can hear drums and multiple bands playing. Shoes must be checked just inside the temple walls and the crowds jostle you through the little covered shoe check. I have been in this temple twice during Pongal, the Tamil Harvest Festival. It is celebrated for four days and everyone shouts the greeting "Happy Pongal!" In front of the temple in Tanjore is a giant Nandi in its own columned pavilion. A saffron curtain hides the Nandi. A big noisy band with a dozen drummers is squeezed onto the raised platform, beating and playing in a wonderful frenzy. At the climax of the morning the curtain is drawn back, revealing the decorated Nandi. Garlands and spirals of fruit and vegetables are draped around his neck. He has been freshly painted with bright bold eyes and a coat of creamy paint. The crowd shouts with joy, raising their hands in salutation and praise.

This temple has the tallest tower in India. Its massive capstone was hauled up a dirt and timber ramp from one mile away. The temple is also famous for having the largest linga in this part of India—it is thirteen feet tall and rests in the center of the holiest chamber.

I spent several days returning to this amazing temple looking for a place to sit and draw. I found one on an early morning when the crowd was sparse and spent several hours in a shady corner with my drawing board.

HARVEST FESTIVAL

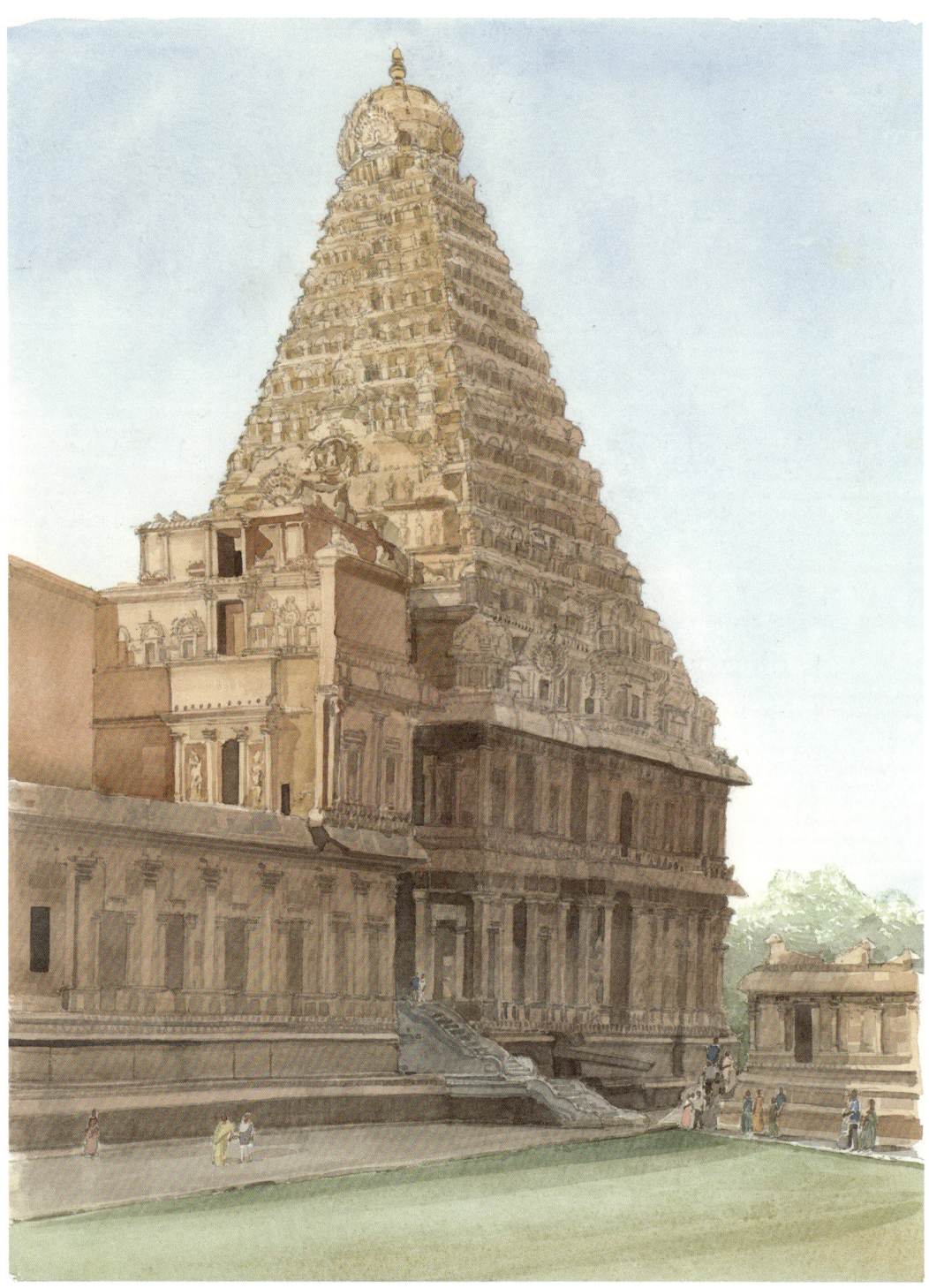

Brihadishwara Temple, Tanjore

HARVEST FESTIVAL

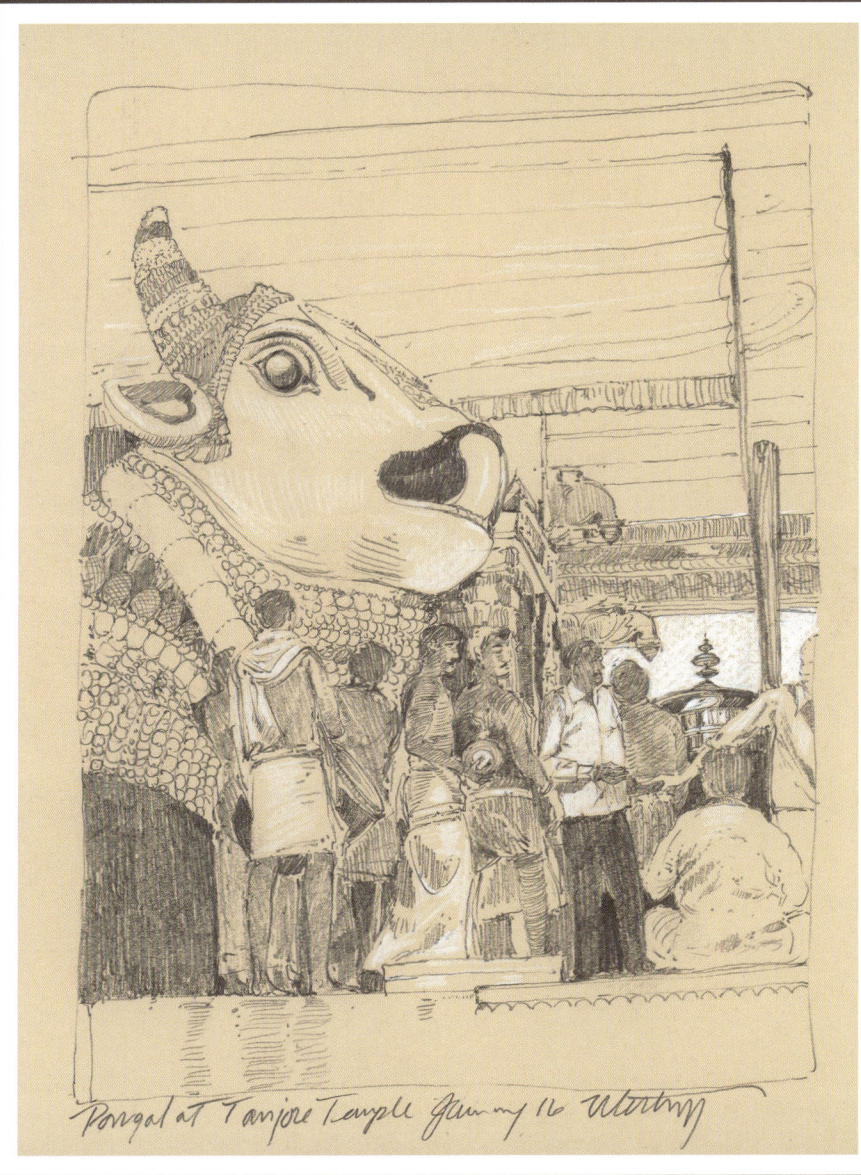

Pongal at Tanjore Temple

TEMPLE CITY

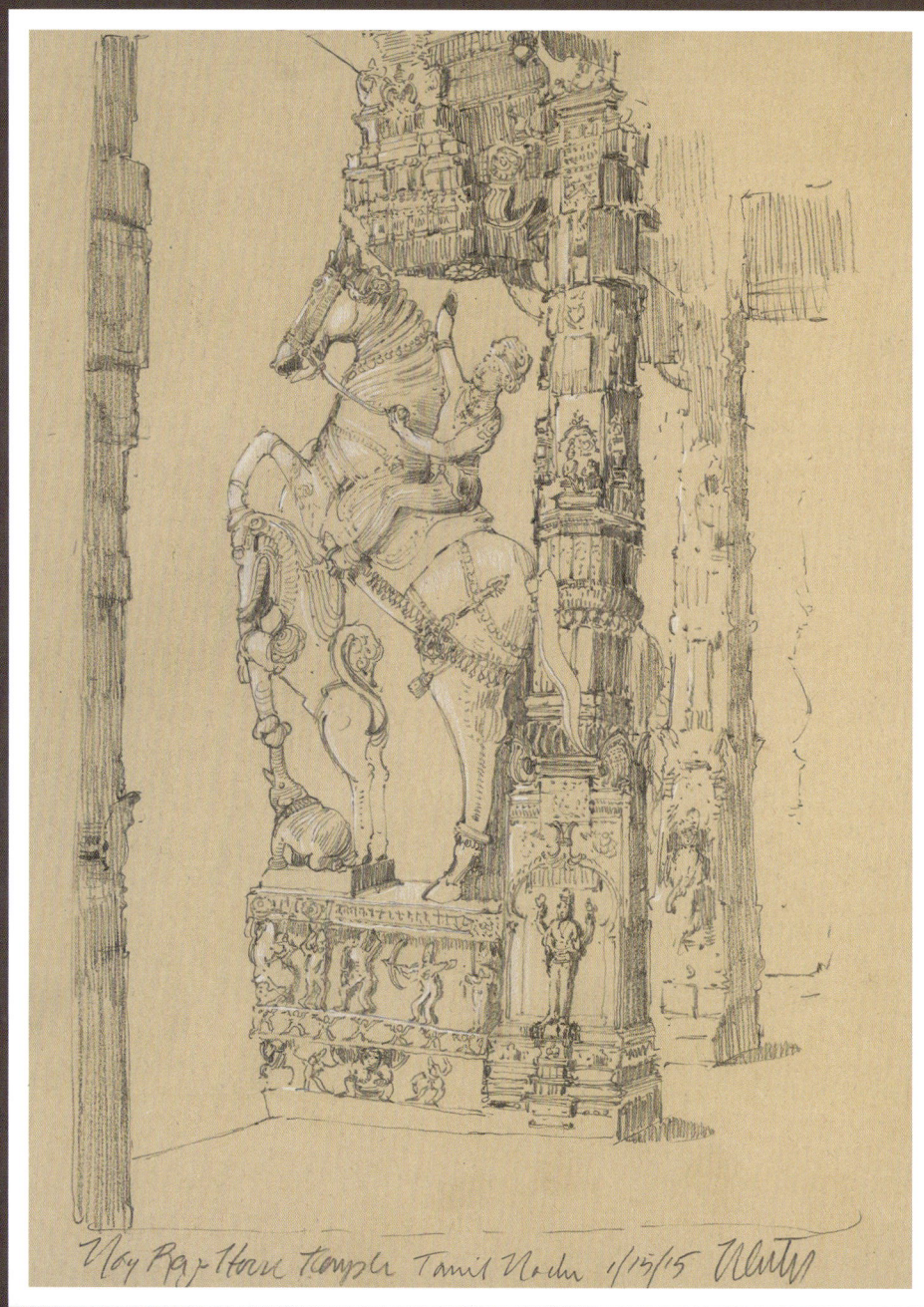

Sri Ranganathaswamy Horse Temple

Temple City

Two hours west of Tanjore is the Srirangam Temple. It stands on an island at the convergence of two rivers, the Coleroon and the Cauvery. Dedicated to Vishnu, it is the largest active Hindu temple on Earth. It has seven concentric walls surrounding the main sanctum and is famous for its multiple towers. The areas closest to the center of the huge complex are reserved for shrines and temples. The other walls enclose a bustling and crowded city. It is full of worshipers, pilgrims, and shoppers. The shrines are mixed with stalls selling everyday supplies as well as souvenirs and things connected to worship.

There are dozens of gateways, tanks, shrines, pavilions, and courtyards. One of the most spectacular spaces is the Sesharayar Mandapam, or Sesha Mandap—often called the Horse Hall. It's a very high, "thousand-column" covered space. The interior columns are elaborately carved with the ten incarnations, or avatars, of Shiva, but the real showstopper is the bank of piers at the northern end of the hall. A dozen life-sized rearing horses project from the columns. Warriors ride the horses and battle demons, dwarfs, wild beasts, and dogs swinging sabers and jabbing spears. They cling precariously to their mounts. These horses are massive

pieces of sculpture and carved as a piece with the columns. They are stylized but totally lifelike, and, alone, are really worth the visit to Srirangam.

In another courtyard, an ancient neem tree is covered with golden-yellow bits of folded paper. They are bought from the vendor across the court and hung on the tree by couples hoping to conceive. They are little fertility offerings to the god of the tree.

I have been looking for some particular sculptures ever since I saw them in my hotel near the Shore Temple at Tranquebar. I have been told they are called Chola dolls, or Chola figures—again depending on who is telling me—a generic term for everything that is a reproduction (or genuine for that matter) of figures from the Chola reign. These are, however, low-fired ceramic devotional figures of particular deities. I think the ones that have charmed me are from the 1940s. Families display them for holidays or festivals—really, they're personal family gods. People look at me blankly when I describe them and just don't seem to understand what I'm talking about. My suspicion is that they have gone out of fashion and aren't made any more. They are glazed, or brightly painted, or white, and have doughy bodies and slightly naive faces.

We were directed to an antique shop and went back twice, but it was closed because of the holiday. Now back in Tanjore, we pass by again. The shop is full of them. The place is dusty and dark, but there are shelves and shelves of these exact objects. I can't help myself and choose six of them: two Krishnas, two Shivas, a Vishnu, and a Nandi. Mingled among these gods are figures of clearly English colonials: boys in shorts with their dogs, thick-waisted women with handbags wearing flowered hats, and soldiers in feathered regimental helmets. I am so tempted to add one of these to my collection gathered on the streaked glass counter, but these are going to be difficult to ship, so I have to pass. I love these figures. They look like miniature versions of the figures on neighborhood temples that are often brightly painted—their soft surfaces faded and their innocent faces and plump bodies just too lovely.

TEMPLE CITY

I have been invited to a closing ceremony of Pongal at a village temple. When I arrive, the ceremony is over, but the local notables are waiting there to meet me. They usher me into the little concrete sanctuary and drape me with the rose garland that the priest lifts from the deity. A row of pretty girls claps and grins. I'm introduced to the mayor and his deputy, both of whom seem slightly bewildered as to why I'm there. At any rate, my guide is pleased. I fear he thinks I am a VVIP.

On a high outcrop above the city, you can see the walls of a fort. Driving there, we pass a huge Gothic Revival 1880s Catholic church. After turning off the busy street toward the fort, the streets immediately narrow and start to climb. This must have been old Tanjore, with its open gutter sewers and its temple above. The climb up the two hundred covered steps is punctuated by small shrines cut into the walls of the mountain and eventually takes you to the top where families are leaning out over the view, pointing at familiar sites and watching a train wind through the city below. There is a tiny Ganesh temple inside the fort. The church at the foot of the mountain and its Gothic spires look spindly and insignificant next to the domed tower of the Hindu temple next to it. From there, the brightly painted buildings of the city look like a quilt thrown on the ground from here.

TEMPLE CITY

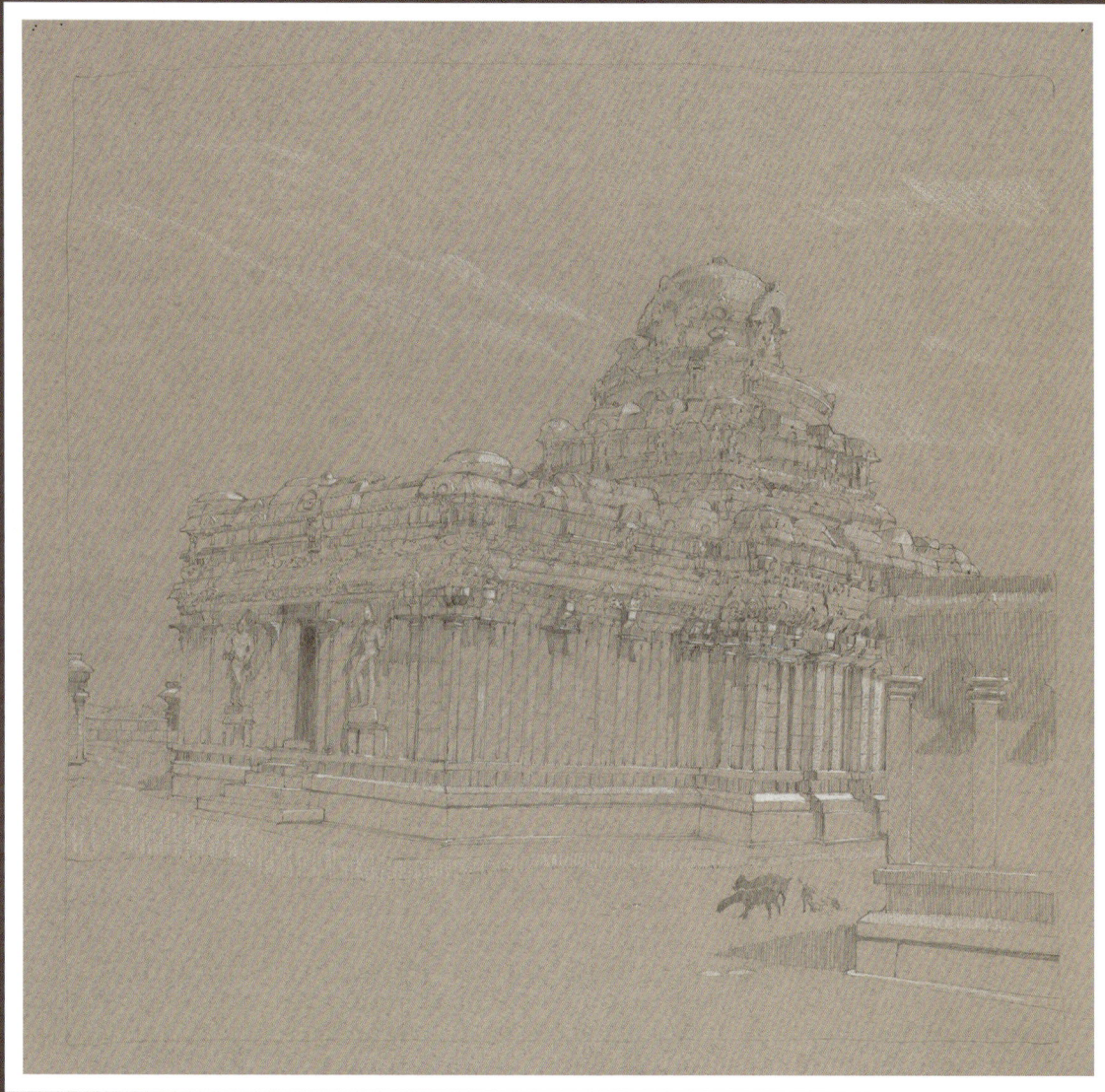

Vijayalaya Choleeswaram, Narthamalai

Off the Road in Chettinad

Art Deco Palaces

Sometime during the late seventeenth century, there began to evolve a mercantile class in the villages of Chettinad. It's unclear exactly what defines a Chettinadi, but it's sort of a collection of clans—loosely connected but certainly having a regional identity, cuisine, and social traditions. There are seventy-two separate villages defined as Chettinad. Somehow the trading tradition grew into a way of life. The men would go off to neighboring countries to buy and sell, and they developed great wealth. This was not just a few families but dozens, if not hundreds. With that wealth came the impulse to build something unique in India; huge mansions sprang up, often as large as a city block. They seem to follow a similar general plan inside. You enter through a gate or possibly a courtyard, then into a front hall, followed by a series of giant rooms designated for specific uses: the women's hall, the men's hall, the rice court, the storage rooms, and the ultimate expression of the community, a dining hall. The dining area is the biggest space in the house and usually stretches the entire width of the house across the rear—easily one hundred to one hundred fifty feet in most cases. These double-height rooms are elaborately painted with mural panels. Crystal chandeliers are hung from carved and painted ceilings—everything intended to make the spaces dramatic and impressive. They were, and are in many cases today, used for wedding feasts and festival banquets. These houses became fortresses (grills and grates cover the open courtyards)

when the men were away trading, often for months at a time. Each had enough food stored for a year. Water was collected in copper vessels. Women and children were locked inside the compound. Elaborate locks on the doors with internal bells that rang when a bolt was thrown kept intruders out and, certainly, the women in.

This economy seems to have thrived into the twentieth century. The most astonishing evidence of that prosperity would seem to be the construction of art-deco-style palaces. They stand next to neo-baroque towers or vaguely French/continental-inspired facades. These deco houses are unlike anything I've ever seen. Nothing in London, Paris, New York, or even the architecturally trendy Los Angeles of the twenties comes close. The nearest Western parallels are movie palaces. Bombay has some art deco houses and apartment buildings, but they don't approach the sophistication or theatricality of these mansions. The families had become very cosmopolitan by this time, so maybe it was in London that they came across the art deco architecture.

In the town of Sidhpur, in northern Gujarat, there is another architectural tradition that seems to have grown out of contact with Western aesthetics. Wide streets in a strict grid are laid out with Victorian row houses—each exactly the same width and height. They vary in decorative detail but seem to have been taken from a narrow style book. Many interiors survive in their original stiff Victorian taste with only occasional nods to traditional Indian culture. The original merchant class that built these neighborhoods has moved on, and almost all of the houses stand empty, and several have been torn down and replaced by the new normal of concrete-modern construction. A movement is afoot there to preserve these odd relics of nineteenth-century cosmopolitanism.

We drove around several of these villages, passing huge walled gardens largely abandoned with dark, water-stained towers looking on the verge of collapse as well as some huge piles freshly painted in cotton candy colors. A common feature is an empty lot with the rubble of a felled house scattered at the edges—taxes are still extracted if the house is standing. It's not hard to imagine that these places must be almost impossible burdens on families now. Generations pass and property divisions occur, so houses end up with twenty to forty owners, frozen by the impossible task of agreeing on repairs or simple maintenance. The detritus of these dismantled houses lies on shelves and tables in shops on the narrow streets of the commercial district. Under layers of dust and grime are crystal chandeliers, stacks of china, and, in one shop, a stack of ten or twenty box radios from the thirties.

The end for this unique community came with World War II, when maps were re-drawn and governments changed. The foreign access that Chettinadi traders had enjoyed for generations dissolved. Many families lost everything. It's actually surprising that most of these houses are still held by the original families. Several have been converted, with varying success, into hotels. The town and region are still relatively undiscovered. There is a tension now between trying to preserve the place as it was and is, and the push to attract more tourists.

Village Temples
Sundar and I start off early, hoping to see a temple before the day heats up. The wide highway runs out as we turn toward a distant red mountain. We pass along narrow shaded roads. Shadows from the ficus and neem trees planted generations ago must make the roads bearable in the summer when, here in the south, water will sizzle when it's dripped on pavement. In many places these ancient trees have been cut down to widen the roads. Often, they are gone for many years before any construction begins. The reason seems to be that the contract for the tree removal—probably obtained with a bribe to a local official—is actually valuable and quick cash. The trees are cut and sold for a profit. The roadsides become raw dusty ditches and the macadam soft and blistering, while the new construction may never come. So many government contracts are skimmed that often there is not enough money to actually pay for the work. (We passed a closed road today when returning to the hotel, where a small bridge has been under construction for more than two years. The detour added forty-five minutes to our trip.)

We finally turn onto a field road with the red granite rock of the mountain sloping away in the distance. We are in a village called Narthamalai.

The rosy amber granite of Tamil Nadu ripples and falls, creating wide terraces. Farmers are threshing and winnowing there, the women tossing the rice in the air, letting the breeze separate it from the chaff. A few men gather the rice straw into mounds. Below us are fields, some glistening, wet, and green with newly planted rows of rice, a few golden with ripe crop, and still others cut and harvested. This is subsistence farming and most of this rice will be used by the families growing it to bring in a little cash.

OFF THE ROAD IN CHETTINAD

As we walk past the fields toward the temple, the couple working look up and nod and smile to us in greeting—he, in a blue lungi folded up and tucked so it hangs just above his knees and, presumably his wife, in a red patterned sari. The hill is shaped like a vast folded loaf of bread with striations of pink and gold. It has barely any fissures and rises to a great height above the plain. There are depressions here and there, the recesses filled with cool water. There must be springs feeding these pools, rising through invisible channels to keep them full even in the summer.

A sixth-century temple sits on a curving ledge below another towering fold of granite that throws afternoon shade over the temple's western face. Its low walls enclose the sacred space and a pair of flanking sanctuaries. The east entrance has a series of shallow steps that break through the low wall and invite you in. It is a solitary and stately little temple, clinging to the slope.

Behind this temple, there are two cave temples cut into the cliff. The inevitable steel mesh closes them off, with padlocks chained to the doors. Through the security panels, just barely visible, is a series of standing figures guarding the linga in a dark sanctuary.

The caretaker shows up and opens the gate into the cave temple and the doors into the main temple too. I finish a drawing after three hours and the sun is now hot, so we retreat, and with the caretaker in the car we drive to another site in what must have been a large city in this valley. A small rectangular temple sits forlornly among the broken shards of other structures. Inside a recently restored high wall is another Shiva temple resting hard against the granite wall behind it, with galleries on two sides. The granite is a vertical wall, really, and must be eighty feet high, dwarfing the temple. On the stone outside the temple proper is a recess that was the beginning of a cave temple—the columns are just barely roughed out and abandoned. It was used instead to record the history of this place. Carved in ancient Tamil are rows and rows of records. It was common to use the exterior of the temple walls to record all sorts of information—the tabulations of the wealth of a place, the names of the donors and patrons. One temple I've visited had the rituals and rites listed, almost like a prayer book.

Just in front of the walled temple, across a narrow terrace, is a cistern. The steps drop into the water just a few feet from the temple door. One side of the tank is the same massive wall of stone that backs the temple itself and there is a stone dam holding the pool. This tank must be like the pools higher on the mountain—fed by springs. The caretaker tells us that the pool is 20 feet deep and stays full even in the dry season.

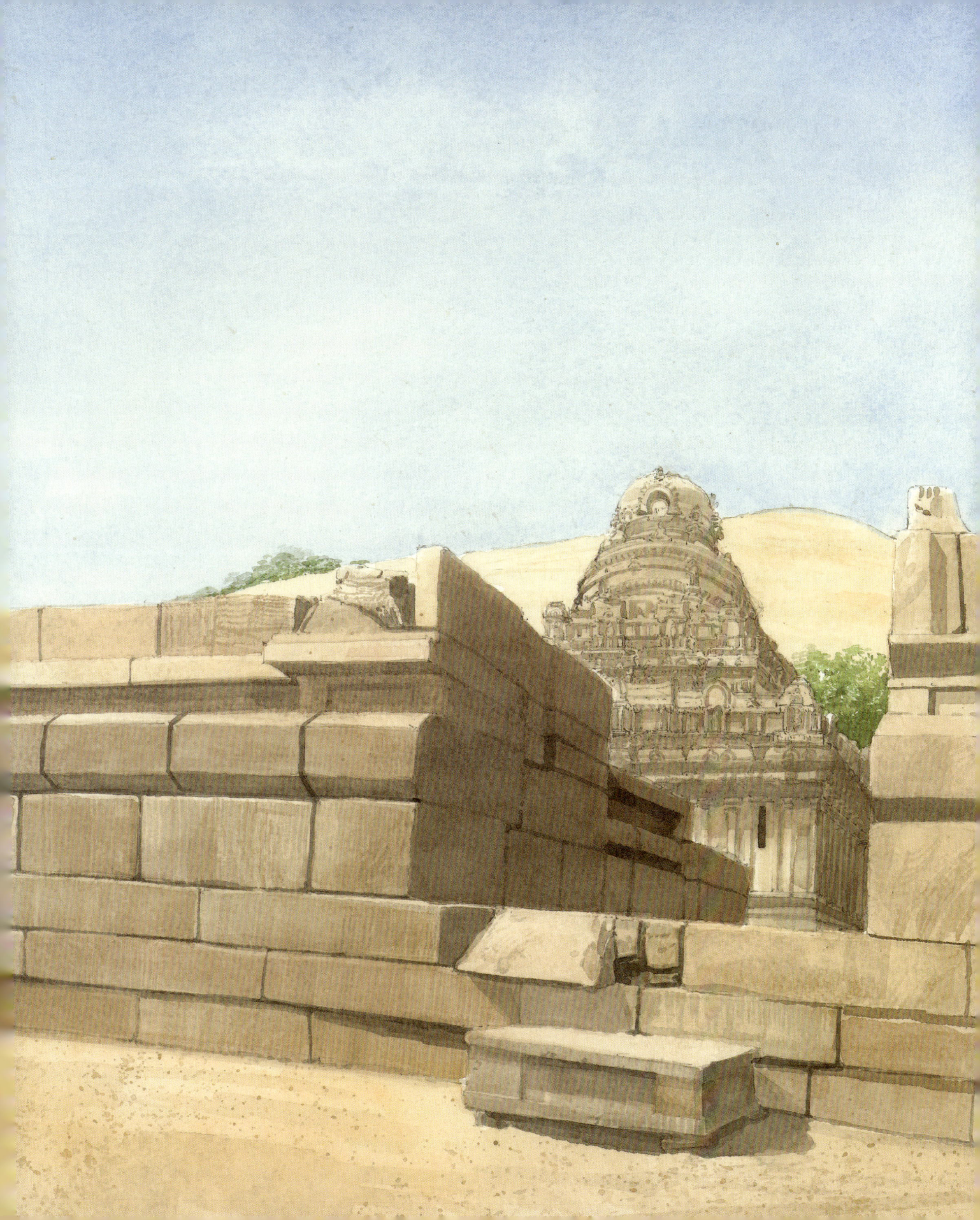

OFF THE ROAD IN CHETTINAD

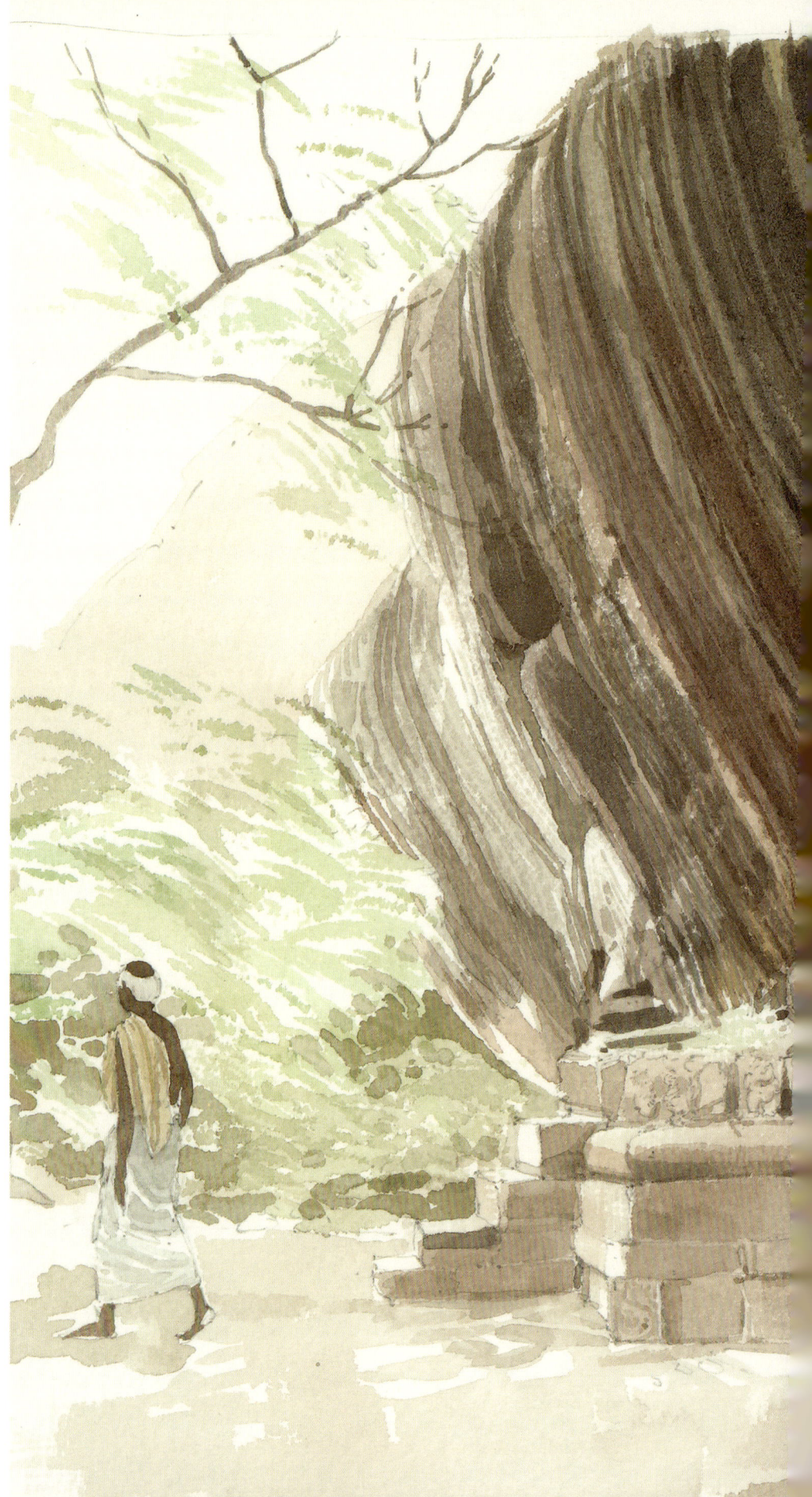

Narathamalai Temple

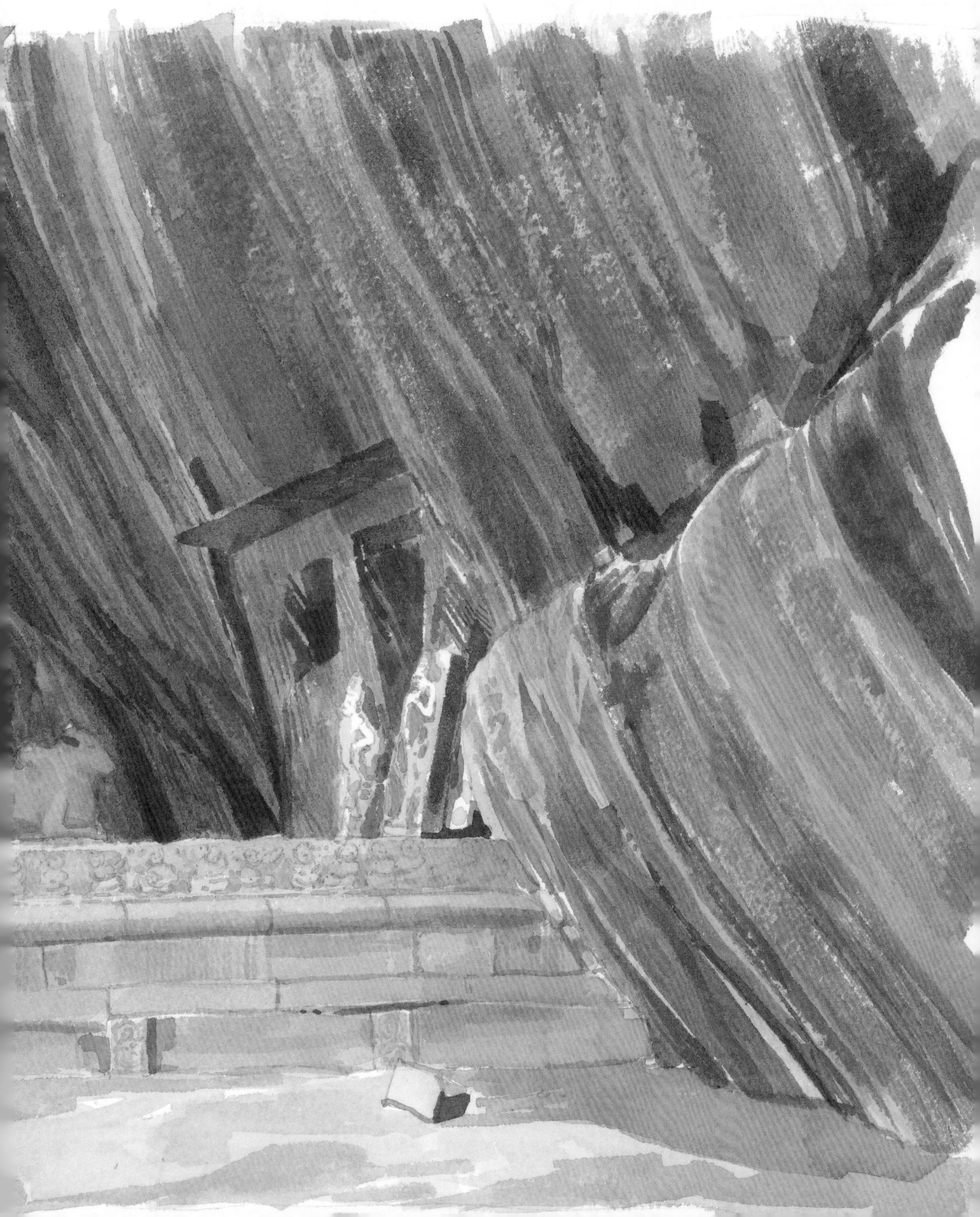

OFF THE ROAD IN CHETTINAD

Not far from these caves by way of a dusty road is a village temple on a hilltop. This is the temple where Sundar has worshiped since he was a child. There is a small shrine at the foot of the hill. It is surrounded by shade trees and its porch has painted panels on the ceiling. Beside the shrine is a partially filled tank, whose stone steps have collapsed or been carried away.

 A path up the hill passes a couple of other tiny shrines. Wide, shallow steps lead up the hillside to the entrance of the main temple and its covered landing. A further flight of steeper, covered steps are painted in bands of red and white. Several dozen steps about ten feet wide zigzag up the hill. Such stripes are normally painted on exterior walls of temples, so this decoration on the steps further heightens the reverence for the god living in this temple and notifies you that you are approaching holy ground. The practice of painting with the two colors evolved in the south, and there are many theories regarding their purpose. One belief is that they symbolize the two natures of man: the male and female, Shiva and Parvati, his wife. One avatar of Shiva called Ardhanarishvara is actually half male and half female.

 They're an amazing sight, these steps. Groups of women come up and down, creating a kaleidoscope of color as their festival saris sweep past the painted risers. There is a wedding ceremony taking place in the upper chamber of the temple, which explains the crowds milling around. I'm invited to sit and watch as the bride and groom are blessed and the crowd cheers and applauds at each ritual blessing. "Please, sir, you may photograph," one of the guests says to me, nodding and smiling and shifting aside as he invites me to sit.

 The last stop this day is in another of the villages in the group of hamlets. I don't know if there is a Western term to describe this loose affiliation of villages—maybe "county" would do. This village has mansion houses similar to the ones in the larger town where my hotel is. At the end of one street Sundar stops the car and points to a walled mansion house with faded polychromed decoration. Smiling, he tells me it is where he grew up. It is now almost abandoned—the difficulties of sharing the costs of maintaining the house are virtually impossible, so it slowly crumbles.

 Sundar wants to show me the medical/dental clinic that has been established here for the needy villagers, and particularly a foundation he is deeply involved with that feeds the elderly poor. The foundation has created a tidy compound with sitting rooms and a hall where people come for classes and lectures. The main function, though, is the kitchen. A cook stands over stoves with

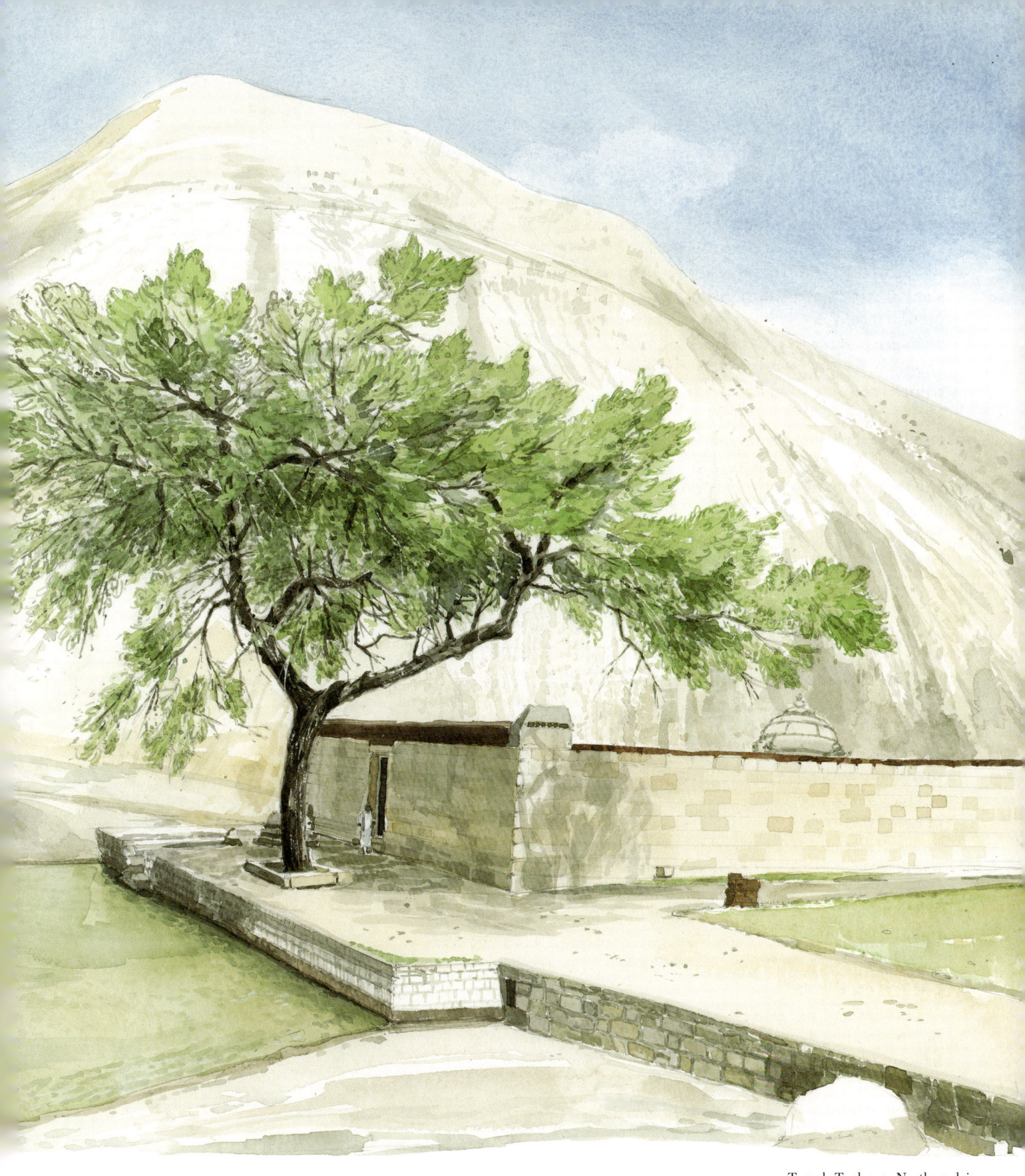

Temple Tank near Narthamalai

bubbling and simmering pots. The charity delivers three meals a day to several dozen extremely poor, aged neighbors. They send them out with boys on bicycles carrying the stacked chrome pots that are used to deliver meals to laborers in most Indian cities. All this is done through charitable gifts. No state monies support it.

Sundar has devised an ingenious way for successful expat Indians to support this amazing place. There is always the fear and suspicion that money does not end up where it's intended in India, so he has created a way for people to send donations directly to the charity through direct bank transfers. He suggests that 1,000 rupees (about $15) per week is a reasonable commitment. It is always surprising how much a small amount of money will buy in India. This whole operation functions on a couple thousand dollars a month. It has transformed this community because people with virtually no means are getting three meals a day and free medical and dental care.

Sir, I Impress You

This morning we set out to return to the rural tank next to Sundar's home temple so that I could draw there, but the car has a problem and needs to be taken to a repair shop. We go to the village nearby where Sundar drops me off to wander the streets. There are two temples in Thirumayam and a fort above the village on one of the granite outcroppings. There is also a unique octagonal stepwell at the side entrance of the main temple. Several bathers are at the edge of the well, splashing water over their heads. Tiny black goats scatter when I approach. They had been chewing recently pasted posters off the walls.

It turns out that this is actually a collection of small temples built together in a sort of compound. A priest is chanting in some remote shrine and his voice mixes with another worshiper—it sounds like a young girl chanting her devotions. Brilliant light washes in past a screen of tall black square columns and I can see the lacework-like carving of the side of the sanctuary. This jewel box of a temple is also built against the wall of a mountain, and the blackish, streaked stone is a perfect foil for the light temple face.

There is a raised platform against the granite wall with dozens of stone blocks from what must be the bases of snake god, Naga, sculptures. The multiple raised heads of the Nagas are missing but their coiled bodies survive. I settle in on a step and start drawing this little interior court.

SIR, I IMPRESS YOU

Several people wander by and hover briefly to watch, but one man stands at my shoulder occasionally asking me a question or scolding someone for standing in my light. "I impress you, sir… You true artist, sir." He asks if I will show him more of my work and carefully prints out his email address. I've sent him several images of drawings.

There is a hall that you pass through entering the main door of the temple group. Carved on the columns are figures unlike any I've seen in India. They have an animated soul that jumps out of the stone. The weight on a turned ankle is visible, as is the tension of a thigh raised in a dancing move or the flexed calf straining to hold the perfect balletic gesture. I've since been to several other local temples and seen similar work, and twice I've been struck by the stylistic similarity to these first figures, so distinctive they look carved by the same hand. There is an orthodox precision to the temple sculpture of each region and period. You can see virtually the same poses repeated in temple work at great distances and varying communities, but some unique facial and anatomical details show through sometimes. The particularly animated figures here could be a locally evolved feature because there is something original and startlingly rendered in them.

Vishnu temple in Thirumayam

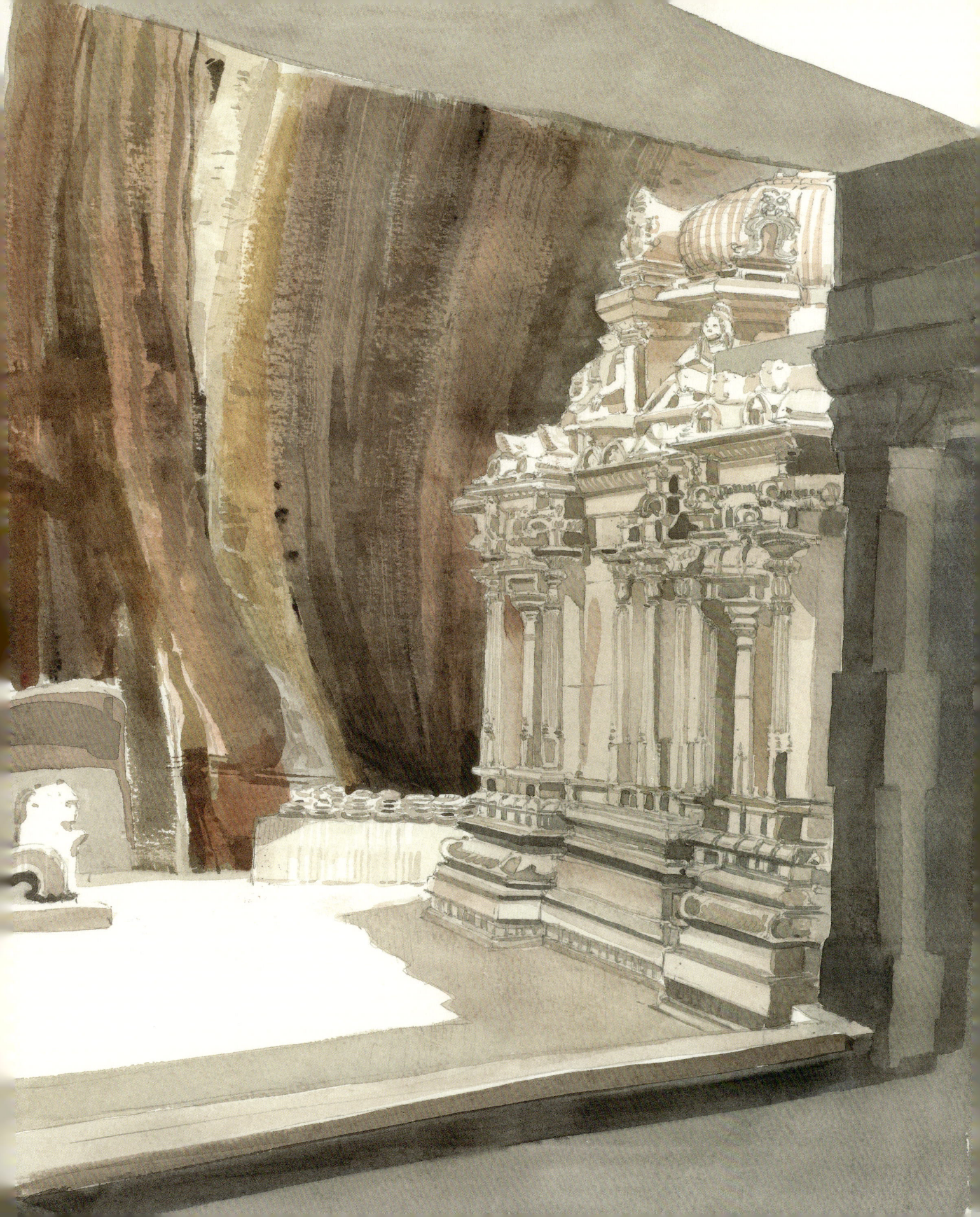

SIR, I IMPRESS YOU

Kudu Mianmalas near Chettinad **164**

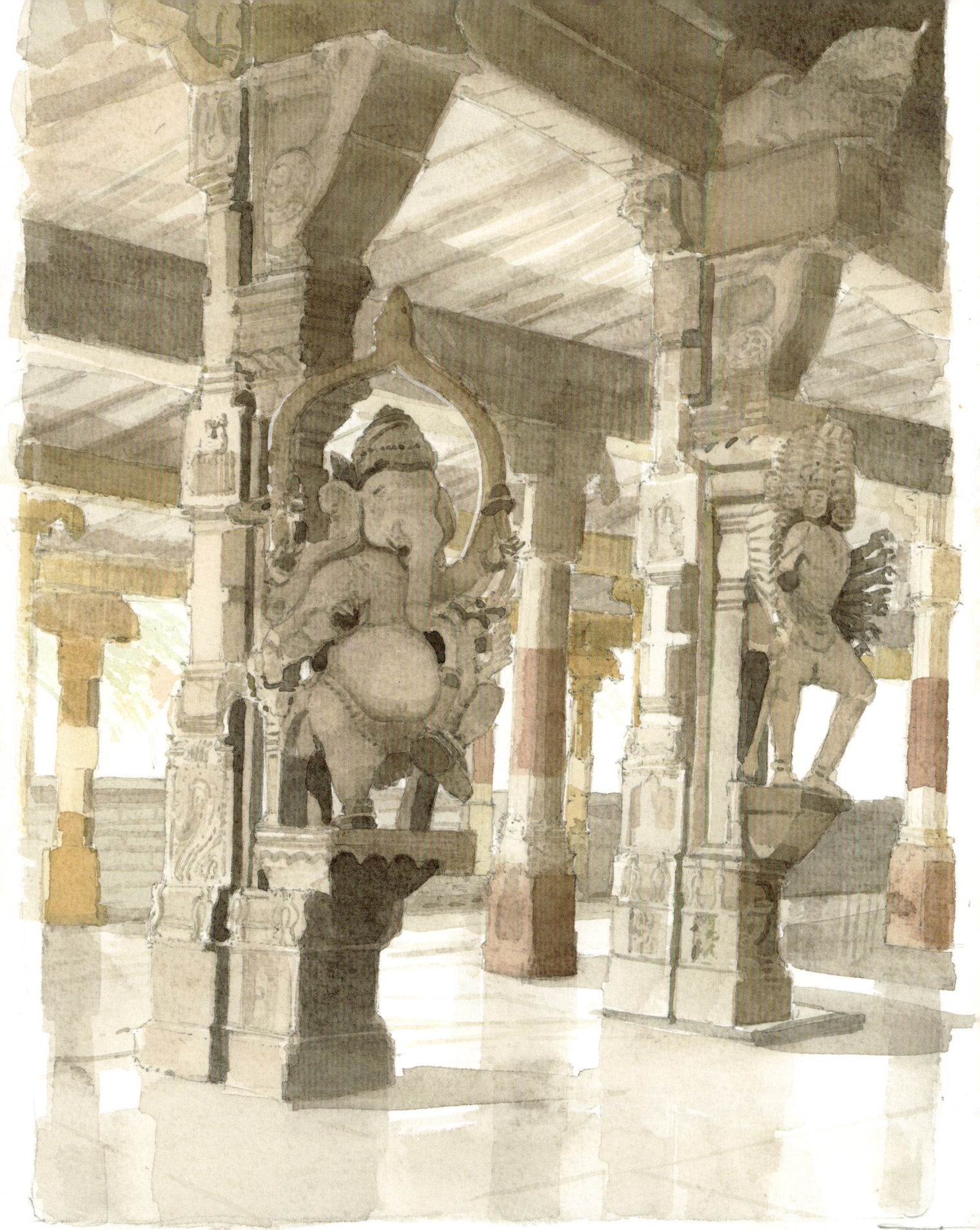

Terracotta Horses

The carvings in the temple of Nemam Kovil, in the village of Karaikudi, raise the bar even higher.

It's dark and there is almost no interior lighting, but the figures spring off the columns. The granite is refined to a point of almost jewelry-like sophistication. The musculature is even more precise here, with the slight lifting of a foot or the shifting forward of a hip. They might rival Italian Renaissance sculpture in their refinement. A sweeping floral garland arching above the head and shoulders frames each figure, as if thrown into the air by the figure, with only an occasional arching brace acknowledging the need for support. The figures could almost be moving as you catch them out of the corner of your eye in the dim light.

The directors of the temple have decided to forbid photography, which is really a disappointment. There have been temple break-ins and statues stolen in the nearby town, so they are worried about security and exposure. I could sit down and do a drawing, but the light is so dim that it's a strain to focus.

We spent a morning wandering through the small local temples, admiring their tall polychromed gopuras. Some of the temples have beautiful tanks, and all are full of activity. Each has some masterpiece of carving, some have madly painted interiors, and some have ugly chrome gates and fences to control the crowds. Occasionally, a temple will rise in popularity from the rumor of a cure and pilgrims arrive by the hundreds or thousands. The result is a sort of ad hoc installation of ramps, railings, and gates.

On the way back to town, Sundar suggests one more stop. It is a village temple, really just a dusty trail to a shady spot under a bodhi tree with a raised platform for deities and local gods. Lining the path to the temple are hundreds of terracotta horses. They are shoulder-to-shoulder, some three feet tall, others up to five feet. They have wide grinning horse faces with bulging eyes and stiff trunk-like legs. Their ears are pink and are the classic Indian pony ears that face forward and remind me of paisleys.

TERRACOTTA HORSES

The tradition here is to donate these horse figures to the village god Ayyanar, who is an ancient pre-Hindu deity (somehow absorbed into the pantheon of Hindu gods) who protects villages from fire and theft. The horses are offered to Ayyanar and his warriors to ride while guarding the village. There is a tradition in Gujarat to use the same clay figures for a different mission—at least in its first stage. In Gujarat, the clay horse given to the temple has a rider on its back. The rider has an opening in the back of his head and a prayer to the gods is written on paper and put into the head. If that prayer is answered, a second terracotta horse will be given to the temple in thanks for the answered prayer—without the rider. Could it be that the second horse is for the god and his soldiers to use? It is such a particular tradition, even though these villages in Tamil Nadu and northern Gujarat are hundreds of miles apart.

The horses are sculpted by a caste of potter-priests, called *velars*, who also administer the rituals involved in firing and sanctifying these terracotta sculptures. Once fired, they are painted brightly. Traces of bright paint are still visible in many places. Each one seems to be unique in its decoration. They are left to slowly melt away through the years, with newer versions often crowding alongside testifying to the active life of these rural and remote shrines. Many traditions, festivals, and rituals are centered at remote holy places like this, and keep these sites alive. At the end of the lane, past the horse sculptures, there is a small, gritty priest waiting to say prayers for us.

A small donation should be left on the plate. You can leave just a few rupees or, if you are moved, you can certainly leave more. The difference between the priest offering the ash or applying it may be connected to your offering, but it's inconsistent and seems to be simply the priest's choice.

I've found these blessings strangely and inexplicably moving. I described this to Sundar today, feeling emotional even as I was telling him. He then spent the next half hour describing to me his awareness of my feelings and matter-of-factly telling me that he believes it is because I have a connection here—as in having had an incarnation in a previous life that connects me to India. He has been watching and carrying this idea around, waiting for me to bring it up, I think.

Divine Intervention

We had a conversation a few days ago about the book *Autobiography of a Yogi*. Sundar told me that reading it is the easiest way to understand a spiritual Hindu life. It was the only book, apparently, that Steve Jobs kept on his iPad (not that Jobs is an example of the way to live one's life at peace).

Sundar said he would find a copy for me. It seems to be almost impossible to find in India. (The book is widely available in the United States, however, and can be found on Amazon and in most bookstores.) The reason for its rarity is that the author spent the last thirty years of his life in California. He was sent to America to spread the teachings of his guru. Yesterday, after a long drive south of Madurai to a Jain temple outside a small town, we were returning to town and talking about finding a food stall there. We decided instead to drive twenty more minutes to a place along the road that Ravi, my driver, knew. It was a simple vegetarian restaurant and it had, oddly, a rack of books for sale. I noticed one that said *Learn Tamil* on the cover. I got up to look at that book, and as I was glancing at its back cover, "phonetic translation for beginner speaking," at my shoulder I noticed the *Autobiography of a Yogi* on the shelf. I picked it up and walked back to the table and laid it in front of Sundar. I can hardly describe his reaction—moved and stunned comes closest. With emotion he said, "God could not wait for me to give you this book. He brought you here to find this. Just think about it, we could have stopped in the village and not

DIVINE INTERVENTION

come here, we could have passed by this place for the next roadside restaurant, but God wanted you to come here and find this book." He was so moved that he dialed his wife to describe the divinity of the event to her.

We left for Madurai the next morning and stopped on the way at a ninth-century site for me to draw. The temple is called Moovar Koli, "three temples," and is all that remains of what must have been a wealthy town. Two temples are still standing, but the third in the row is gone except for its foundation. About a quarter mile away is another foundation for a much larger temple. These are simple, perfect pavilions built for Shiva.

I settle in and work on a watercolor with the sun on my back. We move on to Madurai after a couple of hours.

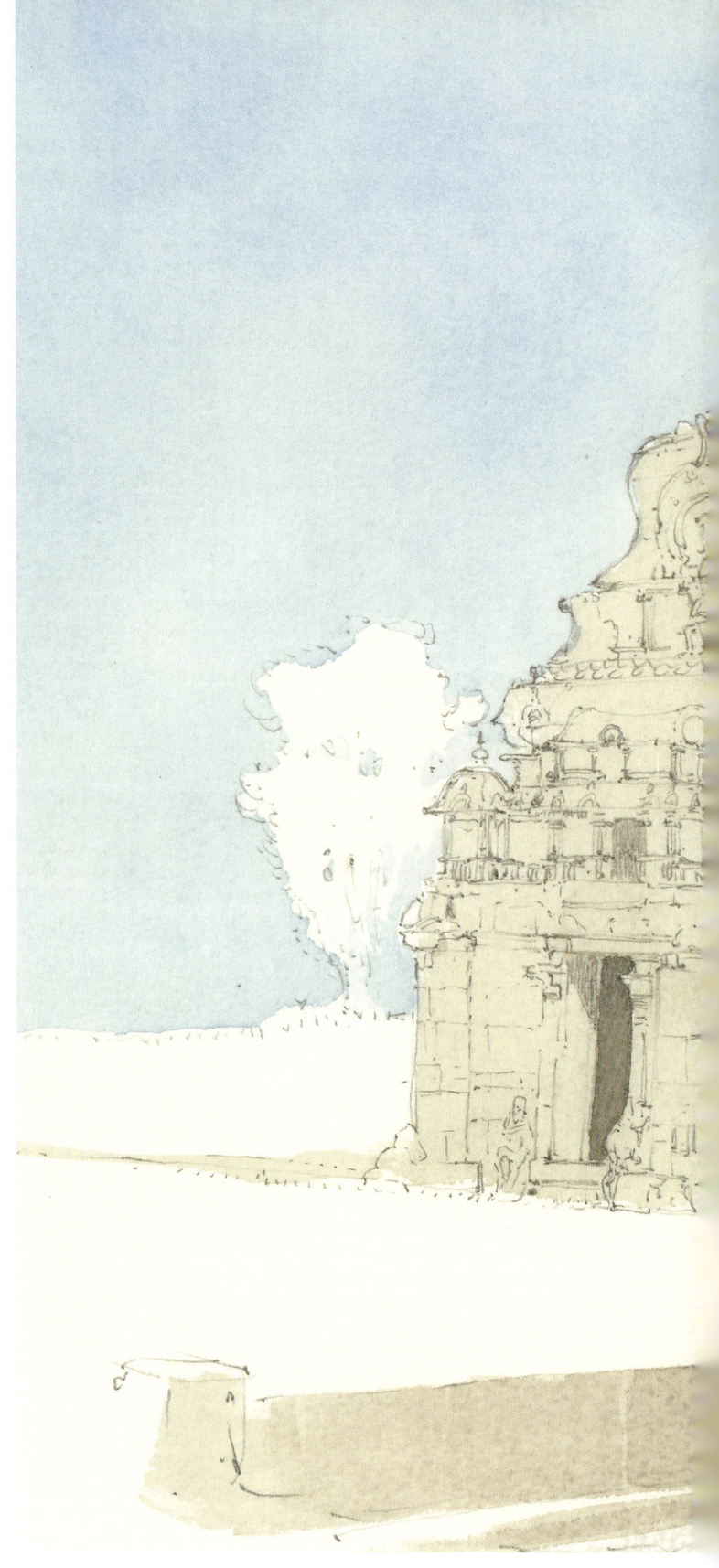

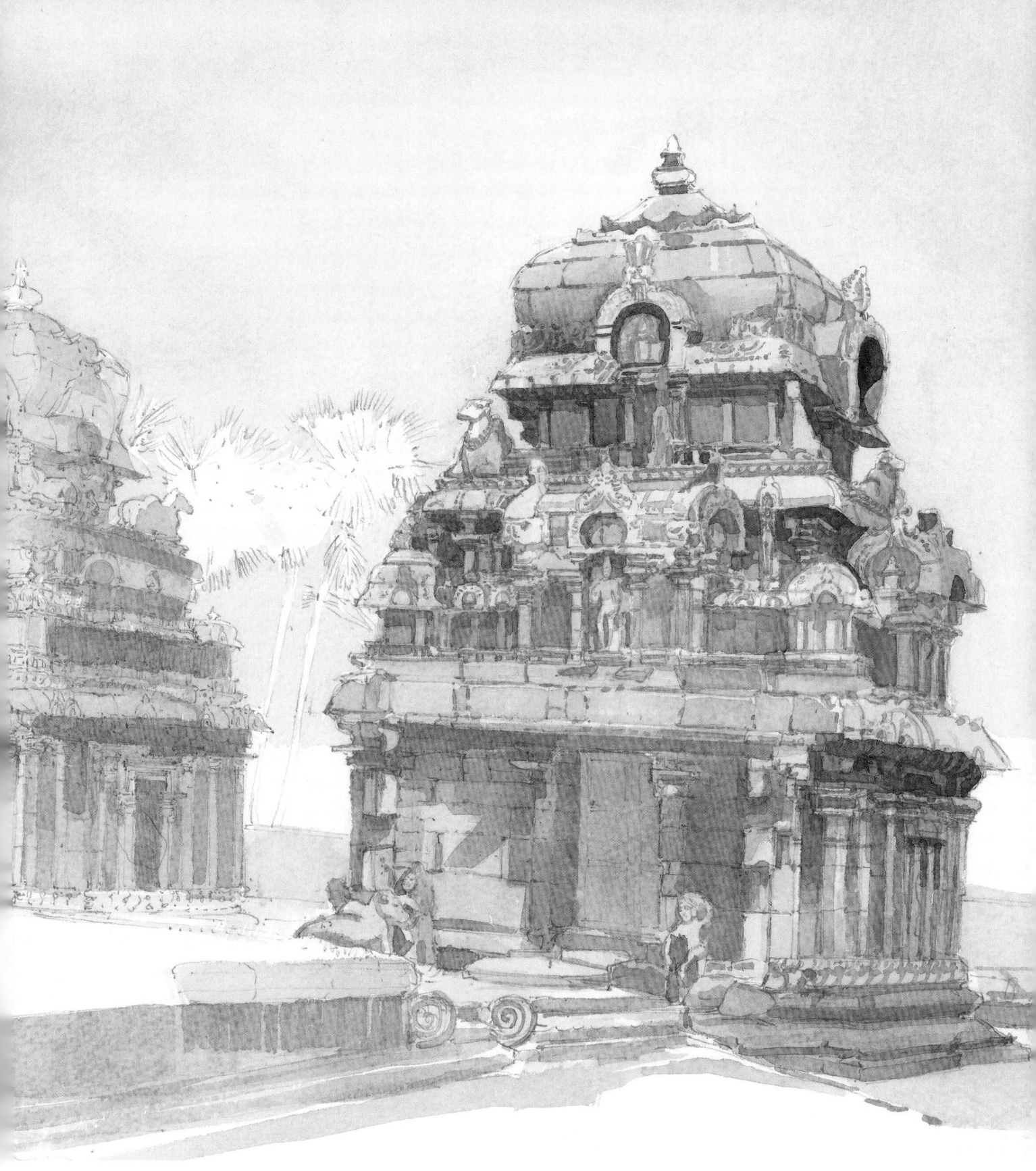

Moovar Koli

200 BCE University

The next morning, Sundar takes me to a Jain site about one and a half hours south of the city called Keelakuilkudi. There is an ancient tank and a village temple behind it. It's difficult to guess how old it is. There are huge stucco figures standing at the gates and many stucco horses lined up in front of the temple facing the water, their once-bright paint fading and flaking.

A small sign points to a trail to the left of the temple that says, "Jain site," and a sandy path leading around granite boulders, some showing traces of stone cutting. This was an important Jain university. Scholars came from hundreds of miles away to live and study with Jain masters.

Jainism is an ancient Hindu sect that evolved in the fourth century BCE and its most conservative traditions are strict and demanding. There are surviving Jain manuscripts from the third century BCE. Two sects of conservative Jainism exist today: Svetambara, white-clad, whose members are ascetic and wear only white robes; and Digambara, sky-clad. Sky-clad monks wear nothing, reject all physical comforts, and pray continually. Strict Jains will wear cotton masks over their faces to avoid possibly breathing in an insect, and walk with a small broom, brushing the way ahead to avoid stepping on any living thing. They eat only vegetables that grow above the ground and even then, only those that can be harvested without killing the plant. The goal of Jain meditation is the attainment of *moksha*, something akin to nirvana. There are still Jain monks and nuns who are observant, but the vast majority of Jains are secular and have the reputation of being skillful bankers and businessmen.

200 BCE UNIVERSITY

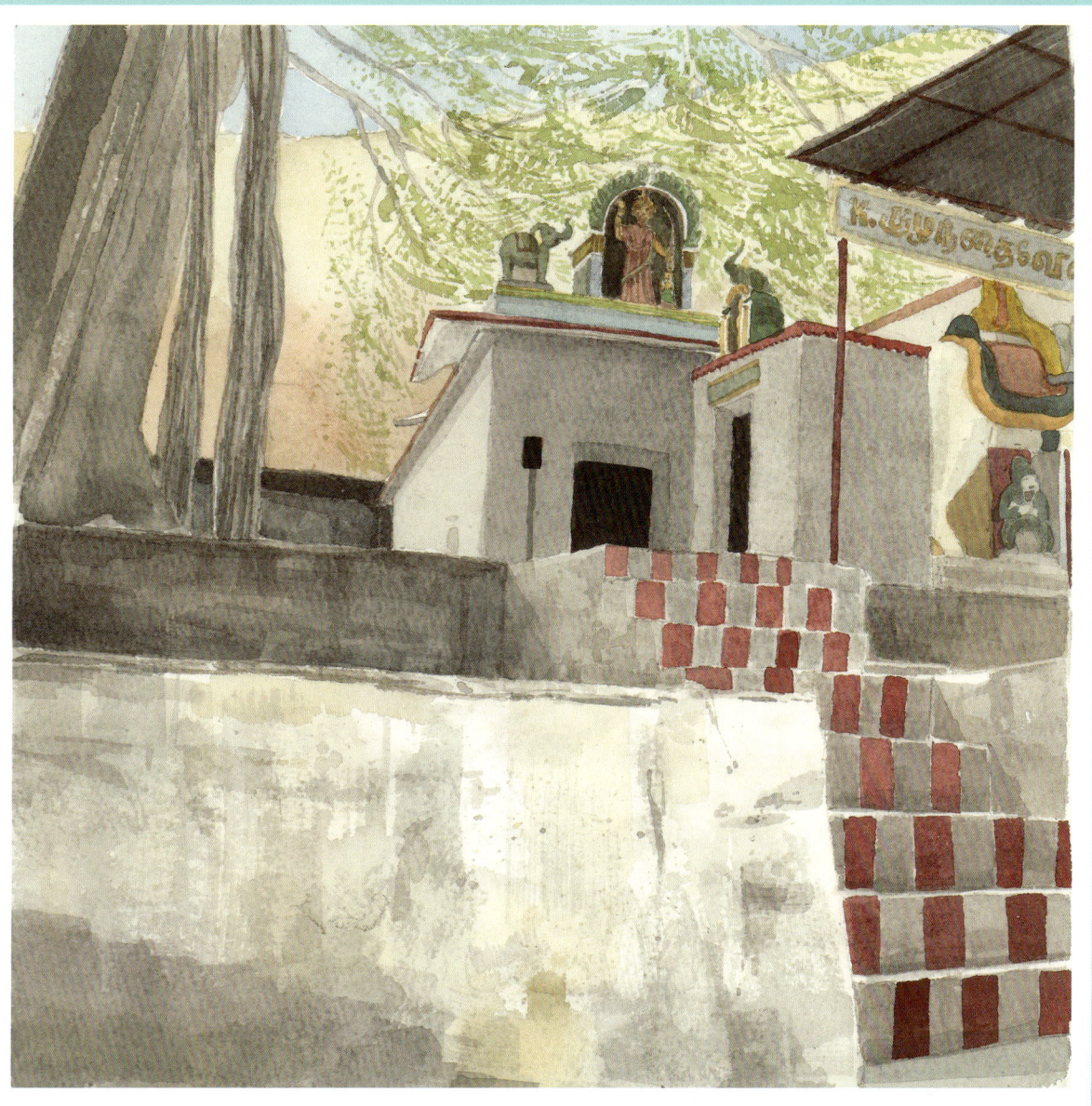

Temple at the Jain abode, Araimalor

200 BCE UNIVERSITY

There is very little left of whatever settlement was here. Jains classically carved shallow figures onto living stone cliffs and cut relatively shallow temples into the same cliffs. Often these temples take the same form—there is a long, recessed gallery with several figures flanking the opening to a sanctuary with Rishabha, the founder of Jainism, seated in meditation. You climb a line of steep steps here to a landing of sorts below a natural cave. There is an elegant figure in the lotus position high on the wall above the cave. It's not the classical face of traditional Hindu figures—it seems really to be portrait-like. It set me wondering if it might have been an actual portrait of a Jain master. Many Jain sites have a curious feature, "Jain beds", which are shallow depressions or slightly raised platforms that were apparently carved as beds for the monks.

As we drive back to Madurai, Sundar brings up the subject of the book that I had found in the restaurant bookshop. He says he has been working hard to understand why God didn't let him have the pleasure of giving me the book. "It was more important for you to have the book than for me to play a role in you having it...," he tells me.

I'm struggling to balance the appeal I feel for the day-to-day intimacy with the divine here and the distance and vague discomfort I feel when very similar expressions of spiritual life are made at home.

The Subramaniya Swami Temple is on the road back to Madurai in Thiruparankundram. When we get close to the temple, it is clear that a festival is in progress. The deities are being lifted on long poles and carried into the temple after having been paraded through the streets. Crowds of worshipers are shouting, priests chanting, and bells ringing. There are camels daubed with bright patterns and a small temple elephant hung with tapestries and bells. We arrive just as the palanquin is being hoisted onto the shoulders of the crowd of men. Sundar says, "You are truly blessed. We could have gone the other way around the block, and you would have missed this." The same remark would leave me uneasy in The Plains, Virginia, with its fundamentalist implications. Here, I respond to the suggestion of divine intervention by sensing my friend's sincerity and the perceived connection with a larger purpose.

The temple is crowded with worshipers. Inside the temple, a series of spacious chambers is cut deep into the mountain. Steps climb up and disappear into the granite caves.
Sanctuaries are cut into the temple's flanks on every level, but the sanctum sanctorum is a small chamber where Lord Kartikeya (the son of Shiva) resides. His two wives, Devasena and Valli, have

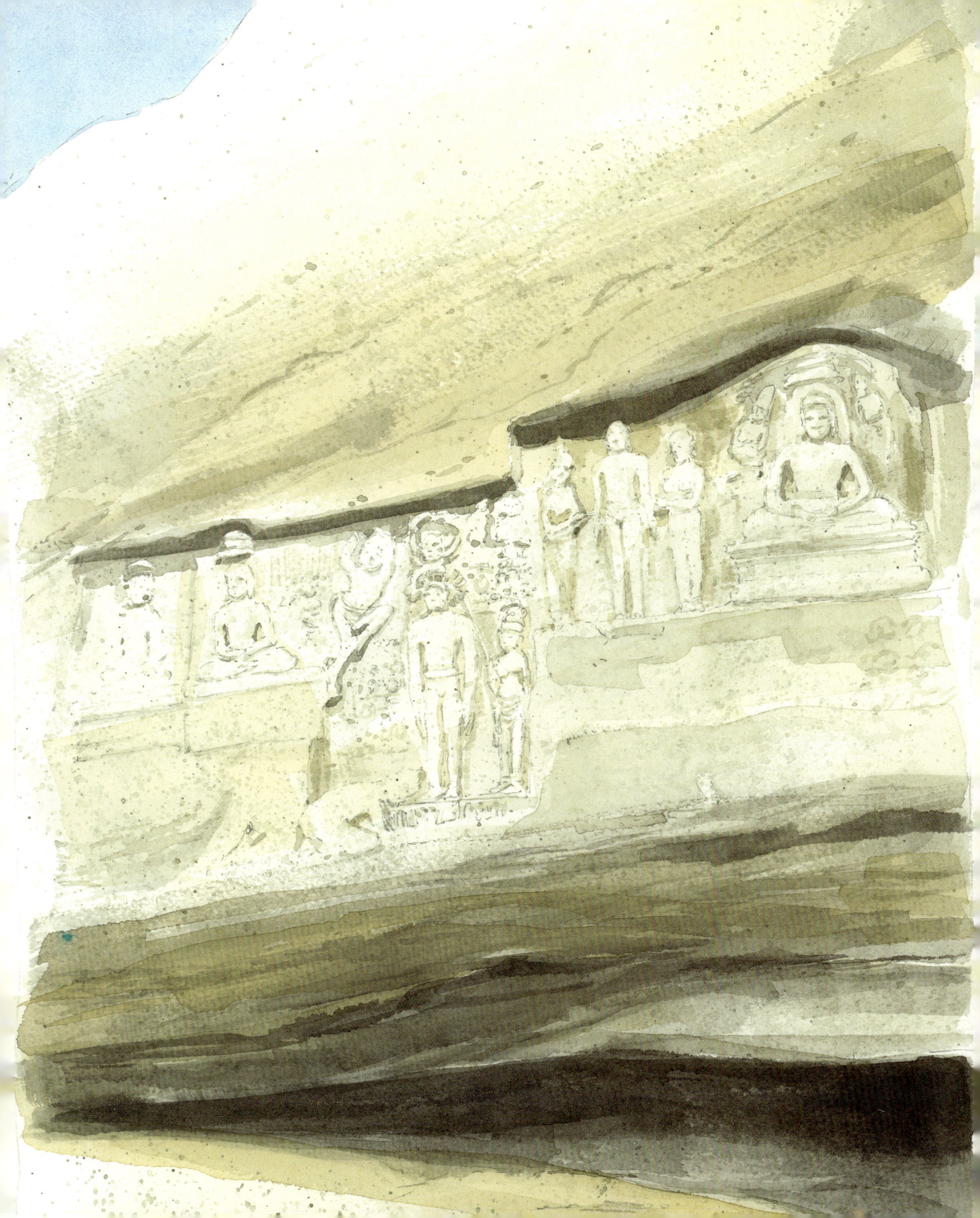

200 BCE UNIVERSITY

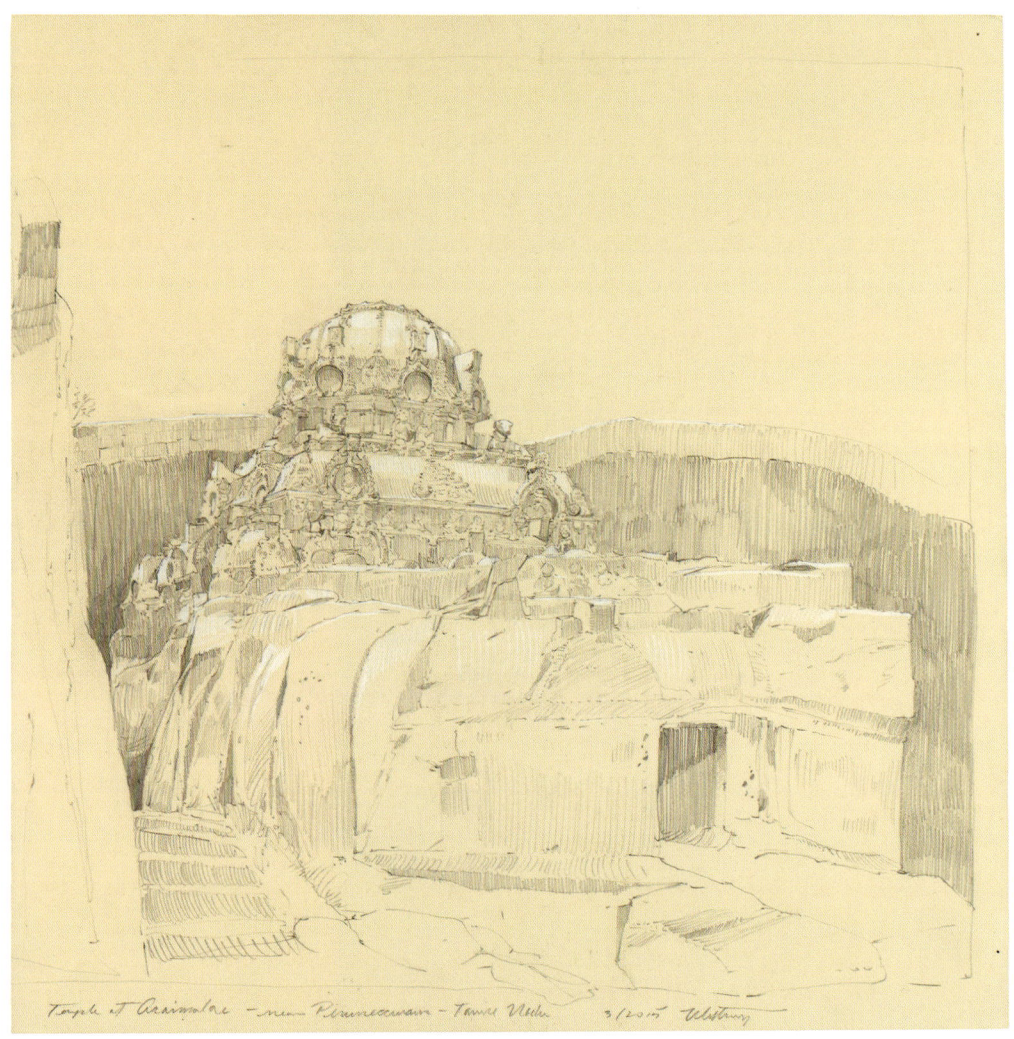

Temple at Araimalor

chambers next to his. Their statues are black and shiny. They are also draped in fresh fabrics, gold thread glittering in the light from the ghee-fed wicks in cups at their feet. We are invited to the front of the line and blessed.

I am the only Westerner in the temple. As we are leaving, we are offered a cup of *prasada*. Prasada is food that has been made as an offering to the gods in the temple and then distributed to worshipers. A smiling family is passing out a sweet rice and nut dish and they insist that I have some. It is a blessing to accept and eat it.

Small children are straining for a finger-full of the sweet rice. They've had their heads shaved and spread with sandalwood paste, as a devotional offering, leaving them looking like they've been dipped in gold. They have black dots painted on their cheeks and foreheads, to protect them from evil spirits, and black kohl lining their eyes.

This evening, Sundar suggests we go out for a true Madurai dinner. He invites a friend to join us and we drive across the city to his favorite place. The restaurant is on the second floor of a shop building. It is full of people. I'm clearly the first Westerner to walk through the door and the manager makes a polite fuss over me. Sundar is determined that I should try everything. He is a strict vegetarian, but the place is renowned for its mutton. He says I must try it, *and* they have "all the offal!"

So I'm served a plate of goat and a plate of goat brains, along with the local version of spiced and deep fried chicken, various vegetables, vegetable biriani, yogurt, big purple wedges of onions, and a plate of fried bread. Everything is spicy, prepared when ordered, and perfect. I am desperate for a beer but, being in a conservative Hindu neighborhood, no beer is available.

We stumble out into the night, stuffed. There is a sweet paan cart on the street. Sweet paan after a meal is spicy and savory. Even Sundar indulges.

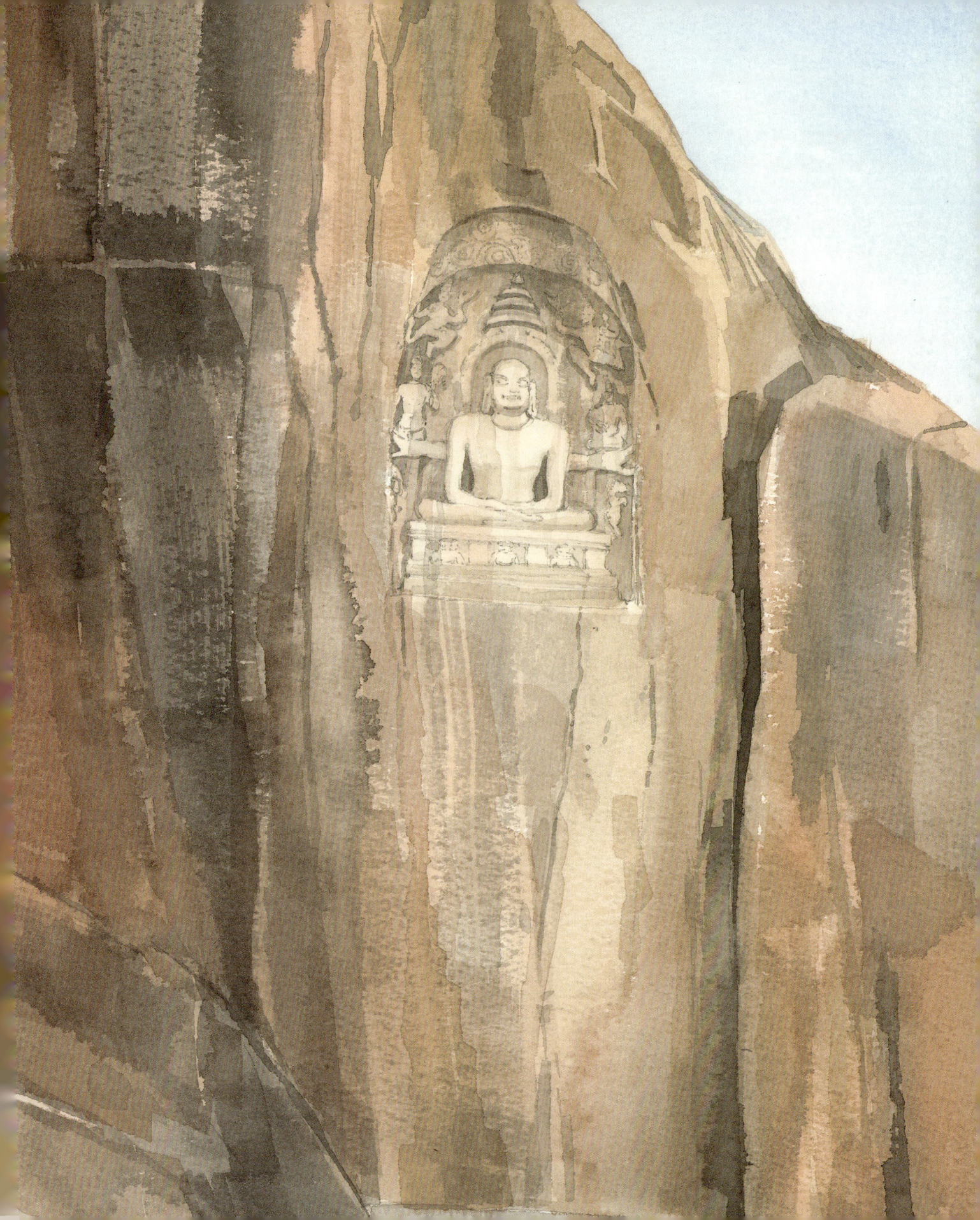

High Emotions

The Meenakshi temple is in the center of Madurai. Five gopuras open into the giant urban temple. It's Independence Day in India today, and a festival day on top of that, so the temple is more crowded than any other in my experience. The first hall of each entrance is crowded with souvenir shops, food stalls, and religious bookstores. This is another temple that restricts entrance into the main sanctuaries to Hindus, but the huge space has many small sanctuaries and a bewildering layout that keeps me slightly off-balance throughout the whole experience.

In front of the main sanctuary's gate, there is a tight clutch of people surrounding someone sitting on the floor. Several guards and ten or twenty worshipers raise their voices in alarm. Women lean into the center of the circle and people begin to squeeze in. It turns out a woman has lost track of her child and has collapsed to the floor, weeping in panic. It has the feeling of something that could spin out of control. I back away as the crowd swells and begins pushing together. Suddenly a woman appears with a little boy in her arms and the wet-faced mother is on her feet, recovered.

Emotions often run high and hot here, just below the surface, and things escalate fast. They can quieten equally fast. I've seen a calm driver (although driving is not an activity for the timid in

HIGH EMOTIONS

India) screech to a halt, leap from the car, and have a seemingly violent confrontation with a traffic circle cop. When he got back in the car you wouldn't know that anything happened—he nodded and smiled in the mirror.

A dispute over 20 rupees with a rickshaw driver can be impassioned. There is a calm, almost serene veneer but the ethnic/religious violence that erupts occasionally is brutal, bloody, and without remorse.

I stop at a shop with Sundar to look at shirts; he tells me that the cotton in Madurai is the best in India. In the south, rice fields gradually disappear, and miles of cotton replace them. The cotton is about ready for picking now and the fields are spattered with white dots. There are also cornfields and what looks like sorghum. On this drive south, past vast fields of cotton divided by scattered boulders, we see views of slowly turning wind turbines in the distance. I buy two shirts and a dhoti made of beautiful thin cotton.

There is the informal country version of a dhoti—a lungi. It's a single piece of cotton, tied at the waist, and woven in an unlimited variety of plaid cotton designs. It is often worn folded up and sort of tucked or bundled in the front. I've been told that a lungi is supposed to be something you might wear at home but never in public. However, the country men tuck them up, very short sometimes, work manual labor jobs in them, and wear them everywhere. It's a caste thing because it's universally worn in the street by workers and is the standard village garment. No young urban dweller would wear one on the street. India has become a jeans and t-shirt society. Also, you almost never see a man in short pants. It's viewed as walking around in underwear.

The flower and vegetable market in Madurai is the wholesale market, where farmers drive for hours to sell their produce. Canvas bags are overflowing with marigolds, sunflowers, rose petals, and jasmine blossoms. Flowers are sold by weight, so haggling buyers stand beside sellers with their scales tipping with handfuls of flowers. There are piles of lotus buds ready to be sold to vendors at temples, and pretty girls sit in the shade stringing jasmine blossoms and rose buds into ropes. The temple sites where you can buy these garlands have paper and plastic garlands for sale now too. Bright, almost fluorescent sparkly things often hang next to the carefully strung garlands. I have not seen the artificial garlands in temples, so they must be used for other purposes, but it's a sign of the times: plastic copies infiltrating these traditional objects.

HIGH EMOTIONS

The vegetable market is a similar scene. Piles of roots and legumes next to eggplants of five or six colors, banana stalks and their purple flowers, prickly gourds, and giant squash.

The seventeenth-century Thirumalai Nayak Palace is the vestige of a building that was once four times larger. It is a hybrid Indo-Euro-Saracenic building with thick columns and wide Moorish arches (designed by an Italian). It was built by the local king who was actually the governor for the ruling clan in Vajarangarar. The place looks as though it's been renovated many times with a generous dose of English tidying up. There is a wonderful, very early photograph in the connected museum that shows the place as a ruined pile with damp blackened walls and collapsing roofs.

Along the way we pass a French Catholic church. The French occupied this territory until the English threw them out. It's early Gothic Revival, painted white with all the details picked out in blue. The sanctuary has taken on a less-than-Western quality now, after generations of Indian use. Gold ribbons are wrapped around the pink marble columns and bright banners are hung across the altar. Christian and Western in its iconography, the church now is decidedly Indian in its evolved aesthetic.

The spiritual quest that I stumbled onto with my friend Sundar was a surprise. I've begun to wonder if my wincing discomfort with conversations about Christian faith and the mysteries of divinity needs work. I find the Buddhist view of the world interesting and appealing, but this is the first time I've experienced Hindu belief and interaction with the gods in daily conversation. It's all the same search, I guess. It's about the hope of understanding our place here and pondering the glimpses we occasionally get of the possibility of the divine.

Baker's Ovens
Delhi

I'm not sure it's possible to say anything about Delhi that has not already been said. It is one of the most beautiful cities in the world—incredibly noisy, dirty, maddening, and totally seductive. It is the starting point for a tour of northern India for a good reason. The struggles of domination of the subcontinent were acted out on this stage. Ancient palaces, forts, mosques, and tombs in the old city and the viceregal splendor of New Delhi make exploring the architecture here thrilling.

The wide avenues and traffic circles designed by Edwin Lutyens in the 1920s for the new capital of colonial India are now renamed to honor Indian patriots and politicians. Bungalows from the Raj still line the streets, now very often behind high security fences and walls. Even the humblest bungalow has been turned into a glamorous residence and they are some of the most valuable real estate in Delhi. They were designed by the lesser-known architect of New Delhi, Herbert Baker. When British civil servants lived in them, they were commonly referred to as "Baker's ovens" because of Delhi's heat.

The compound where Mahatma Gandhi lived and was assassinated is now a museum. There are footprints in stone marking Gandhi's last walk across the grounds. His simple rooms, his loom, and a few of his possessions are here to see, along with a complicated display of photographs about his life and his death. There is also a small shop with homespun cotton fabric for sale and a bookstore with Gandhi's writings. It is a somber and moving site and worth a quiet visit.

If you want to shop—jewelry, silk, antiques, clothes—you can find wonderful places and spend hours being led from one wonder to another.

I'm generally drawn to the more remote and quirky places. About forty-five minutes outside of Delhi you will find exactly that.

The Remains of the Raj

It is a dusty and smog-shrouded ride through the suburbs and into what was rural countryside not so long ago. Coronation Park is rarely visited and is an odd relic. This is the site of the Delhi Durbar of 1911 celebrating the coronation of King George V. It's also the place where a small collection of public statuary from the British Raj ended up after independence. Most of the grandees have broken noses showing the careless way these objects were handled while being removed from the traffic circles and parks of Delhi.

They are raised on red sandstone plinths with polished black marble panel insets presumably for the carving of identification inscriptions. Each is blank. Occasional stucco walls standing near the sculptures with recesses look like they are waiting for other plaques or explanatory inscriptions.

The park is a big flat expanse with stone-paved walkways and scrappy, struggling plantings. Its general bleakness is exaggerated by the layer of dust on everything, thrown up by the passing highways and the general industrial tilt of the area.

George V stands in coronation robes that hang ten feet down the back of the narrow pedestal he towers over. The same blank, black stone panel is set into the base. Just behind the king who

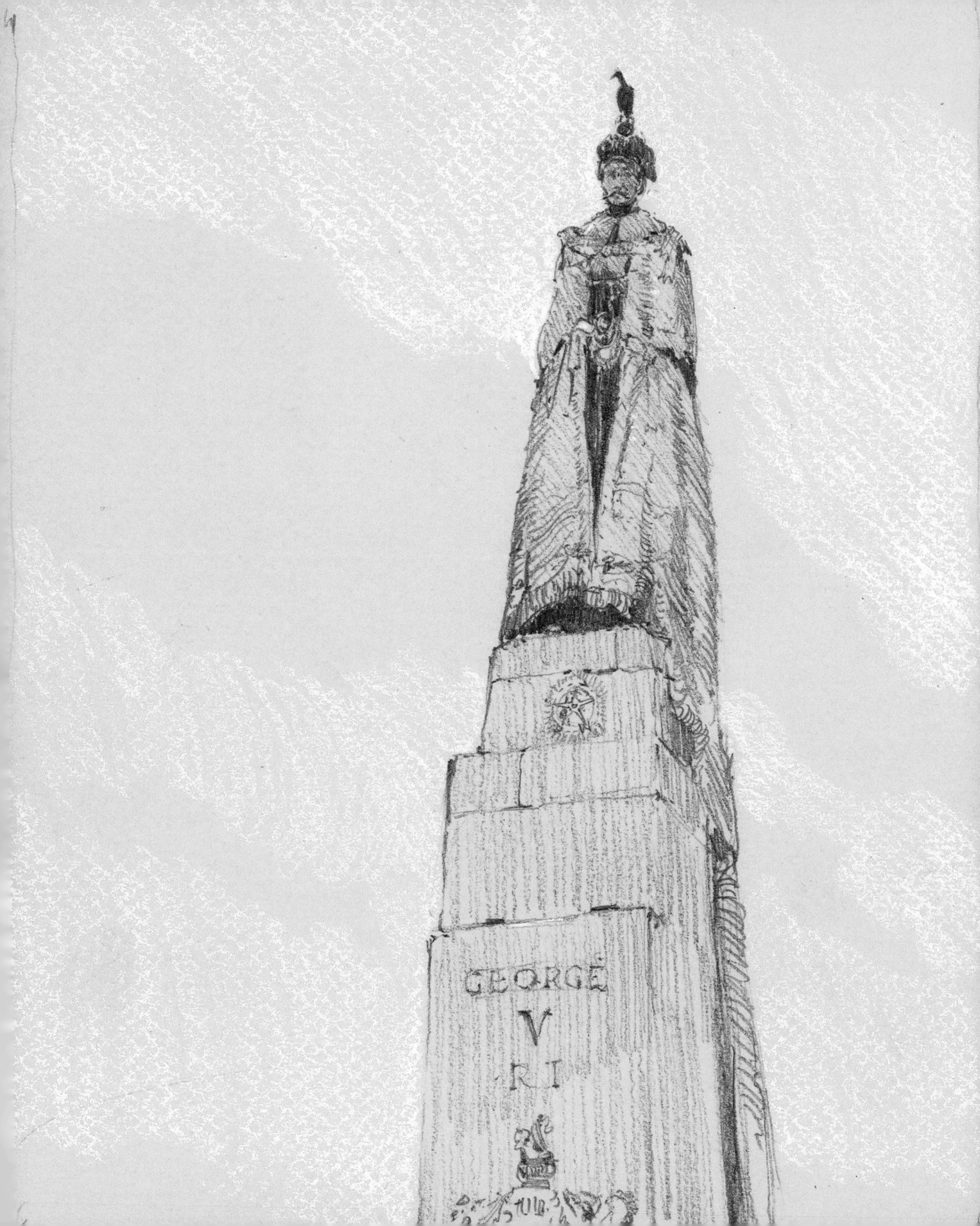

presided over the loss of India is a slum camp of temporary shacks and tents. There are no descriptive markers or any historical explanation, apart from one plaque on a raised obelisk:

HERE ON THE 12TH DAY OF DECEMBER HIS IMPERIAL MAJESTY, KING GEORGE V EMPEROR OF INDIA ACCOMPANIED BY THE QUEEN EMPRESS IN SOLEMN DURBAR ANNOUNCED IN PERSON TO THE GOVERNORS PRINCES AND PEOPLE OF INDIA HIS CORONATION CELEBRATED ON THE 22ND DAY OF JUNE 1911 AND RECEIVED FROM THEM THEIR DUTIFUL HOMAGE AND ALLEGIANCE

Whatever the intent for hastily removing emblems of colonial domination, this place feels like an unfinished industrial park. It's hauntingly demonstrative of the shaking off of the British yoke.

On the way back into New Delhi, we drive through old Delhi—the remains of the ancient city with narrow streets and eighteenth-century colonial churches and shops. It is crowded and noisy and slow going.

The Red Fort is on the way. Begun in the seventeenth century, it was the fortress of the Mughal emperors. It ended up as an outpost for the Raj, with barracks built inside the red sandstone walls and regimental offices supplanting the court. The first view inside the walls is of the pavilion used by the emperor when meeting the public. A raised platform holds the throne. This platform and the niche in which it stands is inlaid with intricate stone patterns and is now enclosed in a plexiglass cube, presumably to keep curious fingers from touching the fragile stonework. The case ruins the subtle focusing effect that the dais was designed to create. When a place is altered clumsily in the name of conservation or security, and the original balance and proportions are lost, it distances you so much from the original intent that it's difficult to absorb. These exquisite architectural visions are fragile. The symbolism and complexity of their design is easily obscured.

I felt a similar frustration outside Kolkata, where a twelfth-century wall carving of The Edicts of Ashoka (the laws, rights, and privileges of the kingdom) is locked behind grills and glass panels. It may have been preserved, but the lack of sensitivity in the preservation is ruinous. If these wonderful things can't be experienced in a genuine way, they may as well be cut up and hauled into museums instead of pretending that they are preserved in situ.

Beyond the royal audience pavilion in the Red Fort are the dusty remains of formal Mughal gardens. There are tanks with lovely covered pavilions standing in the middle, shallow rills, and cascades connecting to other raised chambers. Along the far perimeter is a raised white marble palace. It has an arched center space flanked by two chambers with elaborate arches and vaults. One was for men, the other for women. Water ran between them, and pools in octagonal tanks punctuated the paving. There is not a drop of water in any of these features anymore.

The mosque in the compound is not open today but is reputed to be a spectacular space. Even from the outside it suggests a sophisticated and elaborate design. It has three black-and-white-striped domes. There is a dusty museum in what was the *zenana*, "the women's quarters."

As we drive back toward Delhi, we pass crews of workers shearing the ever-present plantings of bougainvillea on the medians between traffic lanes. Even on the long-haul toll roads that run for hundreds of miles, there are these plantings. The older plantings are dense and thorny—maybe there to discourage pedestrians from cutting through traffic. If that is the purpose it does not work. All the big highways have chain link fence bordering them. The newer sections of road look tidy and efficient. As you pass on to older stretches of road the fencing gets patchy with missing panels and holes cut—the fencing rolled back so people can cross from one side to the other. Even where stone walls have been built to control crossing there are chopped-out sections where locals have decided they need crossings. The initial investment in security fences is not maintained and the leaning, rusted panels decline in efficiency as you drive from new to old sections.

The plantings suffer from the only consistent maintenance I've seen in India. They are clipped and sheared to ugly four-foot-high clumps. They are cut without concern for bloom set, so often the new blooms are cut off. Stretches of road where the rough grass has been burned has damaged or killed the shrubby material. Older roads accumulate litter that blows across the lanes.

There is an extravagant installation of gardens along the new road to the airport in Bangalore. Crews of sweepers, clippers, and pruners keep the well-watered plantings looking tidy—startling for India.

The East India Company Capital
Kolkata

India is always challenging, but Kolkata scrambles your brain. Kolkata, as V.S. Naipaul said, is a dying city. It began a slow death when the English left.

It seems to be melting away. The beautiful architecture of the English Raj is collapsing on itself—many once-great and grand buildings look more like archeological excavations than the centers of commerce and culture they were built to be.

Someone once said that the price of civilization is maintenance. That is demonstrated in boldface caps in Kolkata. The entire place is drenched in seventy years of neglect.

Kolkata has huge early-nineteenth-century churches and libraries that look like they could be in Natchez, Mississippi—same climate, same period—with deep porticoes and balconies trying to protect you from the brutal sun. Streets of bizarre Edwardian fantasies are now coated with grime, and air conditioners punch through limestone walls.

Parts of the city look like London after some apocalyptic event. Despite all this, the shadow of this once great city of palaces is stunning to explore. The huge Georgian buildings of the East India Company are either crumbling or repurposed. Then there is the Victorian stuff—gigantic red brick piles—or the later, elegant Edwardian cut-stone buildings. Now, street food stalls and tea vendors on the curbs take advantage of the shadows cast by these overgrown sentinels of Western culture.

THE EAST INDIA COMPANY CAPITAL

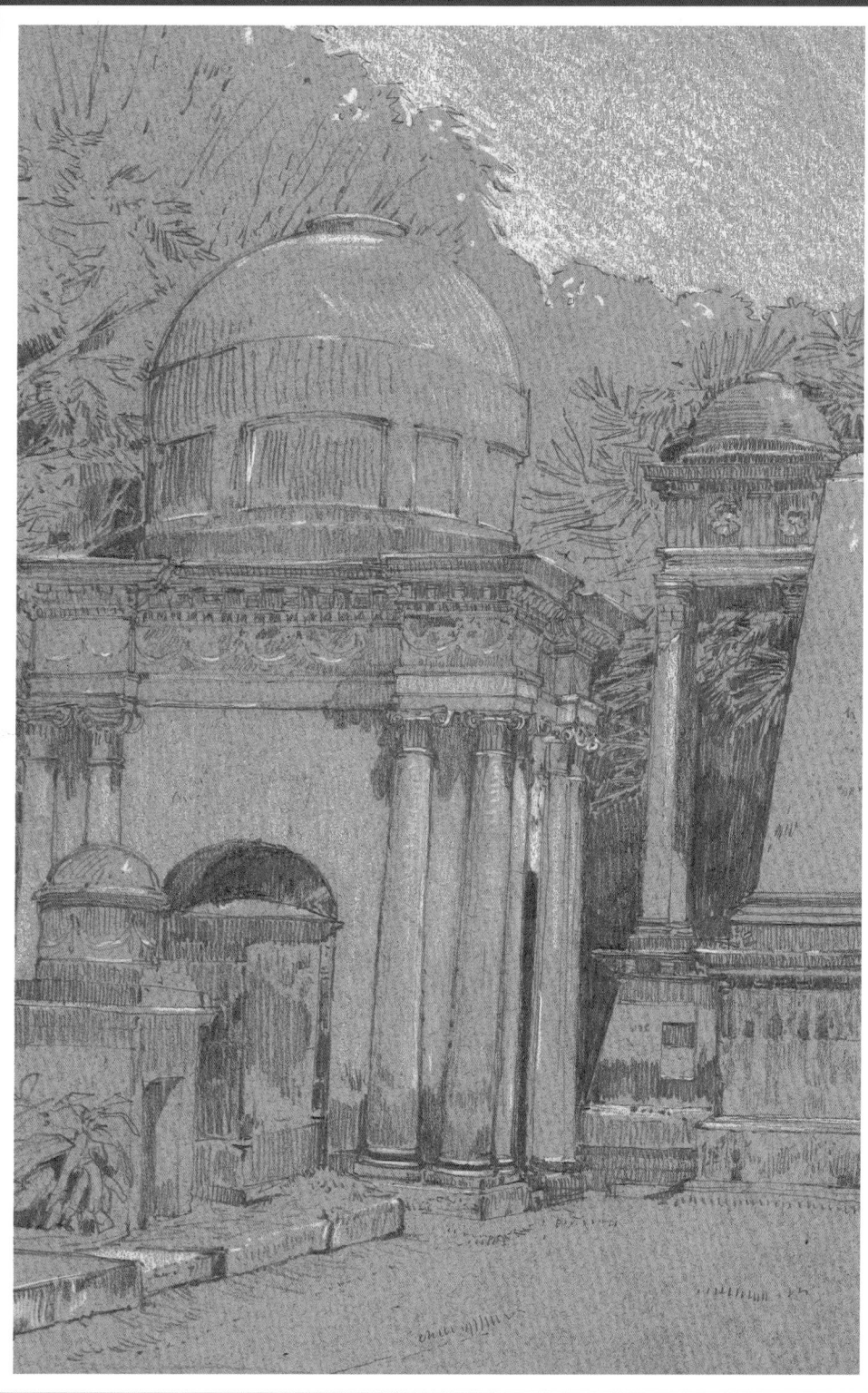

Kolkata, South Park Street

THE EAST INDIA COMPANY CAPITAL

The Victoria Memorial is a giant white marble palace. It was just recently cleaned, so it blazes in the sun and hurts your eyes. Its construction was begun before the transfer of the British capitol to Delhi and long before the possibility of the British leaving India was a remote consideration. It houses a history museum of Victoria's rule, with huge group portraits, painting galleries, a library, and the single largest collection of the work of the British artists Thomas and William Daniell, who made many trips to India to paint watercolors, which became a sensation in England when published as volumes of lithographs.

The South Park Street Cemetery is a shady necropolis of neoclassical funerary monuments. Its columned temples with graceful porticoes, domed follies, and obelisks are still and beautiful in the middle of Kolkata's chaos. The cemetery was established in 1767 and used until the late nineteenth century. Colonel This and Commander That are remembered with marble plaques set in brick and stucco tombs. It is another shadowy image of the colonial expectations of permanence.

The dry season in India is shifting, strangely. In the past it rarely rained until the monsoons came in late March or April. Now, there can be strange squalls of pelting rain in the middle of January or February. The sky will turn dark and suddenly rain pours. Everyone seems shocked and doormen rush around with brooms to push the water away from the front doors of hotels.

The streets of the city are clogged with every kind of transport and humanity. Men push carts of stuff, from bags of garlic to timber. Motorized or man-powered tuk-tuks squeeze between taxis and buses along with pedestrians dodging and weaving through the traffic. Each old neighborhood has its own tradition or trade. In one section of town, every second or third block has a tiled, waist-high structure about five square feet, one side open with a pipe gushing water and men bathing, pouring buckets of water over themselves, some lathered with soap. There are also occasional alleys where men emerge toweling their hair. This is an area of public baths. Many stalls are selling bright plaid or checked cotton towels.

The neighborhood of Kumartuli in north Kolkata is the center of clay festival sculpture. Street after street is filled with craftsmen tapping together wooden armatures, padding them with straw and string, and shaping the faces, hands, and feet of figures with soft clay, adding clay slip as the figures evolve. The straw figures look like Elie Nadelman sculptures. They are built for the annual Goddess Durga Puga festival. The sculptures are floated on straw rafts into the Ganges and allowed to sink and dissolve.

In India, the ephemeral is ritualized. Thousands, in many cases hundreds of thousands, of people make pilgrimages to holy sites during festivals to satisfy spiritual obligations.

On the southern edge of the city there is a famous Jain temple called Parshwanath. The glittery decoration is visible above the high walls of the compound. It is called the "jewel box of Kolkata" and that does describe it. The main temple, built in 1867, is an architectural fantasy encrusted with glass mosaic and mirror. Its window panels are very brightly colored glass, and its floors are inlaid marble. A narrow hall behind the sanctum allows for circumambulation of the space (clockwise). There is a central sanctum, and three Jain priests are performing a ritual when I walk in. They are wearing the traditional Jain facecloth. Across the street is another temple. It's really an identical structure but painted white—simple and serene. Its scale and style are oddly domestic, and its Saracen arches look like exotic Victorian country house architecture.

Kolkata has fantastic eighteenth- and nineteenth-century mansions. Many have multiple courtyards framed by decorated, columned arcades making them look like London townhouses topped with dancing Hindu goddesses. Some are open now as house museums, but it's possible to simply wander into an entrance court and find the owner there. Many of these grand families with connections to the colonial past end up living in one dilapidated section of a palace.

Along one crowded street is the entrance of a Georgian house called Kalibari in a neighborhood called Kumartuli. It was built in 1761 and is a hybrid mix of classical Indian and English eighteenth-century architecture. Winged goddesses rest on arched openings with lime green filigree in high relief in some places and classical keystones and shoulders in others. The archways open onto an interior court, where a covered terrace looks like a garden folly. It has Corinthian capitals atop twenty-foot columns, and a flat roof shading the paved yard. All the columns and walls are painted hibiscus red. Chains hanging from the timber ceiling must have held lamps or lanterns. Laundry was hanging on the iron balconies of the second floor.

A couple of blocks further on, I wander into a crumbling example of the same period—black, dripping, and dirty, with squatters sleeping on the balconies and trash-filled passages. This is a dramatic contrast to the porphyry benches built into the entrance hall—still gleaming where the sun hits them.

St. Paul's Cathedral, built in 1829, is a huge pile of Gothic Revival stucco, all crockets and spires streaked with black stains,

THE EAST INDIA COMPANY CAPITAL

and now sunken below the raised four-lane highway that makes it look forlorn. Once you get inside, it turns out that St. Paul's is actually a beautiful survivor from the British Raj. It's sort of a big hall with tall, wide, leaded windows sparkling as they let in the light.

Some distance away from the center of Kolkata, in the older parts of the city—which had been a separate village—there are the remains of fifteenth- and sixteenth-century Hindu temples. They are built of carved brick and were stuccoed and painted. Most are now overgrown and crumbling, evocative of the village life that once was centered around them.

A temple called Belot is a short boat trip on the Hooghly River from the city docks. Its main temple is dedicated to the goddess Kali, who is an incarnation of Parvati, Shiva's wife. She represents Shakti—feminine energy, creativity, and fertility. She also lives to kill the demons of this world and is always portrayed as black-faced with a wide-open mouth and a red tongue hanging out. She has a necklace of the heads of demons she has killed strung around her neck. Kali is one of the more difficult goddesses to understand. She is alternatingly primordial, creative, nurturing, and devouring, but ultimately embraced as loving and benevolent.

There are also eight shrines dedicated to Shiva, each with a linga. It's forbidden to photograph inside the walls of the compound. I make a quick walk through after checking cameras and my phone. The place has an oddly militarized quality—sandbagged security posts with machine-gun-toting soldiers. There has been some sort of terrorist attack in the past and the high security is now permanent.

We take a ferry back to the dock, collect the car, and drive down the river a little way to find an ancient, abandoned-looking temple that I had seen from the water. I get my drawing board out and we are immediately confronted by a raging caretaker who waves his hands and forbids me to draw. My guide tries to calm him down, but then the driver jumps into the argument and it feels like it's going to come to blows. I back away while neighbors begin to gather. I think that if my guide had offered him 1,000 rupees, he would have turned into a helpful, accommodating lamb.

We wind through the labyrinth of neighborhood streets and turn into a dusty lot filled with boys kicking a ball around. As I get out of the car, I see the tower of a temple behind high walls. The gates are locked but the boys shout into the courtyard for the caretaker. He appears a few minutes later and lets us in. This temple is called Bari Mandir and dates to the sixteenth century. It has nine stepped towers and is dark and crumbling in places, with vines and scrubby plants clinging to the roof. It's believed that this temple

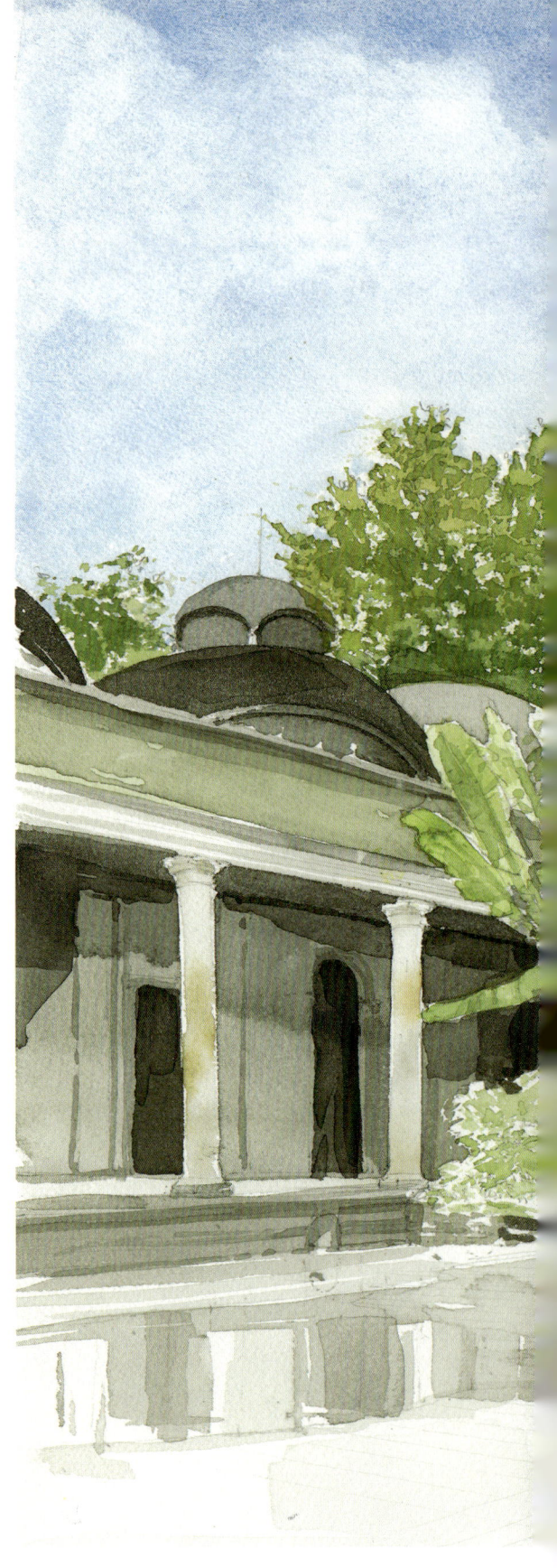

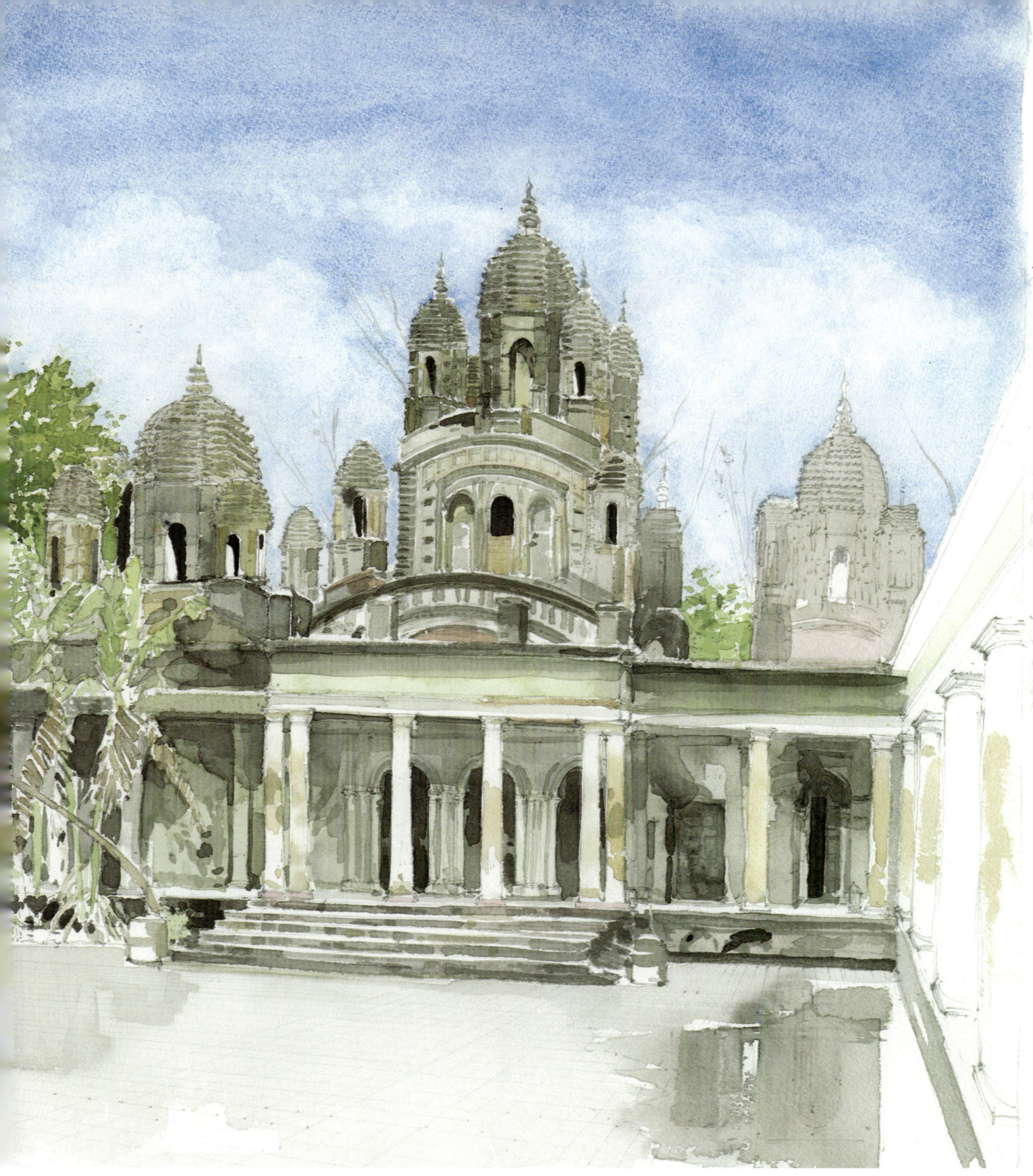

Bari Mandir Temple

is the model used to build the much later Kali temple I had seen along the river.

I get my drawing things and sit down, with the boys standing and sitting nearby to watch. I spend a couple of hours working on a drawing for a watercolor.

There are a variety of things that drive my choices about what to draw or paint. Sometimes it is just the beauty of a place—the way light hits something or how a structure sits in the landscape. It could be the spirit of the place, I guess.

When in India, I am also faced with the fact that the heat might stop me from finishing a watercolor. The temperatures can climb quickly if I spend three or four hours sitting in what was a shady corner and the sun moves and catches me directly in its glare. If I can manage it, I prefer to finish a watercolor where I start it. If it is not possible, I will sometimes take the drawing I made in situ and work on it later—usually the same day or the next morning. It is easy to lose the sense of a place, so I don't like to put off the work. I always carry my camera and take photos of the sites. I like to keep these as reference points that can give me context and capture detail if I return to a watercolor. I also try to keep an accurate diary of the sites I visit and draw. That might seem like a simple routine to follow, but I will occasionally get home to find that I have not been as good at this I had planned. I sometimes have to turn to my itinerary and the photos to help me trace my steps.

Next, we stop at another site with crumbling brick pavilions around a court that has become the play yard for the neighborhood. The place is called Choto Ras Bari. Everyone is friendly and intrigued by the presence of an American artist looking at their temples.

The little shrines are made of soft brick and in various states of collapse. A couple look as though they have been restored a long time ago—replastered and painted but looking very worn down now. Mysterious and beautiful. It's very satisfying to visit some unrestored sites.

THE EAST INDIA COMPANY CAPITAL

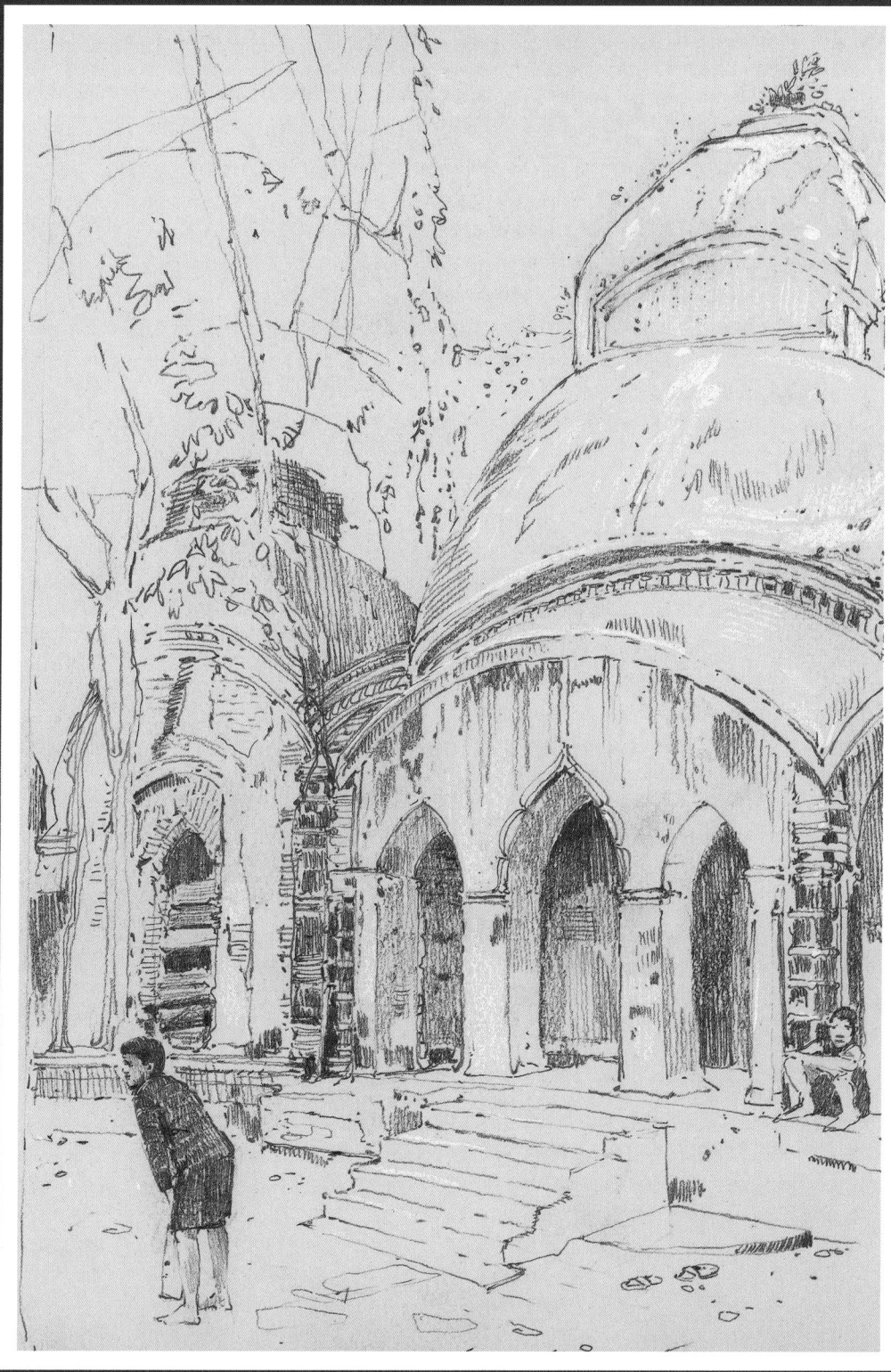

Terracotta shrines, Kolkata

THE EAST INDIA COMPANY CAPITAL

Bits and pieces of the social life of Kolkata's colonial past have been preserved. It's possible to have dinner in a restaurant that might have fed the British before independence. For lunch, I choose a downtown place called Flurry. The interior is from the thirties with a down-at-the-heels Fortnum & Mason look about it. Another evening I go to a famous Bengali restaurant called Peter Cat—crowded and noisy and possibly the dirtiest place I've ever had a meal. The waiters wear black suits but the crowd of busboys wear filthy kotas, vests, and greasy turbans. The level of grime is overwhelming. Another relic from the British past is a place called Mogambo, which has classic Bengali food and attentive waiters accustomed to the wealthy class of Kolkatans. There is also a contemporary restaurant world here with chic dining rooms, smooth waiters, and good wine lists.

Terracotta Temples

Kolkata sits in the delta and at the mouth of the Hooghly river where it pours into the Bay of Bengal. Having been the center of trade for the East India Company (with great loss of blood and treasure since roughly 1690) and then the capital of the British Raj until 1911, it had an extremely well-developed network of influence and trade north along the river. The remains of that connection are still visible on the Hooghly where vestiges of colonial occupation share the riverfront with vast palaces of the Nawabs, the descendants of the Mughal rulers of Bengal, who traded with the English. The embrace of British authority and fashion in architecture is fascinating. Huge classical piles appear along the shore and many survive as house museums with the entrance tickets funding the repairs of roofs and drains. It is not unlikely that you will see the current maharaja in riding clothes coming in from a polo match or a trot through his property.

West Bengal also has a well-preserved tribal tradition of singing called Baul. Bauls are poets, actors, composers, musicians, and dancers. They seem to exist as a cult of traveling musicians living outside of traditional religious orthodoxy. They sing about mystical tales and visions, the yearning for the divine. Their music has a sort of hypnotically seductive quality.

This is also the region of India where a particularly beautiful style of temple evolved. The lack of building stone (although at

some sites laterite was used in foundations) necessitated the brick construction, and the use of carved and molded terracotta tiles evolved as a means of embellishing the temples. The elegant feature of curved cornices evolved from early wooden construction methods that used bamboo and sloped thatched roofs.

Along the Hooghly there are wonderful surviving sites, but the most spectacular are in the Bankura district in West Bengal. Bishnupur became the center of a particularly popular Krishna cult in the sixteenth century, and became a pilgrimage site. It grew to be a trading center and eventually became a large city with dozens of temples. Each (generally) square temple stands on a raised platform usually with steps on its east and west facades. The tiles that blanket the buildings feature scenes of gods, goddesses, animals, demons, complex paisley, and geometric patterns. Their temple facades have arched openings (usually blind on the north and south) and are crowned by high, slightly narrow domes. The temples look stately and rigid until you get close enough to see the detail of the tile. The tiles were originally divided by bands of white mortar and may have actually been plastered completely. Where bits of the white survive, the walls look like giant quilts. In some places the brick has been carved more deeply, but the general impression is of a very flat, but richly embellished surface. Surrounded by brick walls, some have entrance pavilions and the remains of other devotional spaces.

The ancient city must have filled the spaces between the restored buildings, but they now rest in open fields or along dusty streets where several less important examples sit, overgrown and in disrepair. There are supposed to be two main groups, but really the buildings are just scattered through the countryside.

At its height, Bishnupur had a deep, wide moat and fortified double gates. The remains of the moat appear now and then as shallow pools. The surviving village is a series of narrow streets with dogs lying in the middle and tuk-tuks competing with the constantly honking car drivers.

The local guide who met me at my guesthouse this morning persuaded me to take the afternoon to go out into the country to visit the Potter's Village. He is sort of a local legend who has written guidebooks on the local architecture and is tolerated in a sort of bemused way by the other guides. It's forty-five minutes out to a tiny town of clay and kilns. It's here that artisans make small figures and decorative tiles that are sold at temple sites or in tourist shops.

The whole village was bustling with preparations for two marriages that day. I was invited to wander around and see the tents

TERRACOTTA TEMPLES

and halls all decorated for the parties. In one tent, an altar had been set up and a priest was reciting the ritual blessings for the day. The women were sitting around the edge on steps and invited me to sit. They gave me sweet rice balls dripping with sugar syrup—part of the *prasada,* the food offered for blessings at temples. When the news of a Western guest filtered through the crowd, the bride arrived to meet me—almost unheard of on the day of the wedding. She was wearing a gold and orange sari, she was barely five feet tall, and very shy. We were introduced and she invited me to sit down. Pictures were taken and I shook hands with all the women who crowded around.

We walked back to the house of the owner of the pottery works, whose daughter was the day's other bride. She also came out to meet me. No party going here, but the family all gathered—brothers home from college, uncles, aunts, grandmother, and grandfather. They all wanted to have pictures taken with me. It was all lovely and welcoming.

About halfway back to the city, we took a dirt track off to a pair of very early stone temples, one still a living temple with a priest sitting inside making offerings. I took off my shoes before going up the steps and I was stopped because some onlookers noticed I was wearing a belt and they were certain it was leather. Cows are of course sacred in India and it is forbidden to wear leather. I took it off and left it with my driver.

I went into the small temple where I handed the priest a 500 rupee note. He practically levitated, and motioned for me to kneel to be blessed. These villagers live on practically nothing and the priest lives on the donations to the temple. He handed me fruit from the tray resting in front of the Shiva linga shimmering in the candlelight. Flowers were piled on the linga and its thick coating of ghee made the black stone look liquid.

The Sukapha on the Ganges

TERRACOTTA TEMPLES

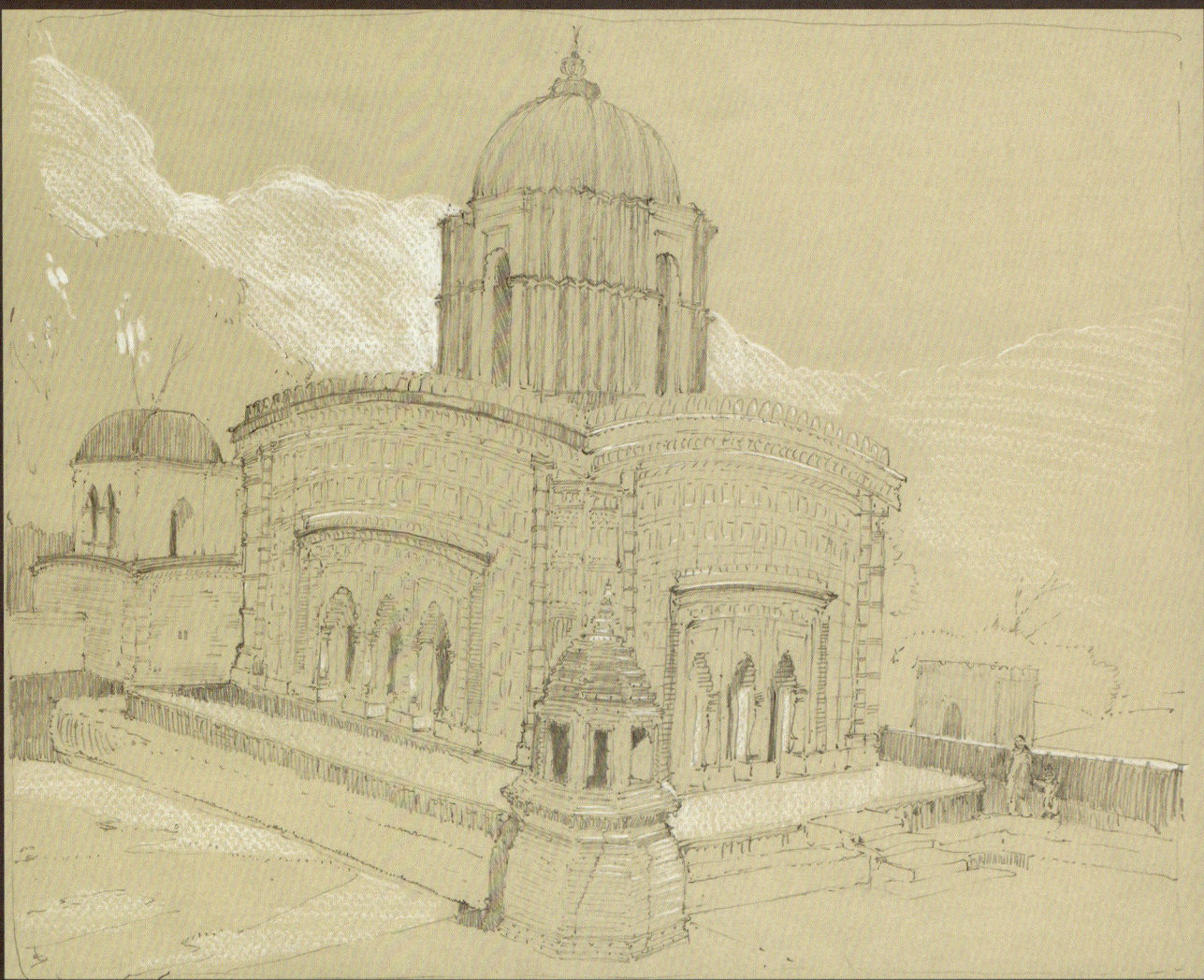

Radhashyam Temple

TERRACOTTA TEMPLES

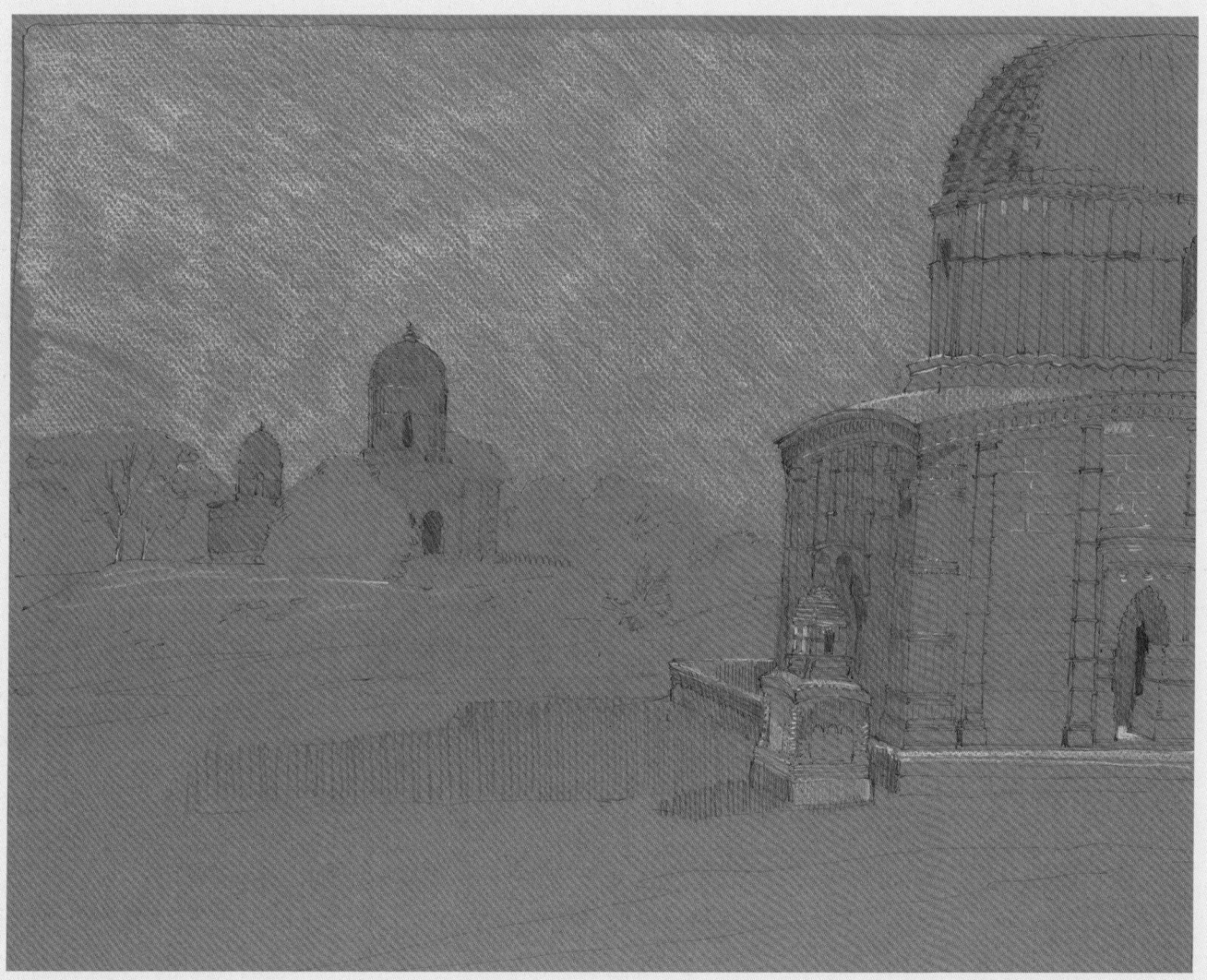

Lalgarh Temple, Kalachand Gram

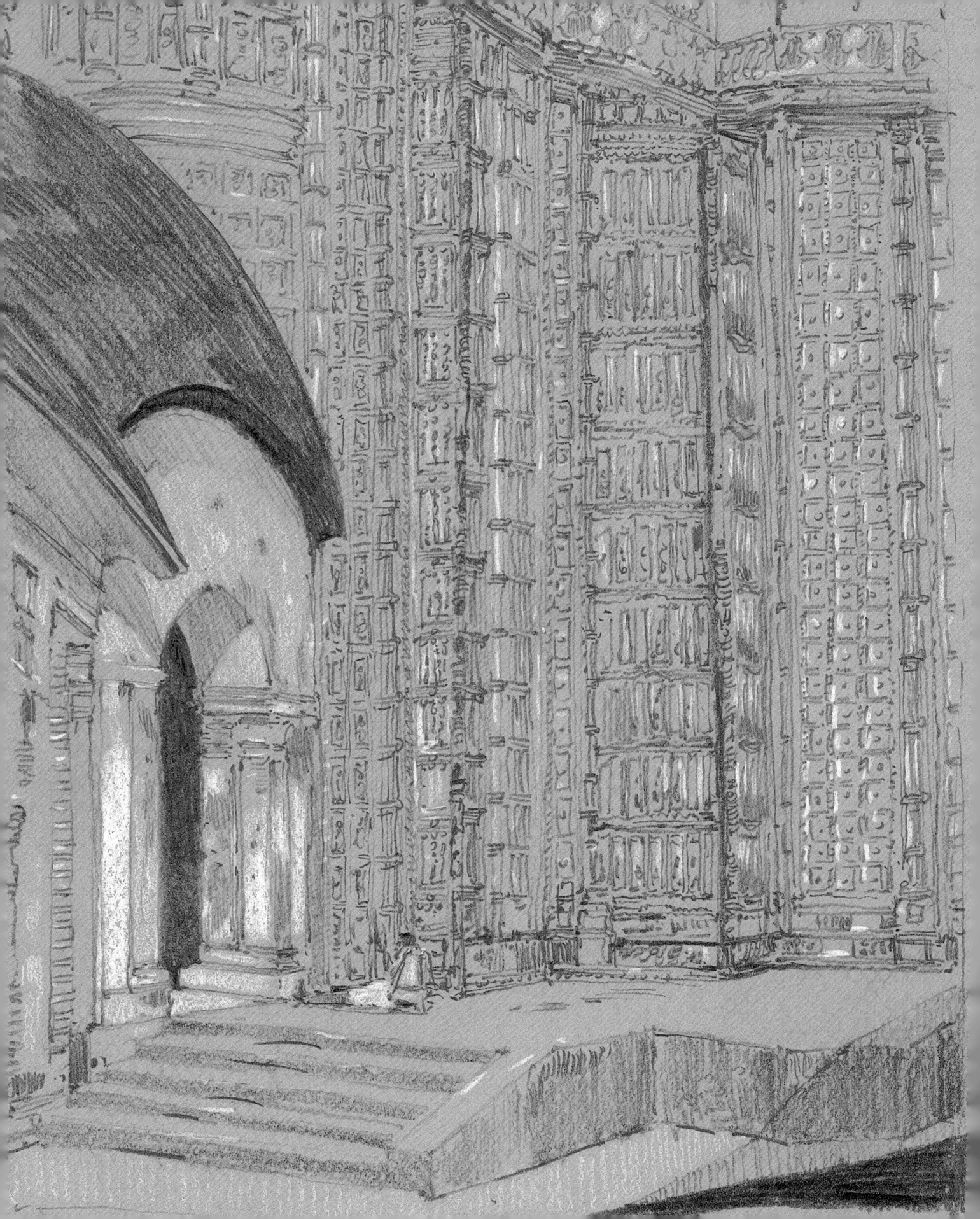

TERRACOTTA TEMPLES

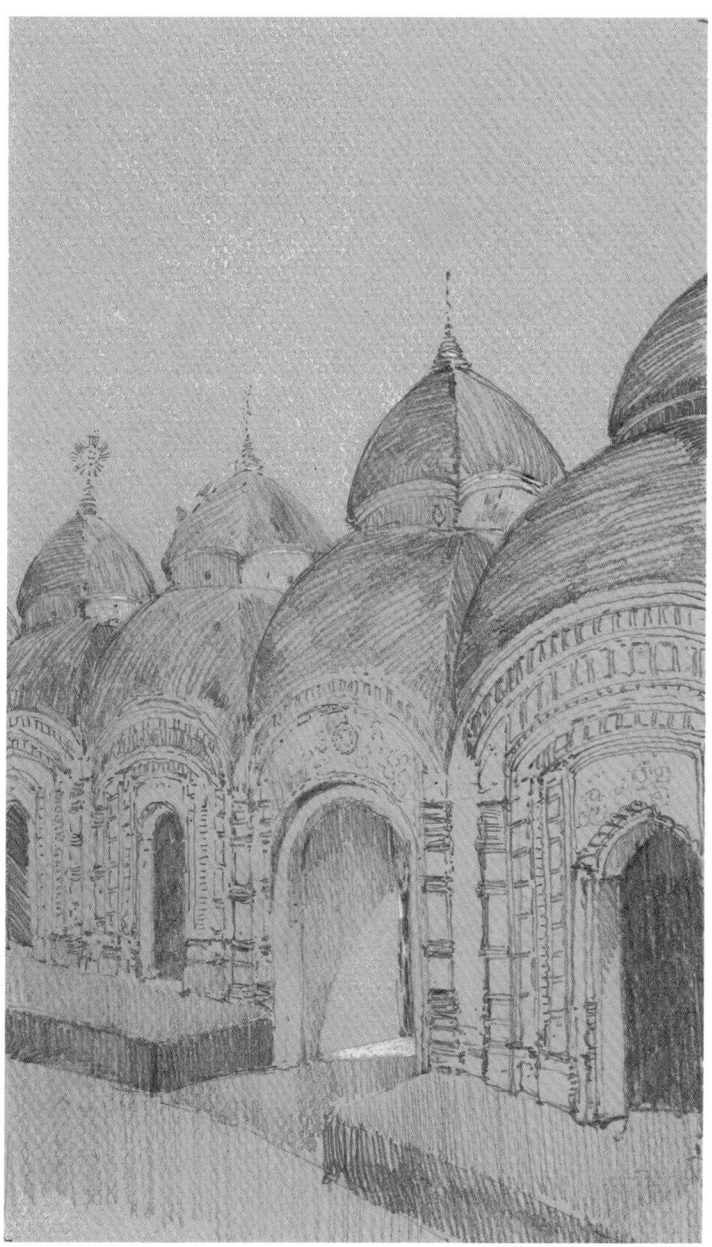

Ambilan Temple, Kalna

205 Kalna Temple on the Ganges

TERRACOTTA TEMPLES

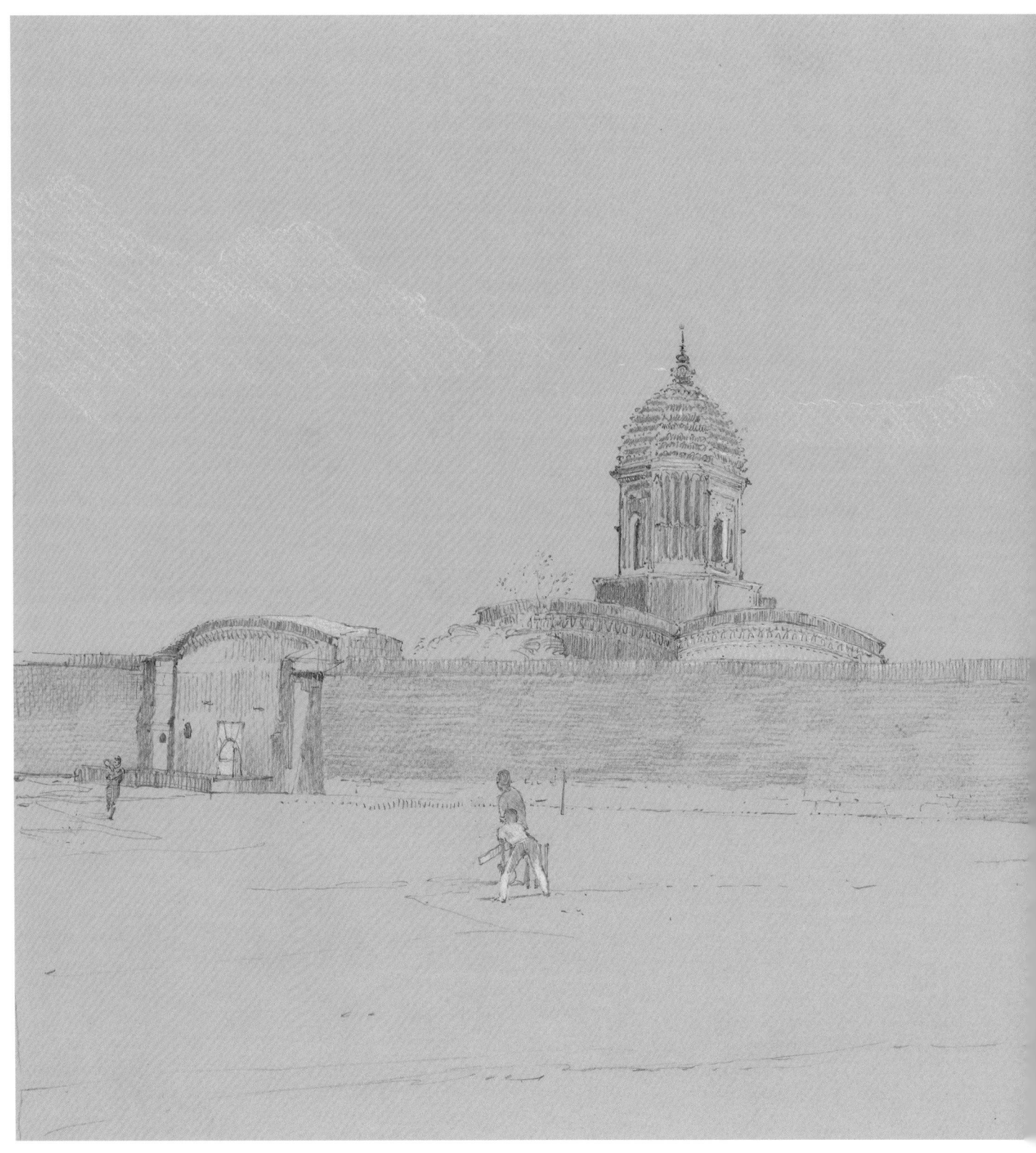

Lalji Temple, Rajdarbar

TERRACOTTA TEMPLES

YOUR DRAWING IS MEDITATION

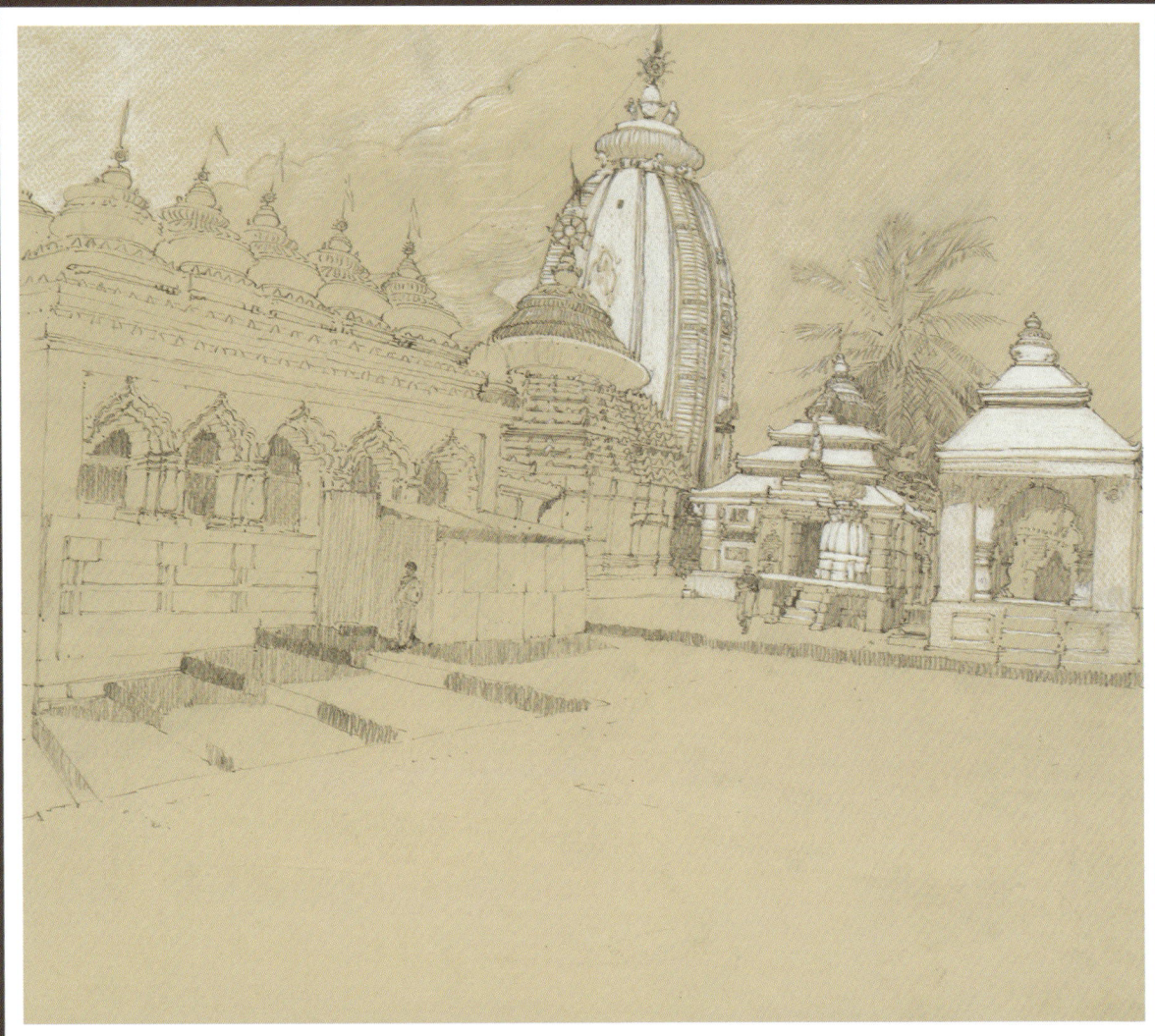

Kutilo Temple

Your Drawing Is Meditation

Odisha

The village temples in the state of Odisha are similar in style to the West Bengal temples of Bishnupur. They are not decorated with pressed tile however, but with carved brick, and the larger urban temples are cut and elaborately carved stone. My guide for this part of India was a fellow named Shreesh. We met at my hotel and drove to a temple complex called Dhabaleswar in the village of Cuttack, about one hour outside of Bhubaneswar.

The temple is a ninth-century site with many shrines, towers, and temples, most painted bright white, and it's still very active. I can't quite figure out why there are so many monks here; either my guide, Shreesh, didn't understand my question or didn't know the answer. I think it has a primary school inside the walls but that can't account for the crowd of begging priests. I was met with a new face with hands out four or five times as I walked through the compound.

I sat down to work on a drawing, and about an hour into it, after many monks had come to see what I was doing, a priest appeared and waving his hands told me that it was forbidden to draw the temple. He ordered me to stop drawing and put my work away. Shreesh argued with him and eventually the economics of the place played out. I had given money earlier, during the walk through the temple, and I said during the shouting that I would stop if he gave me my donations back. After some gesticulating and shouting he turned and walked away. I said, "So, now what?" Shreesh gestured and said, "Finish your work." He told me later that he was sure the priest thought he could extort more money from me because I had already seemed generous.

There is, in the middle of Bhubaneswar city, an eleventh-century temple compound called Brahmeswar. The temple has a big tank on the south side with some shallow terracing between it and the temple walls. It's eerily similar in plan to a temple I drew in Cambodia called Wat Bakong. It's not surprising that there

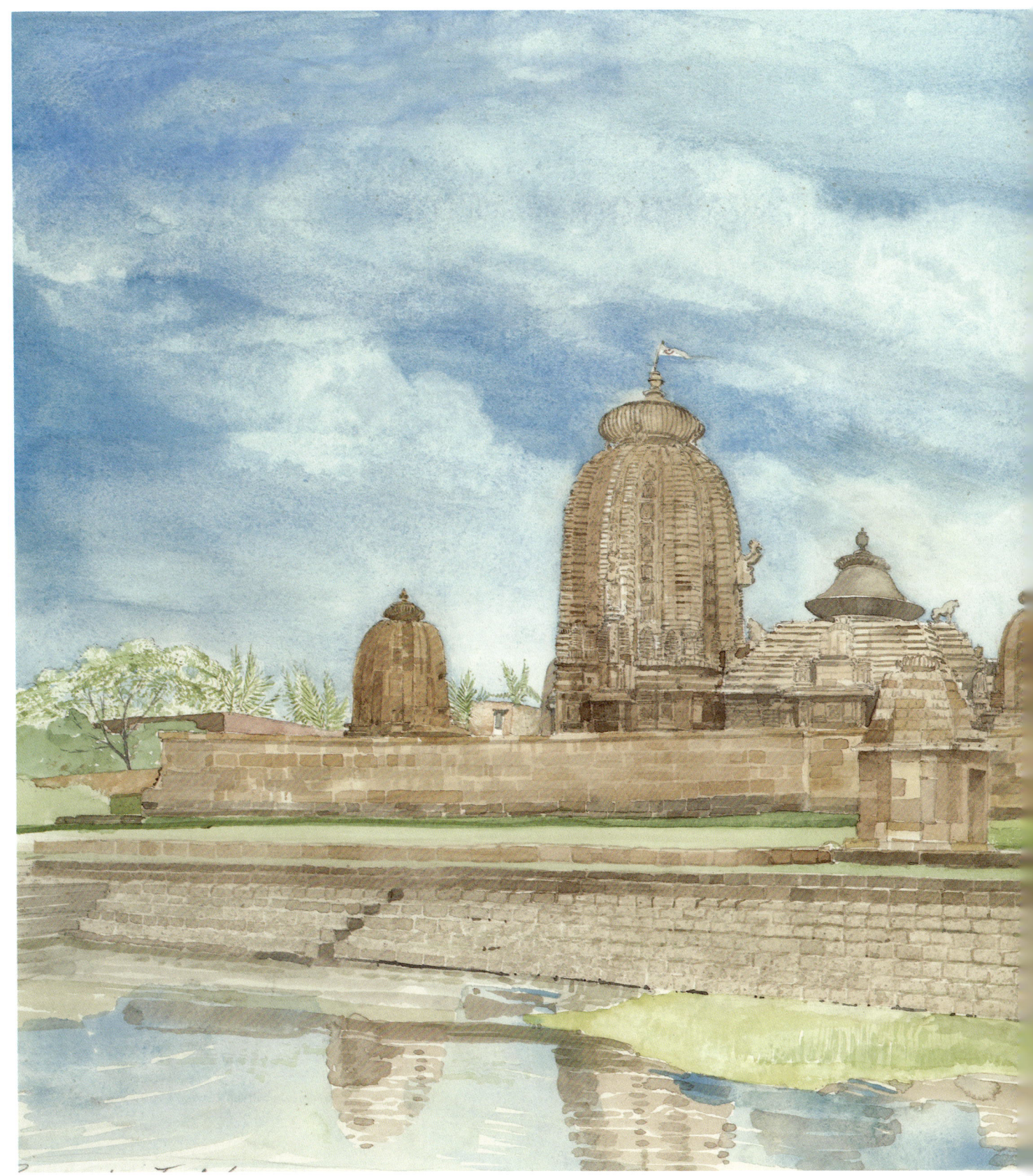

Kutilo Temple

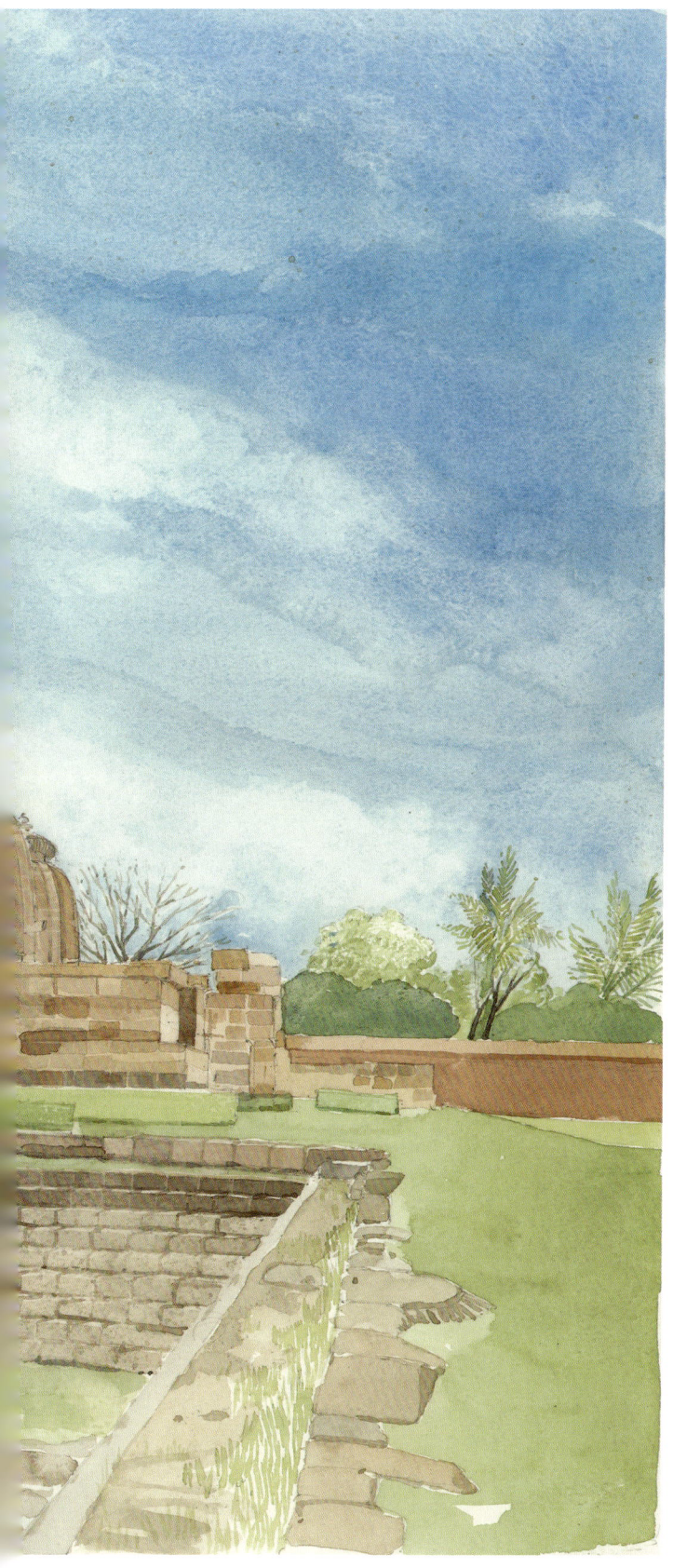

are similarities between India's temples and the vast temples in other parts of Southeast Asia. The architects and craftsmen that built India's towers and tanks were often exported to surrounding Buddhist and Hindu kingdoms. Through the hundreds of years of these building projects, styles moved and evolved slowly, but at their core, they have symbolism and rituals in common. The glories of Angkor Wat grew from the same seed of creativity that sprouted in India.

Brahmeswar has a lintel-topped entrance, small corner pavilions, and one tall central tower without a porch. It is almost deserted, so I sat all alone for several hours working on a watercolor. The day was hot and the sunlight brilliant. Big fluffy clouds floated slowly by. I was alone, and not even a tourist wandered through. The warm gold stone glowed and palm trees waved in the wind. There were no guards or priests to distract me. It was a perfect morning.

The Mukteshvara Temple is set in the narrow streets of the old city. You wind your way past shops and along the walls of small houses, and find yourself at a simple gate surrounded by small shops. There are artists selling small ink drawings of Ganesha on dried palm leaf panels. The little temple is probably the most important site in Bhubaneswar. The architecture is almost a miniature version of the other temples in the city and was the first in a new style that evolved here. It has a unique feature, which is a horseshoe shaped *chaitya* arch. This beautiful gate stands inside the compound at the entrance of the main temple. The slender red flag of Shiva waves in the breeze above the low dome noting that the temple is a living site of worship. A small tank next to the main temple is believed to bring fertility to pilgrims. I found a low wall to sit and draw.

Several years ago, I was at a dinner in Chiang Mai, Thailand. I was happily seated next to a lovely gentle lady and in the course of conversation, I was describing my drawing and painting. I was on my way to Cambodia where I planned to spend several weeks. We had been talking about Buddhism and

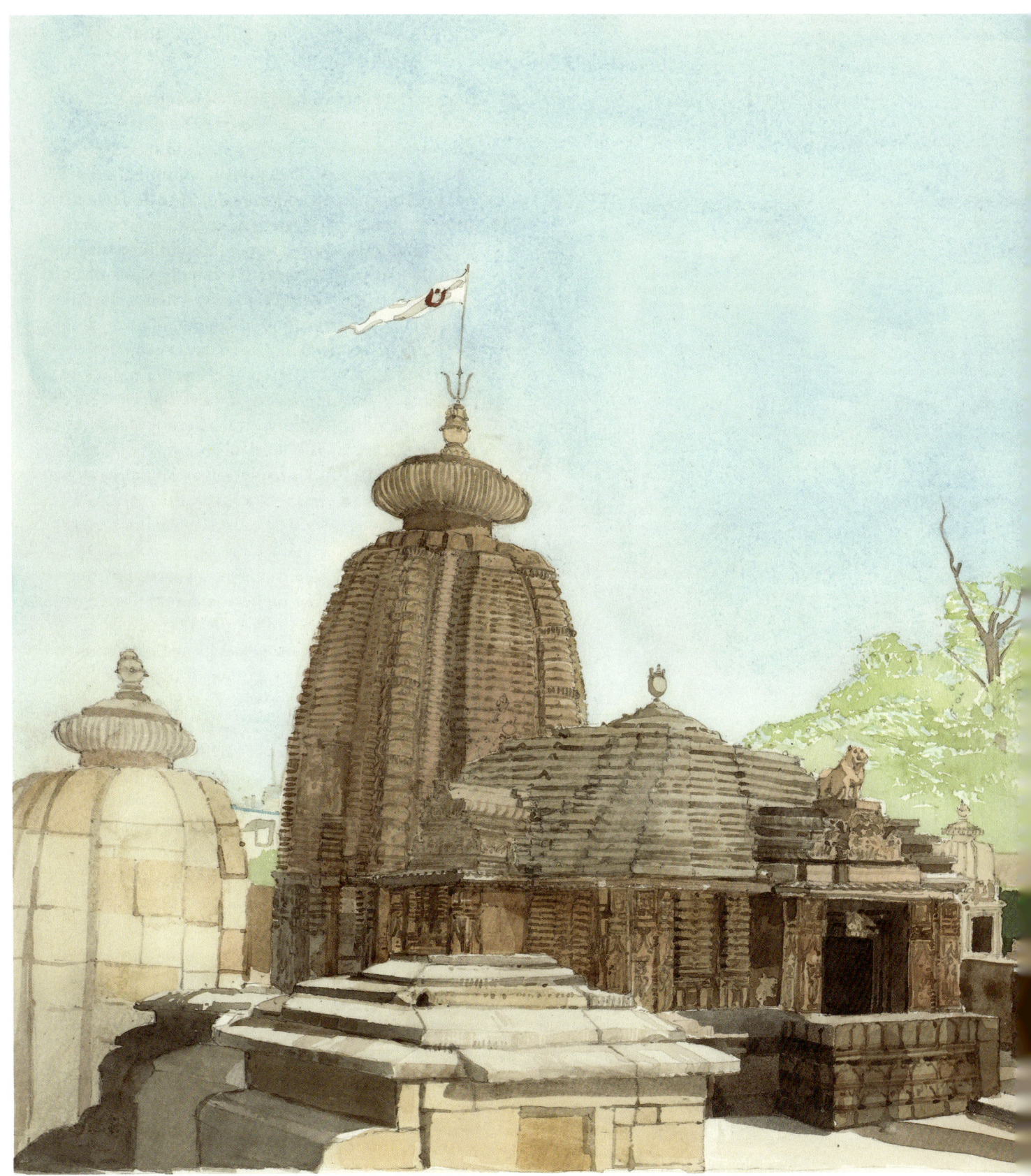

Mukteshvara Temple, Bhubaneswar

YOUR DRAWING IS MEDITATION

her practice of daily meditation. As I described my way of approaching a place to settle in and draw, and the sometimes hours that I spent leaning against a tree or in the shade of an ancient columned gallery, her eyes brightened and she said, "You don't need to study Buddhism to learn to meditate—your drawing is meditation." I had never thought of it. I carry that thought with me and occasionally I look up and realize that it has been three or four hours since I glanced at a watch or thought about anything other than the simple act of looking and drawing. My internal dialogue has quieted, and I have simply been.

Not too far from the city is a first-century BCE Jain cave site called Udayagiri. There are later Hindu carved temples here too, but the Jain caves are the oldest. There must be more than a dozen shrines in various states of preservation. You can climb up the chiseled stone steps to shallow balconies cut into the cliff faces.

There are columned caves with carved friezes of dancing women and raging elephants. The most interesting are Ramayana scenes. They are faded and, as the soft limestone carvings on these hillside temples often do, they look like melting ice cream.

The Ramayana myth has everything: love, hate, jealousy, devotion, demons, kings, queens, lust, celibacy, a magical golden deer, *and* flying monkeys. It is a tale of the life of Rama, who is the seventh incarnation of Vishnu and a popular and widely worshiped god. It is a tale of duty and honor and one of its most popular characters is Hanuman, the monkey king. He is often represented in temple carvings because he is revered as the lord of victory and celibacy.

From Udayagiri, we drove two hours out into the countryside along a more or less dry riverbed to see a few village temples. The government is trying to restore the river's banks and supposedly will redirect water here someday. The road, with patches of construction, winds through an area where laterite is quarried. Laterite is the red volcanic stone that has served as the main material for temples (and domestic construction for that matter) for centuries. It's like pumice, filled with air, so it's lighter and easier

213

to cut than granite, but very strong. Its cutting has been banned on state land (most of India is state-owned) but the cutters have simply moved to more remote sites to dig. Villages are filled with stacks of this stone, and almost everything is made of it.

These village temples vary from grand stone edifices to very humble soft brick buildings. Most have sandstone bases and show the centuries of erosion on their carvings. Our first stop was at Savhaneswar, a Vishnu temple built in 1260. It has the remains of a sandstone base; the brick tower has clearly had lots of rebuilding through the centuries.

When temple repairs are done in the countryside (at non-ASI sites), they most often are completed with cement, roughly done, and then camouflaged by a thick layer of paint, laid on like frosting and dripping and sliding onto the carvings below. In some instances, details are picked out with bright paint. Today, this temple is set up for a festival, with a large tent in the forecourt and the remains of little clay lamps still scattered on the ground from last night's activities.

It's difficult to imagine the scale of the populations that once inhabited these now remote village sites. One clue is how often temples are near one another. They would have been expensive and complicated to build so the towns that supported and built these places must have been big and prosperous.

Shreesh took me to Raghurajpur, a heritage village en route this morning. A little place along the river, it was ruined by the attention of the government. It was designated a INTACH (Indian National Trust for Art and Cultural Heritage) craft village, and been honored with a state guesthouse, dance performance arena, and the cement rebuilding of a temple. There are determined artists trying to sell their paintings of the life of Krishna on parchment and palm leaves. I had to shake off several artisans pressing me to see their showrooms. The village itself is unique and pretty, and were it not for the harassing shopkeepers, it would be wonderful. It has, down the narrow street through its center, a line of small temples. It's because of this feature that INTACH has recognized it. I suspect when a bus, of which there must be many, stops through or brings tourists for a dance performance, the rush of commerce must be unsettling.

At another temple in a village called Niali, I was followed around by a young boy who was studying to become a priest. He was maybe fourteen and very interested in explaining (to my guide) the carvings and figures.

I handed him a couple of 100-rupee notes (about $3) when we were leaving. He turned them over in his hands looking closely at them. I realized he had never seen a 100-rupee note before.

On the way back to town, we stopped at a temple called Barahi, in a village called Chaurasi. It's a pretty stone building resembling the temples near the far-off city of Mysore, and very unlike its neighbors. It's an ASI site, so very tidy with the standard ASI plantings within a few feet of the foundations. The village temples, which are not designated important cultural sites by the ASI, are often slightly dirty and messy, but filled with life. This one, attended only part-time by a priest, although not constantly because it's dedicated to an obscure deity, is still and forlorn like a WWII veterans' memorial in a midwestern public park.

Nearby sits an abandoned temple in the tiny village of Bayalishbati. The temple, called Gangeswari, has trees growing from its roof and tall grass inside its walled compound. It has strange, over-sized embellishment and surprising intricacy in its detailing. The Sun Temple in Konark, is not far away and tradition has it that the Sun Temple's stone carvers lived in this village and built Gangeswari for their own use, and that it's a model for the carving at Konark.

On the road back into the city, we passed a quiet village with the remains of a tenth-century temple called Moita. It is simple—brick with very little decoration—and dedicated to Durga, the goddess of tantric practice. It faces west, which means that it was used for evening prayers. East-facing temples are used for morning prayers. The temple has collapsed to only its ground level and has a curious series of sculptures around the inside wall. They are extremely detailed idols and were important in the tantric rituals performed there. Most tantric sites have been suppressed because of the tradition of sacrifice once practiced by the adherents. This temple is an active one with a priest surveying visitors to make sure shoes are removed.

Beside the temple, a lake has distinct villages on two sides. My driver tells me that there are two castes that share the site and that each collects water from one side of the lake. They are equally poor and share the same piece of ground, more or less, but a rigidly observed segregation divides them. Despite attempts over many years, caste distinctions are still ever-present. Cities can offer people the chance to step away from their caste limitations and the government has supported reforms benefiting the *dalit*, "untouchable," caste.

Village communities will generally enforce caste rigidly. I read another story about a group of boys playing in a field. They were roughhousing, tumbling over each other. When they paused to get a drink, one of the boys stepped back when handed a cup of water to pass to his friend. His face dropped and he said he could not pass the water to his friend. He was an untouchable, and if his friend took the water, he would be ritually soiled by the contact. The proscriptions about cleanliness were so engrained that they overrode the reality of their friendship. I read a story about an untouchable spilling water from his cup onto a girl sitting under him as he rested in the fork of a tree. He ran away out of fear of her relatives. Years later, when he returned to his village, the girl's father hacked him to death for having defiled the girl. It was considered the father's right.

The new India has a long way to go. There was a piece in the newspaper today about the authorities intervening to prevent an arranged marriage (outlawed for many years) between an eleven-year-old girl and a fifteen-year-old boy.

Iron Construction

Puri

The Konark Sun Temple is about forty-five minutes north of Puri. It was built in the mid-thirteenth century and abandoned in the seventeenth. The temple was built using a then-new engineering scheme that set iron rods and beams into the stone. Until this new method was adopted, temples had been built by interlocking block work and relied on gravity and the sheer mass of stone to stand. The iron probably seemed like a good idea on all fronts. Not so much, it turned out. It added strength and rigidity. However, in not too many years, the iron began to rust and spall. Konark was on the coast very near the water and the added stress of the salt spray caused the iron to begin failing quickly. The massive temple began to collapse with the shifting of stone caused by the swelling and weakening of the iron embedded in the walls. The main tower, which was about 230 feet tall, collapsed completely. The entrance tower was severely damaged too, but was stabilized by the British during the Raj.

Much of the main structure's stone was simply pilfered through the centuries after the temple was abandoned, and its sculpture looted. In an effort to stabilize the surviving tower, the English stacked tons of the tower rubble (and sand) into its chamber, so there is some possibility (however remote) that the tower could be reconstructed someday. The surviving tower is still packed with the rubble and, consequently, there is no interior to see.

IRON CONSTRUCTION

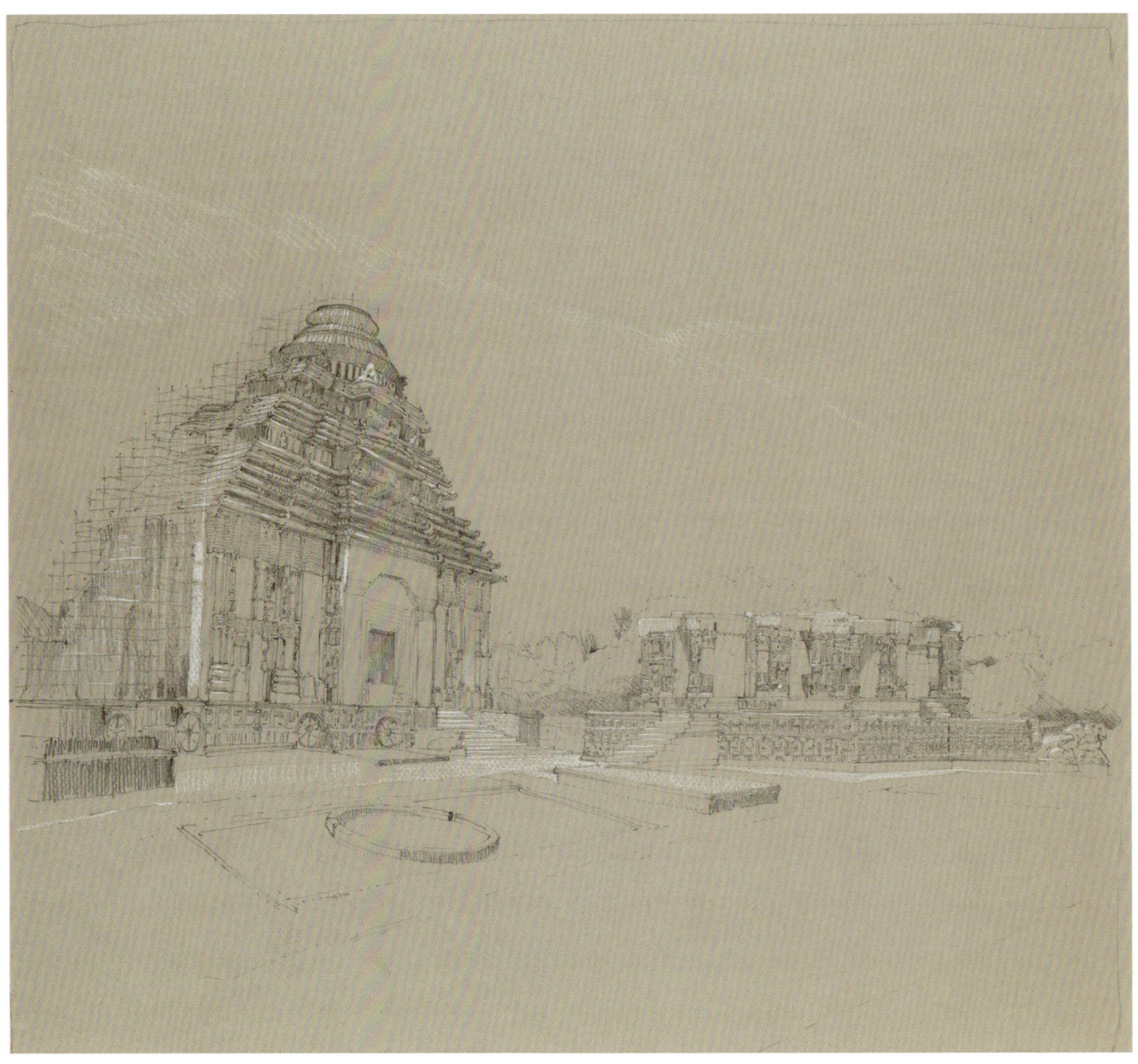

Konark, The Sun Temple, Puri

218

IRON CONSTRUCTION

The tower is square and stands on a high platform famous for its carved wheels, which suggests the entire temple was a chariot for the sun god. Each wheel is actually a sundial. The carvings on the base of the temple are erotic and either illustrate the Kama Sutra—the Sanskrit text on sexuality—or describe the everyday activities of humans on the day that the god Shiva married his wife, Parvati, along with scenes of elephant trapping and hunting.

There is a dance pavilion just in front of the temple on its own massive, raised platform. The entire compound is now in a sunken enclosure. Through the centuries, the sandy base has settled as the ground around has risen with the shifting of soil. The sea is a mile away now.

I find a bench and sit down to draw from the eastern side with the sun burning on the temple's face. I look at my watch four hours later and I'm almost finished. Crowds of tourists and pilgrims wander by because it's an important Shiva festival day and Puri is crowded. Not a bad little drawing.

We go to a nearby restaurant for lunch and I buy Ali, the driver, and Shreesh, my guide, a vegetarian lunch. Shreesh knows the owner and manages a beer for me. In this conservative place that shouldn't sell alcohol, they bring me the drink in a glass with a napkin wrapped around it camouflaging the foamy beer.

We stop by the local craft and book fair. Dozens of stalls display saris and lungis from various regions, each showing the traditional weaving patterns. The book fair is a jumble of academic texts, old novels, and, occasionally, a musty art or history tome. I am always tempted by architectural history books and I've been looking for something on the temples of Odisha, but I can't find anything here worth carrying home.

Shreesh has worked very hard at taking me to some remote temple sites. I'm sure most visitors see temples by walking around them, so my need to occasionally sit for several hours is odd and throws a guide off his rhythm. The reality is that I probably could manage with just a driver who knows an area. That was how it evolved with my driver Nadeem two years ago. He drove me through the countryside and made stops at sites he had learned of (I'm guessing) from driving with guides in the past. I do get some historical background, anecdotes, dates, etc., from guides, but I like the illusion of discovery, and somehow a guide with a narrative in place dulls the experience a little.

Palm Leaf Drawings

The Lord Jagannath Temple in Puri (begun in 1078) is one of the most holy sites in India and one of the pilgrimage sites that every devout Hindu must visit in his lifetime. Consequently, it is one of the most visited temples in India. Since this is such an important and sacred site, many unique traditions are observed. The main road leading to the temple gates is very wide; it must be a hundred yards across. It is lined with pilgrim hostels where thousands, millions of people pass through yearly. The road extends about a half mile. In it, a huge market for temple offerings and foodstuffs has unusual restrictions. Because of its access and proximity to the temple, only vegetables that were available in medieval India are sold in the stalls. No fruit or vegetable imported into India are sold.

 The pilgrim hostels are rudimentary guesthouses and people routinely cook inside these places with the small charcoal braziers that they carry. Thousands of people sleep on mats on the floors. There are souvenir shops of every kind too. I love the stalls that sell the little clay ghee lamps stacked by the hundreds. Other stands sell bundles of white cotton wicks that look like fluffy tassels, fine twisted ones for the smallest lamps and big thick pompom-like bundles for larger lamps. Cars are forbidden within the last few hundred feet of the temple, so you climb into a bicycle rickshaw to be carried close to the entrance. There are pilgrims of every variety milling shoulder-to-shoulder, mendicants in loincloths with closely shaved heads next to women in rich gold-encrusted saris. A young priest passes us in the most elaborate dhoti and robes, with sashes and beads wrapped around his thin body. The crowd opens as he passes. Cattle rest languidly in the middle of the street, dogs in packs race though the crowd occasionally. The confusion and cacophony are thrilling.

PALM LEAF DRAWINGS

This place routinely draws crowds of a million on festival days and even on regular days, hundreds of thousands of people come for the meals that the temple prepares and serves for a few rupees. There are steel switchback railings and gates to manage the crowds and a constant throng of people climbing the ramp to the gateway.

I am forbidden to enter this huge temple compound. It is the strictest Hindu site in India, excluding even non-Indian-born Hindus, so I have to content myself with a look into the courtyard from a viewing platform outside the temple walls. I struggle with the prohibition, though. It sets unfamiliar boundaries for how I can experience the spaces.

Maybe it is because this place—being far away from the general flow of foreign visitors and without the impulse or pressure to adapt to the norms of Western culture—holds more closely the traditions and standards of holy ground.

It takes me some time to adjust my expectations. The personal interactions in India are always warm and intimate, in a way. Expressions of friendship and affection are open, genuine, and sincere. Is it possible that my sense of Western privilege is so much in the way of my accepting the extraordinary Holiness and exclusivity of these places that I am blind to something worth embracing?

Across the street from the main temple gate, there is an ancient library. The original (!) palm leaf drawings of the temple design were, until recently, kept in its cabinets. Through a nondescript doorway you find a narrow stair up to the library. It is a repository of books on theology and history, generally. There are bookshelves with glass doors and rows of dusty decaying books. The shutters are wide open and most of the windows don't have any glazing. The weather floats through the room. Most of the important antique palm leaf drawings have been taken away and are at a research library in Delhi now, and there is not actually a record of what remains in these cabinets.

Two old men are sitting at a small table reading newspapers. When I walk in, one of them gets up and reaches for a ring of keys and motions me to follow—after I have made an appropriate donation to the library. He also carries a long steel pipe, the function of which I discover in a few moments. He unlocks a door with a flourish and we climb up to the next level. Another padlock is opened and one more floor up we are on the roof. As he opens the final door, he begins banging the pipe against the jam. As the door swings open our view is of scattering monkeys.

He has carried the pipe because the roof is one of the monkeys' favorite places to nap, and they are apparently aggressive and territorial. The upper floors are the uniform gray of freshly rendered cement stucco, and the roof shows signs of general restoration. This roof looks over a vast series of buildings connected to the temple's mission: pilgrim hostels stretching down the street and large courtyards surrounded by living quarters for monks. Parts of these buildings seem to be abandoned and collapsing, but look like they are being restored, given the scaffolding tied to several of them.

 The goal of the climb is to glimpse the interior of the Jagannath compound itself. It has a huge footprint of several city blocks with a labyrinth of towers and passageways. Directly across from me is a tower, and standing in the shade of its dome is a man wearing a lungi casually looking down at the crowds. My guide, who is giving me a running commentary on the temple, encourages me, "Be comfortable. You may draw from here."

 The general chaos of the street below is now calmed when filtered into the courtyards and passageways of the temple. The task of feeding millions of pilgrims requires a giant complex with hundreds of workers. Smoke and steam rise from the kitchens and people mill around carrying pots. The tower of the temple is 214 feet tall and a priest climbs it every day to change the flags, which carry the symbol of Lord Vishnu. Tradition maintains that the tower does not cast a shadow, and on this slightly overcast day, it seems to be true.

Wedding of Shiva

Khajuraho

Khajuraho is the remnant of a once-great independent Hindu kingdom. The twenty surviving temples standing beside the once stone-lined tank in north central India are only a few of the eighty-five shrines that covered the plain. There were dozens of tanks. The surviving towers, unique in their design, were mostly abandoned long before the Islamic invaders from the northwest descended into this territory, so they were spared the desecration and destruction that many other sites suffered. Because the site had been lost and was not connected to other cities by well-maintained roads, it never attracted the invaders' attention.

 The English had long heard of these mystical temples before an amateur explorer finally arrived here in the late eighteenth century. What the English found in the jungle was a group of tall, narrow, multi-tiered towers covered with the most complex symbolic figures imaginable, and a dose of highly erotic imagery. The temples are typically raised on a high terrace with a porch, an anti-chamber for worshippers to wait their turn to enter the temple, and a small sanctum sanctorum. Many have elaborately hooded balconies extending from the main tower and there are

WEDDING OF SHIVA

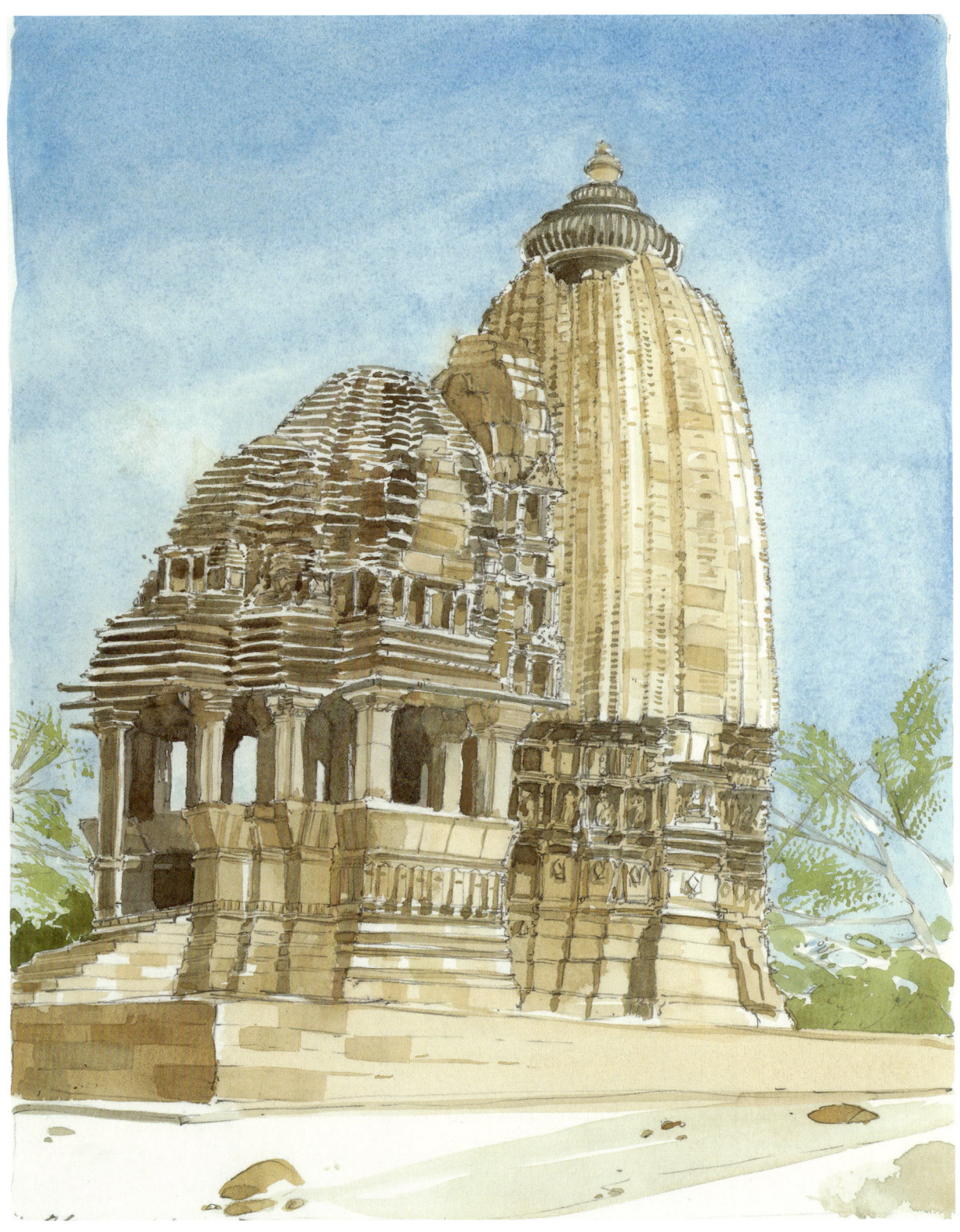

Chaturbhuj Temple, Khajuraho

often carved flanking benches. The arrangement of the temples is ritualized, and the grid satisfies layers of Hindu mathematical requirements. The architecture is a series of squares and circles repeating and dividing, but even as a casual observer you recognize the swirl of pattern and symmetry that makes your head spin.

It takes some time to absorb the iconography. There is one controversial theory that suggests an explanation for the variety of mundane activities rendered on the towers. The erotic carvings, although popular in the imagination of tourists, are a small part of the imagery. The suggestion (at least for those temples dedicated to Shiva) is that they are depictions of the wedding day of Shiva and his bride, Parvati.

There is a Hindu scripture that describes the people who are startled by the passing wedding party of divinities. They are in the everyday acts of an earthly community and those include earthly pleasures. The erotic carvings, though, deserve some attention because they *are* remarkable. They begin with a simple sexual coupling of a man and woman, through groups of three, four, five, or more. There are images of men penetrating women while others assist in the positioning of limbs for greatest pleasure, or a woman being entered from behind while fellating a man before her. There are carvings of coitus with animals and seemingly impossible gymnastic positions. It's carefully rendered, often with anatomical details that are startling. The grounds are full of giggling couples and children being guided away from particularly challenging encounters. The guides always direct tourists to the most surprising scenes and thrill at the blushing reactions.

None (save one) of these temples is active, so there are no priests attending the sanctuaries. There are two main groupings here, and within a couple of miles, other single towers, less restored and less dramatic, survive. In one small, more remote site there are banks of columns that must have been a thousand-column university. The slightly undulating ground is dark red and the warm sandstone of the temples glows in the sun. The shadows deepen and define the figures as the sun sinks in the late afternoon, and the place seems even more magical and confusing.
I have spent many hours leaning against a low wall in the shifting shade, trying to catch some of the complexity of these towers in a drawing. They are so richly carved that the figures blend into an almost texture-like rhythm.

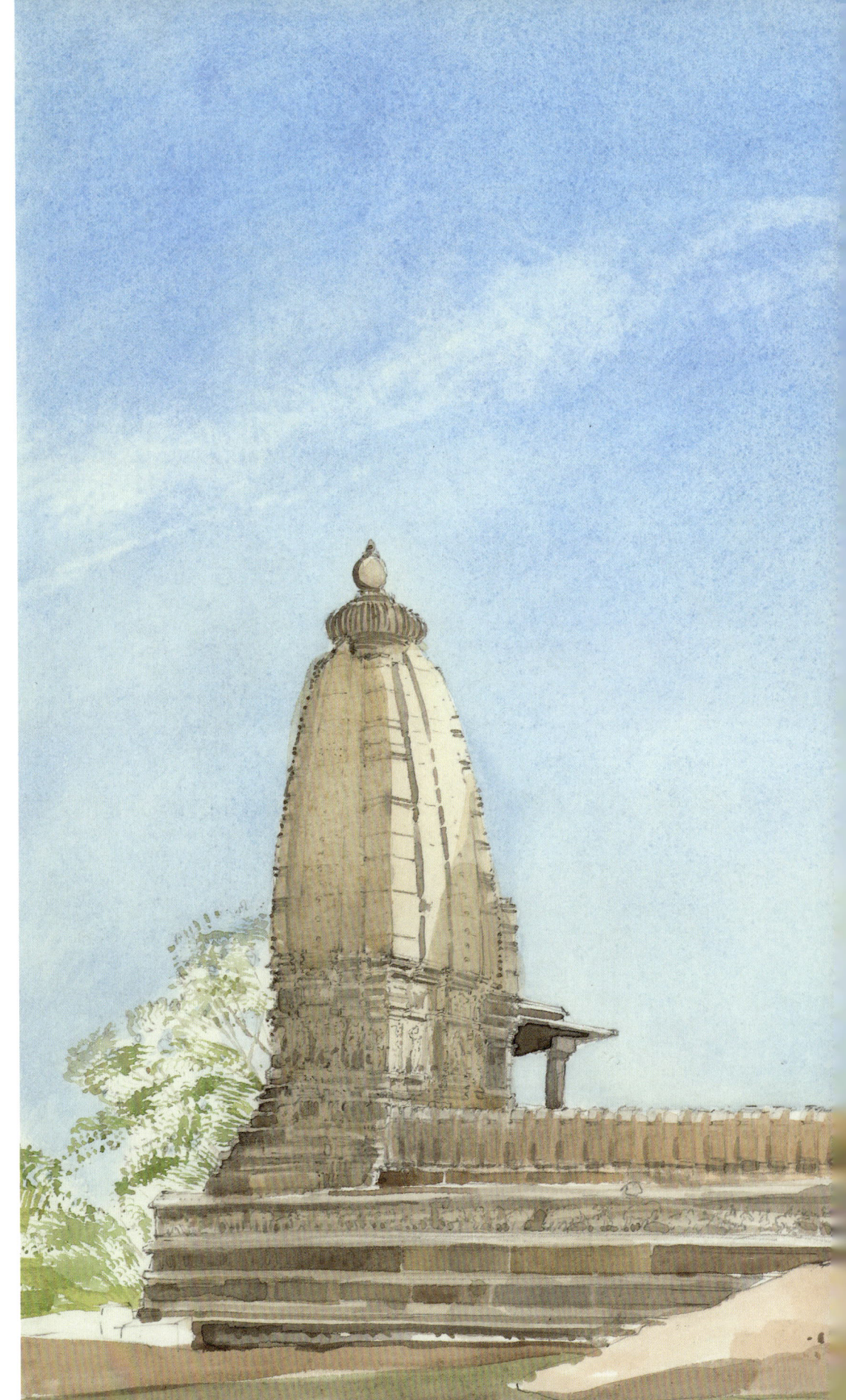

Lakshmana Temple, Khajuraho

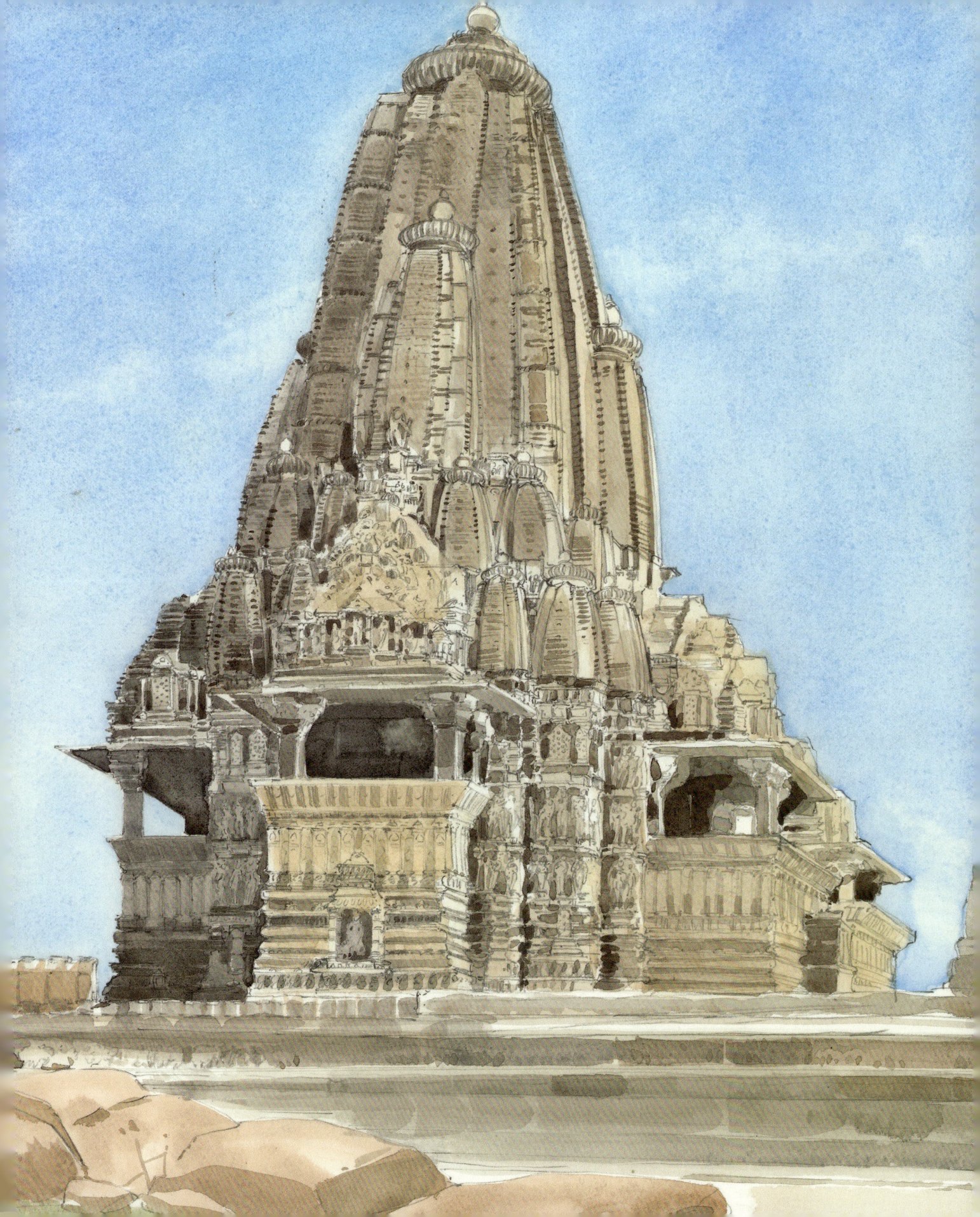

Orchha is about three hours northwest of Khajuraho, past a couple of more or less ruined sites. It is largely the remains of a sixteenth-century city built by a Sikh prince who united (conquered?) the territory. There is a large and beautiful temple called Chaturbhuj, begun in the ninth century, which is like a European cathedral in scale. It has multiple towers and spires and the brave can climb to the roof to look out over the city. This temple is empty and abandoned except for the curious who wander through the big airy halls, dusty and strewn with rubble. I climbed up a hill behind the temple looking for a place to get out of the sun to draw, and sat down with my back against a tomb connected to a small mosque. I spent an hour drawing and then I was chased away by the caretaker who waved and shouted and pointed to the tomb. I think I was defiling the space by resting against the tomb.

 The ancient city sits on an island in the River Betwa, and in the mornings locals still come to bathe at the turn in the river below the fort. That fort is a huge complex of interconnected palaces. There is lovely tile work, courtyards, and tanks with monkeys scrambling over the walls and towers. There is a hotel tucked into the first of the palaces you pass after crossing the crenellated bridge.

There are dusty streets with the crumbling brick buildings of the royal court and an amazing terrace with many *chhatris* laid out in a grid. These chhatris (which means "umbrella," and evolved from garden structures) are memorials built over the cremation sites of important personages. They are often engraved with the important biographical stories of the luminary and are essentially multi-storied follies. There was constant conflict between the Hindu rulers and the frequent invaders, and the architecture here at this crossroad of competing traditions is a complicated hybrid—Mughal in style and Hindu in function. But it is still romantic and picturesque.

A few miles outside Orchha is a hill fort called Ajaygarh. It was a fortified town from the mid-thirteenth century on. Sections of fortification still stand near an enclosure containing a mosque and several collapsing temples with beautiful carvings. It is a haunting and beautiful place, with the remains of water tanks and shrines scattered across the hilltop. I spent several hours exploring and drawing, and only a couple of people wandered by. A climb up several hundred steps to the fortified gates is rewarded with wonderful views across the valley.

WEDDING OF SHIVA

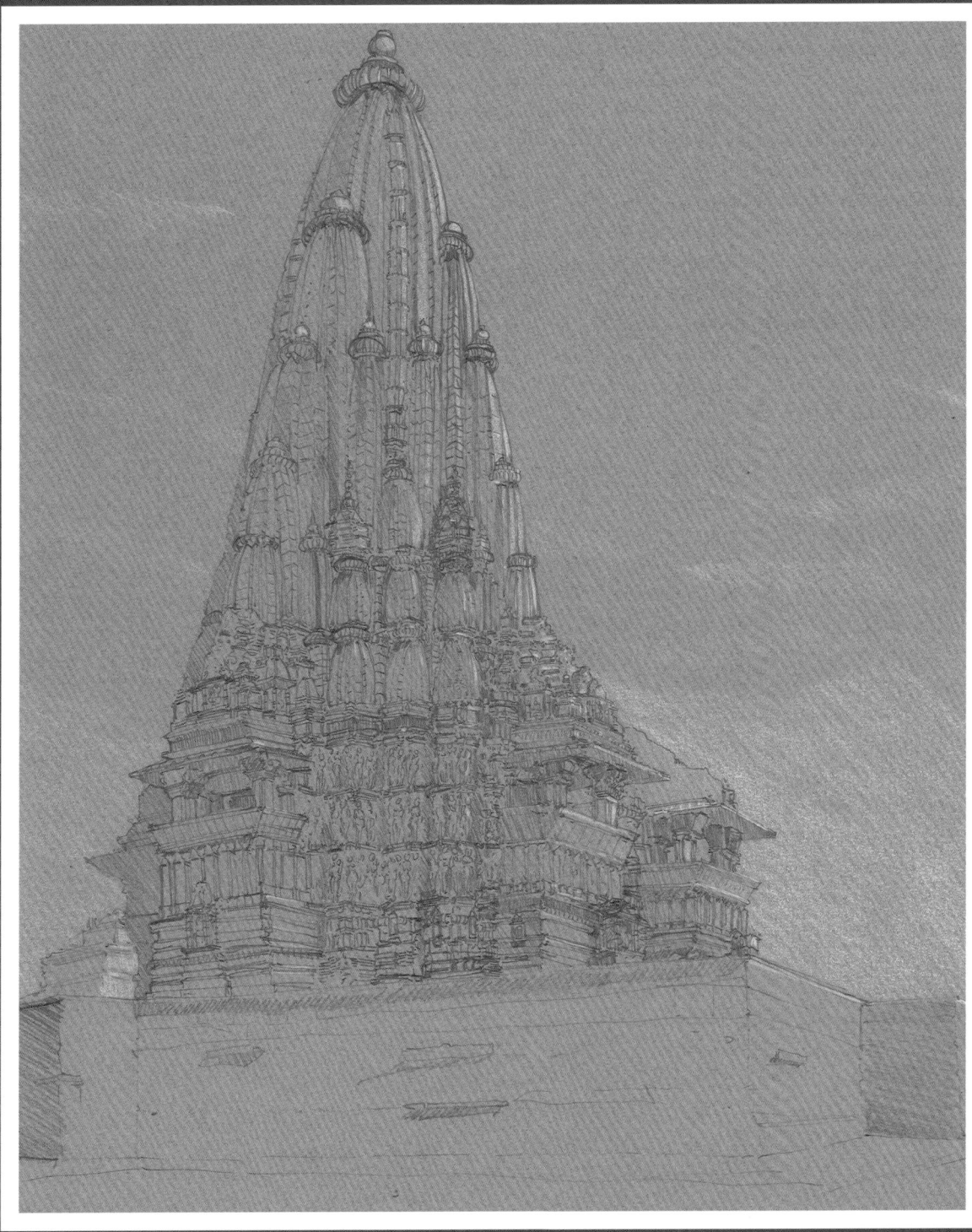

Kandariya Mahadeva Temple, Khajuraho

WEDDING OF SHIVA

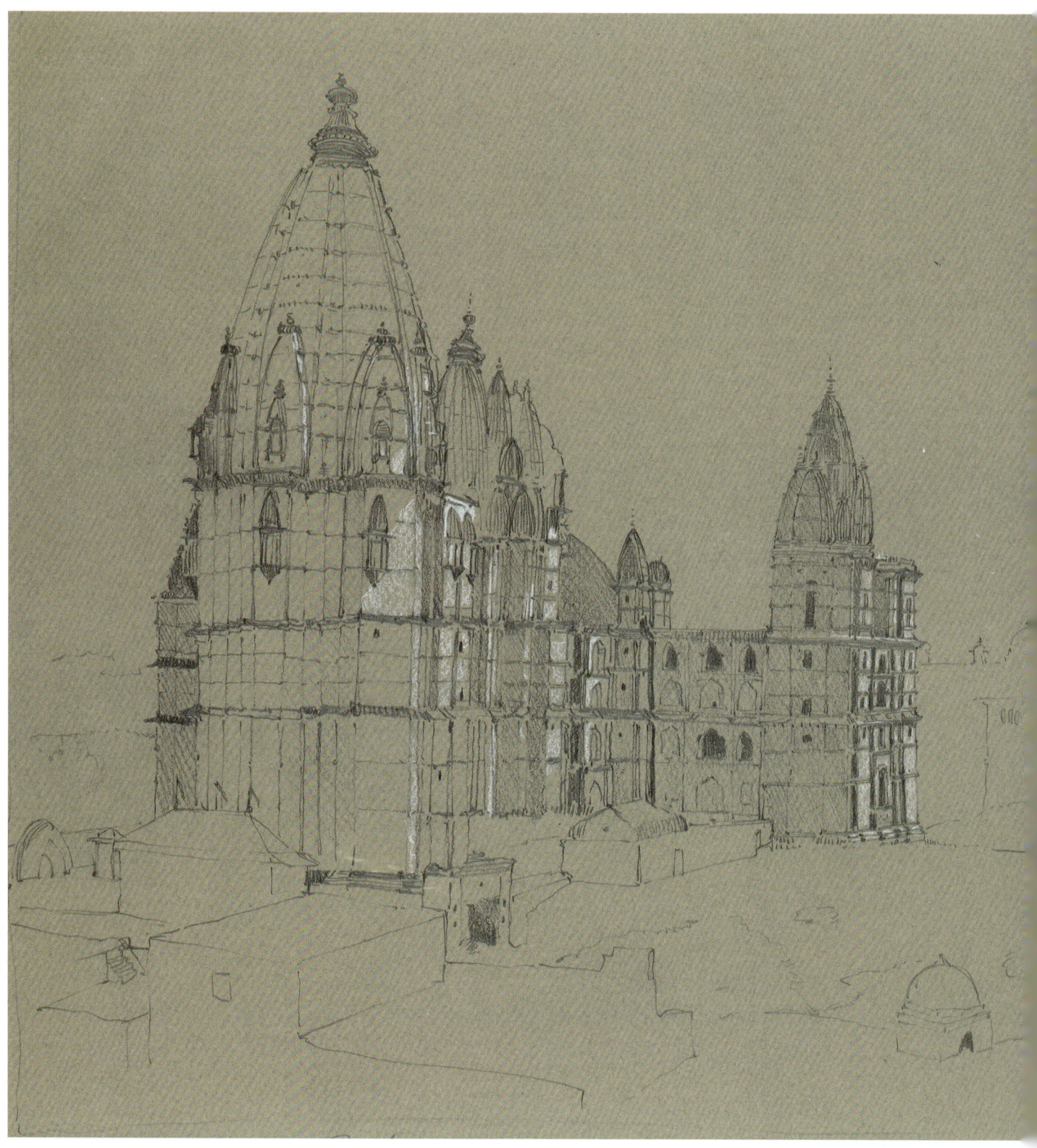

The Great Temple, Orchha

At the bottom of the hill is a crumbling palace of Shah Jahan, the great Mughal emperor (builder of the Taj Mahal) who conquered the region in the sixteenth century. The palace was famous for its baths but is rarely open because of its disrepair. Boys were kicking a soccer ball around the royal courtyard and goats grazed on the grasses growing through the steps to the hooded palace entrance. In the town of Burhanpur, where this palace stands, there is a huge lake with chhatris scattered along its margins. All of them are decaying and tall wispy grasses wave in the wind from their roofs. A nineteenth-century temple in the middle of the town is built in the style of a classical Roman temple—it looks more like a Western church than a Hindu temple. It has amazing murals on the interior walls and thick columns painted bright pink.

WEDDING OF SHIVA

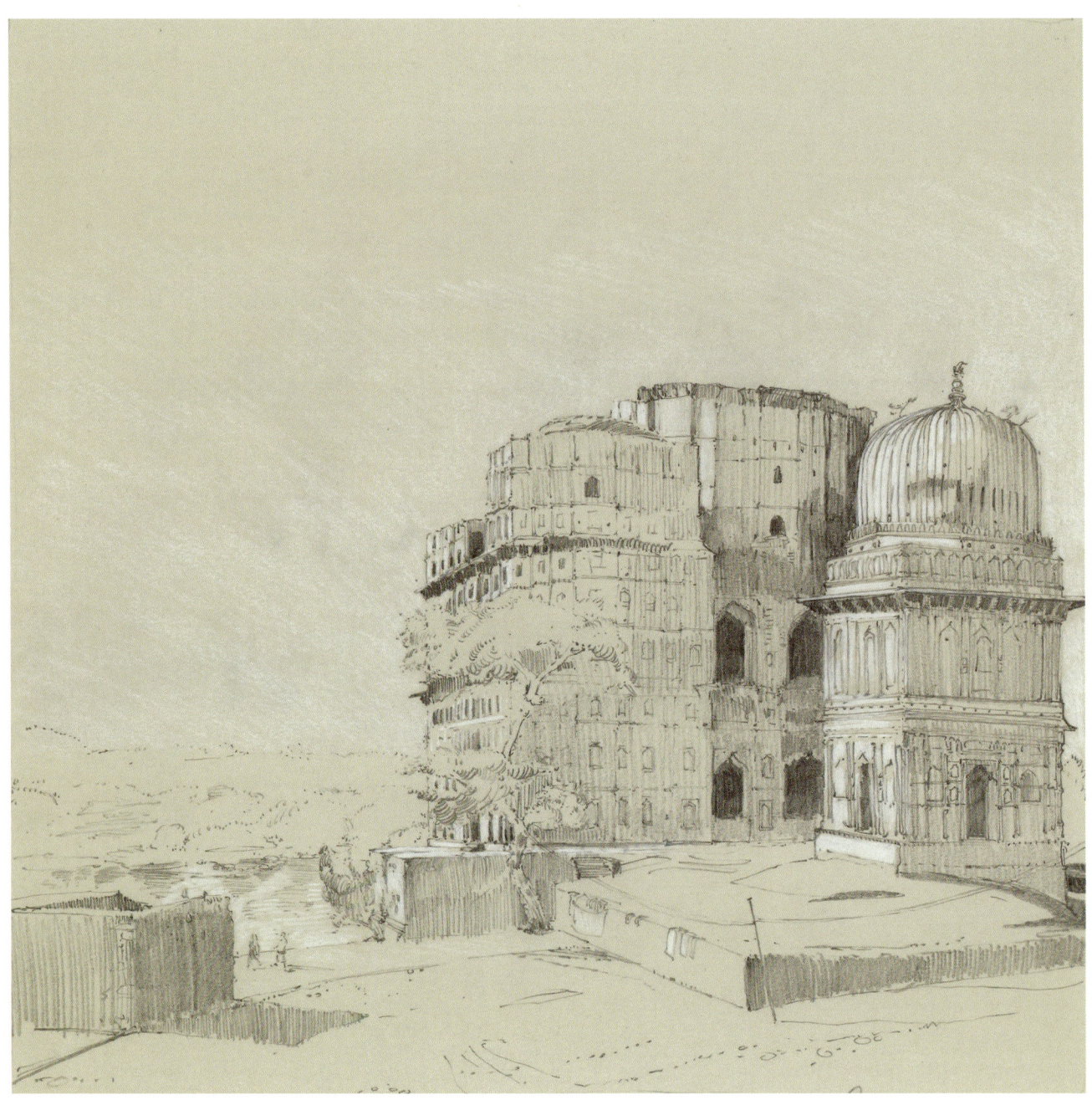

Cenotaph of King Sawant Singh

WEDDING OF SHIVA

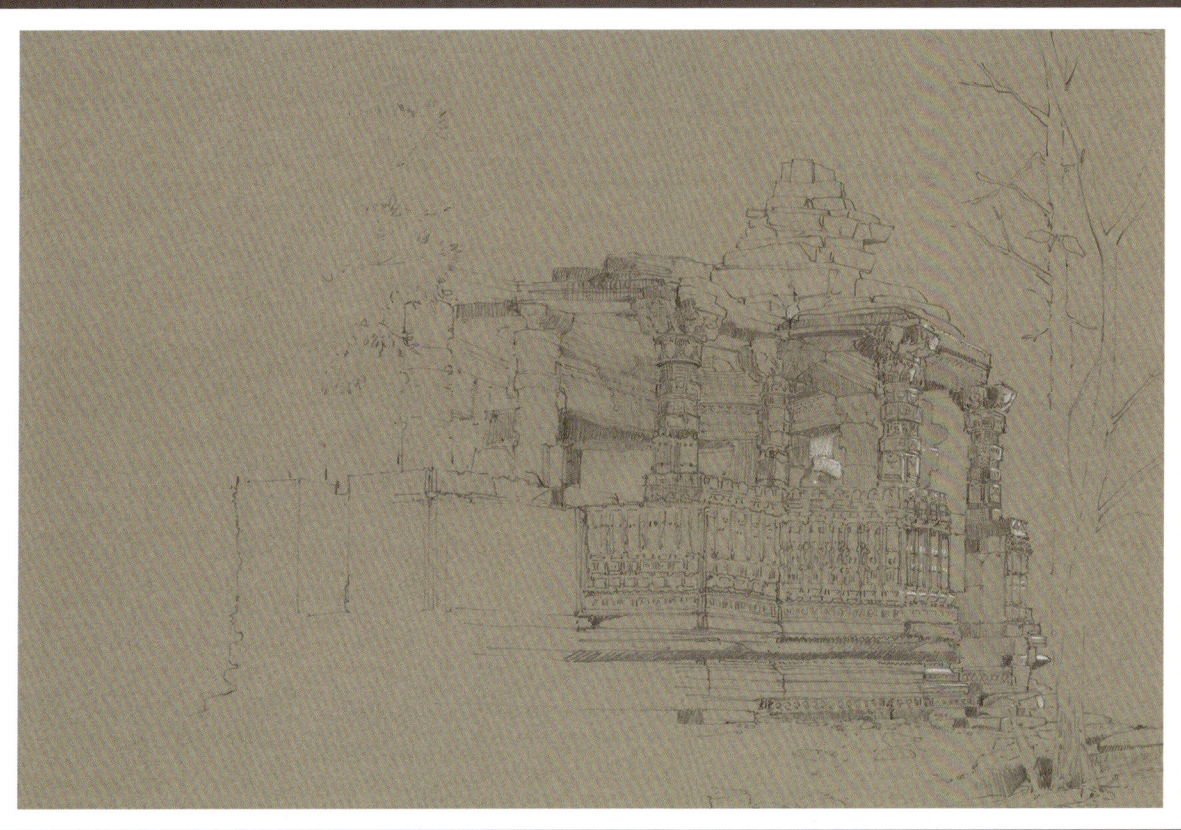

Ajaygarh Fort

On the Ghats

Varanasi

Varanasi (still often referred to as Banares, which was the English version of the city's name) is one of the oldest continually occupied sites on Earth. Many cities have had name changes in an attempt to return the names to the pre-colonial, more authentic ancient pronunciations or in some cases the return to the actual name, which was just too difficult for foreign tongues to manage; Bombay/Mumbai, Madras/Chennai, Orissa/Odisha to name just a few.

Varanasi sits on the banks of the Ganges River and is the holiest city in India. Huge festivals take place here and the local population is made up of a confusing range of holy tribes and castes. It has the character of a city that is rough and transactional. It has been a tourist destination since the sixteenth century and it seems that the locals have adapted to scrambling for the cash and commerce of strangers in clear-eyed ways.

My guide was slightly thuggish and began his circling conversation about his tip the first morning we were together. He asked me to pay him whatever generous tip I was considering in private, and then pay him another very small tip before the eyes of the guesthouse owner, who was in line for a commission on the referral. On the morning that I was leaving, as the owner watched, I handed my guide a small tip (having been generous the day before). He kept his head lowered and slowly turned the bills over in his hands making sure the owner could see the paltry tip, and

shook his head slightly in wonder at how badly he had been treated. It was high theater.

My cousin and her son joined me for several days during the Kumbh Mela festival—one of the largest pilgrim gatherings and celebrated only every twelve years. The tension between a smart Western woman and my guide was palpable. My cousin had spent several days taking trains from Delhi to get to Varanasi in the midst of the millions of pilgrims working their way toward the city, and her nerves were tested by his constant challenging of her observations.

The typical tourist visit here consists of a stay at a slightly remote hotel where you are collected on a boat and ferried up and down the river to photograph the mass of humanity taking a dip in the Ganges. There are hundreds of guesthouses lining narrow streets too. A friend who has spent time in Varanasi told me that I had to stay at a guesthouse on a *ghat*—the steep steps above the river. Staying in the middle of the city will certainly add color to the experience. Wandering out at night to find dinner can be an adventure, and it is easy to get lost in the winding, narrow streets of the neighborhoods. You will see the real life of the place, however. There are open windows with men working at looms, weaving the beautiful local saris, and you will stumble across small local shrines that you would otherwise never see. Many streets have their own vegetable markets, which are colorful and noisy. For several mornings from the balcony of my guesthouse I watched a young yogi with a student practicing the greeting of the sun. Stepping into the chaos of the streets is certainly more authentic than staying on the edges of the city, but it can also be a challenging experience.

The banks of the river are built up into steep stone stairways rising sixty feet above the water's edge, where all sorts of commerce takes place. In the dry season the steps are very high and crowded, but in the rainy season the Ganges rises sometimes to the top steps, just below the foundations of the buildings, and spreads across the wide river bottom across from Varanasi, sometimes several miles wide. The local washers stretch their laundry out on the steps to dry in the sun, while hundreds, if not thousands, of people arrive daily to bathe in the river.

The density of the city and the industrial pollution that floats down the river toward it make the river possibly the most polluted on Earth. I have had Hindus tell me that despite the pollution, no one gets sick from the water in Varanasi. That is not true. The masses of people climbing into the water would be enough to make it dirty, but the accumulation of raw sewage, dead animals, the daily washing of the cremation sites into the water, the habit of just

floating the corpses of certain castes of people or people whose families are too poor the pay for a cremation into the water, and the general waste of the city washing into the river make it a very dangerous brew. I was encouraged several times to take a ritual plunge in the water.

Even though there is actually a strong manufacturing center in the city, the business that brings millions every year is that of cremation. There are several cremation sites on the ghats and they are in constant use. The streets are always crowded with funeral processions. It is believed that if you die in Varanasi you go directly to paradise. Because of this tradition, many hostels for the dying have been built here. The slightly sickening sweet smell of the pyres shrouds the city.

Cattle wander the streets, wild dogs in packs patrol their territories, and pilgrims make their way toward the water in a constant procession. If you step into a private house along one of these streets, the dirt floor of the courtyard is perfectly swept and the stoop is tidy. The few feet left and right of the doorway are swept constantly; pushing the litter back and forth between houses seems to be a civic standard. Side streets are often clogged with craftsmen working away on the goods required at the cremation grounds. There are many shops with men knocking together what appear to be tall narrow ladders. It was only after being in Varanasi for several days that I realized that they are actually stretchers to carry the dead to the riverbanks for cremation.

Varanasi is probably the most colorful place in India. An Indian friend described to me how brilliant the color in India is, how everything is boldly painted, that there is no other place on Earth so colorful. That happens to be true here. It is mainly because of the strongly theatrical and vertical nature of the ghats, which condense the visuals here in a raked stage way. If you hire a small boat at dusk, as the lights are lit on the banks and bands begin to play with drums pounding, it is easy to understand why Varanasi has become such an international tourist destination. It is the place in India where the display of color and texture is most dramatic. At the top of the ghats there are huge stone palaces. Most are closed up or occupied by only a guard to protect them from squatters. Many of the richest families of India had palaces here so they could attend important festivals, rituals, and family cremations. These tall imposing buildings are in various states of collapse, except for one or two being renovated into five-star hotels. The discovery of Varanasi by the world tourist market as a classic *National Geographic* experience has brought dramatic changes here.

Varanasi is the spiritual center of the worship of Shiva. The streets are full of priestly sects. There are dreadlocked, Naga sadhu-ascetic priests who pray and chant to Shiva all day long. There are monks, robed and naked, as well as yoga masters with their devotees. Indian culture is strangely modest everywhere but here. The nakedness of wandering Naga sadhus goes unnoticed and unremarked upon. The sadhus are usually coated with ash to acknowledge the inevitable coming of death and cremation. They sit surrounded by pilgrims often shrouded in a cloud of hashish. They are generally eager for a tip if you want to take a picture—there is something oddly theatrical about the public display by these sects. You can arrange to visit a Hindu wise man and witness his rituals at dusk or dawn, for a price.

The most mysterious and controversial sect is an ancient tribe of priests who are called Aghori monks. They claim to be Shivaic monks but are generally rejected by most orthodox Hindus. The Aghoris' mission is to sift through cremation sites to find any bits of unburned human flesh and consume it. They are dedicated to leaving no trace of the human body after it is burned. Even Indian friends of mine have never heard of this macabre cannibalistic cult.

Looking In

Varanasi is a deeply confusing place, which, I think, should not be approached casually. I have seen people at temples who don't understand any of the complex mythological stories illustrated in the carvings. It is possible to appreciate the aesthetics of these temples on their own terms, they are beautiful in their own right, but somehow the churning humanity in Varanasi with its mysterious and intensely observed ritual life is different. It is possible to observe the place as a sort of theater, as most visitors must do, without understanding it, but I think this place almost justifies the limits put on non-believers in many places.

The ritual of emersion into the water and chanting blessings to greet the sun in the morning is what most people come to witness from the boats. This happens all over India every morning in a public way, but it's actually a private act of faith. Varanasi, with the slow-moving river and the dramatic steep steps as a backdrop, has created a voyeuristic opportunity that has become a sort of pageant acted out each day and an important economic engine for the tourist trade. It is strangely ignored by the participants, as if they are actors in a play. It must be that they have become inured to the overloaded boats jockeying for position. Scores of people descend the steps, men undress and lay their clothes aside wearing only a

sort of G-string, and women in their saris step into the cold water. They don't look up at the boats loaded with Chinese, Japanese, German, Italian, or American tourists. It is strangely unsettling to watch this very intimate and personal act.

Varanasi is the holiest city in India. It is also the clearest example of what is difficult about India, and also, what is so totally seductive and mesmerizing. The veneer of Westernization falls away here. Young men put away their jeans and running shoes to wrap a lungi around their waists and walk barefooted through the streets. The strange mystical cults that thrive here are unaffected by hundreds of years of suppression and modernization. They are the survivors of a tribal world and isolated traditions. There are still aboriginal communities in Odisha, for one example, where tribes cling to an ancient iron age, hunter-gatherer way of life. Varanasi, in the middle of a huge metropolis, is at its heart a place where the same relics of a primitive world thrive. The rites and rituals here are writ large and central to Hindu life. Perhaps because of their scale, they seem more inaccessible. It is here that I bump up against the indisputable reality that glimpsing the rich complexity of this place may be all you can hope for. It is just not possible to experience this place fully. It is really beyond our capacity.

Maybe that is the lesson that India teaches us. We need to accept that however we long to break through cultural checkpoints, there are limits. And that is a powerful lesson and not a bad thing. We step up to the boundary and realize that part of the human experience is to embrace the rich and profound diversity among us. Accepting the mysteries of the other that don't fit into our tidy, parochial, Western way of thinking is liberating, ultimately.

The differences between us can be bewildering, though. Often the most challenging are the differences in the way we search for clues to the mysteries of life and death. In Varanasi, that search is acted out on the street every day and it challenges our mindset. But the impulse to glimpse the flickering images of a divine dimension through the thin places is actually a basic primitive human urge we share. In India, it's in a form and manner so utterly alien to Western traditions that we struggle to fit it into a model we can relate to. Ultimately, there are wonders we may only be able to observe, absorb, and *not* claim to understand, exactly. Finally, we are stopped at the gate and invited to just look in.

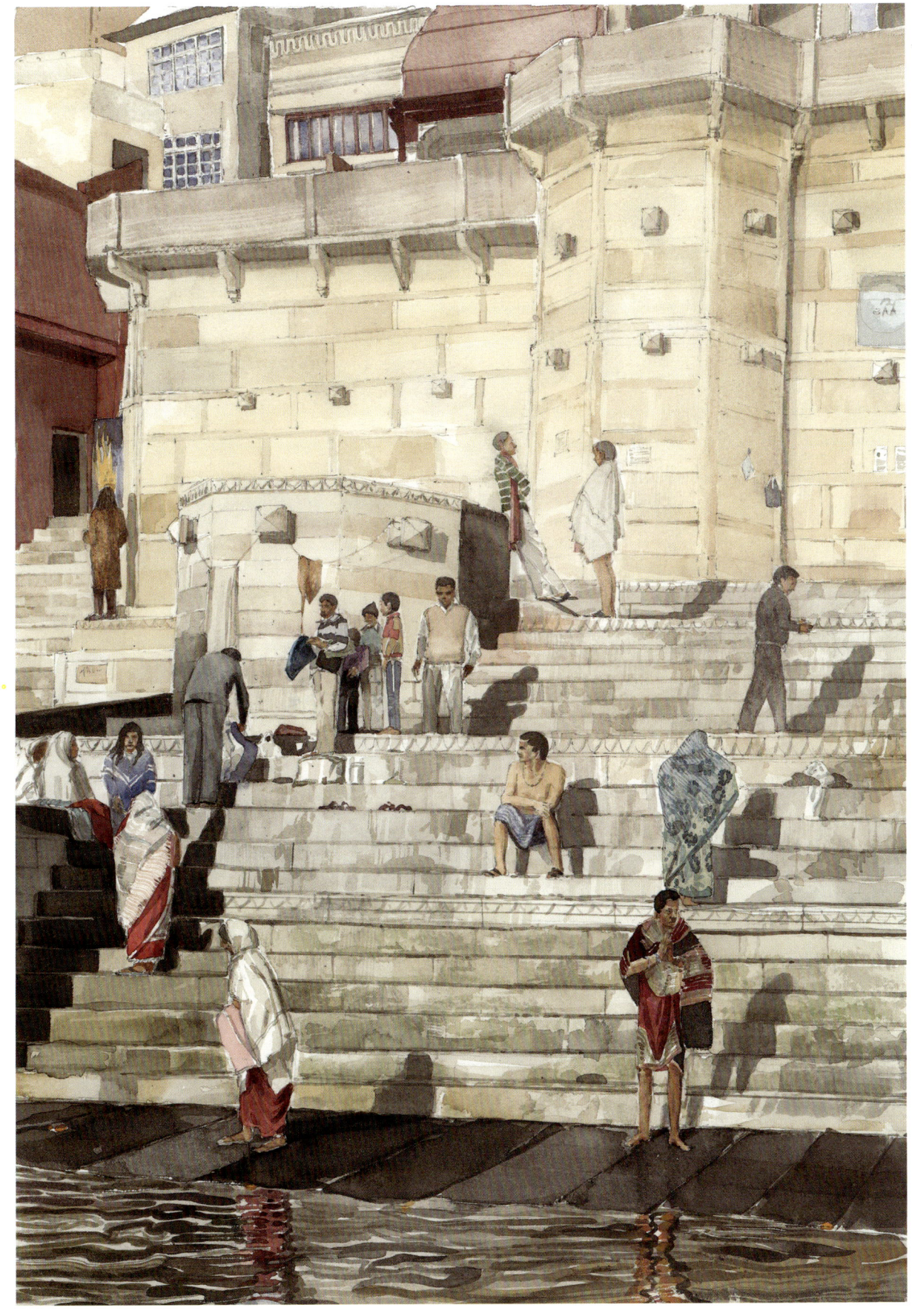

Acknowledgments

This body of work grew from a casual conversation I had one afternoon with my late friend, James Perkins. We were traveling through Rajasthan with a group of friends. His suggestion that I should think about creating material for an exhibition at his gallery in London, after I had been sketching while we traveled, seemed like a remote possibility. This book evolved from the seed of Jamie's idea for that show and I still feel the power of his encouragement and support. Now the circle has been closed and I dedicate this to Jamie.

Laura Fitzgerald Cooper struggled through my cobbled-together journals and gave me insightful and creative input that helped me shape those diaries into a readable form. I thank her for her patience and her skill at plotting a path for me.

Wrexie Bardaglio encouraged me very early on to keep the more intimate voice of my journals intact as I shaped the narrative. She is a poet and brought her ear and guided me as I rewrote and refined some of my scattered notes. Then she sharpened her pencil to review as a proofreader to clean up my general carelessness.

Elizabeth Wise Doublet brought her considerable journalistic experience and skills to the table for me. She has perfect pitch and guided me through a thoughtful editing of the organization and flow. She helped me think through some impressions and encouraged me to express more clearly what I was only hinting at. Finally, she researched references to places and names, often difficult because of the inconsistent phonetic translation from Hindi or Sanskrit, and attempted to clean up my uneven first-person tense. Her gentle encouragement was a constant voice. I can't thank her enough for that.

Most of all, the person responsible for virtually all of this is Trevor Potter. He enthusiastically supported my many trips to India and he guided the process of organizing the exhibition in London. This journey has not been without its complications. The exhibition and publication of this book were scheduled for mid-2020. The effects of COVID-19 made this project seem unlikely and his calm approach to rethinking possibilities tempered my disappointment and anxiety. I thank him for everything.

For TP

G Editions

www.geditions.com
media@geditions.com

Copyright © 2022 by Dana Westring
Preface © 2022 by Gayatri Rangachari Shah
Foreword © 2022 by François Borne

All rights reserved. No part of this publication may be reproduced in any form or by any electronic or mechanical means, including information storage and retrieval systems, without permission in writing, except by a reviewer who may quote brief passages in a review.

First edition, 2022

Library of Congress Cataloging-in-Publication Data is available from the Publisher.

Hardcover edition ISBN 13: 978-1-943876-20-4

Design: Christoph Stolberg

Printed and bound in China

10 9 8 7 6 5 4 3 2 1

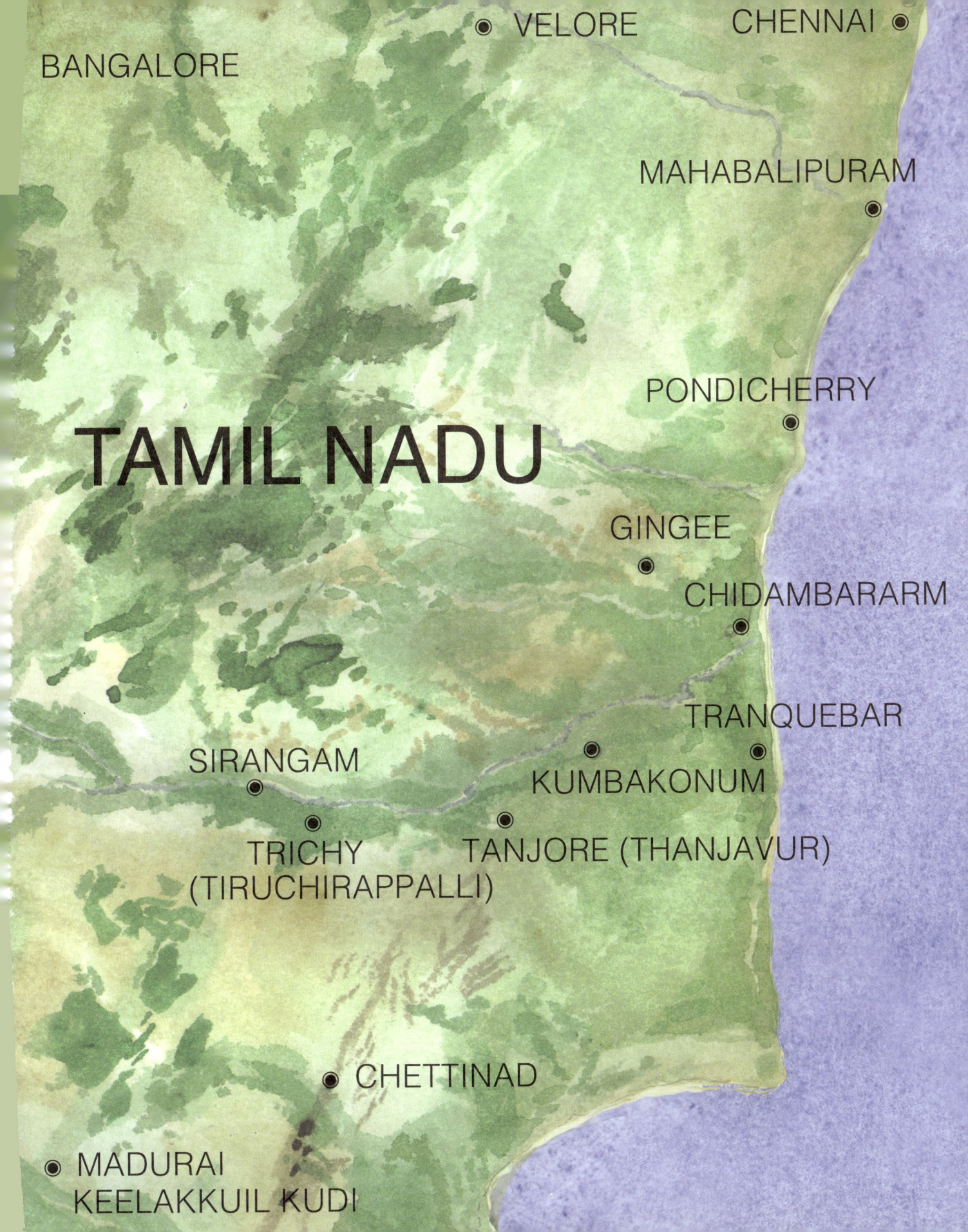